Center for Basque Studies
Conference Papers Series, No. 2

Learning from the Bilbao Guggenheim

EDITED BY

Anna Maria Guasch and Joseba Zulaika

Center for Basque Studies
University of Nevada, Reno
Reno, Nevada

This book was published with generous financial support from the Basque Government.

Center for Basque Studies
Conference Papers Series, No. 2
Series Editors: Joseba Zulaika and Cameron J. Watson

Center for Basque Studies
University of Nevada, Reno
Reno, Nevada 89557
http://basque.unr.edu

Library of Congress Cataloging-in-Publication Data

Library of Congress Cataloging-in-Publication Data

Learning from the Bilbao Guggenheim / edited by Anna Maria Guasch and Joseba Zulaika.
 p. cm. -- (Center for Basque Studies conference papers series ; no. 2)
 Papers given at the conference held Apr. 22-24, 2004, Reno, Nevada.
 Includes bibliographical references.
 ISBN 1-877802-50-6 (pbk.) -- ISBN 1-877802-51-4 (hardcover)
 1. Museo Guggenheim Bilbao--Congresses. 2. Gehry, Frank O., 1929–Criticism and interpretation--Congresses. 3. Architecture and society--Congresses. 4. Bilbao (Spain)--Buildings, structures, etc.--Congresses. I. Guasch, Ana María. II. Zulaika, Joseba. III. Title. IV. Series.

 N3412.4.L43 2005
 708.6'63--dc22
 2005001766

CONTENTS

Part IV: The Local/Global Dilemmas

Part V: The Masterpiece

Introduction

Learning from the Bilbao Guggenheim: The Museum as a Cultural Tool

ANNA MARIA GUASCH
JOSEBA ZULAIKA

> The word is out that miracles still occur, and that a major one is happening here… "Have you seen Bilbao?" In architectural circles, the question has acquired the status of a shibboleth. Have you seen the light? Have you seen the future?
>
> —Herbert Muschamp on the cover of the
> *New York Times Magazine*, September 7, 1997

That future is now. What can we learn from "The Guggenheim Effect"?

The "miracle" referred of course to Frank Gehry's Bilbao masterpiece. Hailed as an "instant landmark," it brought a new sense of relevance to architecture in the transformation of urban landscapes. It was the story of the architect as hero and, as the Greeks believed, of architecture as the first art—*arché*. Bilbao was doing for the Basques what the Sidney Opera House had done for Australia. Gehry, while complaining of being "geniused to death," became not only the master architect, but the master artist. "Why all the hoopla?" Hal Foster wondered.[1] Wasn't Gehry's museum risking the most problematic aspects of modernist monumentality and postmodernist faux populism?

Thomas Krens's media-driven transnational concept for the Guggenheim, with rumored satellites everywhere, has turned out to be, in the museum world, the historic novelty of the 1990s. They were initially derided as "McGuggenheims," but the success of

1. See Hal Foster, "Why All the Hoopla," *London Review of Books* 23, no. 16 (August 23, 2001). At http://www.lrb.co.uk/v23/n16/fost01_.html as of January 11, 2005.

Bilbao provided respectability to Krens's plans. The new museum's "strong operational synergy" meant that Krens determined everything from New York: the works to purchase, the exhibits to organize, the artists to promote. Even if the post 9/11 world appears to have cut Krens down to his pre-Bilbao size—his SoHo and Las Vegas branches have already closed, his Internet museum evaporated, and the projected new Gehry East River Guggenheim in lower Manhattan was definitely abandoned—there is a lot to be learnt from the "Guggenheimization" of museums as institutions in a period that has seen an unparalleled expansion of the number and diversity of museums. Beyond being repositories of works of art, exhibition sites, architectural landmarks, and heritage narratives, museums embody as well various competing ideologies, historicities, and practices of display and legitimation. The "Krensification" of the museum is one such historical structure that prompts questions as to what is its most proper public, what are its strategies of collecting, what discourse or spectacle has become hegemonic, and what is really being displayed in Bilbao.

Museums of contemporary art not only represent one of the most important architectural challenges in the public domain, but they also clearly reflect the ideas that underpin them. And although the museum is principally studied as regards its use, aesthetic demands, and urban design and function, it can also be analyzed as an example of the institutional system of art. From this perspective, one can speak both about the museum as a cultural instrument and about the "museification" of culture itself, all this in a circular network where museums constantly reinvent their discursive strategies through their core functions: collection, conservation, exhibition, and education.

The museum is fast becoming the new paradigm of contemporary culture. We should, therefore, address its discursive role, which is not just about the collection of objects it stores but also the place where different discourses relative to these objects converge. In other words, at present, it would appear that the museum is more interested in strategies linked to its own definition of works of art and its own museification than in the self-referential quality of the artwork itself.[2] This is where the growing visibility of the museum stems from, a visibility evident not just in the construction of new buildings, the expansion of existing sites, the selling of its products and services, and the notable increase in visitor numbers, but also in its role in cultural politics. The museum has become a powerful instrument in a new version of the culture industry; an industry that has recently grown at such an enormous rate that neither Horkheimer or Adorno could have imagined such dimensions when they originally drew up their critical theories of mass culture in which homogenization—including the standardization of products and consumer behavior—was inherent in media culture.

And now, at a time when one is obliged to talk about the globalization of the art system (and indeed of culture in general), or "globalized museification," any examination of the museum and its meaning implies switching attention from the more limited terrain of

2. See Christine Bernier, *L'art au musée: De l'oeuvre à l'institution* (Paris: L'Harmattan, 2002), p. 5.

art to the more general one of culture. This is undoubtedly a key idea in explaining events free of a historicist, causal, or finite burden. The museum is not just a neutral container where an art collection is stored and presented, but it also becomes a "place"[3] where the institution itself reconsiders its relationship with the public to the extent that its exhibits are transformed into the most powerful legitimizing discursive practice within the art system. It would, then, appear difficult to escape this globalized museification, one of whose most obvious paradigms is to be found in Bilbao's Guggenheim Museum, a clear monument to American cultural hegemony over Europe.

In this sense, the Guggenheim, the first global museum, appears to have marked the end of a long process in which the museum, as both an institution and a building, has been the object of widespread cultural debate. Museums as we know them today are a relatively recent phenomenon whose origins date from the late eighteenth century, with the foundation of the British Museum in London and the Louvre in Paris. These institutions replaced what had, from Renaissance times onward, dominated the concept of a museum, namely, a private space for seekers of wisdom, philosophers, and historians. The Renaissance museum accumulated collections made up of all kinds of objects, displayed in *studiolos* or studios full of curios that would eventually be opened up to the public. However, in general, one individual generally reserved the right (and power) to alter the exhibition of these objects.

With the advent of the "modern" museum, objects were imbued with new meaning by which, on being incorporated into their new surroundings, they were conferred with the status of works of art: As a result, the museum transformed the object into an artwork. And from this moment on, the museum took on a double task: protecting the object ("the wealth of a national heritage"), thereby setting itself up as the guardian of a particular collective memory and a reserve of the past, and educating the general population by making the aforementioned objects accessible through the basic principles of democratizing culture.

This is how the museum as container was born. It was, furthermore, structured according to the following design: four walls, with light emanating from above, and two doors (an entrance and an exit), with the single basic aim of conserving these works belonging to distant cultures and transmitting them to future ones. The museum was thus born into a society partly influenced by Platonic ideals, a society that valued the stable, eternal, and atemporal, the essence of opposition to transformation, change, and the ephemeral. This was not a culture that accepted the consequences of time, but rather that sought to dwell endlessly on its own objective symbols.

Soon, however, critical voices began to emerge regarding this museum, a place absent from any place, located outside time in the empirical vision of nineteenth-century society. For example, Filippo Tommaso Marinetti in his "Futurist Manifesto" of 1909 declared that museums were no more than "public bedrooms," and superfluous in a world whose

3. Ibid., p. 12.

glory had been enriched by the beauty of speed. He judged a race car to be more beautiful than the Winged Victory of Samothrace, since there is no need to store and display it.

Similarly, a few years later, at a time when contemporary art was still excluded from French museums, Paul Valéry, in a short essay entitled "Le problème des musées,"[4] compared the museum to a warehouse, where works of art are merely accumulated and juxtaposed: "Our treasures overwhelm and bewilder us. The need to concentrate them in one building exaggerates its overwhelming and cheerless effect. We're always a little lost and disconsolate in these galleries, alone against so much art… What results from this proximity to dead visions is senseless. They are jealous of one another and vie for the attention that defines their existence." Valéry considered museums "resting places of incoherence," spaces resembling temples, living rooms, cemeteries, or schools, without any connection to the present, spaces where at the end of day the art of the past is left to die.

Marcel Proust, in a brief reflection on the museum in 1919,[5] offered another point of view, concentrating on the moment where Valéry stopped: the "life after the death of a work," in which one vision—that of its maker in a studio, who is able to conceive of the museum only as a place of "reification"—is replaced by another: that of the spectator of art in a museum. As Hal Foster argues, "for an idealist spectator like Proust, the museum is a kind of phantasmagoric perfection of the studio, a spiritual place where the material disorder of artistic production is distilled and where the rooms, in their sober abstinence of any decorative detail, symbolize the interior spaces to where the artist retreats in order to create the work."[6] The same year that Proust reflected on the museum as a space of spiritual idealization, Wilhelm R. Valentiner, curator of decorative arts at the New York Metropolitan Museum between 1908 and 1914, in an unforgettable essay entitled *Umgestaltung der Museen im Sinne der neuen Zeit* (Redesigning the museum for modern times)[7] formulated an idea of the museum as a "place" out of which arts emerged from isolation and converged toward a "work of total art" (*Gesamtkunswerk*). For that reason, instead of concentrating on the formal design of the museum, he focused on its contents by juxtaposing and combining the greatest works (represented by masterpieces) with examples of decorative art. His ultimate objective was that the museum should appear neither like a "palace" nor like a "warehouse." (The intermediary form would be termed a "palace for the people.") At the time, this was seen as a way of entertaining tourists,

4. Paul Valéry, "Le problème des musées," in *Pièces sur l'art* (Paris, 1934). In Spanish, "El problema de los museos," in *Piezas sobre arte* (Madrid: Visor, 1999), pp. 137–140.

5. Marcel Proust, "A l'ombre des jeunes filles en fleurs" (1919), in *À la recherche du temps perdu*, vol. 2 (Paris: Éditions Gallimard, 1925–1932). In Spanish, *A la sombra de las muchachas en flor* (Barcelona: Lumen, 2001).

6. See Hal Foster, "Archivos de arte moderno," in *La conquista de la ubicuidad*, ed. José Luis Brea (Murcia: Centro Parga; Gran Canaria: CAAM; San Sebastián: KM, 2003), p. 24. In English, "Archives of Modern Art," in *Design and Crime and Other Diatribes* (London: Verso, 2002). Here Foster refers to the essay by Proust, "A l'ombre des jeunes filles en fleurs" (Paris: Éditions Gallimard, 1919), vol. 2, pp. 62–63.

7. See Monika Flacke-Knoch, "Wilhelm R. Valentiners Museumskonzeption von 1918 und die Zeitgenössichen Bestrebungen zur Reform der Museen," *Kritische Berichte*, nos. 4–5 (1980): 49–58.

and it might also be regarded as the search for some sort of meeting place between art and the general public.

This (to some extent) populist vision of the museum as entertainment was radically opposed to what Walter Benjamin proposed a decade later in his essay "The Work of Art in the Age of Mechanical Reproduction."[8] Here Benjamin argued that, by removing art from tradition and its aura—a consequence of the new possibilities to reproduce it mechanically—one could observe a definitive break in the nature of the museum. As a result of this, he conceived of a new museum where the cultish appeal of art would be replaced by its exhibition value, that of creation directed toward both the market and the museum. In effect, Benjamin identified two ways of appraising art: in terms of its cult or ritual appeal (the value of an authentic work of art based on ritual) and its exhibition value. And indeed, only when the new reproductive technology diminished the authority (and thus the value) of the cultish approach to original works of art would the emphasis shift to its exhibition appeal, a value whose justification was based on a machine-driven and merchandise-driven world. Even though Benjamin referred to museums in cryptic terms—generically terming them "public collections"—it is clear that his notion of them was closely connected to the cultural values of a given time and its immersion in the economic and consumer values characterizing that moment. As such, together with his denial of the traditional notion of the museum as a cultish temple for authentic works of art, Benjamin also highlighted a shift in the capacity for experience stemming from the auratic contemplation of a work of art on behalf of a social response.

It was not until the post–World War II era that a significant change took place in the strategy of Western museums, in the sense of liberating the museum from the traditions of antiquated architecture and promoting its "free" form through the framework of specific projects. These transformations, in most cases, would affect the museum more as a building than as an institution.

One exception, however, was the "museum without walls" or "imaginary museum" of André Malraux.[9] This was a project that would come about, according to Malraux, thanks to certain advances in technologies associated with mechanical reproduction (photographs would substitute for the originals, forming a complete collection of all the works of art in the world, while also including Malraux's personal vision of the art world)[10] and responded to what he termed "the persistent life of certain forms that emerge over and over again as specters of the past." In Malraux's museum, architecture in itself was barely a topic of debate (in fact, his imaginary museum would be derived from a Renaissance

8. In *Illuminations*, ed. Hanna Arendt (New York: Schocken Books, 1969), p. 255.

9. The first edition of Malraux's *Musée imaginaire* was published in 1947. The second edition was published as the first part of the *Voix du silence* in 1951. Here we consulted the Spanish version: "El museo imaginario," in *Las voces del silencio: Visión del arte* (Buenos Aires: Emecé, 1956), pp. 10–126. In English, *The Voices of Silence* (Princeton: Princeton University Press, 1978).

10. While for Walter Benjamin mechanical reproduction replaces tradition and destroys aura, for Malraux, it furnishes the necessary means to reunite the fragments of tradition, thereby creating, as Foster argues, a metatradition of global styles: a new museum without walls whose motif would be the family of man. See Foster, "Archivos de arte moderno," p. 78.

palace with a series of spaces set out in a "row"), and as a counterweight, the power of this museum as an institution would be focused on the comparative effect that it derived from juxtaposing all kinds of different objects, beyond the traditional hierarchies of high and popular art. Malraux's imaginary museum—argues Rosalind Krauss—was, in fact, another way of writing "modernity" and reopening the aesthetic notions with which modern art was created, ultimately centered on the idea of an autonomous art, an idea of art that could be explained from the starting point of *l'art pour l'art*. The imaginary museum made it possible to experiment with autonomous power in the same way that the two principal ways of decontextualizing art operate. In the first of these, works of art are removed from their places of origin and, through an immersion in the museum, all connection with the (representational or ritual) use for which they were originally created is broken. In the second, the works, thanks to their incorporation into a place of reproduction (consisting of many forms, such as books about art, postcards, posters, and so on) are separated from their original scale and each work, whether large or small, is on a par with all the others, thanks to the democratizing effects of the exhibition hall or of the press.[11]

However, the postwar era in which Malraux wrote his essay also witnessed another museum type or paradigm that was especially prominent in Europe and the United States: the "white museum" of modernity, the "universal space" of Mies van der Rohe, and the unembellished container proposed by Jean Cassou[12] as a museum model that went beyond all ideologies and expressed a material form of art close to notions of neutrality, minimalism, and vastness. Brian O'Doherty[13] defines this white cube as a transitional mechanism that attempts to erase or make a tabula rasa of the past while at the same time controlling the future using transcendental forms of presence and power. It is through this space, devoid of any decoration, where the walls assume an ambivalent existence somewhere between a vigorous presence and complete invisibility, that a neutral, pure, and absolute context is sought for the works of art, uncontaminated by the intrusion of human beings. This is the context that would support the notion of the spectator as an "incorporeal eye," or an eye that would perish on entering the "white cube." "In the classic galleries of modernity," points out O'Doherty, "one cannot speak, nor laugh, eat, drink or sleep. In effect, since the 'white cube' encouraged the myth that we are essentially spiritual beings (the eye is 'the eye of the soul') the spectator has been conceived of as free of any vicissitudes or sudden changes."[14] It is, as Thomas McEvilley highlights, like the Platonic vision of some lofty metaphysical king in which form is completely discon-

11. Rosalind Krauss, "Postmodernism's Museum without Walls," in *Thinking about Exhibitions*, ed. Reesa Greenberg, Bruce W. Ferguson and Sandy Nairne (London: Routledge, 1996), pp. 344–45.

12. Jean Cassou, "Art Museums and Social life," *Museum* 2, no. 3 (1949): 155–58. See also C. Duncan and A. Wallach, "The Universal Survey Museum," *Art History* 3 (1980): 448–69.

13. Brian O'Doherty, *Inside the White Cube: The Ideology of the Gallery Space* (Berkeley: University of California Press, 1999).

14. Ibid., p.10.

nected from the life of human experience. Revived in part as a compensatory reaction against the decline of religion, although falsely promoted by our culture into the immovable terrain of mathematics, the notion of pure form dominated the aesthetics out of which the white cube emerged.[15]

The adoption of the white cube model by a large number of modern museums, among which the Museum of Modern Art (MoMA) in New York figured prominently, was paralleled by an increasing tendency toward abstraction. The modern museum, abstract art, and the white cube would thus enter into a symbiotic relationship, excluding all references to the complex world beyond the dominion of pure form. And in this way not only was the decontextualization through which the traditional museum operated reinforced, but also the museum itself was transformed into an object of pure aesthetic appreciation. From here, one can deduce the success that the white cube owed to this strategy of disappearance or invisibility and simultaneously of self-denial.[16] What was important here were the inherent (or formal) qualities of a work of art through the neutralizing of its original context and the religious, political, and symbolic features that previously defined it.

However, as Theodor W. Adorno pointed out,[17] the museum as container, the clearest epitome of the "modern museum," the neo or latest modern box, whose "neutral" characteristics can be found in any number of "architect-free" museums associated with modernity, ends up operating like a metaphor for the anarchic production of consumer products in a mature bourgeois society. The prototype of the "modern object," according to Adorno, taking into consideration the reflections made some years earlier by Paul Valéry, would deprive objects of their own life and would also monopolize certain fields of vision, forming a power strategy linked to hegemonic capitalism. This would lead Adorno to his well-known comparison of the museum to a mausoleum and the consideration of museums as tombs for works of art that would only neutralize culture itself.

The first reactions against the white cube and Adorno's association of the museum with a mausoleum began to emerge during the last stretch of modernity, specifically at the end of the 1960s. At that time, the emerging-counterculture, in the name of life and a cultural renaissance and against the dead weight of the past, saw in the modern museum a symptom of cultural ossification. As Andreas Huyssen demonstrates, museums had come to a halt in the dead eye of the storm of progress, serving as catalysts for articulating notions of tradition and nation, heritage and the canon, providing the master charts for the construction of cultural legitimacy in both a national and a universal sense.[18]

15. Thomas McEvilley, "Introduction" to *Inside the White Cube*, p. 11.

16. Christoph Grunenberg, "The Modern Art Museum," in *Contemporary Cultures of Display*, ed. Emma Barker (New Haven: The Open University and Yale University Press, 1999), p. 31.

17. Theodor W. Adorno, "Museo Valéry-Proust," in *Prismas: La crítica de la cultura y la sociedad* (Barcelona: Ariel, 1962), pp. 187–200. In English, "Valery Proust Museum," in *Prisms*, ed. Theodor Adorno (London: Garden City Press, 1967), pp. 175–85.

18. Andreas Huyssen, "Escape From Amnesia: The Museum as Mass Medium," in *Twilight Memories: Marking Time in a Culture of Amnesia* (London: Routledge, 1993), p. 13.

It was time for the museum to stop being a temple or an alterlike treasure house and start renewing its contact with the present, to seek a new narrative of legitimacy beyond even the material quality of its own objects, a material quality that had provided an empirical foundation for nineteenth-century ideas of civilization as material progress. As a result, already toward the end of the 1970s, new museum typologies began to emerge: the "museum of the information society" that to a certain extent responded to new social structures in which industrial society had given way to the information society. The role of the museum as an "elitist place," as a bastion of tradition and high culture, thus gave way, as Huyssen argues, to its role as a "mass medium," as the place for a spectacular performance, which in turn directly affected policies of exhibition and contemplation. Both the reversal of older priorities between permanent collections and temporary exhibits and the attempt to articulate a critique of the privileged concepts of uniqueness and originality undoubtedly provoked a radical change of expectations on the part of the public. As a result, the museum, from originally being a place of cultural knowledge, was transformed into a key paradigm of institutional criticism, with the institution understood here not only as one of the agencies of distribution, but also the as one of the aesthetic institutions that include the formal elements and organizing principles of the works of art.

Perhaps one of the most paradigmatic examples of the mass-medium museum was, without doubt, the Centre Georges Pompidou in Paris (1971–77). Designed by Renzo Piano and Richard Rogers, this project was transformed into a manifesto proclaiming a new direction in construction, somewhere between the organic building represented by Frank Lloyd Wright's Guggenheim in New York and the minimalist white cube. In its bid to democratize culture by breaking the traditional boundaries between high art and mass culture, the Pompidou was the first museum to apply multiple perspectives. But above all, it was the first to which one could attribute the notion that an institution could be special without being localist. The Pompidou discovered a new kind of public, one more closely associated with the tourist industry and the renovation of urban economies and, despite the negative considerations of Jean Baudrillard that the museification of the Pompidou was just one way of hiding the "real" through simulation,[19] its spectacular creation, fetish value, and great public success make it the most immediate reference for the postmodern museum and for the symbiosis between postmodern architecture and new "museistic" buildings.

With postmodernity and new buildings such as James Stirling's Stuttgart Staatsgalerie in Stuttgart (1977) or Hans Hollein's Museum of Modern Art in Frankfurt am Main (1991), both reference points for an architectural genealogy that would soon spread

19. In *L'effet Beaubourg: Implosion et disuasion*, Baudrillard defines the Pompidou as the "monument to mass simulation games" that operated like an incinerator, absorbing all cultural energy and devouring it. The Pompidou, argued Baudrillard, is like a machine to produce emptiness. It is a little like nuclear power plants: Their real danger wasn't safety, pollution, or a possible explosion, but the system bigger safety system that surrounds them. And the same model that was used for nuclear power plants, a model of absolute safety that generalizes everything in the social field and that is also a deterrent model, was also used for the Pompidou: cultural fusion and political deterrent. See Jean Baudrillard, *L'effet Beaubourg. Implosion et disuasion* (Paris: Galilée, 1983), pp. 10–11.

through the United States, Europe, and Japan, the museum became a new type of communal building termed the "cathedral of our time." Every city, even the smaller ones, attempted to make their museums social catalysts, with typologies and iconographies that reflected a new kind of public appreciation for old buildings. The ritual of visiting museums and seeing art thus increasingly came to prevail the world over. Architecture was everywhere, and the public appetite for it was insatiable.[20] However, instead of a museum whose principal distinction was its invisibility or the silent contemplation of works of art, now the new spaces seemed to embody Malraux's fictional notion of the museum without walls. In other words, it had become a network of asymmetric relations and decentered movements where all stylistic and chronological sequence had disappeared, where space and temporality were valued at the expense of history, and where a visit to the museum had become an example of how art and architecture critically operate within the museum itself.

These new "flexible use" museums were conceived not just as architectural emblems, but also as urban catalysts and ambitious aesthetic mechanisms that allowed their creators to demonstrate their expertise in architecture and knowledge of art history. And although any real innovation or progress as regards the design of exhibiting spaces was minimal, there was a powerful interweaving of concepts and plans for new museums within more general projects of urban renewal, giving cities a facelift and a new lease on life. And this is how museum buildings became seismographs of contemporary architectural culture at the same time as the came to represent the attitudes of their architects toward architecture. As Vittorio Magnano Lampugnani argues, these museums are "works of art" that house other works of art and, generally, in this conflict, the works of art they house are relegated to a secondary level, with architecture establishing its absolute supremacy over art:

> The architecture of the museum becomes the favorite place for architects. And while it is a platform for presenting new and different styles, it ends up imposing a kind of "love of oneself," the same persistent way, and above all the same indifference towards the true challenge of the building. But architects are only responsible for this to a certain extent. Their authority depends on the client, the community, the sponsor, the curator, who in turn consult artists and the public. Their authority, though nothing more than their program, is by nature social. The fragility and fortifying of museum architecture is a direct product of the society to which it belongs.[21]

Although this is indeed a *society*, it is one where art runs the risk of being ranked on the same level as entertainment, instead of being understood as a means of learning.

The fact that museums have to grow or expand is something that one now takes for granted, which explains the proliferation of new museums throughout the world, designed

20. Vittorio Magnano Lampugnani, "The Architecture of Art: The Museums of the 1990's," in *Museums for a New Millennium: Concepts Projects Buildings*, ed. Vittorio Magnano Lampugnani and Angeli Sachs (Munich: Prestel, 1999), p. 14.
21. Ibid.

by the most prestigious international architects: Renzo Piano, Frank Gehry, Mario Botta, Richard Meier, Jean Nouvel, Santiago Calatrava, Yohio Taniguchi, Daniel Libeskind, Herzog and De Meuron, Zaha Hadid, Tadao Ando, Rem Koolhaas and Norman Foster. "Expand or perish!" exclaimed Thomas Krens, the director of the Solomon R. Guggenheim Museum in New York, on his arrival there in 1988, at a moment when it seemed to be undergoing a profound crisis as a result of a precarious financial situation and a huge collection shut away in warehouses. And instead of concentrating all his efforts in one place, as was the strategy of MoMA in New York, or seeking multiple locations in the same place, as was the case with the Tate Gallery in London, Krens had no hesitation in a formulating a new and radical policy, foreshadowing what would be the museum model of the twenty-first century, the model of a global museum, indeed, the first global museum. This model might be summed up in the following statement: "All a museum needs are great collections, great architecture, a great special exhibition, a great second exhibition, two shopping opportunities, two eating opportunities, a high-tech interface via Internet, and economies of scale via a global network."[22]

From this precept one of the main ambitions of the Solomon R. Guggenheim Museum, or what was termed the "Guggenheim Consortium" under the managerial leadership of Thomas Krens, was to become an international chain of satellite institutions operating in semiautonomous fashion, in what might be considered one of the boldest plans to reactivate the postmodern museum from the basis of a new economy emerging out of nascent globalization.

Old museums should be put to one side not only by politicians, but also by the public, in favor of new, spectacular, glittering, brilliant, and exciting museums with new, futuristic architectural visions unimaginable a few years before, which would foster not only excitement, but pride on the part of their visitors. We might, then, as James Cuno argues,[23] talk in terms of a new museum paradigm: the "exciting museum" as a museum type capable of responding to the economic problems of a given region and contributing to its own political future. This notion of the "exciting museum," of a museum that captures one's attention and excites the visitor, has also been put forward by Victoria Newhouse.[24] Her favorite example is Frank Gehry's Guggenheim Museum in Bilbao, a museum that has become a "catalyst for the new art." And while previously museums were identified by their collections, now this is by their architecture: In other words, the dominant image is the container, rather than the content. In this sense, the Guggenheim Bilbao is a brilliant museum that demonstrates that now museums don't vie with one another on the basis of their collections, but rather that they have come to represent their cities and indeed may form the basis of urban regeneration in these urban conurbations.

22. "Hip vs. Staley: The Tao of Two Museums" *New York Times*, February 20, 2000, p. 50.

23. James Cuno, "Against the Discursive Museum," in *The Discursive Museum*, ed. Peter Noever (Vienna: Hatje Cantz, 2001), p. 45.

24. Victoria Newhouse, *Toward a New Museum* (New York: Monacelli Press, 1998).

And the Guggenheim Bilbao shows that it is possible to promote an entire city, beyond just creating a collection of art.

The picture coming from Bilbao is a complex one that, besides museums, architecture, and art, also has something to do with tourism, urban renewal, economic growth through cultural industries, and the effect of a single flagship project on the transformation of the image and reality of a city. In fact, it has been labeled a "Cinderella story." As a result, after Bilbao, every city has dreamed of its own Guggenheim Effect. Gehry's optimistic artichokelike building (or is it, as has been said, the reincarnation of Marilyn Monroe?) amid Bilbao's postindustrial ruin has become an icon of what architecture can do for a city in decline. Andy Warhol seems to be right in his prognostication that every museum should become a supermarket. In the process, some the obvious lessons will come from addressing the asymmetries implicit in the Cinderella version of the New York/Bilbao relationship; the role of flagship developments in the revitalization of cities, the cultural implications of architecture as spectacle and ideology; the interactions between the art community, auction houses, and Wall Street capitalism; the formation of new capitalist hierarchies, whereby capital and consumption are local, but franchise control is international; the museum as institution seeking legitimacy in symbolizing the new imperial order; and the Benetton strategy of intertwining the politics of artistic representations with postmodern consumerist techniques.

Gehry's building, together with the museum idea dreamed up by Krens to make the Guggenheim an international corporation interested in questions of growth and expansion, as well as stimulating business in the visual arts, have, without doubt, put Bilbao on the map. Indeed, they have probably also contributed to improving the city and to its clear economic recovery. However, many questions still arise as a result of this strategy of a global policy: Is cultural colonialism less disagreeable than its economic or political equivalent? Is it legitimate to promote a museum model that encourages universal cloning, as opposed to supporting more potentially distinctive dimensions? Or how does a branch museum interact with its local artistic community? Does such a museum's general program support artistic activity in its local community, that is, in Bilbao and, by extension, the Basque Country?

The symposium "Learning from the Guggenheim," held at the Nevada Museum of Art in Reno from April 22 to April 24, 2004, attempted to answer these and many other questions. Twenty-one experts on the subject—artists, architects, art historians, anthropologists, art theorists, town planners, economists, museum directors, and tourism experts—were invited to establish a dialogue and find common ground from an interdisciplinary perspective while addressing numerous aspects of the Guggenheim Bilbao Museum. In the following chapters, **Jon Azua** analyzes the phenomenon by which the Guggenheim in Bilbao, located (like the Walt Disney Concert Hall in Los Angeles) in an abandoned or semi-abandoned urban area, has become a civic catalyst functioning as a key agent in a significant urban transformation. **Javier Viar** provides an overview of Bilbao's museum history that situates the novelty of the globalizing New York institution,

together with the role of the Guggenheim in revaluing and invigorating the already exis-tent Fine Arts Museum. The Guggenheim Bilbao constitutes not only a remarkable con-struction project in the public domain, but also, as **Jeremy Gilbert-Rolfe** argues, reflects the materialization of architectural positions that shaped it, while at the same time becom-ing a seismograph of shifts in contemporary architectural culture. The true effect of the Centre Georges Pompidou lay in the "brutal" work of its architects, more than in any analysis of its permanent collection. Such is the case, contend **John Welchman** and **Beat-riz Colomina**, with the Guggenheim, whose emblematic authority lies both in Frank Gehry's design and in the way in which the building itself is perceived as an ensemble of space that can lead us into the sculptural, as well as architectural realm. This is what is known as "sculptural architecture," implying the redefinition of the museum's spatial sequence as a collection of expressive forms that cannot be defined in terms of tradition-al concepts.

On the other hand, the notion of developing an international chain of museums where works of art, instead of being confined to a permanent home, are exhibited in changing locations and under varying local conditions—a new version of the franchise—is explored by **Serge Guilbaut**, **Ery Camara**, and **Joseba Zulaika**. **Allan Sekula, Antoni Muntadas**, and **Hans Haacke**, meanwhile, examine how the museum, beyond the "McDonald's syndrome" of being a corporation whose potential expansion depends sole-ly on opening up new branches, can also become a powerful metaphor for cultural busi-ness in the context of a new global economy. The museum as an exponent of a new cul-ture born out of the necessities of global tourism is addressed by **Dean MacCannell**, **Lucy Lippard**, and **Andrea Fraser**. **Anna Maria Guasch** analyzes the ways in which the global interacts with the local (both national and regional) together with the question (among others) of whether the Guggenheim Museum could have been managed better by a team of local conservative politicians, with their own particular geographic and cul-tural perspectives, rather than from some central offices in Manhattan. And in the con-text of a growing globalization where the differences between center and periphery have disappeared, **Keith Moxey** analyzes how the museum not only serves as a metaphor for the fluid and labile nature of aesthetic value, but also becomes a place where aesthetic issues are questioned, rather than answered.

Part I

"COME TO BILBAO"

The Fate of the Symbolic in Architecture for Tourism: Piranesi, Disney, Gehry

DEAN MACCANNELL

The reason for visiting a place may have nothing to do with its architecture. However, within a touristic frame, architecture is always in play. Architecture provides context, even when it is not the primary object of attention. At O. J. Simpson's house on Bundy Drive in Los Angeles, Jim Jones's Church in San Francisco, and the Book Depository in Dallas, for example, the generic architecture serves to underscore the banality of evil.

At historical attractions, the fame of the building *as architecture* can eventually eclipse the fame of memories and famous or infamous figures associated with it, simply by outliving the memory or the figure. This has been the trajectory of Sainte Chapelle in Paris. It was built in the middle of the thirteenth century by Pierre de Montereau to serve as a container for the "true Crown of Thorns," which France had purchased from Baldwin of Constantinople for F 3 million. The "true Crown of Thorns" fiasco is long forgotten, but Sainte Chapelle stands as a "perfect gem of Gothic architecture."[1]

Within a touristic frame, it makes little difference whether it is the architecture that is foregrounded or something else about the site. Everything tourists visit is symbolic of human achievement or error, of our dependence on nature (ecotourism), of our ability to harness nature (the Grand Coulee Dam), of other monumental successes or failures, of natural and historical miracles and disasters, of hope and despair, of victory over adversity, of the virtues and vices of tradition and of the avant-garde. As a class, tourist attractions, architectural and all the other kinds, share a common social footing. They are all symbols or they function symbolically. It is their "symbolicity" that makes them stand out from others of their class as objects of veneration.

From an architectural standpoint, this is not necessarily an appropriate way to approach the built environment. Jeff Kipnis has remarked, "I do not think architecture's

1. According to Karl Baedecker, *Paris and its Environs: Handbook for Travelers* (New York: Macmillan Travel, 1995), p. 222.

primary function is symbolic. I am particularly loathe to read the embedded cultural codes of a project."[2] I agree with Kipnis that this kind of reading should not necessarily be attempted by architects and architectural critics. But it is central to understanding the gathering of tourists around a building. And I think that if symbolic analysis is done with sufficient sensitivity and precision, it may be possible to get beyond symbolism to some of the issues of which Kipnis would approve.

The Guggenheim in Bilbao has no more inherent right to stand as a symbol of the Basque region than a locally distinctive telephone box or vegetable. (The Basque region is also known for its gastronomic "Bean Route.") The Guggenheim had to *earn* the right to represent. It is said of Frank Gehry, sometimes in the same breath, that his architecture is both old-fashioned and completely new. This paradox may be clarified by an examination of the connection of his work to the symbolic. Gehry's buildings are not superficially referential or casually symbolic. In what follows, I suggest that Gehry's buildings rigorously and accurately model the structure of the symbol itself. In this respect they are as old as any of our adaptive human cultural arrangements. The second part of my argument is more contentious. Specifically, design for tourism, from Piranesi to Disney, as found in Piranesi's "Views of Rome" and at Celebration, Disneyland, the Mall of the Americas, and so on,[3] has been driven by a desire to foreclose the possibilities inherent in the symbol, and it is antisymbolic, that is, modeled on the symbol, but opposed to the potential inherent in the symbol. Gehry's work appears to be "new" because he has inserted symbolic structures, properly so called, into a terrain—tourism—and into a consciousness that is teeming with pseudosymbols of the Piranesi-Disney type.

In 1979, by national referendum, Spain changed its constitution permitting culturally distinct regions to petition for semiautonomous status within the state.[4] Future autonomous regions included Catalunya, Galicia, and Hegoalde, the latter comprising the four provinces that made up the Basque Country, including Bizkaia Province and its capital, Bilbao.

The sometimes violent struggle for Basque autonomy continued throughout the region. A core grievance in this struggle has been Basque resentment at being exploited as tourist attraction by the Spanish national government, France, and Europe as a whole. Even as they grew more economically dependent on tourism at the local level, the Basques resented being marketed in Paris and Madrid as rustic descendents of the Cro-Magnons,

2. Quoted in *Frank O. Gehry: Individual Imagination and Cultural Conservatism*, ed. Charles Jencks et al. (London: Academy Editions, 1995), p. 71.

3. For analysis of Disney's experimental new town of Celebration in Florida, see Dean MacCannell, "New Urbanism and its Discontents," in *Giving Ground: The Politics of Propinquity*, ed. Joan Copjec and Michael Sorkin (London: Verso, 1999), pp. 106–30. For the Mall of the Americas, see Margaret Crawford, "The World in a Shopping Mall," in *Variations on a Theme Park*, ed. Michael Sorkin (New York: Hill and Wang, 1992), pp. 3–30.

4. For the content of the following account, I am indebted to both Bill Douglass and my student and informant, Julie Lacy, who speaks Euskara and who was resident in Bilbao during the building of the museum. See also Julie A. Lacy and William A. Douglass, "Beyond Authenticity: The Meanings and Uses of Cultural Tourism," *Tourist Studies* 2, no. 1 (2002): 5–21.

as the "Indians of Europe." On the French side of the border, the militant secessionist group Enbata linked the region's loss of population and industry to national policies that emphasized cultural tourism. The secessionists argued that the Basque Country was not made just to be the playground of rich bourgeoisie from distant cities. They followed their words with action, blowing up travel agencies, real-estate offices that sold vacation chalets, and the nonnative palm trees planted around the resorts.

The creation of Eusko Juarlaritza, or the Basque Autonomous Government, in 1979 transferred tourism development from Madrid to Euskadi (the Basque name for the autonomous region). In order to balance themselves on their tightrope, the new local tourism planners dropped from their rhetoric all references to rusticity and, for example, to the Basque people as the "Indians of Europe" and began to place more emphasis on natural beauty, gastronomy, jazz festivals, and so on. The previous tourist economy based on rustic imagery and folkloric festivals did not go away, so an effect of the new tourist imagery was to blur and dilute regional identity. The transfer of responsibility for local economic development to the region also permitted the national government to turn up their anti-Basque rhetoric characterizing Basques as terrorists. The regional economy continued its downward spiral. The only economic hope, tourism, remained a contested domain both culturally and politically. In Bilbao, the loss of its iron and steel mills had left the place an abject rust bucket. Investment in a new subway system, airport, and public housing were said by planners to be ineffectual—throwing good money after bad.

The Bilbao museum was thrust up from this local matrix and from some cultural politics in New York of nearly equal intensity. Thomas Krens, director of the Guggenheim in New York, was under criticism for selling off a part of the collection and for compromising the museum's integrity by unsuccessfully (until Bilbao) trying to franchise its name. To succeed, the Bilbao Guggenheim had to accept as its own and somehow orchestrate all these tectonic forces in motion.

According to William A. Douglass and Julie A. Lacy, "there is a Basque card game called *mus*. Like poker, it involves the art of bluffing. The players challenge each other to an all or nothing outcome by declaring *ordago*. 'There it is!'" *Ordago*: the Bilbao Guggenheim. It was a huge gamble. Krens demanded from Eusko Juarlaritza $20 million up front for the franchise name, a commitment of an additional $100 million toward construction costs, the promise of a $50 million art acquisition program, and an ongoing subvention of $7 million annually toward operating costs and upkeep. This was an unimaginably enormous loan against future budgets of the Eusko Juarlaritza ministry of culture. The planners optimistically projected four hundred thousand visitors a year would justify the investment.[5] It was hugely controversial. ETA promised to blow it up, and on opening day, an ETA guerilla was killed attempting to plant a bomb.

What could possibly symbolize an extravagant gamble of this magnitude on a cultural terrain this fraught? *Ordago*!. It is all there in the building, the rugged landscape, shin-

5. See the McGraw Hill *Architectural Record* Web page at http://archrecord.construction.com as of January 11, 2005.

ing historical reference to the region as a center of metallurgy, solidarity, the struggle for independence, economic regeneration, even the desire to blow it up. The *Christian Science Monitor* called it "an explosion of titanium."[6] It is most evidently symbolic of a people who would risk everything on a bluff. Immediately, the image of the Guggenheim became the international icon, displacing the ETA terrorist as the prime symbol of the region. From year one, more than a million people annually have visited the museum. The vast majority of these were from outside Euskadi and almost half from outside Spain. Today, anyone who visits Spain will at least think about going to Bilbao and will express disappointment if they miss it. The people of Bilbao, even those who were displaced to make room for the museum, take pride in it and now embrace it as their own.

Let me briefly recite what we know about symbols, or the symbolic. First, symbols represent what is held in common in the human community: language, law, our most precious beliefs. It is our common hold on symbols that allows us to function together as a human group. They also *represent*. The symbols themselves are not the actual laws and beliefs, just as the words in our language are not the things they name—the diamond is not the agreement to marry and the flag is not the state. Thus, the thing that holds humanity together, the symbol, also perpetually marks the absence of what holds humanity together.

The importance of the symbol to collective life, combined with the absence within the symbol of what it represents, provides humanity with its most perplexing existential problem. Are the roses a symbol of love or a sign of infidelity? Nothing in the roses suggests what the correct answer to the question is. And nothing is more important to our survival *as humans* than our inability to come up with definitive answers based on symbolic exchange. That symbols are occasions of evaluation, interpretation, and, yes, a lot of *guessing*, is what makes humanity different from other socially organized species. There is, of course, enormous resistance to this idea from those who would prefer to think there are *formulas* for success, life, courtship, winning wars, and so on.

The essential problematic of the symbol leads to two opposing symbolic strategies that are deployed throughout life and culture. Both strategies are found in architecture that attracts tourists. The first strategy of symbolic representation is difficult and uncommon. The symbolic object, monument, law, hero, or in this instance, the building, accepts the fact that it marks an absence, acknowledges its incompleteness, and tries to remind us of our collective responsibility perpetually to renew all our social contracts.[7]

Whatever architectural value they may or may not have, Gehry's works are exemplary *symbolically*. They are processual and subversive in the way life must be in order to be called "human." If we listen to the words of the steelworkers on a Gehry building, we can get a sense of the way the construction process is symbolic of life itself. Complaining

6. "Laying the Cornerstone for a City's Dream," *Christian Science Monitor*, July 2, 1997, p. 13.

7. Elsewhere I have written about the way the Vietnam Memorial in Washington, D.C., fulfills its symbolic promise. See Dean MacCannell, *Empty Meeting Grounds: The Tourist Papers* (London: Routledge, 1992), pp. 280–82.

that no room is like another and no floor above repeats the floor below, a steelworker remarks, "just because you got it right yesterday doesn't mean you will get it right tomorrow."[8] The welders often have nothing to stand on and must work suspended in air from harnesses. "We build in virtual space… Usually you are in a square building and you have a floor below you… Here it is wide open." "In a normal building, a few inches off can be rectified. A few inches off [here] could mean a few feet off in another part of the building. It's a disaster… If you are off the corners won't match up and nothing will fit together." "We're doing a lot of things on this job that we have never done before." This is not just a building. It is a parable for human life.

It is also human to want to deny these exigencies. There is a strong desire to believe that everyday life can be cut and dried, repetitive and routine, happy and banal. This leads to the second symbolic strategy. This strategy is the one most in evidence in tourist settings. It dodges or evades the incompleteness at the interior of the symbol. It tends toward superficial referentiality and pretends that what is symbolized is immanent in the representation. These buildings, monuments, laws, heroes, and so on are overstated and deterministic. While invoking "the symbolic," they deny the need for human discourse continuously to negotiate symbolic meaning. Mario Gandelsonas's Harvard Design School lecture on Peter Eisenman illustrates this point. Professor Gandelsonas's design work may be admirable, but his sociology lacks a dimension or two:

> The establishment of society can be seen as the establishment of order through conventions, or more specifically the establishment of a language through symbolic codes. Before order, before language, there exists a primal chaos where there are no rules … there is only an infinite field of potential for manipulation… [T]he making of rules involves at once a repression of chaos, of the amorphous, and the invention of social codes … which express the spatial organization of a tribe.[9]

If society actually had been founded in this way, it wouldn't have lasted a week. If the symbol and the law succeeded in establishing order, if they were not open and incomplete, if they did not permit us to make life up as we go along and to fail in our conformity as well as to succeed, we would have been carried off by stronger beasts long ago.[10] Against the above, Gehry's architecture acknowledges that there is something beyond words requiring symbolic expression in built work:

> In any Gehry project, the [design] process starts with listening to the client—an intense sort of listening that involves paying close attention not only to specific requests but to body language, facial expressions, unfinished thoughts… Having … uncovered needs and desires that

8. Quote from an article by Usha Lee McFarling on the construction of the Disney Concert Hall. See "Beauty and the Beastly Project," *Los Angeles Times*, August 6, 2001, pp. A1 and A11.

9. Mario Gandelsonas, "From Structure to Subject: The Formation of an Architectural Language," in Peter Eisenman, *House X* (New York: Rizzoli, 1982), p. 7.

10. Joan Ockman makes a parallel observation in "Toward a Theory of Normative Architecture," in *Architecture of the Everyday*, ed. Steven Harris and Deborah Berke (New York: Princeton Architectural Press, 1997), pp. 123–52.

the client might not even have been aware of, Gehry starts making drawings and the draw-ings lead to ... dozens of models more than any other architect would dream of making.[11]

Once the design is "complete" there is still something beyond that requires expression. It is in the essence of the symbol that it cannot symbolize everything it represents.

Only the overwhelming burden of conventional usage suggests that we should con-tinue calling deterministic symbols "symbols." Technically, they are *images* of symbols that respond to the human need for order by representing the symbol as exactly what it is not. They suppress the emergence of meaning from collective dialogue. In the place of dia-logue, these false symbols articulate the pretense of an agreement, what Erving Goffman used to call derisively "the veneer of consensus."[12] The false symbol may provide a sense of false comfort, an "architecture of reassurance."[13] Everybody loves Mickey, right?

The second symbolic strategy is the default program in architecture that has been made for the purpose of attracting tourists. It doesn't have to be like this. Tourism, in and of itself, is not predisposed to alignment with regressive cultural forces.[14] But commer-cialized tourism has effectively been designed and engineered into this conservative posi-tion.

A basic vocabulary of architectural design for tourists was originally devised by Gio-vanni Battista Piranesi in his series "Views of Rome." It has been brought to its zenith in our times by Disney at the new town of Celebration in Florida and the Disney theme parks, and it animates the program of all nostalgic places made with tourists in mind. Piranesi was born in Venice in 1720 and died in Rome in 1778. His career began at the end of an economic boom, just as large-scale construction supported by the church and its wealthy patrons stopped.[15] Several major works completed just before Piranesi entered the architectural profession included De Sancti's Spanish Steps, Salvi's Trevi Fountain, and Galilei's Lateran façade. These have proven themselves to be enduring tourist attractions. Piranesi was trained to be an architect and always identified himself as one, but he received few commissions for the kinds of public works he admired so much and nothing on a grand scale. He mainly did remodeling work.[16] His fame would come as an archi-tectural etcher, rendering existing buildings and monuments as well as imaginary archi-tectural environments, most notably his redesigns of Appian Way and a famous series of

11. Calvin Thomas, "The Maverick," *New Yorker*, July 7, 1997, p. 41.

12. Erving Goffman, *The Presentation of Self in Everyday Life* (Garden City, NJ: Anchor Doubleday, 1959).

13. Karal A. Marling, *Designing Disney's Theme Parks: The Architecture of Reassurance* (Montreal: Canadian Centre for Archi-tecture, 1997).

14. Lucy Lippard, in *On the Beaten Path: Tourism, Art and Place* (New York: The New Press, 1999), argues that there is a great deal of untapped potential in the array of tourist attractions to open dialogue on questions of culture, history, and the environment.

15. See John Wilton-Ely, *The Mind and Art of Giovanni Battista Piranesi* (London: Thames and Hudson, 1978), p. 11. Fund-ing ran out during construction of the Trevi, so the tourist custom of throwing coins in the fountain to assure one's return to Rome was devised as a scheme to collect money to be used to complete the work.

16. A. Hyatt Mayor provides an account of the financial situation in northern Italy during Piranesi's day and its effect on young artists and architects. See *Giovanni Battista Piranesi* (New York: H. Bittner, 1952), p. 5.

fantasy prison interiors. Between 1748 and the last year of his life, Piranesi made 135 "views of Rome." Rome had just become the centerpiece of the European Grand Tour, and in all authoritative art-historical accounts on the subject, it is remarked that Piranesi made his "views" with sales to tourists in mind.

There were other forces at work here than a shrewd entrepreneurial move to provide tourists with prephotographic views that they could take home to show where they had been and what they had seen. Piranesi made his views with an eye toward controlling both the putatively symbolic object and the tourist. According to his representational strategies, the symbol, in and of itself, is inadequate. It needs enhancement. It needs to be "sold." As for the tourists, their perceptions of the attraction are also inadequate. Thus begins the idealization and standardization of the touristic experience of Rome. Piranesi's representational strategies are widely admired.[17] Sergei Eisenstein found in Pirenesi's "methods of producing an ecstatic effect" a precursor to cinema. I do not disagree with the admirers of Piranesi, or Disney, or the effects of their imagery. But I will argue that these masterworks of touristic representation narrow symbolic potential. And they narrow symbolic potential all the more effectively when they are masterfully executed, as they certainly are in the cases of Piranesi and Disney.

Piranesi's etchings combined several experimental methods. The Bibiena family of set designers, working in the Venice of Piranesi's youth, perfected a "science of illusion" based on a modification of classical Renaissance perspective called *scena per angolo*. Also, painters and architects were experimenting with a form called *vedute ideate*, which were architectural fantasies, cityscapes that did not refer to any actual places, allowing the artist a free play of the imagination.[18] Piranesi was the first to apply the new techniques outside of stage sets and architectural fantasies, to the representation of actual places and objects. He drew the real as fantasy. He remarked: "These speaking ruins have filled my spirit with images that accurate drawings … could never have succeeded in conveying, though I have always kept them before my eyes.[19]

Piranesi effectively imposed the introduction of a single viewpoint onto the symbolic. Agreeing with May Seklar, Manfredo Tafuri comments that "the spectator … is obliged, more than invited, to participate in the process of mental reconstruction proposed by Piranesi."[20] Tafuri further remarks that Piranesi's images constitute a perfect integration of Enlightenment democracy with "the reign of the most absolute coercion."[21] The strategy would not work if the fantasy were foregrounded to the point that it occluded the sym-

17. See, for example, Manfredo Tafuri, *The Sphere and the Labyrinth: Avant-Gardes and Architecture from Piranesi to the 1970s* (Cambridge, MA: The MIT Press, 1987), who argues that Piranesi belongs at the head of the procession of the "avant-garde."

18. See Wilton-Ely, *The Mind and Art*, ch. 1, for an excellent discussion of the historical bases of Piranesi's techniques of manipulation the representation of space and objects.

19. Piranesi, quoted in Wilton-Ely, *The Mind and Art*, p. 12.

20. Tafuri, *The Sphere and the Labyrinth*, p. 26.

21. Ibid., p. 31.

bolic object. Then we would have a comic-book Rome that would be perfectly aboveboard. Piranesi's genius allowed him to do the opposite, to put his fantasy across as objective rendering. His etchings are not truthful, but they contain a Barthesian "ring of truth."

In the literature, Piranesi is often held up as a paragon of objective representation. John Wilton-Ely has done as much as anyone to explicate the precise techniques of misrepresentation devised by Piranesi. He nevertheless concludes: "In each etching Piranesi attempts an unexpected approach without ever jeopardizing the basic function of the *veduta*, the communication of fact." Wilton-Ely allows that in only one "view" Piranesi failed to "restrain his sense of the dramatic within the boundaries of fact."[22]

Piranesi eschewed elevations that architects would have selected to show their works to advantage. His views are quirky, more spontaneous and intimate, as if rounding a corner, a somewhat disoriented tourist had just caught a "very own first glimpse" of a famous building. But there is something more happening in these views than some new angles.

If one experiments with architect's vellum and a transparent straight edge, it is possible to find not one, or two, but several sets of vanishing points deployed along multiple horizons. Sergei Eisenstein undertook a series of formal observations of Piranesi's "system of expressive means" and concluded that "through a system of new foregrounds … by their displacement [they] plunge forward from the etching, attacking the viewer."[23] This effect is achieved, in part, by setting wider vanishing points for objects in the foreground and narrower vanishing points for objects in the background. These modifications of classical rules of perspective produce an effect of curving space. The static image becomes spectacle or entertainment, moving around and past the viewer. Eisenstein describes the ecstatic (or ex-static) effect:

> And as though picking up their signal, all the other elements are caught up by the whirlwind… [T]hey resound from the etching, which has lost its self-enclosed quality.
>
> … [I]n our imagination we have before us, in the place of the modest, lyrically meek engraving … a whirlwind, as in a hurricane, dashing in all directions: ropes, runaway staircases, exploding arches, stone blocks breaking away from each other."[24]

Piazza Popolo

Piranesi's approach and result are clearly different from those of his contemporaries. One 1759 view of the Piazza Popolo by Piranesi's contemporary, Charles de Wailly, is a standard CAD "fly by" at about 75 feet of altitude, achieved by laying out an accurate plan view and setting up what was then an impossibly elevated point of view using classical Renaissance perspective.

22. Wilton-Ely, *The Mind and Art*, p. 29.
23. Sergei Eisenstein, quoted in Tafuri, *The Sphere and the Labyrinth*, p. 85.
24. Eisenstein, quoted in Tafuri, *The Sphere and the Labyrinth*, p. 70.

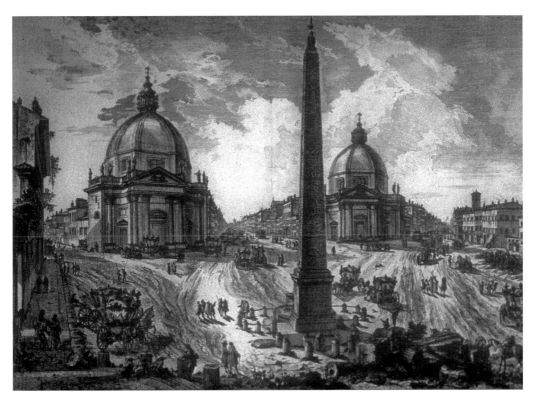

Giovanni Battista Piranesi, Piazza Popolo from his "Views of Rome" series. Piranesi sells Rome through the use of a single viewpoint to bring a very human perspective to the Piazza Popolo.

Piranesi's view is much closer in elevation to that of a camera or a human eye and in fact, the spot where Piranesi seemed to have set up his drawing board was very often used as the ideal camera placement in the next century.

One photograph taken by the Scottish surgeon Robert MacPherson about 1857 is obviously an effort to replicate precisely Piranesi's view. It nicely illustrates the dilemma of capturing Rome on film at anything close to the extraordinary impact of a Piranesi view. The result is a fine photograph in its own right, but it does not reproduce the Piranesi effect of the entire scene seeming to hurtle past the tourist.

Viewing a Piranesi etching, the subject might continue to think itself occupying neutral space and participating in the "objective" reconstitution of the things that are depicted via application of the laws of perspective. But these laws are so bent and broken that the so-called subjective view point has been entirely constituted outside itself. This is one of the earliest constructions of the tourist viewpoint or attitude (in the pejorative sense), or of the limitation of the symbol.

The forced introduction of a single viewpoint onto the symbolic engenders a kind of mirroring, ego-mimetic relationship in which the presentation of the attraction isolates and freezes the consciousness of the tourist in a narcissistic circularity. The contemporary symptomology of the touristic subject position is well-known. Tourists camouflage their

thought and sometimes themselves in most unattractive ways. They wear stigmatizing shoes and hats, T-shirts with vulgar messages, carry cameras, talk loudly in public, and repeat trivial, banal observations about the places they visit. The standard of hygiene and physical setup of a museum toilet is as much a part of tourist discourse as the collection. I once observed an American woman in the Louvre giving a little passing wave to a painting by Michelangelo and remarking, "I just love paintings in round frames." Only beings who are self-confirmed in their ultimate superiority can behave in this way. Touristic expression is not merely trivial. It is militantly trivial. Often it does not even measure up to the standard of "ready made phrases of humbugs" [Stendhal]. These observations of tourists have been taken by Daniel Boorstein and others as a reason to deride and dismiss them. It would be smarter to ask what specific thoughts are screened off and occluded by this masking and chatter, and what mechanisms of repression prevent tourists from having anything new to say.

By preprogramming multiple points of view in the same image—in practice, multiple placements of the drawing board for different regions of the image—then reuniting the elements viewed from different perspectives in a simulacrum of classical perspective—Piranesi freezes or fixes the touristic standpoint while seeming to leave intact the freedom proffered by Renaissance perspective. Three hundred years after its invention, perspective is perverted—the equality of multiple points of view is alloyed with "the reign of absolute coercion." The viewer is no longer invited to roam around in the depicted scene, confident that the same set of rules of visual representation and perception will remain in effect. Piranesi has created a kind of ultraconservatism of place or of placement. Even the slightest change of viewpoint will cause the entire spatial ensemble to fall apart. All that is holding it together is attitude, a drive to mythify simultaneously the place and the tourist: Here is everything you *as tourist* can ever experience about this place *as symbolic*.

Those who visited Rome after Piranesi drew it expressed disappointment that Rome itself fell quite a bit short of Piranesi's depictions. Wilton-Ely summarizes: "Of little wonder that the generation of the early Romantics such as Goethe, brought up on such images, underwent a profound disillusionment on their initial encounter with the reality."[25]

None of this would be the slightest bit interesting unless there was the possibility of contestation over the symbol, a contestation that is suppressed by touristic representation. At issue are questions that might well give "Western man" some identity anxiety. What does ancient Rome symbolize? Historians tremble in the presence of Roman materials, and so did Freud. There is simply too much "there there" and too much that is buried and invisible. Rome symbolizes the impossibility of knowing origins and destiny. Michel

25. Mayor comments, "Piranesi's visions of fallen grandeur invaded the north of Europe like railroad posters that set people in a fever to pack their bags for Rome. But while his etchings startled the imagination, the actual ruins did not. Goethe complained that the Baths of Caracalla and Diocletian did not live up to Piranesi's view of them, and Flaxman told Farington that he had found the ruins of Rome 'on a smaller scale, and less striking, than he had been accustomed to suppose them after having seen the prints of Piranesi.'" See *Giovanni Battista Piranesi*, p. 27.

Serres[26] comments that Rome has always been marked as having shaped not merely the destiny of "Western man," but of destiny itself.

None of this escaped Piranesi. Piranesi knew, or believed he knew, that ancient Rome was historically prior to ancient Greece. Throughout his lifetime, he was a passionate advocate of the Etruscan origins of Greek culture and civilization. He was motivated to overstate the value and grandeur of ancient Rome as a way of compensating for the lack of historical evidence for his chauvinistic belief. While Piranesi was not alone in his misconception, serious historians in his day were perfectly well aware of Greece's priority. If the historical evidence was not there, perhaps he could convert some believers based on the *aesthetic* superiority of early Roman materials, a superiority which he could "bring out" in his etchings. Those old Greek things were really Italian.

This manipulation of the symbol constitutes an urgent denial of the specificity of the past and an aggressive aesthetic reinscription of the past in contemporary banalities. It is this limiting process, and not the full potential of the symbol, that is dependably transmitted through time. At an exhibition of Phoebe Hearst's Piranesis several years ago these quotes from William Vance were used to label the Ponte Salario and adjacent engravings: Americans "enthusiastically adopted the reverential attitude toward ancient Rome enunciated by Goethe, Byron, and Stendhal, attitudes implicit in … the celebrated eighteenth-century engravings of Piranesi, which were known even in America… The heroes of the Roman Republic—Cincinnatus, Cicero, Cato the Younger—were American heroes because they were champions of liberty, and liberty was the meaning of America."[27] In other words, those old Italian things were really American.

In the presence of the image of Ponte Salario, we are directed to think about America, other tourists (famous tourists), and the maker of the image. We are *not* directed to think about the bridge or its history. The progressive banalization of the touristic image here has fallen well beneath Piranesi's rhetorical practice. At least Piranesi tells us that the bridge spans the Aniene about two miles outside of Rome and that it was made by "NARSETE." He gives us a historical clue. "Narsete" is the historical figure we call "Narses," the dreaded eunuch who headed the unpopular administration of Italy beyond Rome during the first half of the sixth century. Piranesi further elaborates in his label that "among ancient bridges, it is the only one that remains intact down to our times [ed e fra i ponti antichi l'unico rimaso interro a nostri tempi]." In Piranesi's times, anyway. The French and papal armies blew up Ponte Salario in 1867, terrified that Garibaldi's Red Shirts might make use of it in their advance on Rome. Thus, Piranesi's image of Ponte Salario is one of the best records we have of its appearance in the last century of its existence.[28]

26. See Michel Serres, *Rome: The Book of Foundations* (Stanford: Stanford University Press, 1991), in which he rereads the founding myths and histories of Rome together—treating the myths as history and the histories as myth.

27. From my field notes.

28. Guiseppe Vasi provided a similar view of the bridge at about the same time.

The Narses bridge was built on the foundation of one more ancient still, which, it is said, was the site of a famous battle between Titus Manlius and a Gaulish giant. The legendary battle ended with Titus taking as trophy the huge gold collar worn by the giant, which the victorious Roman removed by the expedient of first taking off the giant's head.

Just as occurs in the presentation of self in everyday life, underlying the bridge's banal representational strategies are fertile grounds for anxiety. Many of the symbolic way stations of the tourist do not merely endure as dignified ruins. They are sites of often unavowed hideous events, and the venerated objects themselves are susceptible to cataclysmic termination, as occurred in the case of Ponte Salario when it was dynamited in the nineteenth century. This kind of memory is inappropriate to the narcissistic subject that desires that the object's beauty, but not its blemishes, to be set in stone to endure forever, only to be made more attractive by time and the gradual advance of nature.

Given the structures that are foundational in this series of etchings, it is overdetermined that "The Tourist" would put in an appearance here. Indeed, before the invention of photography, Piranesi came up with what more than a century later would become the standard touristic photographic practice of mythic appropriation: "Here I am in front of …" or "This is me beside…" This is also the formula for the contemporary advertising of tourist entertainment and spectacle: The poster or television spot does not focus on the attraction, but on a group of happy tourists who are allegedly having fun there.

The tourist hails the phallus: Trajan's Column erected ca. A.D. 100. It honors Marcus Ulpius Trajanas the first non-Italian Roman emperor. It specifically celebrates Trajan's military conquest and annexation of Rumania, Armenia, Arabia, and upper Mesopotamia. It is still called Trajan's Column, and it still stands in the Forum of Trajan, but the statue on top of Trajan's Column is no longer a likeness of Trajan. Trajan has been replaced by Saint Peter.

A difficulty in dealing with Rome as symbolic of memory is that it too much resembles our individual memories and dreams. That is, memories are not memories at all. Rather, they are images that are engraved after what one thinks one is remembering, or perhaps what one is supposed to remember, or wants to remember. Frontierland and Main Street USA come to stand for and replace the American experience. The subsequent image replaces the memory. Saint Peter replaces Trajan on his column. What we call memory under the regime of this version of the symbol is really the history of forgetting.

The year Piranesi died, according to Hyatt Mayor, a Piranesi contemporary said that he was "the Rembrandt of antique ruins… He seemed for the first time to reveal the Roman ruins to us from a distance. I say from a distance because on the spot we do not find that his picturesqueness and his warmth are always true… [T]hey seem like a beautiful unfaithfulness."[29] In 1940, using language that today would nicely apply to Disneyland, Aldous Huxley remarked about Piranesi's views: "Men and women are reduced to

29. Mayor, *Giovanni Battista Piranesi*, p. 27.

Disneyland. A perfect fictional construction of heritage.

the stature of children: horses become as small as mastiffs… Peopled by dwarfs, the most modest of … buildings assumes heroic proportions." The persistent complaint against Piranesi's art has not been that it can be bettered, whether by photography or by direct experience. It is what eventually became the standard complaint against all travel posters: that his views are better than you get with a camera or even with your own eyes. This "flaw" in representing what the tourist can expect to experience would eventually be corrected by Disney via the incorporation of Piranesi's representational strategies not merely into two-dimensional imagery but also into the actual architecture and planning of the Disney tourist destinations.

Here are some images of Disney Imagineering putting Piranesi's principles into practice at Main Street USA and Toontown. What Disney and Piranesi give us is not just melodramatic architecture and architectural renderings. It is also a system of practices for constructing the touristic ego in the guise of prettified ruins. The historic past and childhood are overwhelmed by fantasy versions of themselves. As if a false version of the past can be a guide to the future. This may go beyond selective and manipulated memory and become a psychotic response to the symbolic double bind.

This system of practices is most advanced in places that do not resist being treated as historical blank slates: Southern California, Florida, the Nevada desert. Rome is no longer the best mirror for the touristic ego. It is more like the id. Rome is called "eternal,"

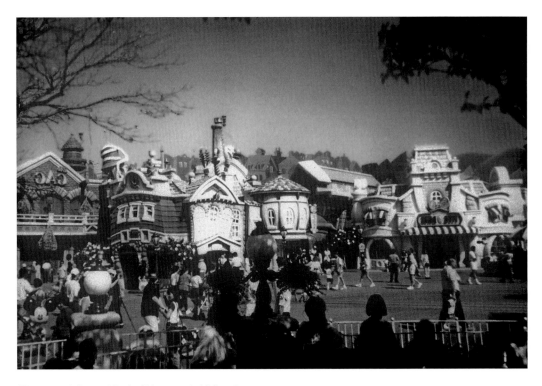

Toontown. A fantasy blend of history and childhood memory.

but it achieves its eternal status in an Oriental, not a Western way. Its identity is *not* set in stone, but is ever changing, like the weather. A freeway encircles the arch of Settimio Severo. The stones of Rome themselves, like actual memories, have been subject to an endless and utterly promiscuous recombination. Ultimately, Rome would not sit still for Piranesi's portrait of it and drove him to extraordinary fantasy, anticipatory of the modern-day theme park.

Piranesi's redesign of Apian Way proposes a pseudoruin, a ruin turned inside out with enough presence to swallow whole and forever both the individual consciousness and history. Are there differences between this and what Disney would eventually realize? Not many. In Piranesi's work our equality before the pseudosymbolic attraction is most often predicated on our supposed inferiority to it. Disney uses the same manipulative representational strategies, but they are inverted in such a way as to elevate or pretend to elevate the tourist over the attraction. This is the Disney formula for the "architecture of reassurance."

If you look for the vanishing point in a Disney rendering, you will usually not have to get up from your chair, because you are pretty much sitting on it. The tourist becomes the ultimate horizon, both figuratively and literally. Piranesi reaches for a similar effect. He has not strayed as far from convention as Disney, so his tourist is in the middle ground.

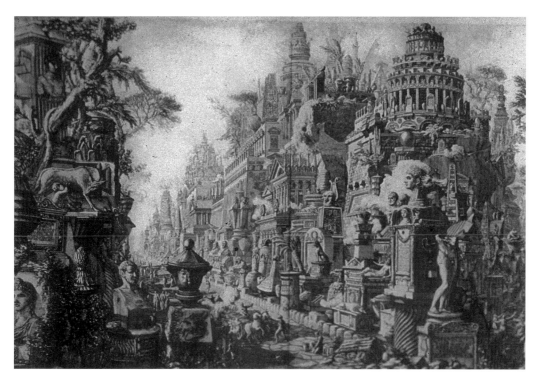

Giovanni Battista Piranesi, Appian Way from his "Views of Rome" series. A heightened representation of surface detail helps to sell an image of tradition.

Conclusion

Disney, Piranesi, Gehry: Here are the similarities between Piranesi and Disney. Both had a troubled relationship with history and tradition and were self-appointed conservators of a mythic "history." Both emphasized surface details that purport to be nostalgic representations of times that never existed. Both were successful at creating and selling ersatz tradition that simultaneously masks the lack in the heart of the symbolic and the lack in the heart of the ego. Both achieved real economic success in the tourism "industry" from their efforts.

The main effect of the Piranesi-Disney symbolic strategy is to occlude origins with a fiction of origins, to cover up the fact that each attraction might represent a real turning point, a crossroads, a momentous decision. Rather than preparing us for future transformation, the Piranesi-Disney attraction represses the processes that gave rise to the event or object it marks. Pseudosymbolic objects and ritual evasion *seem* to point the way to the present. They *seem* to be steps in an ineluctable progression that constitutes *us*. But they can also suppress and destroy the memory of every authentically formative moment. Within the Piranesi-Disney frame, heritage in use cannot be thought of as heritage unless it has already been killed and cooked for consumption by tourists. In this frame there is no recognition of a historical dialectic. All that appears is the self-congratulation of bland

contemporary conservative ideology. The memory of different versions of the past grappling with different desires for the future is doubly suppressed, first at the unveiling of the monument or the opening of the park and second by the touristic elevation of objects and events that pretend to stand outside of their own history. As I have suggested, when this symbolic strategy goes even slightly off, it immediately becomes psychotic.

Gehry's architecture attracts tourists, but it is based on a different set of principles. It is not founded on a fantasy of controlling history, culture, or nature. It opens dialogue with these realms. The dialogue is not necessarily reassuring. There is in these structures a sense of urgency that the symbolic will die unless we "have something new to say," something growing and beautiful.

This architecture insists that the tourist reflect on things beyond the overwhelming presence of the architectural conceit itself. It brings us close to people, things, ideas that would not otherwise allow us proximity. That is, it functions something like a word. This lives up to the affirmative promise of tourism and sightseeing that is everywhere else foreclosed by the institutions of tourism and bad design for tourism.

Importantly, this architecture acknowledges the absence or lack at the heart of the symbol and in the human subject. It confronts this originary wound, but it does not attempt to pretend that there is no lack, or that lack can be covered over or filled in with mythic clutter. It does not enter into a pact with the tourists to reinforce their fragile egos. This architecture fully acknowledges that the subject is split between an only apparently meaningful signifier and an unnamable precipitate caused by the signifier.

Such places are pointedly not explicit. They do not exhort or seek to instruct us about family values, or racism, or sexism, or our precious traditions. They allow for reflections of the second, third, and fourth order. Tourists will come away with their thoughts altered on many levels, including, perhaps, sex, race, and so on, even if this was not a part of the program. The architect fills the space in a way that makes the world transparent.

A strong architectural symbol, a symbol properly so-called, as opposed to a pseudosymbol or an antisymbol, can only go so far as to mark a point of entry into language and the symbolic. It marks the traumatic self-recognition of our own humanity with a moment of silence. Such buildings do not seek to provide alternate theories of language, history, or culture. They embody ethical attitudes toward being human. Simply to acquiesce to the symbolic, to the human, is not an ethical or even an adaptive act. These buildings face the duplicity of language with their silence. What is "in" the silence? The promise of an originary moment in humanity that is something other than, or more than, merely linguistic. They witness resistance to the capture of humanity by social convention, by social fantasy, and by the tissues of equivocation made possible by language.

"Isn't This a Wonderful Place?"

(A Tour of a Tour of the Guggenheim Bilbao)

ANDREA FRASER

If you haven't already done so, walk away from the desk where you picked up this guide and out into the great, high space of the atrium. Isn't this a wonderful place? It's uplifting. It's like a Gothic cathedral. You can feel your soul rise up with the building around you. This is the heart of the museum, and it works like a heart, pumping the visitor around the different galleries. If you look up, you can see walkways, elevators, and stairways leading up and around the walls of the atrium between the galleries. These are the arteries. The separate galleries all lie off this central space and to go from one to another, you must come back here.

In the great museums of previous ages, rooms linked from one to another, and you must visit them all, one after another. Sometimes it can feel as if there's no escape. But here there is an escape: this space to which you can return after every gallery, to refresh the spirit before your next encounter with the demands of contemporary art. This building recognizes that modern art is demanding, complicated, bewildering, and the museum tries to make you feel at home, so you can relax and absorb what you see more easily.

As you look around, you'll see that every surface in this space curves. Only the floor is straight. These curves are gentle, but in their huge scale powerfully sensual. You'll see people going up to the walls and stroking them. You might feel the desire to do so yourself. These curving surfaces have a direct appeal that has nothing to do with age or class or education. They give the building its warmth, its welcoming feel. And in this way, the atrium tries to make you feel at home and prepares you for the purpose of the building: the art it contains.

Let's take a closer look at one of the stone-clad pillars in this space. If you stand with your back to the entrance, there's one to your right, holding up a large stone box that actually contains a tiny gallery. Go right up to it. This pillar is clad in panels of limestone. Run your hand over them. Squint along the surface. Feel how smooth it is.

Paradoxically, these sensual curves have been created by computer technology. Because of the way the surface of the pillar curves, each of these panels is slightly different. No two are quite the same. And this is true for all the curved walls of the building.

At the heart of the
Guggenheim Bilbao.
© Andrea Fraser.

If these panels had been produced by conventional means, this would still be a building
site, and the cost of the building would be astronomical. But these panels were cut and
shaped by robots working to a computer program developed for aircraft design. To a
computer, the mathematical problems involved in fitting together this vast jigsaw are sim-
ple. This process is very new, and it should have a revolutionary effect on the way archi-
tects work, because it will allow them to embody more freely the productions of their
imaginations, as well as allowing them to build more cheaply and to a better quality.

Now turn to your right and look at the glass tower that contains two of the eleva-
tors. The glass surface of this tower also curves, and again the curves are produced by
panels fitted together. But here they overlap, like the scales of a fish. This is no idle
metaphor. The architect who designed this building, Frank Gehry, has always found inspi-
ration in fish. He dates this obsession from the days when he used to go with his grand-
mother to the market to buy a live carp, which he would then take home and keep in the
bathtub until it was time to cook it. Here little Frank would play with the carp, and here
the magic of its sinuous, scaly form somehow entered his bloodstream.

If you look to your left now, beyond the pillar under the stone box that we looked at
a moment ago, you'll see the entrance to a large space. This is the largest gallery in the
museum and, believe it or not, it's known as the Fish Gallery, because the long, curving
shape of this part of the building is derived, once again, from the shape of the fish. Let's
go in there now. Press your pause button until you are in the gallery.

You are standing in a room of 3200 square meters. It's 150 meters long and between
12 and 25 meters high. Contemporary art is big. In fact, some of it is enormous, and this
gallery was designed to accommodate the huge pieces that artists have begun to create.

–Official audio guide, Guggenheim Bilbao Museum

Yes, "in the great museums of previous ages, rooms linked from one to another and you must visit them all, one after another. Sometimes it can feel as if there's no escape."[1] But "here, there is an escape"—an escape from order: the order of one after another; the order of a rational, linear progression of rooms, objects, exhibits; the order of regulated movement; the order of looking; the order to look—to look at all and only look. Here, we are invited to feel. We are invited to touch.

Here, there's an escape from the rules of behavior that have always told us not to touch. We are made aware of our desire to touch, so direct, that we share with those around us, that transcends age and class and education.

Here, we can escape from our social selves, from social determination.

Here, we can escape from identity in a place of endless differentiation. We can escape from our place of origin. We can feel at home away from home.

Here, we can escape the boundaries of our discrete bodies. We become formless matter, fluid, pumped through the building's heart, its arteries, its corporeal passages, passages formed in masturbatory memories (what else are we to suppose little Frank was doing in the bathtub with that fish?); fantasies of sensual curves, sinuous forms and powerful scales; fantasies of overcoming the weakness and smallness of little individualities with the magic of towering cybernetic members. Contemporary art is "big." "In fact, some of it is enormous."

Here, we can even escape the forces of gravity. We feel our souls rise up, limbs like airplane wings.

Here, like architects and artists, we can be free to embody the productions of our imaginations.

And that is the museum's revolutionary effect.

In the great museums of previous ages, rooms linked from one to another, and you must visit them all, one after another. Sometimes it can feel as if there's no escape.

Douglas Crimp is sometimes credited with introducing Foucauldian theory to the study of museums. In his 1980 essay "On the Museum's Ruins," he writes: "Foucault has analyzed the modern institutions of confinement—the asylum, the clinic and the prison—and their respective discursive formations—madness, illness and criminality. There is another institution of confinement ripe for analysis in Foucault's terms—the museum—and another discipline—art history."[2]

Tony Bennett took up the challenge with his 1988 essay "The Exhibitionary Complex." Nevertheless, he appears to open the essay by misreading Crimp's proposal: "It seems to imply," he writes, "that works of art had previously wandered through the

1. Guggenheim Bilbao, introductory audio tour, as transcribed by Andrea Fraser, June 2001. Much of the research informing this essay was conducted in the context of the development of an artist project with Consonni, Bilbao, and with the assistance of the staff of that organization, Franck Larcade, María Mur, and Aranxta Pérez. Additional research was assisted by Yasmine Nessah. The introductory audio tour of the Guggenheim Bilbao also served as the basis for the videotape *Little Frank and His Carp*, video stills from which are reproduced with this essay.

2. Douglas Crimp, "On the Museum's Ruins," in *The Anti-Aesthetic*, ed. Hal Foster (Seattle: Bay Press, 1983), p. 45.

streets of Europe."[3] It's a wonderful image, but one that unfortunately has little to do with Crimp's argument, which is concerned above all with the way technologies of reproduction may undermine the ordered discourse of the museum. A much more literal application of Foucault's work on carceral institutions can be found in my "Museum Highlights: A Gallery Talk."[4] A 1989 performance in the form of a museum tour, "Museum Highlights" juxtaposes the museum to another institution of confinement—the poorhouse—and develops the hypothesis that museums emerged in the context of the formation of urban public spheres as systems of goads and deterrences to particular forms of social behavior and cultural identification.

What Bennett is primarily concerned with, in any case, are not exhibits, but the publics constituted by exhibitions—publics that one *could* say, according to his own arguments, had indeed wandered the streets as unruly crowds before being constituted as orderly audiences by and for the orderly displays organized for their edification. Bennett goes on to distinguish carceral institutions from the nineteenth-century museums and exhibitions, panoramas and arcades that he dubs "the exhibitionary complex." Following Foucault, Bennett views institutions as technologies of order and discipline, "instruments of the moral and cultural regulation of the working classes."[5] However, whereas institutions of confinement developed technologies of surveillance that rendered the populace visible to the forces of order, institutions of exhibition served rather "to render the forces and principles of order visible to the populace." As such, they constituted "a set of cultural technologies concerned to organize a voluntarily self-regulating citizenry."

> [T]hrough the provision of object lessons in power—the power to command and arrange things and bodies for public display—they sought to allow the people, and *en masse* rather than individually, to know rather than be known, to become the subjects rather than the objects of knowledge. Yet, ideally, they sought also to allow the people to know and thence to regulate themselves; to become, in seeing themselves from the side of power, both the subjects and the objects of knowledge, knowing power and what power knows, and knowing themselves as (ideally) known by power, interiorizing its gaze as a principle of self-surveillance and, hence, self-regulation.[6]

I wonder if the anonymous author of the Guggenheim Bilbao's introductory audio tour ever read "On the Museum's Ruins" or "The Exhibitionary Complex." I suppose it's irrelevant. Reflections on the function and purpose, meaning and effects of museums and their architecture now found in the fields of art, art history, architecture, anthropology, sociology, history, and cultural studies, as well as museum studies must also be informing, directly and indirectly, developments within the field of museums. In contemporary art

3. Tony Bennett, "The Exhibitionary Complex," in *The Birth of the Museum: History, Theory, Politics* (London: Routledge, 1995), p. 59.

4. Andrea Fraser, "Museum Highlights: A Gallery Talk," *October* 57 (Summer 1991): 103–23.

5. Bennett, "The Exhibitionary Complex," p. 73.

6. Ibid., p. 63.

museums in particular, it's safe to assume that most of the educators preparing didactic materials, curators preparing exhibitions, directors setting policy and planning expansions, and architects developing new physical structures are at least aware of the critical discourse on museums. So it's not surprising to hear an echo of this critical discourse in the halls of new art museums themselves—even or especially as a negative representation: that is, as what new art museums do not want to be—prisons; carceral institutions; institutions of confinement, of discipline, surveillance, order, regulation; factories of edification and of taste.

But here there is an escape…

Of course, the audio guide isn't telling us anything that hasn't already been proclaimed in the reams of writing generated on Frank Gehry's Guggenheim Bilbao. "Exultant eruption," "frozen explosion," "stormy volumes," "floral splendor," "titanium tentacles," "Tower of Babel," "a Basque bomb," "Lourdes for a crippled culture," "the reincarnation of Marilyn Monroe" are among the metaphors compiled in one critic's survey of the literature.

The building has been described as a "world of sand castles and fairy tales," a euphoric world of "radical heterogeneity," and "a place of contested borders"—like the Basque region itself. It finds beauty and meaning in "social fragmentation" and "diversity," proving that "many languages can not only coexist but also babble around within a broad and vibrant vista of the world."

It's a statement "on behalf of irregularity."

It "lives in the spirit of risk and experimentation."

It's "a sanctuary of free association. It's a bird, it's a plane, it's Superman. It's a ship, an artichoke, the miracle of the rose."

Its "free-flowing and undulating surfaces" are the very "'images of architectural freedom'" and a monument to art "understood as an excessive, impossible, even farcical dream of freedom."

"If there is an order to this architecture, it is not one that can be predicted from one or two visual slices of its precisely calculated free-form geometry. But the building's spirit of freedom is hard to miss."[7]

Yes, "here, there is an escape."

… this space, to which you can return after every gallery, to refresh the spirit before your next encounter with the demands of contemporary art. This building recognizes that modern art is demanding, complicated, bewildering, and the museum tries to make you feel at home, so you can relax and absorb what you see more easily.

Have new museums like the Guggenheim Bilbao finally succeeded in replacing the pedantic discipline of a nineteenth-century ordering of things with the fluid freedoms of

7. The sources of these descriptions of Gehry's Guggenheim include Herbert Muschamp, "The Miracle In Bilbao," *New York Times Magazine*, September 7, 1997, pp. 54–59; Joan Ockman, "Applause and Effect," *Artforum* (Summer 2001): 140–49; Anthony Vidler, "Aformal Affinities," *Artforum* (Summer 2001): 140–49.

Here we can escape.
© Andrea Fraser.

unprogrammed flows? Is the "Bilbao Effect" indeed a realization of the "myth of the next reality" in heterotopic spaces of radical heterogeneity? Or is the "Bilbao Extravaganza" another symptom of the spectacularization of museums and their transformation from public educational institutions into corporate entertainment complexes—a process in which the Guggenheim has been counted as leading the avant-garde?

However, the audio guide reminds us explicitly that art museums are not all fun and games. Modern and contemporary art, at least, is still "demanding, complicated, bewildering." Art remains a challenge to be met, a bitter pill after which one needs to "refresh the spirit" with a draught of soaring space. The architecture recognizes this. The architecture knows. The architecture understands. It not only sees (and speaks), but also listens to its visitors. And in the wisdom of its understanding, it works not to reinforce art's impositions, but to provide a respite from art's disturbing effects: to lighten the burden of what appears to remain a rather unpleasant aesthetic duty.

A kind of discipline is still at work here, but it's one that the "architecture," at least according to our audio guide, explicitly disowns. It's not a discipline deployed *by* the institution of the museum, but *within* the museum, it seems, by the institution of art itself. Or, I would say, by the art museum as an institutionalized form of art.

A program of movement is in fact laid out for us. We can go from one gallery to another as we please, but we must always come back "here." It's not a linear movement through a succession of rooms, but rather a spiral up through space. The grand staircases of beaux-arts museums elevated us for civilization. To enter the Guggenheim Bilbao, however, we must first descend, pouring into the museum lobby through funnel-shaped front steps. It is only from there that we are to ascend. From the atrium to the galleries

to the atrium to the galleries to the atrium again, we are to wind our way from uplift to bewilderment to sensual communion to confronting demand and on to magical release in a dialectic of aesthetic transformation that promises to sublate us into fluid and finally even into air.

Yes, here there is an escape.

As you look around you'll see that every surface in this space curves. Only the floor is straight. These curves are gentle, but in their huge scale powerfully sensual. You'll see people going up to the walls and stroking them. You might feel the desire to do so yourself.

One may be able to speak of technologies of discipline common to an entire range of "exhibitionary" institutions—from panoramas and dioramas to expos, fairs, and the ever-growing family of museums. However, in order to understand the functions, meanings, and effects of art museums as a particular class of "exhibitionary" institutions, it's necessary to consider the very particular form of discipline they impose.

This may very well be what Crimp had in mind when he called for a Foucauldian analysis of the art museum. When he returns to Foucault in his essay, it's not with reference to the prison or the asylum. Rather, it's to a reflection on the work of Manet, in which Foucault found an acknowledgement of "a new and substantial relationship of painting to itself, as a manifestation of the existence of museums and the particular reality and interdependence that paintings acquire in museums."[8]

What began to make modern art so "demanding" in the nineteenth century may have been less the physical closure of museum spaces than the emergence of a kind of discursive closure that, in the words of Pierre Bourdieu, "categorically demand[ed] purely aesthetic disposition which earlier art demanded only conditionally." It is this demand that was "objectified in the art museum: there the aesthetic disposition becomes an institution."[9]

There, we can add, the aesthetic disposition also becomes a social discipline, as the dialectic of aesthetic transformation is inserted into a specifically moral economy of freedom and renunciation, sacrifice and self-realization.

The aesthetic discipline institutionalized in the museum has been exemplified by the asceticism, silence, and stillness associated with art museums until so very recently; a discipline practiced in the renunciation of what so much aesthetic philosophy has described as the direct, immediate, obvious, easy gratification of the senses; a discipline performed in the bracketing off of corporeal wants and material needs, of economic interests and social prejudice; a discipline realized in the neutralization of "ordinary urgencies" and "practical ends"; the prerequisite of taste, of aesthetic pleasure, of contemplation and reflection, even of critical distance and reflexivity—the prerequisite of all there is to be gained from a trip to the museum for an encounter with works of art.

Art museums were built and their contents collected and ordered to accomplish this aesthetic neutralization. The social world, with its noise and movement, urgencies and

8. Michel Foucault, quoted in Crimp, "On the Museum's Ruins," p. 47.

9. Pierre Bourdieu, *Distinction: A Social Critique of the Judgment of Taste*, trans. Richard Nice (Cambridge, MA: Harvard University Press, 1984) p. 30.

ends, was banished by the silence and stillness of windowless rooms. The uses of objects and representations were neutralized by their withdrawal from everyday life and by the juxtaposition of forms "originally subordinated to quite different or even incompatible functions."[10] And above all, perhaps, the economic value of things as commodities was neutralized by their permanent withdrawal from private consumption and material exchange into the public collections of public institutions.

These curving surfaces have a direct appeal that has nothing to do with age or class or education.

In Bourdieu's analysis, however, the aesthetic neutralization institutionalized in the art museum is anything but neutral. Aesthetic principles exist, rather, as the "universalization of the dispositions associated with a particular social and economic condition." The aesthetic disposition "is one dimension of a total relation to the world and to others, a lifestyle, in which the effects of particular conditions of existence are expressed in a 'misrecognizable' form."[11] Like the philanthropic acts of donation through which so many objects find their way into museums and with which so many museums themselves were founded, the aesthetic and its institutions are both the product and the manifestation of a distance from economic necessity: of economic power that is "first and foremost a power to keep economic necessity at arm's length." The world of artistic freedom institutionalized in the museum is a world "snatched, by economic power, from that necessity": "the paradoxical product of a negative economic conditioning."[12]

In other words, according to Bourdieu, the aesthetic and its institutions presuppose "a distance from the world … which is the basis of the bourgeois experience of the world,"[13] an experience of the world, that is, common to the patrons of art museums, the previous owners of much of their collections and, in the American tradition, their founders and trustees.

The particular symbolic power of the aesthetic lies in the almost complete circularity of its essentialism: another kind of institutional closure, perhaps; another kind of prison. As Bourdieu demonstrates over and over again in *Distinction*, a disposition to aesthetic experience is a clear product of social and economic conditions such as "age and class and education." However, it exists as a manifestation of those conditions to the extent that it denies and distances them in its affirmation of the "direct appeal" of surface, shape, color, and form. And it is this distancing that defines the experience it produces. The aesthetic is thus the perfect product of determination: It frees us through a negation of the (negative) determinations of the freedom of which it is the "paradoxical product."

Like all essentializing ideologies, the aesthetic accomplishes its seduction by way of a cruel ruse: the promise that the pleasures and satisfactions, advantages and capacities—in a word, the freedoms—provided for by particular social and economic conditions can be achieved by an individual effort of the mind and a willful disciplining of the body. If muse-

10. Ibid.
11. Ibid., p. 54.
12. Ibid., pp. 493, 54–56.
13. Ibid., pp. 44, 54–55.

um visitors were to be "liberated from the 'struggle imposed by material needs,'" as a Philadelphia Museum of Art pamphlet promised in 1922, it was not by way of the satisfaction of those needs, but by way of their distancing and displacement, mastering and renunciation: a liberation to be achieved by submission not to the omnipotence of a surveilling gaze of power so much as to the omnipotence of the neutralizing gaze of the aesthete institutionalized in the art museums.[14]

They give the building its warmth, its welcoming feel. And in this way, the atrium tries to make you feel at home and prepares you for the purpose of the building: the art it contains.

But museums aren't like that anymore. They're neither ascetic nor silent and still, but warm and welcoming and open to the street and full of everyday life. And they're not only for the well-educated middle and upper classes, but teeming with the most diverse people with the most diverse interests and reasons for being there. "The museum is really free space. People do what they want to do," from "sleeping there, to looking at art, to having a meal … to picking each other up."[15]

Aestheticism may still be represented in a modernist corner of the collection, but you'll also find Pop Art and maybe even pop culture—fashion, movies and motorcycles—as well as contemporary art in all *its* diversity, from painting to performance, photography, digital media, big slabs of rusty steel, and monumental puppies made of flowers.

And most important of all, museums no longer leave their visitors at the mercy of such demanding, complicated, and bewildering art. Having learned from such groundbreaking studies as *The Love of Art*,[16] fifteen museums now offer a wide range of educational programs and materials to help guide visitors without backgrounds in art through their experience at the museum.

Like this introductory audio tour.

Now…

Let's take a closer look at one of the stone-clad pillars in this space. If you stand with your back to the entrance, there's one to your right, holding up a large stone box that actually contains a tiny gallery. Go right up to it. This pillar is clad in panels of limestone. Run your hand over them. Squint along the surface. Feel how smooth it is.

Like so many other visitors, I obediently run my hand over the limestone panels. Yes, I do feel how smooth it is. I press myself against the column. I lift up my dress and press my body against its "sensual curves." No one moves to stop me: not the security guards—men in uniforms with guns—patrolling from the walkway-arteries, or the gallery attendants—women in gray skirts, elegant red jackets, and colorfully printed silk scarves carefully tied so that the word "security" is visible between lapels. After all, I'm only fol-

14. Quoted in Fraser, "Museum Highlights: A Gallery Talk."

15. In the words of The Museum of Modern Art's chief curator of architecture, Terence Riley. See Hal Foster et al., "The MOMA Expansion: A Conversation with Terence Riley," *October* 84 (Spring 1998): 3–30.

16. Pierre Bourdieu, et al., *The Love of Art: European Art Museums and Their Public* (Stanford: Stanford University Press, 1991).

Here we are invited to
feel and touch.
© Andrea Fraser.

lowing the suggestion of the official audio guide. Then someone takes out a camera to snap
a photo. The offending apparatus is immediately surrounded by a swarm of women in red.

Freedom, it seems, still has its limits.

The threat of ETA attacks explains the presence of an X-ray machine at the coat-
check counter and guards with guns on the catwalks. The plaza in front of the museum
is named after a policeman killed there by ETA militants whom he discovered planting a
bomb in flowers destined for the opening ceremonies. The main job of the guards and
gallery attendants, however, appears to be preventing people from videotaping and pho-
tographing the art and architecture. Visitors are encouraged to caress the walls, but
they're strictly prohibited from photographing them. The museum is aggressive in polic-
ing its image and has threatened unauthorized reproductions with legal proceedings.
When a local artist who runs a pasta shop started selling dry macaroni in the shape of
Gehry's building, the response from museum lawyers was swift and unequivocal: Cease
production of the noodle or prepare to be sued.[17]

Such image control is evident everywhere in the museum's interior. Like the impec-
cably dressed gallery attendants and information staff whose appearance and behavior
is closely regulated by guidelines laid out in an employee handbook, the museum is spot-
less. The white walls are reportedly touched up daily. The glass always sparkles. The floor

17. Letter from the law firm Uría and Menéndez to Fausto Grossi, Bilbao, July 4, 2000, made available by the artist as
part of his art project. That Fausto Grossi gets slapped for a noodle while I'm able to exhibit a video shot in the museum
with hidden cameras with impunity—even at a conference organized by the Guggenheim itself ("Museum as Medium," Mex-
ico City, April 2002)—is a perfect example of how corporatized museums and a celebritized art world are colluding to bring
about the particularization of universal principles such as freedom of expression, which increasingly appears rather as a form
of privilege. For an extended discussion of this issue, see my "A 'Sensation' Chronicle," *Social Text* 67 (Summer 2001): 127–56.

also looks clean enough to caress. Together, the security, corporate hospitality culture, and shine make the lobby feel like a cross between a business hotel and an airport—all that's lacking are trolleys with piles of luggage. It wouldn't be surprising in a museum that prides itself on the fact that between 85 and 90 percent of its visitors are from outside the region.

Paradoxically, these sensual curves have been created by computer technology.

If the discipline imposed by the art museum has always in some sense been an order of freedom, what the Guggenheim Bilbao represents may not be the transgression of that order so much as the imposition of another kind of freedom: the "paradoxical product," perhaps, of a new set of social and economic conditions.

The Guggenheim Bilbao Museum has now become the inevitable example of the success of museum-driven urban revitalization plans. Supported by the governing conservative Basque Nationalist Party (PNV) and publicly financed to the tune of $150 million by various levels of government in the Autonomous Community of the Basque Country, the Guggenheim Bilbao is the product less of cultural policy than of economic policy.[18] As is well known, the social, economic, and environmental devastation of Bilbao had reached catastrophic proportions by the mid-1990s. With the collapse of mining, steel, and shipbuilding industries, the metropolitan area had lost 20 percent of its population and 47 percent of its industrial jobs in the two preceding decades. Its birthrate fell by almost half, to 7.4 per thousand. It contained an estimated 465 hectares of industrial ruins, up to 50 percent of the total industrial land in some municipalities. Entire valleys were devastated by pollution, with hills dotted by toxic ponds of flooded open-pit mines and a river reduced to a bubbling ribbon of orange sludge. Last but not least, it was the metropolitan center of a region home to a militant separatist movement that had claimed over 800 lives since the 1960s.[19] The Guggenheim Bilbao Museum became the centerpiece of a plan to turn Bilbao around: to rescue its image, revive its economy, and transform it, if not into a global city, at least into an internationally competitive city in areas of culture and advanced services.

18. On the amount paid by the Basque government, see Kim Bradley, "The Deal of the Century," *Art in America* (July 1997): 48. That the Guggenheim Bilbao was the product of economic and not cultural policy is one answer to the riddle of why a nationalist party in power in one of the more nationalist regions of the world would spend $150 million on a museum more or less guaranteed to include no "national" culture. Another answer is that the museum can also be considered the product of a foreign policy. Through the museum project the PNV pursued a kind of anti-Madrid globalism, bypassing the national cultural-policy apparatus to establish a relationship with an international organization—the Solomon R. Guggenheim Foundation. It seems that the PNV understands the global public sphere quite well: It is defined not by nation-states, but by cosmopolitan financial and cultural centers for which national boundaries may be increasingly irrelevant, particularly in the context of a unified Europe. Considering the Guggenheim Bilbao as the product of a neoliberal nationalism on the part of the PNV would be an interesting topic for another paper.

19. See Mark Kurlansky, *The Basque History of the World* (New York: Walker, 1999); Joseba Zulaika, "'Miracle in Bilbao': Basques in the Casino of Globalism," in *Basque Cultural Studies*, ed. William A. Douglass et al., Basque Studies Program Occasional Papers Series, no. 5 (Reno: Basque Studies Program, 2000), pp. 265–74; Arantxa Rodríguez, Galder Guenaga, and Elena Martínez, "Bilbao: Case Study 2," *Urban Redevelopment and Social Polarisation in the City (URSPIC)*, European Union in collaboration with the Department of Applied Economics of the Universidad del País Vasco-Euskal Herriko Unibertsitatea (University of the Basque Country), Bilbao, Spain. At http://www.ifresi.univ-lille1.fr/site/2_Recherche/22_Programmes/225-URSPIC/Cases2/Bilbao/BILBAO2.htm as of January 18, 2005.

The scope of the Basque government's ambitions is evident in the *Revitalization Plan for Metropolitan Bilbao* outlined by Bilbao Metropoli-30, a public-private partnership group created to promote redevelopment.[20] The Guggenheim Bilbao is listed alongside a series of other initiatives, such as the revitalization of the stock exchange, the redevelopment of the port, a new urban train system designed by Sir Norman Foster, a new airport by Santiago Calatrava, the new Euskalduna Palace Concert and Conference Hall by Federico Soriano and Dolores Palacios, the European Software Institute, and the Technology Park of the Basque Country. Other projects include a new central train station by James Stirling and Abandoibarra, a thirty-hectare riverfront area next to the museum, redesigned by Cesar Pelli to include space for advanced services, high-income housing, shopping, leisure, and culture.[21]

"Cultural Centrality" is one of the "eight critical issues" identified by the plan that would "allow Metropolitan Bilbao to compete successfully in the European system of cities." "Cultural Centrality" means that Metropolitan Bilbao's "competitive advantage in the face of other cities in its sphere will be set by its new position as cultural center of international dimension"—that is, as "an obliged point of reference in cultural circuits and industries which are developing at an international scale."[22] "Cultural Centrality" is linked to the expansion of tourism, the city's ability to attract congresses and fairs, and, perhaps above all, the creation of an environment favorable for the development of advanced services.

By the time the Guggenheim Bilbao Museum opened on the banks of the Nervión River in 1997, metropolitan Bilbao seemed on its way to accomplishing the economic restructuring envisioned by these strategic revitalization plans. According to a study of 1996 indicators by Arantxa Rodríguez, Galder Guenaga, and Elena Martínez, service employment had already made up for many of the industrial jobs lost between 1975 and 1996, increasing its share of the economy from 41.7 percent to 65.2 percent while manufacturing dropped from 45.5 percent to 26.9 percent.[23] However, service industries, and particularly advanced service employment, were strongly concentrated in Bilbao and in historically affluent communities on the right bank of the Nervión River. In the historically working-class communities and industrial zones of the left bank, unemployment and poverty rates continued to rise. Economic restructuring in metropolitan Bilbao appeared not only to be reproducing and exacerbating "earlier patterns of differentiation between the left and the right bank areas of the river," but producing "new forms of social and spatial exclusion; demographic decline, rising unemployment and increasing poverty levels." According to the study's analysis, high unemployment rates "are only the most visible effect of a more profound dynamic associated with increasing deregulation and flexi-

20. Rodriguez et al., "Bilbao: Case Study 2"; Bilbao Metropoli-30, "Revitalization Plan for Metropolitan Bilbao," 1998, at http://www.bm30.es/plan/pri_uk.htm as of January 11, 2005.

21. Bilbao Metropoli-30, "Revitalization Plan for Metropolitan Bilbao."

22. Ibid.

23. Rodriguez et al., "Bilbao: Case Study 2."

bilisation of the labour market" running parallel to the expansion of services: "the pre-
carisation of employment conditions, evidenced by the proliferation of weakened forms of
the labour relation (part-time, temporary and intermittent contracts, etc.), is of even
greater importance."[24]

*Because of the way the surface of the pillar curves, each of these panels is slightly different. No two
are quite the same. And this is true for all the curved walls of the building.*

Saskia Sassen opens one of the final chapters of *Cities in a World Economy* with the
question "What is the impact of the ascendance of finance and producer services on the
broader social and economic structure of major cities?"[25] The tertiarization of the econo-
my of metropolitan Bilbao seem to show every sign of following the pattern of increased
social polarization analyzed by urbanists such as Sassen. When manufacturing was the
leading sector of urban economies, it facilitated unionization and other forms of worker
empowerment.[26] It was based on household consumption, so that wage levels mattered.
Now, "components of the work process that even 10 years ago took place on the shop
floor … have been replaced by a combination of machine/service worker or worker/engi-
neer," typically through computerization. Work that was once "standardized mass pro-
duction is today increasingly characterized by customization, flexible specialization, net-
works of subcontractors, and informationalization." Economic regimes "centered on mass
production and mass consumption" reduced "systematic tendencies toward inequality." So,
Sassen adds, "did the cultural forms accompanying these processes."[27]

And the cultural forms accompanying the new production processes? Art museums
have long been considered institutions founded in opposition to mass popular culture. In
the United States, cheap manufactured goods, jazz, burlesque, and pulp fiction are among
the emerging forms of popular culture named in the early documents of the Philadelphia
Museum of Art. Against such cultural evils, philanthropists and reformers sought to
impose, through museums, their own distinctive and exclusive cultural forms as exclu-
sively legitimate public culture. Do current trends toward the popularization of art muse-
ums represent the collapse of this project? Many observers think so and even offer some

24. Ibid.

25. Saskia Sassen, *Cities in a World Economy*, 2d. ed. (Thousand Oaks: Pine Forge Press, 2000) p. 117.

26. Here it is important to note that in addition to its well-known history of militant nationalist separatism, the Basque
Country, and Bilbao in particular, also have a long history of militant trade unionism and socialist politics. Bilbao was home
to one of the earliest chapters of the First International, the first Socialist Party chapter in Spain, the first general strike on
the Iberian peninsula, and to "La Pasionaria," Dolores Ibarruri. In the first half of the 1970s, the Basque Country was also
the home to over 35 percent of all labor conflicts in Spain. While the old Basque financial and industrial capital behind the
PNV might have mourned the passing of Bilbao's industrial might, it's unlikely that they shed any tears for the collapse
of its unions. However, to be fair to the PNV, it was the Socialists in Madrid who settled on a policy of "liberalizing" Bil-
bao's heavy industry, which had been subsidized for decades by the Franco regime. This policy played some role in expand-
ing the ranks of radical Left and nationalist political parties with disillusioned socialists—including many Franco-era immi-
grants from other parts of Spain and their descendents. See Cyrus Ernesto Zirakzadeh, *A Rebellious People: Basques, Protest,
and Politics* (Reno: University of Nevada Press, 1991), pp. 54-5, 65; and John Hooper, *The New Spaniards* (New York: Pen-
guin, 1995).

27. Sassen, *Cities in a World Economy*, pp. 118–19.

of the immensely well-attended exhibitions presented by the Guggenheim as examples—exhibitions such as The Art of the Motorcycle, Armani, and a retrospective of the work of Norman Rockwell. What such exhibitions may represent, however, particularly in the context of museums like the Guggenheim that aggressively pursue mass-media publicity campaigns, is not the popularization of the museum, but rather its opposite: a new subjection of cultural goods produced for mass distribution and consumption to the distinctive and exclusive modes of appropriation that are what finally distinguish high from low, elite from popular culture.

Within ever more popular art museums, cultural goods are subjected to a chiastic symbolic process. On the one hand, "popular" culture is articulated within the distinctive and socially and functionally neutralizing systems of perception, appreciation, and classification that define aesthetic appropriation. On the other hand (and at the same time), these exclusive and distinctive modes of appropriation are inserted into popular cultural networks as the art museum itself becomes an ever more "popular" institution. And because the symbolic neutralization performed by art museums is inseparable from the economic neutralization that defines their public or nonprofit status, this distinctive system is severed from the social and economic conditions of its production and realization. The result is not the democratization of the museum, but the mass marketing of rarified tastes that manifest an economic condition in a fundamentally misrecognized symbolic form.[28]

The unique, customized, and individualized objects and environment that the Guggenheim Bilbao both architecturally represents and contains can be seen as the perfect products of the leading production processes of a new economic regime. At the same time, it may be that the mass marketing of unique, distinctive, and rarified tastes by ever more popular museums contributes to consumer demand for ever more individualized products and services, demand that in turn contributes to the expansion of the production processes—and labor relations—required to satisfy them.

If these panels had been produced by conventional means, this would still be a building site, and the cost of the building would be astronomical. But these panels were cut and shaped by robots working to a computer program developed for aircraft design. To a computer, the mathematical problems involved in fitting together this vast jigsaw are simple.

So if, as Bennett writes of late-nineteenth-century world's fairs, museums always served "less as vehicles for the technical education of the working classes than as instruments for their stupification before the reified products of their own labor," the Guggenheim Bilbao may exist rather as a monument to the obsolescence of that labor.[29] As the audio guide tells us, it is rather the product of computers and robots, obsession and magic, fantasy and imagination, facility and freedom. It's the product of a world in which the human labor of production does not exist.

28. For a more extensive discussion of these issues, see my "A 'Sensation' Chronicle."
29. Bennett, "The Exhibitionary Complex," p. 81.

The tour starts to seem
interminable.
© Andrea Fraser.

Construction of the Guggenheim Bilbao Museum began in 1993 on the Nervión River a few kilometers upstream from where the Euskalduna shipyards once stood. The shipyards were closed in the late 1980s amid violent protests that left one demonstrator dead. The Euskalduna Palace Conference Center and Concert Hall that now stands in their place was designed to look like a grounded ship. Between the Euskalduna Palace and the museum extends the 30-hectare Abandoibarra development area.

Widespread opposition to the museum in its planning stages seems to have given way to an acceptance of its positive effect on the image of the city and its contribution to urban regeneration. Although interpretations of the numbers differ, the museum reportedly generated economic activity that added 47 percent to the gross regional product in its first year of operation, contributing to the maintenance of 3,800 jobs, mostly through tourism. Even with these numbers declining, the public investment in the museum would have been repaid within three years by increased tax revenues. Bilbao and the Basque Country increasingly appear in the international media in connection with topics other than terrorism. While inflows of foreign capital don't seem to have increased significantly, the crucial role of the museum and related redevelopment projects in transforming Bilbao is not only a matter of direct investment. As suggested by Rodríguez et al., by bringing together culture, leisure, shopping, advanced services, and high-income housing in the center of the city, it "provides the basis for a new model of collective identification based on the lifestyles and aims of emerging power groups and urban elite."[30]

30. Rodriguez et al., "Bilbao: Case Study 2."

For most Bilbao residents, it's difficult to imagine that the museum's displays serve as object lessons in civic order, as Bennett suggests of nineteenth-century museums. Residents hardly go inside (only 10 to 15 percent of visitors are local). The museum itself, with its chaos of curves and surfaces, may instead serve as a lesson in the *disordering* of their lives by a new economic regime. The promises of that regime, however, may remain for others to enjoy. The museum as a workplace itself provides evidence of the kind of jobs the new economy can be expected to bring. The information staff consists of sub-minimum-wage interns supplied by the degree program in tourism at the Deusto University across the Nervión River. Tours are given by freelancers, often also students. Gallery attendants and security guards are subcontracted. Art preparators are hired on a show-by-show basis, with no benefits or provisions for workplace accidents. These are hardly the kind of jobs that would provide residents with the material basis to pursue the new freedoms the museum represents. Instead, they impose other kinds of "freedoms": the freedom of freelancing, the freedom of temporary work and flexible hours, and the "freedom" of insecurity. But they are precisely the kinds of flexible, part-time and art-related jobs traditionally favored by artists who want time to "embody more freely the productions of their imaginations."

This process is very new, and it should have a revolutionary effect on the way architects work, because it will allow them to embody more freely the productions of their imaginations as well as allowing them to build more cheaply, and to a better quality.

Hal Foster concludes his 2001 essay "Master Builder" by asking of Gehry's architecture and then of himself: "So what is this vision of freedom and expression" proclaimed by so many Gehry fans? "Is it perverse of me to find it perverse, even oppressive?" He answers: "[It] is oppressive because, as Freud argued long ago, the artist is the only social figure allowed to be freely expressive in the first place, the only one exempted from many of the instinctual renunciations that the rest of us undergo as a matter of course. Hence his expression implied our unfree inhibition, which is also to say that his freedom is mostly a franchise."[31]

According to Freud, however, the instinctual satisfactions available to artists come at the price of turning away from reality,[32] making art what Bourdieu might have called a profession of social fantasy. The attractiveness to artists of flexible positions and individualized relations that are "vague and ill-defined, uncertainly located in social space" is that "they leave aspirations considerable room for manoeuvre."[33] And while the "privilege" of freedom—and instability—was once reserved for artists and intellectuals, it is now being extended to a whole range of service occupations, and beyond. So it is no longer only into our own fantasies (and those of our patrons) that we artists project our uncertain futures. Those fantasies already may have merged with what Bourdieu called neoliberalism's

31. Hal Foster, "Master Builder," in *Design and Crime (And Other Diatribes)* (London: Verso, 2002) pp. 40–41.

32. Sigmund Freud, "Formulations Regarding the Two Principles in Mental Functioning," in *General Psychological Theory*, ed. Philip Rieff (New York: Collier, 1963) pp. 21–28.

33. Bourdieu, *Distinction*, p. 155.

"utopia of unlimited exploitation": a system of structural instability not only of employment, but in the "representation of social identity and its legitimate aspirations."[34] And through the increasingly popular publicity generated by institutions like the Guggenheim, artists (and some architects) have become the poster girls and boys for the joys of insecurity, flexibility, deferred economic rewards, social alienation, cultural uprooting, and geographical displacement, as if it's all just one big, sexy lifestyle choice.

In the context of neoliberal economic regimes, the art museum is emerging as a privileged site for valorizing the precarization of work. Through representations of art and artists, architecture and architects, flexibility, spontaneity, customized products, individualized relations of production, and even insecurity itself are represented as positive values, sources of creativity, dynamism, and growth. The products of disempowerment are transformed into promises of freedom and previously unimagined pleasure.

Now turn to your right and look at the glass tower that contains two of the elevators. The glass surface of this tower also curves, and again the curves are produced by panels fitted together. But here they overlap, like the scales of a fish.

Why have modern and contemporary art museums become a favorite tool of urban regeneration and redevelopment schemes? How is it possible that cultural forms that even museums themselves admit are "difficult, demanding, bewildering," cultural forms widely identified with obscurantism, elitism, and exclusivity, cultural forms ridiculed in the media and periodically subjected to censorship, vandalism, and protest—how is it that such culture could possibly be placed at the center of multimillion-dollar development schemes whose logic depends on attracting massive numbers of visitors and worldwide media recognition?

The question has been taken up, but the answers offered only seem to beg it once again.[35] Is it just that a contemporary art museum offers a particular conjunction of attributes, like a product profile that suits a particular audience profile, sought-after market, or target economic sector?

Could one the argument rest on a roster of substantive attributes that might tally up to a balance of the art museum's contradictions? Such a list may be informative. Taking another look at the text of our introductory audio tour, we can put "freedom" at the very top of the list. Then would come "open," like the space of the atrium and the plan of the museum, and "flexible," like the uses to which the building's materials have been put and the flow of our movement through it. That flow could be called "dynamic, moving, self-transforming." It allows us to experience the "future" of museums, of culture, of production in all its "novelty." It allows for "growth": the growth of the institution and its

34. Pierre Bourdieu, "Utopia of Endless Exploitation," *Le Monde Diplomatique* (March 1998): 3; Bourdieu, *Distinction*, p. 156. It may be in this sense that the vision of freedom Gehry represents does indeed correspond to "'the cultural logic' of advanced capitalism," as Foster suggests in "Master Builder," p. 41.

35. For a discussion of perspectives on this question, see Evdoxia Baniotopoulou, "Art For Whose Sake? Modern Art Museums and Their Role in Transforming Societies: The Case of the Guggenheim Bilbao," *Journal of Conservation and Museum Studies* 7 (November 2001).

architecture to enormously powerful scales; our growth as "individuals"; the growth of "individualism" itself, perhaps, in the unique forms and objects and spaces of the museum in all its "diversity" and "democratic" populism.

This is no idle metaphor. The architect who designed this building, Frank Gehry, has always found inspiration in fish.

My list is actually borrowed. All the terms in quotation marks are derived from an "ideological schema" of the rhetoric of neoliberalism set out by Pierre Bourdieu and Loïc Wacquant. Each appears in a series of oppositions:

state	market
constraint	freedom
closed	open
rigid	flexible
immobile, fossilized	dynamic, moving, self-transforming
past, outdated	future, novelty
stasis	growth
group, lobby, holism, collectivism	individual, individualism
uniformity, artificiality	diversity, authenticity
autocratic ("totalitarian")	democratic[36]

The only term I left out was the first, "market," a term to which all the others in the right-hand column are directly or indirectly made to refer. I would add one final opposition to the set: local and global.

The fantasies of freedom packaged by the Guggenheim Bilbao can certainly be read as symbolic manifestations of the freedom from national, civic, and communitarian order, cultural tradition and social determination, and political and economic regulation that are the foundation of neoliberal programs. They are freedoms increasingly realized by the global mobility of capital, production, and the transnational elites among whom cultural producers can be counted in growing numbers. And they are also freedoms increasingly sought and enjoyed not only by artists and the individual and corporate patrons of museums, but by the corporate entities many major museums themselves have become.

A more revealing exercise may be to consider the terms in the left-hand column as describing what museums have been considered—and no longer want—to be: instruments of the "state," institutions of confinement and "constraint," architecturally and discursively "closed" structures following "rigid" organizational and conceptual models that are as "immobile" and "fossilized" as their "outdated" displays of the "past." Et cetera.

No, we're not dealing with "idle metaphor" here, but with extremely active homologies, homologies that accomplish their work of structuration by linking apparently distant

36. Pierre Bourdieu and Loïc Wacquant, "New Liberal Speak: Notes on the New Planetary Vulgate," *Radical Philosophy* 105 (January–February 2001): 2–5.

or even opposed spheres through parallel sets of oppositions—oppositions that may themselves serve as the motor for the very "dynamism" they affirm.

He dates this obsession from the days when he used to go with his grandmother to market to buy a live carp, which he would then take home and keep in the bathtub until it was time to cook it. Here little Frank would play with the carp, and here the magic of its sinuous, scaly form somehow entered his bloodstream.

Like Frank Gehry, our "master builder" and "Greatest Living Artist" (as Foster facetiously calls him), contemporary art museums are transforming the old (culture, cities, economies) into the new—even as they transform themselves.

Folksy memories of grandma's quaint preindustrial consumption practices unfurl into towering cybernetic members. Obsessions, far from being pathologies, are realized on monumental scales. Idle metaphors spring into activity. They are put to work like robots, like computers, performing their magic of production without need for human labor.

If the Guggenheim Bilbao represents an institutionalized form of art, it isn't because Gehry has been considered an artist and his building a sculpture. Nor is it in the sense, as Foster and others have suggested, that the museum has "trumped" contemporary art, corralling it and swallowing it whole, appropriating and incorporating its transgressions.[37] The Guggenheim Bilbao is neither more nor less an institutionalized form of art then the "great museums of previous ages." Rather, it's a different dimension of art that has become institution here, a different fraction, if you will, of the artistic field, whose products of imagination and freedom correspond to a different, ascendant fraction within the field of power.

If you look to your left now, beyond the pillar under the stone box that we looked at a moment ago, you'll see the entrance to a large space. This is the largest gallery in the museum and, believe it or not, it's known as the Fish Gallery, because the long, curving shape of this part of the building is derived, once again, from the shape of the fish. Let's go in there now. Press your pause button until you are in the gallery.

Peter Lewis, the president of the Solomon R. Guggenheim Foundation, the parent corporation of the Guggenheim Bilbao, has described its director Thomas Krens and himself as "change agents." "To accept the status quo is early death. Change is valuable for its own sake, whether or not it turns out to be an improvement."[38]

From an institutional aestheticism that reached its peak with modernism and museums of modern art, we have now moved on to what can be called institutional trangressivism: the museological manifestation of the avant-garde traditions whose legacies now dominate the field of contemporary art. Art for art's sake has been discredited in the field of art as in museums, and, as Peter Lewis would have it, it has been replaced with change for the sake of change.

Interestingly, unlike most museum directors, Thomas Krens does not have a doctorate in art history. Rather, he has two masters degrees: one in studio art and one in busi-

37. Foster et al., "The MOMA Expansion."
38. Quoted in Martin Filler, "The Museum Game," *The New Yorker* (April 2000), p. 100.

ness.[39] His appropriation of for-profit business models, aggressive globalizing through an international network of branch museums, ties to corporations, deals with foreign governments, and exhibitions featuring luxury consumer products have all inspired much critical writing. Under Krens's directorship, the Solomon R. Guggenheim Foundation has even been described as a rogue institution and compared to rogue corporations like Enron.[40] Despite often hostile appraisal, however, the Solomon R. Guggenheim Foundation has nevertheless become the leading model within the highly competitive market that the field of art museums has become. And the compelling force of that model has rested, above all, on the success of the Guggenheim Bilbao.[41]

You are standing in a room of 3200 square meters. It's 150 meters long and between 12 and 25 meters high. Contemporary art is big. In fact, some of it is enormous, and this gallery was designed to accommodate the huge pieces that artists have begun to create.

Thomas Krens has said "growth is almost a law… Either you grow and you change or you die."[42] As Foster has suggested, the gargantuan scales that one finds in contemporary art museums as well as in the contemporary art inside it are mechanisms of the spectacularization of art and its institutions.[43] They exist as two points in a self-justifying and self-perpetuating logic of expansion in which they serve, in turn, as symbolic manifestations. Big art demands big spaces. Big spaces demand big art. Big, spectacular art and architecture draw big audiences. Big general audiences, with less specific taste for the specific traditions of modern and contemporary art and architecture, are drawn by big, spectacular art and architecture. Museums need big spaces to accommodate big art and big shows and the big audiences they draw. They need big shows and big art to draw big audiences to raise big money to build big spaces and organize big shows with big art to draw big audiences.

The growth in the physical dimensions of museums like the Guggenheim Bilbao, however, is only the most visible symptom of museum expansionism. It can also be seen as a manifestation of institutional ambitions and the strategies employed to realize them. It may be no accident that two of the most enormous museum spaces in Europe, the

39. See Filler, "The Museum Game."
40. Jerry Saltz, "Downward Spiral: The Guggenheim Museum Touches Bottom," *Village Voice*, February 19, 2002, p. 65. See also Michael Brenson, *The Guggenheim, Corporate Populism, and the Future of the Corporate Museum* (New York: The New School/Vera List Center for Art and Politics, 2002).
41. It's now clear enough that the Guggenheim's expansion strategy is primarily a financial strategy. When it struck the deal with the Basque government, it was in dire financial straits. The Guggenheim's primary assets were its collection and its image. But how does a museum generate income from collections, if entrance receipts are not enough? The Guggenheim had already tried deaccessioning some works, amid much controversy. But instead of selling works from its collection, the museum hit on the idea of renting them—to itself. Branch museums financed by foreign governments and corporations, but directed entirely by management in New York, would pay the Guggenheim for the privilege of presenting its exhibitions and collections. The museum could thus capitalize not only on its collections, but also on the value added by its expertise and the ever increasing brand power of its global image. Thus, like so many corporations of the 1990s, the Guggenheim's expansion strategy allowed it to draw new investment that would cover debt from existing operations.
42. Thomas Krens, quoted in Filler, "The Museum Game," p. 104.
43. Foster, "Master Builder"; Foster et al., "The MOMA Expansion."

Contemporary art
is big.
© Andrea Fraser.

Guggenheim Bilbao's Fish Gallery and the Tate Modern's Turbine Hall, were developed by institutions pursuing expansion through the development of branch museums: the Tate within Britain and the Guggenheim globally.

The Guggenheim Bilbao is now only one of a growing number of Guggenheim branches in a family of franchise museums that spreads from St. Petersburg to Berlin, Las Vegas to Venice and soon to Rio de Janeiro. The Guggenheim Foundation's growing international network of branches has also made it the leading model of globalization for museums, demonstrating that a global museum has potential for global sponsorship that single-location museums could never hope to secure.[44] That potential includes attracting sponsorship from public and private local interests in a wider range of localities, as well as being more attractive to globalized corporate interests looking to reach more markets with their contributions.

As in so many other fields, one of the primary effects of globalization on the field of museums has been to transform it into a highly competitive market. Museums could once be relatively secure in local support, whether public or private, individual or corporate. Nations supported their patrimony. Cultural philanthropy, historically tied to urban reform movements, tended to be local, even for corporations, driven, at least symbolically, by civic pride. Certainly museums played roles in the competitive struggles of nations and cities and their regional elites, and these struggles had economic and political as well as social and cultural stakes. Generally, however, the forms of competition that existed

44. Guggenheim curator Lisa Dennison calls "the concept of global sponsorship" one of the "big secrets" of Krens's success. Corporations "want to support a museum that has many bases in as many places as possible. And ideally that means you're touching more markets." Quoted in Filler, "The Museum Game," p. 105.

between museums themselves were of a highly sublimated kind: struggles defined by the criteria of the cultural fields to which to museums themselves belonged—such as conservation and research in art, history, ethnography, science, et cetera.

In the past decades, however, the spread of the American model of private support, through Thatcherism in Britain to neoliberalism on the European continent and beyond, have made museums increasingly dependent on private sponsorship. At the same time, these new private funders themselves, particularly corporations but also foundations and increasingly mobile elites, have undergone a process of globalization that makes them less interested in local institutions. Finally, enormous growth in the number of museums has created more competition at every level. The combination of these three factors may have effectively restructured the field of museums itself. Competition between museums may always have existed, but it now appears that the *survival* of many museums depends on their ability to compete, locally, nationally, and globally, for sponsorship and also for audiences.

Walk over to the left-hand side of the gallery and look up at the ceiling. You'll see a lighting gantry…

Oh, this tour is starting to seem interminable. Do we really need to know about the gantries? I turn off my headset and head back to the atrium. I want to give the walls another good grope.

On Not Having Seen the Bilbao Guggenheim

Lucy R. Lippard

You can't escape the Bilbao Guggenheim, even if you've never seen it. To paraphrase Walter Benjamin: "Will not the media coverage become the most important part of the experience?"[1] In these days of virtual tourism and torrents of received information, not having seen a famous tourist site may almost be an advantage. I've never seen the Egyptian pyramids, the Taj Majal, or Antarctica, and I have seen the Great Wall of China, Chichén Itzá, and Chartres. What's the difference? I can see all of them in my mind's eye. Sometimes I can't remember if I've been to a place or just know too much about it, or maybe dreamed it. If I had seen Bilbao, could I have kicked the preconceptions and actually have had a lived experience?

There are virtual tours of endangered archeological sites so that the remains remain unknown and protected. There are virtual archival tours of sites already destroyed. The Center for Land Use Interpretation has a database for tours of what they call "banal and dramatic" sites: "Margins in Our Midst" and "Landscapes of Conjecture." Working through a process of extrapolation, they "reconstruct a theory of the present."[2] Because I'm into rural issues, my favorite virtual tour is the "Corn Cam" Web site (www.iowa-farmer.com/corn_cam/), written up by Carla Corbin, which allows the agriculturally alienated urbanite to watch corn grow at fifteen-minute intervals. This could easily be mistaken for an old conceptual real-time artwork or a new vaguely ecological artwork. But it was produced by the magazine *Iowa Farmer Today*, beginning as "something of a joke … a digital version of the custom among farmers to drive around Sunday afternoons to check the progress of each others' fields."[3]

1. The original quote from Benjamin ("A Small History of Photography," 1931) is "Will not the caption become the most important part of the photograph?"

2. The Guggenheim was way ahead of me here. As I found out from Jon Azua's charts at the conference, a virtual Guggenheim is already in the works.

3. Carla Corbin, "American National Identity and the New Landscape of Agriculture: Scale, Power, and Abundance," *Journal of American and Comparative Cultures* 25, nos. 1–2 (Spring–Summer 2002).

But as an advocate of lived experience, virtual tourism doesn't really cut it for me. Because Gehry's Guggenheim escapes me, I'm going to escape to something I have seen.

Why haven't I been to Bilbao? Three years ago I had a gig in Barcelona and it was within reach. But I chose to go instead to Galisteo, Spain, in Extremadura, near the Portuguese border. For years now I've been writing a book about the village I live in—Galisteo, New Mexico. It's named after that somewhat larger Spanish town in the province of Cáceres that I visited instead of Bilbao. I should say that Galisteo, Spain, is related to Galisteo, New Mexico, in name only. In 1581, a small group of Spanish conquistadors—the Rodríguez-Chamuscado expedition—came through the valley, looking unsuccessfully for gold. Like their predecessors and successors, they randomly named the Pueblo Indian villages they went through, mostly after saints. Chamuscado was born in Arroyo de la Puerta in Coria, Cáceres, quite near Galisteo. A lot of early New Mexican immigrants fled Extremadura because of poverty and droughts. (Smart idea, to flee to New Mexico—still the poorest state in the union and constantly plagued by major droughts.) Anyway, they left a few calling cards from home in the local place names, overwriting and obliterating the Indian names. With each expedition, the Spanish names changed. But for some reason, Galisteo (aka San Lucas de Galisteo, Santa Ana de Galisteo, Santa María de la Gracia de Galisteo, and Santa María de los Remedios de Galisteo) kept its first given name, remaining the only New Mexico pueblo named after a Spanish town. Its Tewa name—Tano'ge or Tano'ouinge—was of course ignored.

So I had this obsession about seeing the town of Galisteo, Spain. On the way, we stopped at Trujillo, home of the Pizarro family. In the plaza stands an equestrian statue that was made to portray Hernan Cortez, but the place that had commissioned it couldn't pay for it, so the generic rider's name was conveniently changed—and here's the conquistador Francisco Pizarro in his hometown. The reliefs on the family *palacio* show the history of the conquest of Peru. Pizarro's lover was Inez Yupanqui, sister of the Inca emperor Atahualpa. Because of connections to New Mexico (which Pizarro never saw), the Trujillo museum has been adopted as a sister to the National Hispanic Cultural Center in Albuquerque, New Mexico. There is now an Extremaduran and Ibero-American Museum of Contemporary Art in a renovated prison in Badajoz. I've never seen that either.

Equestrian statue, Trujillo, Spain. Cortez becomes Pizarro and leads the way to a brave new world of Ibero-American heritage.
© Lucy R. Lippard.

Galisteo, Spain, bore no resemblance whatsoever to Galisteo, New Mexico. It's a little out-of-the-way walled white town on a low hill with a lovely medieval bridge and a park at the confluence of the Jerte and Alagón Rivers. The town was an *alcazaba*, or fortress, of Medina Ghaliayah, a leader of the Spanish moors in the tenth to eleventh centuries. There's an almost ugly Iglesia Parroquial from the thirteenth century. The gates to the village are called Puerta del Rey, Puerta de Santa María, and Puerta de Villa—neatly divided among the monarchy, the church, and the municipality. In the fourteenth century, Galisteo was listed as one of sixty-three *juderías* between Cáceres and Badajoz. The town fell into decadence, as historians say, in the sixteenth century, which is when people began to emigrate to New Spain. I was interested in the Moorish/Jewish history because in the last couple of decades, New Mexico has become obsessed with crypto-Jews, *conversos*—who may also have been Muslims—fleeing the Inquisition in Spain and then Mexico, ending up in "this miserable kingdom," as New Mexico was called in the sixteenth century: ("Ocho meses de invierno, quatro meses de infierno [eight months of winter, four months of hell]" is how they described it.) So far no one has yet unearthed the Moorish history of New Mexico.

The year we were there, Galisteo, Spain, had been infused with money and energy by a grant from the European Union, which has been busy transforming Spain into a "modern" country, thereby removing many of the reasons some primitivizing tourists chose Spain, but putting in place a tourist structure that will probably please a still larger group of comfort-oriented visitors. The *almohad* wall, with bell towers and storks' nests, has been restored, so it's possible to walk around and above the town on the parapet, looking down into people's backyards—far more interesting than the street facades—allowing the nosy cultural tourist to get a glimpse of "authentic" village life.

The Galisteo wall will not attract a lot of visitors, since Spain is cluttered with marvelous Moorish ruins. It has been restored for the same reason that Bilbao is pouring money into the

Backyard seen from Almohad wall, Galisteo, Spain. Once used to repel would-be invaders, the wall now encourages the inquisitive visitor to see some authentic local life.
© Lucy R. Lippard.

Guggenheim, offering two examples of municipal evolution and dependence on tourism on very different scales. The Galisteo wall will be touted as "heritage," although it was built by people who were expelled from the country in 1492, people who are today framed as the enemy. Spain is in the peculiar position of exploiting *mudéjar* tradition, while fighting off al-Qaeda. Muslim immigrants have not had an easy time in Spain in the ensuing centuries. But their *cultural* legacy is welcome. The Galisteo wall, then, is not an interruption, the imposition of a foreign body, or a stepmother ship landing,[4] like Gehry's Guggenheim in Bilbao. It's the reconstruction of a past nobody wants to live again, a tiny part of the Islamic/Jewish/Christian puzzle that created Spain and to some extent New Mexico.

But you don't want to see *all* my travel slides.

My point is that without thinking much about it, I opted for the most conventional kind of historic tourism over the modernist architectural spectacular, in part because the context is always more fascinating than the object, and I had my Galisteo context already constructed, and in part because my idea of visionary architecture is Samuel Mockbee's Rural Studio in Alabama. Nevertheless, history, created and recreated, is the mother lode of tourism. And as is now well known, a history unmoored, a history that serves up events and places out of context, refusing to share its story with people unlike its creators, devolves into commercial heritage. Marie-Francois Lanfant has written that: "The discovery of heritage … in some sense breaks the very chain of significance which first invested it with authenticity." Now it is just *marked* to certify "the identity of a place for the benefit of anonymous visitors." Dean MacCannell goes even further, concluding that "cultural tourism blocks our access to cultural origins."[5]

We were in Galisteo, Spain, on a Sunday morning, so the *ayuntamiento*, the town hall, wasn't open. We didn't see any other foreigners, but the town was clearly gearing up to be a tourist destination on a small scale, and they were already used to the idea of us being there. A big brick hotel named after Medina Ghaliayah was under construction outside the walls. Galisteo, Spain, is about to become a mild version of the theme park. "While this may be the only game in town economically," writes MacCannell, "it is not a very human thing. It marks a moment when the people, via treachery or other means, have been made to give up on themselves as consumers of their own heritage, believing they must accept cultural assembly-line work, making reproductions of their heritage and culture for anonymous others." (In New Mexico this often tragic role is played by Native Americans.) MacCannell recommends that we cultivate "respect for the gap" between tourists and the toured, "a gap that can be narrowed but never closed."[6]

4. Artist Janet Koenig had predicted this in an image of 1987 where she shows the New York Guggenheim as a "mother ship" landing. Another building that seems (but is not really) out of context is Egyptian architect Hassan Fathy's adobe mosque in Abiquiu, New Mexico.

5. Marie-Francois Lanfant and Dean MacCannell, in MacCannell, "Cultural Tourism," *Conservation* 15, no. 1 (2000): 23, 26.

6. Ibid., p. 24.

Restored Almohad wall, Galisteo, Spain. Spain's problematic Muslim past is being reinvented as a potentially lucrative future through the development of a Moorish heritage industry. © Lucy R. Lippard.

Hotel under construction, Galisteo, Spain. The Medina Ghaliayah hotel might well serve as the basis of a future Moorish theme park. © Lucy R. Lippard.

David Nickell contends that loss of cultural property can be even more destructive than loss of land. "One can see this," he says," in communities marketed as stereotyped images of themselves for tourism. The conquering people … may find the history and the folklore of the places intellectually interesting, but it can never be authentically theirs." Then he adjusts the blame: "A corollary of this," he writes" would be that people who have lost their sense of heritage become a threat to their place."[7]

Tourists traditionally go to see old things or new things, not much in between, unless it's a monument, the site of a tragedy or—less interesting—of a triumph. Going to Bilbao is a lot cooler than going to yet another quaint old Spanish town. Never having been cool, I'm resigned to knowing what I like. And déclassé though it may be, I like old things, and I like to see how new things age. Too bad I won't be around to visit the Guggenheim Bilbao in fifty years. If I ever do get there, I suspect I'll be more interested in wandering the industrial ruins than in gawking at the featured attraction.

7. David Nickell, "Cultural Property and the Sense of Place," *The Land Report*, no. 74 (Fall 2002): 6.

The first thing I read about the Bilbao Guggenheim that really grabbed me, and this was after that Spanish trip, was Joseba Zulaika's article in *Neon*, the Nevada State Art Council's paper.[8] It struck me because my interest lies in the cultural landscape, or landscape and social relations, rather than in architectural objects, and he provided a contextual image of the city itself. I was particularly taken by his account of Frank Gehry's fear that the harsh industrial wastelands of this now legendarily "tough" city might soon be "strategically beautified," mitigating the striking effect of his "metallic flower."

We're aware that tourism is fueled by seduction and hyperbole. Thomas Krens has even used the word "seduction" to describe his strategy for museological imperialism, and he has openly compared the Guggenheim Bilbao to (an adult?) theme park. I can't talk about the erotic aspect of Gehry's building—you *do* have to be present for that—so I'll recommend Andrea Fraser's video for those into virtual entertainment. However, this is as good a time as any to recall that the museum has been called "voluptuous" by various male critics. Marilyn Monroe is mentioned. It's constantly referred to as a flower, and we know from Judy Chicago what a flower really is… Then there are also constant references to the flowering of Bilbao and of the Basque Country, although few to the blossoming of corporate culture.

In *Culture Incorporated*, Mark Rectanus details the magnitude of the role of corporate sponsors in museums, as Hans Haacke has done so effectively in the past. Corporate sponsors fund as much as 70 percent of the Guggenheim's exhibition costs in the United States and Europe. The exhibitions themselves, says Rectanus, are "tailored to marketing objectives as well as their client and employee needs."[9] Corporations are already wired to promotional media and have their own global communication channels and can expand the museum's influence. Corporate philanthropy is being replaced by sponsorships, and they have helped make the Bilbao Guggenheim a "must see." If tourism began as religious voyages, visits to the Guggenheim Bilbao have also been called "pilgrimages," and Gehry's building has been called a "miracle," thanks to the corporate deities. In photographs, Gehry's brilliant building appears as a vision, a glowing golden paradise or temptation at the end of an arduous journey. Salvation is just around the corner, in the quintessential tourist experience: Map in hand, one winds through unfamiliar avenues, asking directions in labored language. And then There It Is! Looming at the end of a narrow alley, recognizable from the art-history books, removed from urban reality, a riveting illustration of spatial power.

Mark Jarzombek has called the Bilbao Guggenheim "central to a narrative in which political symbolism, regional identity and international tourism are conflated."[10] Zulaika points out the building's dependence on

8. Joseba Zulaika, "Tough Beauty: Bilbao as Ruin, Architecture and Allegory," *Neon* (Winter 2000–2001), n.p.

9. Mark W. Rectanus, *Culture Incorporated: Museums, Artists, and Corporate Sponsorships* (Minneapolis: University of Minnesota Press, 2002), p. 10.

10. Mark Jarzombek, *Urban Heterology: Dresden and the Dialectics of Post-Traumatic History* (Lund, Sweden: Lund University, 2001), p. 18.

how it relates to the allegories cast by the city's ruins... For the magic of "toughness" to work through Gehry's luminous building, it is required that everything else relinquish its Disneyland dreams... It makes a world of difference whether his building generates a dialectical image with the recently closed Altos Hornos—the life and blood of thousands of families for a century—or whether it is assimilated into Abandoibarra's garden city as a sort of "Benetton provocation" that shocks visually in order to sell the new Bilbao."[11]

So the transformation of the tough city into a garden city could drag the Guggenheim into a far more banal competition for centrality, deprived of its triumph over a Duchampian ready-made stage set. Either its striking contrast (or its lack of affinity) with the city is a virtue—or it suffers the negative disjunction of plop art, public art plunked down from a gallery onto an unrelated urban pedestal.

And what if other architects pull off other miracles—or disasters? (Pelli, Calatrava, Hadid, and others have already weighed in.) How many blockbusters can this context take without beginning to look like Las Vegas? Or will Bilbao become a stunning collage of competing masterpieces? It's a cliff-hanger. Will trite urban renewal and beautification win out? Will the museum age as well as its historic counterparts? And looking further into the future, what will the flower look like when it wilts? Will the Guggenheim make an attractive ruin, providing mulch for a new blossom, or will it get deadheaded in its own turn?

The Basque government has gambled very big on this building. The whole city is held hostage to the flower. Will this single art object be able to co-opt the future of an entire urban landscape, of an entire region? Will the tough city remain as a critical watchdog or become a hangdog witness to the new touristic spectacular, a kind of memento mori? Pellegrino d'Acierno calls Rome "collision city—the eternal city of incessant architectural shocks."[12] Bilbao is now in the running for collision-city status. A major player in this narrative is Euskadi 'ta Askatasuna (ETA, Basque Country and Freedom), which tried to blow up a Jeff Koons on the day of the opening (not an altogether terrible idea in itself). The accompanying murder of a security policeman just spikes the image of toughness. I can't help but recall the death and injuries of workers constructing sculptures by Richard Serra, who is Gehry's, Krens's, and maybe Bilbao's favorite art star. (His second huge work for the museum—at a cost of $20 million to the local government—is one of the most expensive artworks ever commissioned).[13]

The eminent and outraged Basque sculptor Jorge Oteiza was not alone in seeing Krens and Gehry as reverse conquistadors. The Guggenheim is often called a flagship for development, and such bellicose metaphors are underscored by the fact that it was built with the help of 3-D modeling developed by the French military. At least it's been a

11. Zulaika, "Tough Beauty," n.p.

12. Pellegrino D'Acierno, "Thirteen Ways of Crossing the Piazza: Rome and Its Cinematic Double (excerpt)," from an unpublished "Architourism" reader, Columbia University symposium, 2002.

13. It was remarked at the conference that one of the glass panes in the Bilbao Guggenheim's atrium had already fallen out. Luckily, no one was hurt.

more benign occupying force than the United States in Iraq. This conference's organizers point out that in the early 1990s, Bilbao, this "marginal Basque city," was suffering a historic economic downturn and 20 percent unemployment. "Gehry's optimistic artichokelike building (or is it the reincarnation of to Marilyn Monroe?) amid Bilbao's postindustrial ruin has become an icon of what architecture can do for a city in decline." It's been called a Cinderella story. Does the citizenry of Bilbao think the shoe fits?

I wish I knew more about the Basque in the street's reactions. A friend of mine talked to some locals in Bilbao who had never visited the museum. "Who cares?" said one of them. "They took all our arts funding."[14] Selma Holo contends that after Franco's death, museums were consciously deployed to promote democracy, although the Bilbao Guggenheim has steadfastly refused to enter debates around nationalism and Basque autonomy.[15] Gehry talks about using "a cultural facility to awaken the community. When it's done, the world comes flocking to see it. It attracts industry and population. That's the desired effect of these kinds of buildings."[16] But what happens when the tourists go home? What's in it for the locals? Rumor has it that attendance is down at Bilbao, now that everyone who can afford the trip has checked off this high spot on the architourism list.

"Bilbao is a good example that the margins of Empire are often more important to it than the center," wrote the conference organizers. The concept of the local must always be countered by the global. That certainly goes for marginal tourism, where distance is a synonym for the exotic, as in Galisteo, Spain, which is entirely local and ordinary for anyone but restless cosmopolitans. Museology is also becoming dependent on distance. Consider, as Ali Hocek has, the parallels between the "remoteness" of the sites of classic land art and the "remoteness" of new museums from their home bases—the Tate Modern across the river in an industrial building, the Guggenheim across an ocean in an industrial city, and the Dia:Beacon across the state in an industrial locale.[17]

I was disturbed to hear that there are ecological objections to Gehry's flashy material, that titanium mining creates some serious problems for the landscape. The politics of materials, crucial to workers in crafts fields, doesn't get much attention in art or architectural criticism. It has broader ramifications. A metalworker friend says that in her field, you have to ask where the iron, silver, or diamonds are coming from. Right now, gold is going up, which signals an unstable world where people don't trust anything but hard coin.[18]

Meanwhile, back in Galisteo, Spain. Here lived the economically depressed future conquistadors, many of humble origins, patronizingly ennobled as hidalgos—*hijo de algo*, "son of something or other." They came to New Mexico in the sixteenth century because they

14. Antonio Lopez, "Journey Through Time," *The New Mexican*, January, 28, 2001, G2.

15. Selma Holo, *Beyond the Prado: Museums and Identity in Democratic Spain* (Washington, D.C.: Smithsonian Institution Press, 1999).

16. Frank Gehry, quoted in Sara Doran, "America's Greatest Architect," *American Way*, February 1, 2004, p. 61.

17. Ali C. Hocek, "Site-Specific in Beacon?" Letter to the editor), *Art in America* (September 2003): 31.

18. Thanks to Jan Brooks for this information.

were in the same desperate straits as Basque miners and industrial workers in the late twentieth century. They came to colonize indigenous peoples who were already fighting other indigenous peoples. Eventually the mestizo descendants of those indigenous peoples and those emigrants in New Mexico came to idealize Spain, the mother country, and call themselves, proudly, "Spanish"—not "Hispanic," not "Chicano" (too political), and definitely not "Mexicano." And if they are able, Hispano–New Mexicans come to Spain and peer at monuments to find their roots.

So what's new, or what distinguishes the Guggenheim Bilbao from historical tourist destinations such as Galisteo, Spain? To begin with, the Guggenheim *is* new. Only in the worlds of art and commerce does the new outrank the old with such ease. Planned obsolescence must scare the hell out of architects, whose creations are so colossally costly. (Think of Stephen Holl's Bellevue Art Museum in Washington state—new, but now dark.) To paraphrase Carl Andre's famous statement "A thing is a hole in a thing it is not," the Bilbao Guggenheim is the new as a hole in the old, just as Brian Tolle's Irish Hunger Memorial in lower Manhattan is the old (emerald grass and the ruins of stone cottages) as a hole in the new. (And it's a couple of blocks from Ground Zero, which is a new hole in the new.) The ruins of Dresden's Frauenkirche and the cathedral in Berlin were left intentional holes in postwar cities to maintain a message about the past. Years ago, cultural geographer J. B. Jackson wrote that for Americans, history is "a dramatic discontinuity," giving rise to "the necessity for ruins," which provide the incentive for restoration, a return to social origins, "a born-again landscape."[19] This may be the role Bilbao serves for American enterprise.

The *almohad* wall around Galisteo Spain is a kind of ruin rerun, or a "ruin in reverse," a Robert Smithson term picked up by Bonnie Ott and Matthew Potteiger in a Michaelangelesque conceptual earthwork proposal called *The Temple of More Talus* that "inverts the physical process by which architecture is made," revealing the temple not through construction, but "through the natural processes of erosion, and its by-product talus." Urban renewal, or the even more optimistic phrase "urban regeneration," has been sternly criticized in the last decades, sometimes from the preservation angle, sometimes from the community activist angle, sometimes from the aesthetic angle. The original idea for a Guggenheim Bilbao was to recycle one of the historic industrial buildings for a museum that would then have joined the proliferating European industrial site-recycling projects. It turned out to be impractical. It would not have drastically changed the context or landscape of Bilbao, and in turn, such slight change would not have attracted hordes of tourists. They don't come to see the art. Philip Johnson put it succinctly: "If the architecture is as good as in Bilbao, fuck the art!"[20]

The very American, or international, Guggenheim as an instant landmark in the Basque Country also brings up the notion of cultural trespassing. (I'm perhaps overly

19. J. B. Jackson, *The Necessity for Ruins and Other Topics* (Amherst: University of Massachusetts Press, 1980), p. 102.
20. Philip Johnson, quoted in *Frank O. Gehry and Kurt W. Forster: A Dialogue* (Stuttgart: Hatje Cantz, 1999).

aware of the tremendous challenge of cross-cultural communication—which I live almost every day in Galisteo, New Mexico, where Spanish is the first language of the older people, and a ninety-four-year-old friend calls me "La Americana" as though it were still 1848.) Yet this aspect seems to have been swept under the rug. I think I might feel like a trespasser in Bilbao, especially knowing something of Basque nationalism. But I would feel quite at home in the Guggenheim. Like its contents, the often-forgotten art, it will be as familiar to international visitors as other franchises have become—upscale McCulture, like Armani or Prada.

Gehry has been quoted as saying that "democracy is good for architecture. Pluralistic ideas are what we want. Represented in architecture, they lead to a visual chaos that is part of our lives and part of our system of democracy. To homogenize everything requires a different kind of government, a dictatorship."[21] This from the employee of the Guggenheim franchise! (Visual homogenization is not the only kind.) The United States has been the modern world's greatest homogenizer, exporting a monolithic democracy; aka. capitalism. The Spanish architect Santiago Calatrava, who demands an architectural morality, even though his new Milwaukee museum wing is just as much of a prima donna as Gehry's Guggenheim, sees buildings as "passages" in a larger context,[22] as does Zaha Hadid's notion of an "urban carpet" that runs out of her Cincinnati museum into the city.

Michael Sorkin has talked about the creation of urbane disguises in urban design. Tourism offers locals a disguise, whether they like it or not. Disguise makes everyone anonymous: Tourists and residents alike are overwhelmed by the setting. All tourist towns need a back room where the residents can take their shoes off and put their feet up and be themselves, rather than residents of Galisteo, Santa Fe, or Bilbao. Even Galisteo's *almohad* wall is a kind of a disguise. It's a fortress that ironically has become a revolving door, welcoming, rather than repelling invaders.

We in Galisteo, New Mexico, may have to get out our costumes and funny hats soon. There is already a rather feeble legislation in place to protect the many major pueblo ruins in the Galisteo Basin. In the unlikely possibility that the government offered to restore one of the two- thousand-room pueblos (now unprepossessing piles of rock, adobe, and cholla catus), where would I stand? New Mexico's two main industries are tourism and the military. Our Galisteo has become a bedroom community, rather than the working landscape of its several-century-old history. We will need some industry, cottage or otherwise, if we are to maintain our so-called "rural character"—at the moment dependent on the open space provided by two tax-break absentee ranch owners. They're preferable to subdivision developers, when push comes to shove. Yet when I was invited to represent Galisteo at a county meeting on tourism, I announced with some confidence that Galisteo doesn't want any tourists—except for the annual weekend studio tour and

21. Frank Gehry in *American Way*, p. 59.
22. Santiago Calatrava in *Porcupine* 5, no. 2 (2001): 110.

"Tourist, You are the Terrorist!" Graffiti in Barcelona. Tourism is challenged spontaneously in the global language of English. © Lucy R. Lippard.

Historic marker, Galisteo, New Mexico. Tourism is embraced by a sign stamping authenticity on the pueblo. © Lucy R. Lippard.

the fire department's one-night fiesta. I don't want anyone peering into my backyard, as I did to the residents of Galisteo, Spain. I still remember my disbelief when my picture was taken by a busload of Japanese tourists years ago as I trudged along in SoHo in black jeans and the like, lugging a giant bag of laundry that identified me as a local.

So to bring this talking in circles back to the beginning, not having seen the Bilbao Guggenheim has been a liberating experience. Even though I'm beginning to feel like the old lady trying to hold back progress in Boyd Webb's 1978 photo piece called *The Conservationist*,[23] it's allowed me to conflate the role of the art critic with that of the tour guide and to give you a glimpse of two places you probably will never see.

23. The decidedly not cool older woman is fiercely defending her dully traditional décor against a workman painting the wall pure white.

Part II

THE LOCAL POLITICS OF BUILDING

Guggenheim Bilbao: "Coopetitive" Strategies for the New Culture—Economy Spaces

JON AZUA

The Guggenheim Bilbao is an important phenomenon that invites analysis from different points of view: museums, art, city renewal, and economic development, for example. At the same time, it is an extraordinary example of how the Solomon R. Guggenheim Foundation is pursuing its own strategy.

It is controversial, personal, admired, and criticized. This paper, written from the deep and direct experience of one of those involved in the project (as deputy prime minister of the Basque government during the Bilbao-Guggenheim negotiations, member of the board of trustees of the Solomon R. Guggenheim Foundation, researcher or strategy consultant (mainly in the field of cities and regions) and after having been involved in several projects associated with Bilbao's recovery. Of course, this is ultimately just a personal approach that attempts to contribute to the work done by those who are looking to rethink the future—to learn from experiences, and to provide a better way of thinking.

Introduction

In the prologue to *The Humanities in Western Culture: A Search for Human Values*,[1] Robert C. Lamm explains both the importance of the humanities and the reason why we should study them in order to interpret the present and forecast the future of a given society. From his text, we can extract a series of observations that will act as basic guidelines throughout this paper.

The study of the humanities is based on the belief that the quality of life can be and must be improved over time and, furthermore, that the study of the humanities is at the

1. Robert C. Lamm, *The Humanities in Western Culture: A Search for Human Values*, 10th ed. (New York: McGraw Hill, 1996).

disposal of all communities and individuals. The study of art and the humanities allows us to identify artists as individuals and the influence they have exerted (or received), as well as the explaining need to promote them and to spread their work, all this based on and viewed from the principles and values of the community. Each epoch and each cultural and/or artistic movement demands that we should inquire about its context, the questions that surrounded it, and, above all, the solutions that it offered. Only an interdisciplinary approach will allow us to understand the life, values, and cultures of a given society. Thus, by examining and understanding the past, we can prepare for the future.

It is according to these principles that I approach the study of a specific artistic-cultural project, the new Guggenheim Bilbao Museum. This has become an authentic multiple phenomenon of culture, communication, and regional economic development,[2] which allows us to go beyond the purely cultural in order to analyze its more general context and above all to employ the three successive phases posited by the theory of cultural epochs—a period of chaos, a period of adjustment and a period of equilibrium in cultural change—as a partial methodology by which we can understand the new cultural movement in which we find ourselves. In this way, we can better appreciate the cultural-economic symbiosis that is now the subject of extremely intensive debate in an ebullient Europe.

Therefore, I will here examine a practical application (the Guggenheim) within the framework of the renovating process of a city (Bilbao)[3] as the focal center of a living community (the Basque Country)[4] that, on the basis of its own principles, values, and culture participates in the complex process of the construction of a more unified Europe,[5] with all these aspects being immersed in a permanent confrontation of conflicts and ideas that are germane to the cultural epoch in which Europe is developing.

Beyond Europe, all around the world, culture (and not only museums) operates as an engine for new regional and urban economic development processes. Indeed, no longer can strategic city making take place without a relevant role for culture.

The Guggenheim Bilbao: A Cultural Project ... and Something More

Some years ago, I had the opportunity to meet Evan Dobelle, at that time the president of Trinity College, in Hartford, Connecticut. The motive for this meeting was his interest in

2. Less than a year after its opening, it had broken all kinds of records: the museum with the largest number of daily visitors in Spain, the largest number of patrons, and so on. It is also viewed as the project that provides the greatest impulse for the revitalization of the city.

3. Located on the Atlantic coast of Northern Spain and the economic and financial capital of the Basque Country, Bilbao has a population of approximately one million (including its metropolitan area) and is immersed in a profound process of revitalization.

4. The Basque Country, one of the three historic "nations" of the Spanish state, has a population of approximately 2.1 million inhabitants.

5. The European Union is advancing in giant steps through a process that currently includes twenty-five countries, and an extension to twenty-eight is provided for. With the coming into force of its single currency (the euro) in January 1999, it now represents a single market that is larger than the United States and, together with Japan, these areas will constitute the world's three great economic blocks.

understanding what made Bilbao different from the other cities of the world, so that it encouraged the popularity and success of such a singular project as the Bilbao Guggenheim. His reflections were as straightforward as they were reasonable and interesting: "Today, there are more than 150 cities in the world completely immersed in a revitalizing process. All these share instruments, ideas and even 'leaders and planners.' Why does Bilbao, with one visible project, have such an impact?" He subsequently concluded that "the answer cannot be the Museum. We know the Foundation, we have collaborated with it for many years, it is important but it is not the number one in New York. Therefore, there must be something more." During these past few years after the Guggenheim Bilbao's opening, hundreds of international visitors have repeated similar questions and observations.

Finding that "something more" is what motivates this paper. I will try to find it from the points of view of culture and the humanities, as well as those of economics and city or regional development. This great avant-garde building of modern and contemporary art will thus allow us to understand better a natural community (that of the Basques) that confronted a serious crisis with the necessary creative tension to reinvent a new model, a new city and, what is more, a new museum.

The theory of cultural epochs will allow us to place the Guggenheim Bilbao project within the framework of a more complex cultural process that is impossible to interpret until it is first understood: How and why strategy is relevant for museums, art and cultural institutions, the role of culture as an engine of economic development, and the key role of the new global-local "glokal" dialogue. The glokal involves permanent "coopetition"—both competition and cooperation—with many agents involved, a simultaneous dialogue and contradiction between global and local spaces, and the "k" factor (technological knowledge).[6] It thus involves "coopetitive" strategies for the creation of a new "glokal" culture.

A Four-Part Strategy

Bilbao is the heart of the Basque nation. Since its foundation—it was 700 years old in the year 2000—this port city has directed the history of a vigorous industrial community that came to find itself in a period of chaos. This was due to a series of factors: permanent identity crises as a result of belonging to various politico-administrative areas (several kingdoms throughout history, and today Spain and France), the succession of wars it has endured (the most recent being the Spanish Civil War of 1936–39, an antecedent of the World War II), a lack of territorial unity (seven Basque provinces divided between two autonomous regions in Spain—the Basque Country and Navarre—and three in France), the process of recovering its language, Euskara, the use of which was prohibited during the Franco dictatorship, and several profound and intense industrial economic crises during recent periods (1975, 1980, and 1992) that obliged it to transform its industrial base and that constitute the starting point of the study here.

6. The "glokal" is a model devised by the author, a Bilbao think-tank organization focused on strategy, competitiveness and regional development.

It is, therefore, hardly surprising that once a period of adjustment had been reached, that is to say the end of Franco's dictatorship, together with the beginnings of a process of recovering self-government,[7] there emerged innovative proposals and new structures of government and administration and of economic management, accompanied by the integration of new intellectuals and new philosophies of administration, economics, and education. It is here that we can see the emergence of a strategy in which four crucial elements converge (see Figure 1).

Figure 1: A Four-Part Strategy

Euskadi—the Basque Country—was embroiled in a strategy of modernizing and industrializing its economy in the context of a new future horizon represented by (at that time) the forthcoming European Union.[8] This new framework would not only generate economic and social tensions, but might also leave Basque society—by virtue of it being a peripheral region—outside the main axes of European development. At the same time, Bilbao (home to 50 percent of the Basque population) was suffering a deterioration characteristic of industrial cities caught up in a process of decline, losing its motivation and its capacity to attract projects for the future and thereby accentuating the well-known infrastructure deficits suffered by large cities. Furthermore, cultural institutions were being progressively

7. Following the death of the dictator Francisco Franco in 1975, Spain began a process of transition toward democracy. In 1980, this process led to the creation of the Basque government and parliament, opening the way to a long process of devolution of sovereignty. Today, Euskadi (the Basque Country) is the autonomous region that enjoys the highest degree of self-government in Spain and one of the highest in Europe.

8. Spain joined the European Union (then known as the European Economic Community) in 1986.

abandoned, with increasingly scarce resources, limited creativity and artistic-cultural promotion, and minimal nonpublic initiatives, so that cultural infrastructures were the only elements in the Basque Autonomous Community that remained below the Spanish average.[9]

At the same time, the Solomon R. Guggenheim Foundation was living through its own bitter crisis. With its leading museum in New York closed for renovation and its failure to find financing for a project to open a new museum in Salzburg, Austria, it had sunk into a profound operating deficit and needed an innovative project to reinvent its strategy. Thus, visions and opportunities encountered a common space for a strategy involving the convergence of four elements: A new concept of the museum, capable of leading the contemporary art world of New York, yet gaining that position from abroad; the provision of new cultural and avant-garde museum infrastructures acting as motivating symbols of leadership; the revitalization of the city, converting it from industry to advanced services as the head of the European Atlantic Arc,[10] and the modernization and internationalization of the economy (and of the mentality of the population) against the background of a new European space currently under construction.

These four convergent elements coincided on the basis of a series of common factors: the search for cultural leadership, efforts at economic revitalization, internationalization, and the active cultural presence in Bilbao of the avant-garde. Furthermore, cooperation between two substantially different cultures and communities occurred, at least on paper: between American culture, in the form of an international institution rooted in the creative world of contemporary art, and a variety of politico-administrative institutions controlled by a Basque nationalist ideology and culture that was committed to recovering the identity and personality of a small society in a changing world that was afflicted by what we might call "globalphobia."[11] The differences between the two cultures and communities are clear. However, this cannot be said of the similarities.

A Long Road to Travel

In an attempt to attain *arete*[12] by striving to achieve competitiveness through solidarity, Basque nationalism (through the institutions of self-government) labored to construct a new socioeconomic and cultural project in a fully democratic way while at the same time, as Isocrates observed with respect to the people of Greece,[13] the Basque people suf-

9. See "Equipamiento e infraestructuras 1980–1990" [Synthetic Index: Amenities and Infrastructure 1980–1990], in *Ekonomiaz: Revista Vasca de Economía* (1992).

10. The European Atlantic Arc is an integrating space made up of peripheral European regions that face the Atlantic, composed of the Canary Islands, the Portuguese coast, and the coasts of Galicia, Asturias, and Cantabria in Spain, the Basque Country, the United Kingdom, and France.

11. According to this line of thought, we are witnessing an unstoppable globalization of the economy in which the domestic economy has lost its raison d'être, the free market guides the operation of society, and global governmental institutions (political, financial, and so on) emerge.

12. An Ancient Greek term equivalent to the sum of qualities that make up excellence.

13. Isocrates (436–338 B.C.), an Athenian orator and rhetorician who saw the union of all Greeks as a cure for Greece's ills, remarked that "the name Greek is no longer a mark of race, but of outlook, and is accorded to those who share our culture rather than our blood."

fered—and still suffer—from a lack of their own territorial, administrative, and political space in which to set up their own nation. Inspired by the Platonic maxim of gaining the commitment of the people by way of politics,[14] Basques became engrossed in a modernizing strategy that would allow them to reach the much-desired, but at that time still distant new Europe of the twenty-first century.

The second element was the social welfare state. Unlike classic liberal ideas that favor the market as the perfect—and only—dispenser of resources, the policies implemented within the framework of this approach favor solidarity. They form a support network of welfare for the community made-up of universal health coverage, independent of individual contributions; a system of economic agreements that guarantees free obligatory education up to the age of sixteen, with a concomitant freedom of choice on the part of the parents, both in the public and private education systems; and a minimum social wage for all the population that has no alternative income. This is complemented by an efficient network of social assistance, particularly for the handicapped and the elderly.

The third element in achieving socioeconomic and cultural transformation was self-government. All policies and the instruments that apply them are grounded in the spirit of self-government. The prevalent mood today is strengthening the ideas and values that underlie the principle of self-government, endowing it with the maximum ratios of efficiency and efficacy.

The fourth element was the achievement of a measure of peace and stability in the Basque Country. In an atmosphere of turbulence affected by the madness of a marginal terrorism committed by one part of the population that has not shared in the spirit of the transition, but has instead adopted a process of rupture and that argues for the use of violence in the name of politics, the strategy of modernization and internationalization promoted by democratic Basque nationalism has clearly opted for peace and the normalization of the country, making dialogue the basis for cohabitation and the instrument for the progressive recovery of political autonomy and sovereignty, two principles that can never be renounced.

The final element of the approach is territorial integration. By democratic means, conviction, and time, the recovery of cultural identity and the new concepts associated with virtual spaces give this element a new value in the implementation of socioeconomic and cultural transformation. Here that we once again find a certain parallel with the values of ancient Greece, in the sense that we can speak of this period as being characterized by the presence of values that accompanied the development of the Greek arts. In addition to the search for excellence, on which we already have commented, these include optimism, freedom, self-respect, and a respect for the legacy of history. Optimism is a value based on faith, conscious of many difficulties, but with an overriding belief in the strengths of a people who are capable of overcoming the adversities of history, as well as their own prob-

14. In *The Republic*, Plato states that all citizens are obliged to participate in politics and in the government of their nation.

lems and contradictions. Freedom is an everlasting vocation, accompanying all individual and collective activities. Self-respect and community pride result from the completion of projects such as the Guggenheim Museum, reinforcing the capabilities and strengths of the community so that it may confront new projects. And with its deeply rooted history, the community faces a new future without renouncing its own cultural identity.

Focusing on a City

It has been observed that global cities, in contrast to the historic cities, capitals, port cities, or the industrial metropolises that preceded them will not be determined by location or geographical considerations, but rather by their capacity to adapt to change and their ability to offer continuity and order in a turbulent environment. Clearly, many cities, and particularly national capitals, international financial centers of the first order, priority ports, and historical centers have the potential to transform themselves into global cities, but not all of them will be successful. The process is one of self-selection, of mission, and of local initiatives.[15]

These words perfectly define the underlying spirit of the revitalizing project for Bilbao and its metropolitan environment. As in the Middle Ages, cities are essential for the development of a civilization. One might therefore, without great exaggeration and in the light (when considered retrospectively) of the success achieved by the Guggenheim Bilbao project, here adopt the idea of Robert C. Lamm that agriculture is the business of rural areas and culture is the business of cities.[16] In this way, we can note the emergence of the symbiosis between them.

The revitalizing process inspired by the principles I have mentioned led to the objectives and missions reflected in Figure 2.

Figure 2: Focusing on a City

Revitalizing Bilbao and its Metropolis

- From an industrial to a services city
- Within a new physical framework, transforming its port, regenerating its estuary, dismantling its obsolete industry, and reinventing its accessibility
- With a "natural" marketing effort: a living architectonic museum that sells its own image
- Attracting external flows: intellectual capital, investment, companies
- A leader in amenities and infrastructure
- Promoting cultural assets
- Recovering the self-respect of the population
- Exercising its real role as a capital

15. See *Cities in a Global Society*, ed. Richard V. Knight and Gary Cappert (London: Sage, 1996).
16. Lamm, *The Humanities in Western Culture*.

Basque society has thus opted for the creation of new regional spaces that will form a type of "Euskopolis,"[17] adopting the structure of a metropolis made up of the different conurbations that form the Basque Country in a time frame of fifteen to twenty years. In that period, new infrastructures and technologies, combined with the culture of the citizens, will keep Bilbao competitive. This new city will have to serve a series of basic functions: as a center of innovation; a center for education, research, and social assistance; a center of culture, recreation, sports, and tourism; a center for transportation, logistics, and trade; as a market and skilled labor center; and as a center of production, industrialization, and the provision of advanced services.

Driven

Quite apart from being an avant-garde and universal museum that gives Basque society in particular and European society in general the opportunity of seeing one of the largest and richest collections of modern and contemporary art in the world, the capacity for "contagious education" in the vast field of arts, and the opportunity to access a new form of understanding (beyond simply cultural contributions) of the exhibition, promotion, and financing of developments in the arts, the Guggenheim also offers a unique opportunity for integrating different cultures and, above all, represents a jewel in the crown of world architecture, one that cannot be repeated and that marks the frontier between the twentieth and twenty-first centuries.

As if this were not enough, and beyond its present contributions, the driven character of this project and its natural adaptation to the revitalizing structure of Bilbao helps the city to draw closer to the objectives and functions that must govern the future of the new economic spaces of tomorrow. Figure 3 reflects the basic characteristics of the project.

Figure 3: The Guggenheim Bilbao Museum, Symbolizing:

- Universality, internationalization
- Local know-how
- The support of first-class economic-cultural forums
- Avant-garde management of culture and, particularly, of museums
- The strengthening of one's own cultural resources
- Attracting and training professionals in the educational and cultural communities
- The driving force behind the Basque Country's firms

Furthermore, Figure 4 indicates some of the innovations that this project requires.

17. "Euskopolis" is a term employed by the author and in general use throughout the Basque Country to refer to a conglomerate made up of six Basque towns and cities: Bilbao, Vitoria-Gasteiz, Donostia–San Sebastian, Irun, Pamplona, and Bayonne.

Figure 4: Opening New Avenues

Figure 4 helps us to reflect on the cultural values that lie behind the project: The work of art of Frank O. Gehry represents the mixture of individual creativity (an essential presence in all works of art) with the functional direction of its use—a museum to exhibit the art of our time on a large scale and in a free and open manner. In this, it is in communication and permanent complicity with the city and its people in the same way that the different materials he employs (steel, titanium, stone and glass) communicate and are in complicity with the historic landscape of the country.

The project also demonstrates a unique experience in the comanagement, co-ownership and cofinancing of the building itself, of the foundation, and of the artistic collection. In this way, private initiative shares responsibilities—and successes—with public Basque institutions. Above all, it has achieved what few megaprojects have succeeded in doing, gaining the support and adherence of almost everyone.[18]

Finally, in tune with the new times, culture is also a source of wealth and employment. It is sufficient to note the different new activities and lines of business associated with a cultural project of this type which can be integrated into the economic strategy of the country, thereby strengthening it.

18. Following the rejection, criticism, and attacks faced by almost all megaprojects, just one year after its opening, the Guggenheim enjoyed practically unanimous adherence and support and has been transformed into the symbol and advertisement for Bilbao.

Toward a New Cultural Epoch?

I remarked in the introduction that a knowledge of history allows us to prepare the future. We have noted the new world of values for the coming century associated with the Guggenheim Bilbao Museum and its new economic and business alternatives. It is now worth trying to draw some comparisons in the history of art and the humanities.

Lamm observes, with respect to the art of the 1990s, that it had ceased to be a bohemian activity and that New York was no longer the primary center of artistic activity.[19] It is the proliferation of styles, fashions, and artists that stands out, reinforcing the importance of the individual and of the specific work above movements or schools. We can immediately see, therefore, the difficulty in identifying the author or work with a school, which appears to question the generalization of ideas, principles and common criteria beyond certain aspects. Whether or not Lamm is right, the truth is that throughout the world, new initiatives are enhancing culture and shaping new ways of educating through art, promoting, conserving, and exhibiting art, as well as teaching people, governments, and institutions about a new world in which the terms "culture" and "economy" define a key binomialism.

In light of the new avenue opened up by the Guggenheim Bilbao project, a fresh era of positive crisis adjustment provokes great changes for the beginning of the twenty-first century. In other words, art museums and other related institutions lead toward new ways of interpreting the world around us.

Before reviewing the current impact of this institution, let's go back seven years to remind ourselves of some of the things that those in charge of this initiative explained just before the Guggenheim Bilbao's opening:[20]

> The Bilbao-Guggenheim Museum will be opened in 1997. Designed by the architect, Frank O. Gehry, it aims to become one of the principal museums of modern and contemporary art in Europe. To the end, in addition to having the Guggenheim collection, considered the finest private collection of modern and contemporary art in the world, it will be housed in a building that seeks, in its architectural excellence, to be emblematic of the City.
>
> The project is one of the initiatives being taken by the various Basque Government bodies with a view, on the one hand, to contributing to the renewal of the economic structure of the Basque Country and, on the other, to enhancing the possibilities of converting Metropolitan Bilbao into a reference point for the Euro-region that has come to be called the Atlantic Axis.
>
> The inauguration of the Bilbao Museum will mark a new and important era in the history of the Guggenheim, and will provide our institution with an international scope unique among cultural institutions. (Tom Krens)

19. Lamm, *The Humanities in Western Culture.*

20. The following information is taken from an official booklet edited by the Guggenheim Bilbao to promote and advertise its opening, published in the summer of 1997.

Media, local artists, almost all the political parties … most were against the project: "Cultural Imperialism"; "More Guggenheim"; "They will never come to the Basque Country"; "The Museum is unbuildable"; "There will be neither art nor the Guggenheim's Collection"; "No one is coming to visit it"; "Basques are not going to accept the project"; "Too expensive"; "More job creation and fewer museums."

Art + Culture

Seven years on, and the basics are still the same. The Solomon R. Guggenheim Foundation has recently approved a strategic plan for the next decade,[21] and their mission links the original path with the ongoing long-term strategy for the new epoch:

> To collect, conserve and exhibit modern and contemporary art, within the setting of a flagship architectural work, as part of the international outlook of the Solomon R. Guggenheim Foundation, striving to reach the highest standard of artistic excellence and the widest audience in order to educate society about art as a foundation for the values of tolerance and freedom, and serving as a symbol of the economic and cultural vitality of the Cities, Regions and Countries in which their facilities are based.

Art is the essential key in all the ongoing initiatives. An international network, together with expansion efforts, allows better exhibitions, better educational programs, allows more people to learn through art, attracts more and better artists and collections, shares different values, and contributes to enhancing better relationships between different countries, regions, cultures, and people. This allows for the real democratization of art. Leading the museum world retains and attracts artists, educators, collectors, management, trustees, governments, sponsors and, mainly, imagination, creativity, trust … and the future. Different initiatives (*non*profit as well as for profit) are oriented—exclusively—to serve the *vision*.

Beyond Art …

As I have already mentioned, to understand the decision process behind the Guggenheim Bilbao, it is necessary to understand the way in which four elements converged:[22] Country building in the Basque Country, revitalization to transform the city, innovation in the search for a new way to create and develop the museum and culture industry, and an entrepreneurial approach to creating a new type of museum that exploited the role of the avant-garde in Bilbao's cultural life.

The overall strategy in which these four elements converge rested on the interaction not only of Guggenheim and Bilbao, but other agents both public and private agents, four

21. The Solomon R. Guggenheim Foundation's board of trustees approved a new *Strategic Long Term Plan* (2004–2014) in October 2003, based on this mission.

22. See Jon Azua, *Netting Coopetitive Strategies: Business, Government and Innovative Regions* (Bilbao: Enovatinglab, 2003).

strategies located, moreover, in a specific dynamic context: Bilbao, as an active container for different visions aligned to converge in a unique new project.

To understand country building in the Basque country, one must go back to at least 1980, when Basques recovered a considerable part of their decision-making capacity and self-government, following a brief preautonomous period at the end of the Franco dictatorship, when democracy began to be regained in Spain (1975–79).

At that time, when we had yet to join the European Economic Community and were in a clearly peripheral situation, far removed from competitive, promising regions and centers and led by a fledgling, inexperienced public administration, the new Basque institutions embarked on a fast-changing process of strategic interaction, intent on changing the rules on behalf of Basque citizens, along with dealing with the changes and transformations taking place in the economy and society.

Against this background, and with its own framework of economic, fiscal, and financial relations with the Spanish government, Basques undertook a number of major initiatives. In 1991, with industry in full recession and unemployment soaring out of control, our country building embraced a number of opportunities and challenges making up a wider effort to modernize and internationalize the Basque Country based on the following key factors.

The first was the need to remake the image of Bilbao and the Basque Country. A negative image resulting from economic recession, the existence of violence ravaging the country, and the general opinion or impression that nationalism was synonymous with negative isolation and confrontation, became both a cause and consequence in a vicious cycle generating discouragement, unwillingness to make forward-looking decisions, inability to attract foreign investment, and justifications for policies having an adverse effect on development of the country.

In order to modernize and internationalize the Basque Country, we also had to reinvent of the economy. A regional economy based on outmoded heavy industry overly concentrated in just a few sectors (steel and shipbuilding, for example) made it necessary to marshal our real and historical competences and build a new entrepreneurial culture, incorporating new promising industries, creating new industrial relations frameworks, and preparing the human resources that the new economy would need.

We also had to build infrastructures. The infrastructure gap we started with, where both physical and intelligent infrastructures were lacking, meant that we would have to multiply our efforts to provide enormous sums, projects, and regenerative, imaginative programs. It should be noted that by the time the Guggenheim project started, with the exception of cultural infrastructures, all other indicators placed the Basque Country (in relative terms) above the Spanish average.

So, within this overall effort, the Basque Country and the city of Bilbao used culture as a key engine or strategic goal, providing not only a major physical renewal, but also a new injection of self-esteem on the part of the people. Here, culture played a dual role. Culture per se, as something intrinsic to humankind and, above all, to society in the spe-

cial process of regaining self-esteem and values, provided a sense of identity and a sense that the region is capable of lending strength to all forward-looking projects. And paired with economic development, culture has become a key factor in the financial system and development of the country.

The Next Steps: Is the Guggenheim Bilbao a Case to Repeat?

In many ways, the case of the Guggenheim Bilbao and the role it played in revitalizing the city and the Basque Country is unique. Nevertheless, paying attention to the lessons of the Guggenheim Bilbao, some general considerations can be drawn. First, museums aren't what they used to be. The new century suggests the need for new thinking and new strategies. The Guggenheim and Bilbao have defined and achieved a successful model. It shows that culture, beyond its intrinsic value, is can be a motor of economic development. Cities and regions need to introduce culture into their overall development strategies. Next, art has to be shown. New spaces, new regions, and new people have the right to see it, to learn to understand it, to work with it, and to have the opportunity to create and enjoy it. In this respect, too, the Guggenheim Bilbao presents a successful model (See Appendices A and B).We need to see museums in a new context: the nexus formed by art, culture, and the economy. Rethinking the future In this way will lead to new ideas, new principles and new alliances.

Some of the possibilities I envision can be briefly outlined by reference to the work of today's new economic thinkers.

The first point to emphasize is the extensive debate aimed at Rethinking *principles*—making sense of uncertainty (Charles Handy) and restoring principles at the source of everything (Stephen Coney). We also need to rethink *competence*—what is involved in creating the advantages of tomorrow, designing growth strategies (C. K. Prahalad), and reinventing the bases to compete (Gary Hamel). Rethinking the *complexity* of society and its structures and establishing new methods of *control* can lead us to (and across) new frontiers with respect to management and desired final objectives (Michael Hammer) by concentrating on restrictions, not on costs in terms of excellence (Eli Goldratt), through new forms of thinking (Peter Senge) Rethinking *leadership* can involve converting oneself into the leader of leaders (Warren Bennis), establishing new "coalitions" between cultures and communities (John Kotter), dealing with an ever more confused world (Al Ries and Jack Trout). Finally, rethinking the *world* and its *new spaces*, from the nation-states to the configuration of networks (John Naisbitt), may lead to changing the nature of capitalism (Lester Thurow) and the invention of a new biology for economics and business (Kevin Kelly).

These new ideas and principles—to mention but a few—summarize the values of our culture and inspire the change that we are living through on the threshold of a new era, a process of crisis and adjustment that requires us to overcome increasing uncertainty with the aim of bringing forth a desired future, with the understanding that our times require new organizations, because the future will not be a mere continuous projection of

the past, but rather a broad discontinuous series. In a nonlinear world, linear or unidirectional thought makes no sense. Change requires creative organizations and shared leadership.

These principles and values lie behind the Guggenheim Bilbao project considered here. It is a living experience and a practical application of the complex and varied world of the arts and humanities that impregnates our economy and society as a whole. It goes beyond culture and represents a new reality and a new challenge for the future.

The Guggenheim Bilbao Effect is a result of a unique convergence of groundbreaking strategies: The Solomon R. Guggenheim Foundation's vision in attempting to lead both the New York art world and the whole ongoing international art and museum world, the Basque Country's strategy of modernizing and internationalizing the country, its people, and their economy, efforts to renew Bilbao for the new challenges, and the Guggenheim Bilbao Museum's own concept of a new museum, driving the community's development through a new liaison between culture and the economy.

Appendix A: Results of the Guggenheim Bilbao's Impact

- Impact of Building the Museum
 - GDP generation 10,056 million pesetas
 - Employment sustained 1,452 jobs

- Impact of Building the Museum on Taxes
 - Revenue generation 20.1% of the investment made
 - (For Basque authorities) (2,300 million pesetas)
 - Pay Back $n = 3$

- Putting Bilbao on the map: Image as a modern city
- Promoting tourism: 60% of visitors from outside Spain
- Improvement of residents' quality of life
- Creation of new business activities
- An attractive venue for conferences, seminars, courses
- Neighboring provinces benefit from the museum's presence
- Other museums and cultural institutions benefit from this impact: collections, management, budgets, visitors, friends, trustees, collaborative companies, sponsorship
- Art learning and related activities: galleries, artists, art schools
- The Solomon R. Guggenheim Foundation's strategy and international presence
- The psychological effect
- Lessons for the city, culture, strategies

Appendix B: Impact of the Activities of the Guggenheim Museum Bilbao during 2003

Total direct expenditure generated by the activities of the museum	154 million euros
Additional income for the Basque treasuries	27,7 million euros
Employment maintenance contribution	4,547 jobs
Total impact, 1997–2003	
– Direct expenditure	1,073 million euros
– GDP generation	990 million euros
Employment	4,204 million euros
– Income, treasuries	172 million euros
Visitors	834,000
Friends (members)	14,800
Corporate members	160
Corporate trustees	34

Appendices C through G show a brief summary of relevant facts needed to understand the successful alliance of art with culture, taking account of the data available in December 2003.

Appendix C: Highlights—The Relevant Facts (2003)

Educational Issues (New York)

- Docents	15,419
- Reading room attendance	12,500
- Gallery educators	7,233
- Interns	75
- Learning through art (students)	97,017
- Public programs (assistance)	25,035
- On-site school programs	9,200
Total Served	169,579

Educational Issues (Bilbao)

- Students	28,124
- Docents	10,300
- Library users	2,130
Total served	311,886

Global Attendance

- New York	893,532
- Bilbao	874,807
- Berlin	143,628
- Las Vegas	205,957
- Venice	250,000
Total	2,367,964

Creating a Unique Network throughout the World

Solomon R. Guggenheim Foundation
 Solomon R. Guggenheim Museum, New York
 Peggy Guggenheim Collection, Venice
 Guggenheim–Hermitage Museum, Las Vegas

Management agreements
 Guggenheim Museum Bilbao
 Deutsche Guggenheim Berlin

Long-term alliances
 Kunsthstorische Museum, Vienna
 Karlsruhe, Germany
 Mass MoCA, U.S.A.

Collections and Acquisitions

1) Enhancing key sources

Bilbao: Fund	$ (Millions)
Initial program (1997–2000)	40,00
2000–2004	33,00
Recently approved (2004–7)	30,00
Deutsche Guggenheim Berlin Commission Program	18,00
Additional Alliance and Share Commissions, Enhancing loans and coopetitive alliances and	
New Collections associated with Ongoing Projects	375,00

Source: Jon Azua, based on calculations from Guggenheim reports.

Appendix D: The Guggenheim Global Network
(Currently Encompassing Five Museums)

The Solomon R. Guggenheim Foundation			Management Agreements	
Solomon R. Guggenheim Museum	*Peggy Guggenheim Collection*	*Guggenheim Hermitage Museum*	*Guggenheim Museum Bilbao*	*Deutsche Guggenheim Berlin*
Flagship New York	Fully consolidated branch in Venice, Italy	Wholly owned subsidiary; programming agreement with the Hermitage Museum	Collaboration with the Basque Government	Collaboration with Deutsche Bank
Foundation established 1937, Frank Lloyd Wright building opened 1959	Founded in 1976	Opened October 2001	Opened October 1997	Opened November 1997
Designed by Frank Lloyd Wright—NYC Landmark	Eighteenth-century landmark palazzo on Grand Canal	Designed by Rem Koolhaas	Designed by Frank Gehry	Designed by Richard Gluckman

Appendix E: Guggenheim Cultural Network with Alliances and Expansion Projects

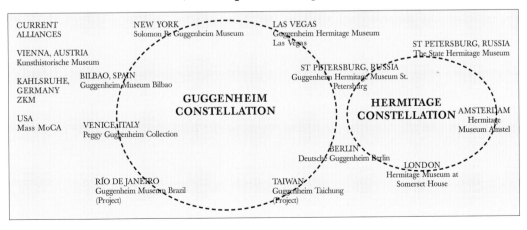

Source: Solomon R. Guggenheim Foundation.

Appendix F: Guggenheim Exhibitions Opening or Closing in 2003

Solomon R. Guggenheim Museum, New York

Connecting Museums, June 18, 2002–January 25, 2003
Moving Pictures, June 28, 2002–January 12, 2003
The Hugo Boss Prize 2002: Pierre Huyghe, January 24–May 4, 2003
Mathew Barney: The Cremaster Cycle, February 21–June 11, 2003
Learning through Art, May 15–June 15, 2003
From Picasso to Pollock: Classics of Modern Art, July 4–September 28, 2003
Watercolors by Kandinsky, July 4–September 28, 2003
James Rosequist: A Retrospective, October 17, 2003–January 25, 2004
Kandinsky and Klee: The Bauhaus Years, October 1, 2003–January 25, 2004
Fellini! October 30, 2003–January 24, 2004
Kazimir Malevich: Suprematism, May 13, 2003–September 14, 2003

Peggy Guggenheim Collection, Venice

Thinking Big, September 6, 2002–January 6, 2003
Marc Quinn, May 22, 2003–August 25, 2003
The Spiritual Landscape, December 13, 2003–February 8, 2004

Guggenheim Museum Bilbao

Henri Matisse, October 2, 2002–February 16, 2003
Rubens and His Age: Treasures from the Hermitage Museum, October 2, 2002–February 16, 2003
German Painting, February 5, 2002–February 16, 2003
Joseph Beuys, February 19, 2002–January 19, 2003
Process and Materiality, February 19, 2002–February 16, 2003
Kandinsky in Context, July 5, 2002–January 19, 2003
Shirin Neshat, July 23, 2002–May 18, 2003
Calder: Gravity and Grace, January 22–May 22, 2003
Bill Viola: Going Forth by Day, February 8–May 5, 2003
Jasper Johns to Jeff Koons: Four Decades of Art from the Broad Collection, February 15–September 7, 2003
Learning through Art, June 2–July 6, 2003
Jean Dubuffet: Trace of an Adventure, November 11–April 18, 2004
Moving Pictures: Contemporary Photography and Video from the Guggenheim Museum Collections, October 7, 2003–April 25, 2004
Art through the Ages: Masterpieces of Painting from Titian to Picasso, August 30, 2002–May 4, 2003
American Pop Icons, May 15–November 2, 2003
A Century of Painting from Renoir to Rothko, November 6, 2003–May 2, 2004

Deutsche Guggenheim Berlin

Gerhard Richter: Acht Grau, October 11, 2002–January 3, 2003
Kazimir Malevich: Suprematism, January 18–April 27, 2003
Richard Artschwager: Up and Down / Back and Forth, May 10–July 7, 2003
Tom Sachs: Nutsy's, July 23–October 5, 2003
Bruce Nauman: Theaters of Experience, October 31, 2003–January 18, 2004

Organized by the Guggenheim for presentation at other venues

Kandinsky in Context, July 5, 2002–January 19, 2003, Undine, Italy
James Rosenquist: A Retrospective, May 17–August 17, 2003, Houston, Texas
Kazimir Malevich: Suprematism, October 2, 2003–January 11, 2004, Houston, Texas
Matthew Barney: The Cremaster Cycle, October 10, 2002–January 5, 2003, Paris, France
Giorgio Armani, May 8–July 13, 2003, Berlin, Germany
Giorgio Armani, October 18, 2003–February 15, 2004, London, England

Source: Solomon R. Guggenheim Foundation (http://www.guggenheim.org).

Appendix G: Public Interest

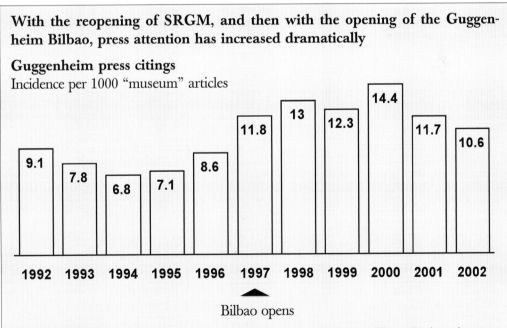

With the reopening of SRGM, and then with the opening of the Guggenheim Bilbao, press attention has increased dramatically

Guggenheim press citings
Incidence per 1000 "museum" articles

1992	1993	1994	1995	1996	1997	1998	1999	2000	2001	2002
9.1	7.8	6.8	7.1	8.6	11.8	13	12.3	14.4	11.7	10.6

▲
Bilbao opens

Since 1998, Bilbao believes it has received an estimated 103 million citations in press coverage (80 million from the international press and 23 million from radio and TV).

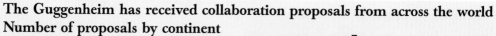

The Guggenheim has received collaboration proposals from across the world Number of proposals by continent

Source: Dow Jones; Team analysis; Guggenheim reports.

Although the role played by culture was central to the effort to modernize and internationalize the Basque Country, something more than culture was involved. Appendix H shows the key elements included in this general renewal strategy of the city.

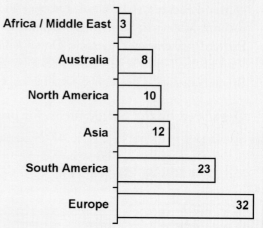

Continent	Number
Africa / Middle East	3
Australia	8
North America	10
Asia	12
South America	23
Europe	32

Appendix H: Key Elements Transforming Bilbao

Components of the Strategy	Description/Key Concepts
Metropolitan area renewal strategy.	The Basque government, provincial and city governments. undertake renewal plan (1986–87). Important firms join the effort: Bilbao Metropolis-30. Comparison of similar experiences worldwide Shared strategic plan 8 vectors Ongoing process (Today's new horizon: 2010)
International marketing of cities	Presence/leadership in all types of international cities' venues Trademark: Bilbao
Endogenous development	Fostering development of local firms and professionals by strengthening their competitive advantages
Masterpiece	The Guggenheim conceived as a singular, emblematic world masterpiece, lending new image to the city
New vision of architecture	Frank O. Gehry's genius exceeds all expectations. His vision connects with leading trends in architecture worldwide
From outmoded industry	The technological essence of the Basque Country's industrial past (new materials, design, construction, structure, etc.) opens way to a new economy

Competitiveness	Encourage move to high-tech services Based on: Competitive advantage of nations Clusters with promise for the future "Coopetition" as a guideline in different policies Over 1000 executives involved Sector basis: Industrial policy. "Building on what we have" Prior phases: Restructuring, attraction, investment, work reorientation
Modernizing the economy	Encourage move to high-tech services Technology, quality, knowledge
Image abroad	Internationalization Generation of networks abroad Counteract negative impacts
New business	More than a museum: opportunities thanks to the Guggenheim Capacity for subcontracting local firms Move to publications, multimedia, opportunities for profit, new education, new modes of management, cultural institutions Tourist attraction New jobs in new services Stepped-up infrastructures and investments
Internationalization	Coexistence of different cultures (to and from the country) Presence in key international venue
Development of infrastructures	Work of art in itself Accelerator of competitive infrastructures: hotels, restaurants, schools, entertainment and leisure, transportation infrastructures
Binomial: culture and economy	Culture as a key variable in development of the economy and region: Attraction of talent and investment Sponsorship and endowments Projects to generate synergies
Revitalization of Bilbao	Firm deadlines Accelerator of renewal process Reinforcement of plans under way

Although strategic thinking took place that was looking for something more than a new museum, one should not underestimate the role played by the Guggenheim. I have already mentioned the attractive original vision. (The courage and wisdom of the Guggenheim board and its director, Tom Krens, have never been sufficiently recognized.) Appendix I demonstrates a brief description of the main strategic intentions involved in realizing this vision. Finally, Appendix J shows the Guggenheim Bilbao's relevant intentions.

Appendix I: Guggenheim Foundation Intentions

Components of the Strategy	Description/Key Concepts
To gain the lead in New York and compete abroad	Leadership generating: image funds incorporation of best patrons, artists, professionals, visitors from the world of art
Global network	Present worldwide through a decentralized permanent collection Cost reduction Optimization of management Optimization of art programming Optimization of educational network
Global partners	Consistent with a "glokal" economy, "glokal" partners, accompanied by new projects
New physical spaces	Entire collection on view New modes of collaborating with other venues in other cities The art of today and tomorrow (large format, architecture, design) requires new spaces
New notion of culture	In addition to culture and museums per se, new spaces of strategic opportunity opened up in this field. To be the first in managing the process
Economies of scale	Collection, management, programming, publications, curators, etc.
Museums in twenty-first-century	Create new rules for museums (particularly Europe Ownership): management financing collections programming works on loan interaction between art agents Culture-leisure-entertainment
Binomial: architecture and culture	From mere container to as much a work of art as the content, or more.

Appendix J: The Guggenheim Bilbao Museum

Components of the Strategy	Description/Key Concepts
Model for museums of the future	First in Europe (as noted: collection, organization, art programming, funding, stakeholders, network, etc.)
City landmark and trademark	Not just a building, but "the symbol and emblem of the city" A building in consonance with its use Strictly complied with construction budget and deadlines Construction revealed the power and capacity of local firms and workers
Communication between museum and city	Essential part of the city's layout. Ongoing synergies with the rest
Driver of enterprising local firms	Points way to internationalization of local firms
Local education	Project associated with commitment to education: in art and in the world of associated business activities, beyond its own values in themselves
Self-financing	Steady decrease in government funding
City economic impact	City-building project: Impacts Appeal Endogenous development Spread to other cultural policies

The Guggenheim Bilbao, Partner in the Arts:
A View from the Fine Arts Museum of Bilbao

JAVIER VIAR

I'm going to consider here several aspects of the Guggenheim Bilbao that affect the Fine Arts Museum of Bilbao, the other great museum in the city. Specifically, what I'd like to examine is the influence of the Guggenheim on the Fine Arts Museum. I will explore the nature of this influence, together with several other questions that I believe to be equally important in both the explicit and the implicit relationships that these two institutions share. I think that the global mark established by the Guggenheim in Bilbao is a topic of tremendous interest, and the intrinsic nature of the Guggenheim has, despite some differences, more in common with the Fine Arts Museum than any other institution in Bilbao. I will try to highlight these differences as a means of understanding the Guggenheim's particular identity.

The Guggenheim Bilbao was built physically very close to the Fine Arts Museum. A cursory glance at a map of Bilbao shows just how close the two buildings are, barely 200 meters (650 feet) apart or, what amounts to the same thing, a five-minute walk from one another.

Perhaps many are unaware of Bilbao's Fine Arts Museum. However, within Spain it is considered to be the second or third most important museum of its kind, even taking account of the enormous distance that separates the rest from what ranks at the top of the list of Spanish museums of all varieties: the Prado in Madrid. Among specialists, the Fine Arts Museum of Bilbao is highly respected, possessing works of great value and a consistent international presence through the loans of important pieces and exhibits. Some of our paintings frequently travel throughout Europe and are also regularly seen in the United States. MoMA, the Metropolitan Museum of Modern Art in New York, the Art Institute of Chicago, the St. Louis Art Museum, and the Museum of Fine Arts in Boston are just some of the places that have borrowed some of the masterpieces from our collection.

Founded in 1908, the Fine Arts Museum of Bilbao is almost one hundred years old. During these nearly one hundred years it has naturally experienced different transformations that have influenced its fundamental identity, its legal character, and its location, not to mention enduring more weighty problems. It has also known different periods of institutional support, some of great shortage, inattention or even heroic resistance, and others of greater prosperity. I will admit that, in many important aspects, its current situation has been heavily influenced (to a greater or lesser degree) by the presence of the Guggenheim. However, it's also true that the current situation is the product of the (to a certain extent hidden) idiosyncrasies of the museum itself, which it has embraced completely naturally. There are other aspects, too, that derive from the coexistence of the two museums: for example, certain overlapping concerns or identity problems that would probably have emerged without the specific existence of the Guggenheim, to judge by several other projects. However now, with a commitment on both sides, it is to the Guggenheim that the Fine Arts Museum can, indeed must, look to address new issues, issues that I will return to later.

The Fine Arts Museum was founded by the Provincial Council of Bizkaia and the Bilbao City Hall, who were its sole owners until 1991, when the Basque Autonomous Government (through its Ministry of Culture) entered as a third partner. The Fine Arts Museum does not, therefore, fall under the jurisdiction of the Spanish Ministry of Culture, as do all other Spanish museums, and as such retains a good degree of autonomy in its financing and regulation. As regards this aspect, the Guggenheim Bilbao is similar, even though its respective institutional support comes from the Provincial Council of Bizkaia and the Basque Autonomous Government rather than the Bilbao City Hall.

Currently the Fine Arts Museum pursues an encyclopedic approach to its collection. That is, its collections essentially include Western art from the late twelfth century up to the present, although it also houses both Etruscan and Roman art, as well as an interesting collection of Japanese and Chinese decorative art. Yet it hasn't always been organized like this, since really the present institution is the result of merger between two museums: the original Museum of Fine Arts (which, although founded in 1908, didn't actually open until 1914) and the Museum of Modern Art, founded in 1922 and inaugurated in 1924, with the merger subsequently taking place in 1945. Nor has it always occupied its present site. The Fine Arts Museum that opened in 1914 occupied three rooms in a neoclassical building located in the heart of Bilbao's old quarter. The building was, at the time, the Arts and Crafts School although it had been originally built in the nineteenth century to house the Public Hospital. As regards the Museum of Modern Art, from its foundation it was located in several areas of a building owned by the Provincial Council that today houses both the Provincial Library and the Music Conservatory.

One question worth considering, in however modest form, is the historical and social context in which the Fine Arts Museum emerged, for it was very different from that of the Guggenheim. The Fine Arts Museum enjoyed the stability of the interest in culture that captured the enthusiasm of a middle class made recently prosperous by the boom of

industrialization. The systematic exploitation of rich, nearly all open-surface seams of iron ore in Bizkaia, near to both the sea and the Nervión river, led to a swift and intense economic takeoff from about the middle of the nineteenth century and especially after the last Carlist War ceased to affect the region adversely in 1875. Until that time, Bilbao and its hinterland had been principally a commercial area, although it did have an iron industry with several foundries and some small-scale riverside shipbuilding concerns, as well as a tradition of looking toward Europe in its trading and commercial dealings. The apogee of this economic expansion occurred in 1914, during World War I, when Spain remained neutral and benefited from an increased demand for production. This was, of course, the same year that our museum opened. Until that time, surplus profits from mining had been invested in the development of the iron and steel, shipbuilding, and banking industries.

The entrepreneurial and dynamic middle class that emerged out of this boom was full of cosmopolitan pride. Moreover, it possessed a sufficiently open aesthetic taste, although typically its members were conservative anglophiles, and it facilitated the education of a number of artists, enabling them to visit Impressionist Paris and return with a certain spirit, although tempered, of the revolutionary ideas emanating from the French capital. These artists were essential in the establishment of cultural events and institutions, of which one was the Fine Arts Museum that exists today. Indeed, two Bilbao painters were the first directors of the two museums that ultimately merged to form the current one: Manuel Losada in the Fine Arts Museum and Aurelio Arteta in the Museum of Modern Art. However not just artists, but also an entire social framework, the most learned and cultured sectors of that emergent middle class, served to underpin the establishment and development of the museum. For example, various significant individuals from civic life were able to influence the institutions of the age to create the museum, find buildings, and acquire works to fill them. It is true that many such individuals, mainly from the upper middle classes, also held political office and as such could have a direct bearing on the aforementioned issues. Yet one should also bear in mind that this was less a case of the principal collections in the museum's early days being donated from the private collections of people flush with the philanthropic spirit. That same middle class created the museum practically out of nothing, without any artistic tradition, without any real collections, without an age-old aristocracy that previously would have furnished palaces, churches, and convents with quality art.

I said before that the Guggenheim emerged in different historical circumstances. One might argue that if the Fine Arts Museum emerged during the apogee of economic success and power in Bizkaia, the Guggenheim did so at its lowest point; during the industrial decline into which Bilbao fell during the last decades of the twentieth century. And in doing so, the Guggenheim served as the engine of a profound economic transformation, an engine composed of significant foreign parts, rather than resulting from a previously established domestic prosperity and a widespread, radical relationship with the society around it. However it is also clear that one of the reasons that might explain the intro-

duction of the Guggenheim to Bilbao, the swift acceptance and approval of investment in the project, stemmed from a certain culture of business management and risk taking shaped during a century and a half of complex economic development.

The Fine Arts Museum had to wait until after the end of the Spanish Civil War (1939) for construction to start on its own building, and this was ultimately completed in 1945. The building was constructed at one end of the small, but delightful parks in the Ensanche neighborhood of the city and resulted in the merger of the two existing museums. Once the collections were merged and its own building had been constructed, the Fine Arts Museum was able to open its doors in the shape that we see today; to such an extent that the changes that have taken place ever since—that is, during the last sixty years—have been due to the museum's own physical growth or in an administrative sense, rather than in what one might term its intrinsic character.

This character is based on the nature of its collections and, at the same time, its temporary exhibitions, publications, and educational activities. Similarly, the nature of the collection as a whole is based on three main areas on which the museum currently focuses: historic art, that is, universal art dating from between the twelfth to the nineteenth centuries; contemporary art, that of the twentieth century; and Basque art, of which the museum houses the most important existing collection. This is due to the fact that, from the very first moments of the museum, those Basque artists I mentioned filled its rooms with the best of their own work. An attention to Basque art has, therefore, been a constant and comprehensive feature of the museum. However, there is one qualification with respect to that portion of universal art: that one shouldn't really use the term "universal," at least in practice, since the museum's collection almost exclusively houses European work. By way of a figure to define the extent of the museum, I should mention that it contains sixty-five hundred objects, a little over four thousand of them composed of works on paper or canvas, of which at any given time we are able to exhibit 550. These three principal areas into which our collection is divided condition the museum's other activities: exhibitions, publications, and educational projects.

Allow me to list some of the masterpieces that the museum owns while at the same time informing you of some of the most important recent exhibitions. I said before that our collection begins in the twelfth century. We have three pieces of good-quality Romanesque art: a sculpture of the Lord Christ dating from the twelfth century, together with two thirteenth-century works—all three from Catalonia. We also have several beautiful fourteenth-century French and Gothic virgins, together with some exquisite anonymous Italian ones from the same era. The museum's collection of Hispano-Flemish art is very important, with work by the Master of Saint Nicholas, Diego de la Cruz, Barthomeu Baró, and, above all, Bartolomé Bermejo. Flemish art of the same era is represented by the work of Benson, Gossaert, Mandijn, Martin de Vos, Vredman de Vries, and German art by three splendid sculptures, two of them anonymous and the third by Michel Erhart. Painting from the Court of Phillip II is represented to a high level with Antonio Moro and Sánchez Coello at the head of this collection, together with the mys-

tical mannerism of El Divino Morales and El Greco. From the seventeenth-century Italian school, one might highlight Gentileschi, Crespi, and Piola, and from the Spanish Baroque, there are four works by Zurbarán, two by Murillo, and a wonderful Ribera, while from the Flemish Baroque, there is a Ruisdael, a Van Dyck, and two works by Jordaens. From the eighteenth century we have a Bellotto, two Parets, and two magnificent Goyas, while from the nineteenth century there are works by Pérez Villamil, Esquivel, Lucas, Haes, Beruete, and Benlliure, the French artists Ribot, Gaugin, Serusier, and Le Sidanier, and by the American Mary Cassatt. This latter work, in fact, will shortly be seen in the United States at the Museum of Modern Art in New York and the Boston Museum as part of the Americans in Paris exhibition.

The contemporary art collection contains work by Juan Gris, Julio González, Lipchitz, Metzinger, Hayden, Maria Blanchard, Kokoschka, Tàpies, Bram Van Velde, Michaux, Alechinsky, Bacon, Kitaj, Peter Blake, John Davies, Arroyo, Paladino, Serra, and Barceló, while that of Basque art covers the spectrum of art produced in our country from the mid-nineteenth century up to the present: Bringas, Zamacois, Barroeta, Guinea, Guiard, Regoyos, Iturrino, Zuloaga, Echevarría, Larroque, Tellaetxe, Ucelay, Lekuona, Oteiza, Chillida, Balerdi, Larrea, Basterretxea, Zumeta, Ortiz de Elgea, Mieg, Ramos Uranga, Mari Puri Herrero, Vicente Ameztoy, Txomin Badiola, Pello Irazu, Jesús Mari Lazkano, Daniel Tamayo, Alfonso Gortázar, and Cristina Iglesias.

As regards exhibitions in general, during the last five years, one might highlight the following: Orazio Gentileschi, in collaboration with the National Gallery in London; El bodegón español (Spanish still life) which included all the great still lives in Spanish painting from Zurbarán to Goya and Picasso; Carravagio, in collaboration with the Prado Museum; Mujeres impresionistas (Impressionist women), Sorolla-Zuloaga, which brought together two of the great figures of Spanish art from the turn of the nineteenth to the twentieth centuries, as well as Lipchitz, Bartolomé Bermejo y la pintura hispano-flamenca (Bartolomé Bermejo and Hispano-Flemish painting), El esplendor de Génova (The splendor of Geneva), and, La ciudad que nunca existió (The city that never existed). This latter exhibition was an exploration of unreal or impossible architecture throughout the history of Western art, from second-century A.D. Roman frescos from the Museum of Naples to actual buildings by Miquel Navarro, Catherine Yass, and Ann Veronica Janssens, by way of Belloto, Vredman de Vries, Leger, De Chirico, Wols, Klee, and Vieira da Silva.

Although the focus of the topic here is not on a detailed summary of the museum's historical evolution, I would say the following by way of concluding the story I began earlier: that during Franco's dictatorship (1939–75), despite the enthusiasm of its management and the presumed (at least theoretical) support of some political leaders, and even if it was during this time that the current building was constructed, the museum generally experienced a period of lethargy, if not real poverty. However, this didn't stop the growth of collections, mainly as the result of new donations and bequests. Yet by the 1960s, the original building had been outgrown and the idea of constructing a second one

had to be raised. Together with this idea it was understood that the new space would be exclusively dedicated to contemporary art. This was quality contemporary art, and a new building was necessary not just because it required a lot of space to be displayed, but because as a result of the precarious economic situation, there could be no further acquisition of great international signatures. The new wing of the museum was inaugurated in 1970, with which the structure of the museum essentially took shape, with no other changes until the early 1980s. During the early years of the new democracy (after 1975), the museum began to enjoy more support, from which one can trace its later transformation, measured by certain important extensions and the purchase of new work.

That said, I should return to the theme under consideration here: the impact of the Guggenheim on the Fine Arts Museum. If I've arrived at this point by way of a history of our museum, it was in order to explain not only the potential transformations that the Guggenheim might imply, but to establish and explain our institution. This would, in turn, explain much of the support that the Guggenheim Bilbao project itself received from its inception, for one should not forget that shortly before the Guggenheim project emerged, Bilbao had discussed the possible creation of a Center of Contemporary Art, which would have been constructed in a unique building in the city—the old wine warehouse, the municipal Alhóndiga—a proposal that was ultimately rejected. This all took place in 1989, two years prior to the emergence of the Guggenheim project.

Here I would like to pause a while and concentrate on this proposed project, because I would like you to appreciate its scope. The building was basically to be composed of a glass cube that began as a project measuring ninety meters (295 feet) on each side and ended up measuring forty (130 feet). It would have been grafted onto the old Alhóndiga, an interesting building dating from 1909 whose interior would have disappeared with only the original façade remaining that would have operated as a pedestal around the cube. A second glass cube would have been raised over an attached square, and a high footbridge would have connected both. One of the idea's original promoters, the sculptor Jorge Oteiza, made a very bare, almost minimalist geometric design, and work began on suitable architectural shapes to bring the project to life. It seemed that one of the cubes would be merely emblematic or symbolic and would remain empty—empty and illuminated like a beacon representing the light of culture—while the functional part would remain enclosed. It was thought that these structures would ultimately house a great center of contemporary art. The project was originally a municipal initiative, but faced strong protests, principally on the basis of the impact it might have had in a congested area of the city, but also for the upheaval required of the old warehouse. Ultimately this was forgotten. Whatever the case, nobody opposed the creation of a center for contemporary art. This was not what they rejected, and other potential sites were considered. I'm convinced that the idea for this center (although of a different nature) and its ultimate rejection contributed to the acceptance of the Guggenheim project. The need or desire for a major center for contemporary sculpture had already taken root among both politicians and the public.

What would have happened if this center had been built and not the Guggenheim? First of all, had it been built, there would be no Guggenheim today. However, in posing this question, I'm mainly referring to what might have happened to the Fine Arts Museum. Undoubtedly the impact on Bilbao would not have been the same. That much is obvious. It would have been a purely local cultural project. Therefore it would have enjoyed more limited public support and would have had a more local outlook. Ultimately, it would have lacked any great international appeal.

Yet as regards the Fine Arts Museum, it is highly likely that it would have been more affected by a project like that of Oteiza's and Oíza's cubes than by the Guggenheim. This is principally because of the similarity between the two, because of the fact that they shared a certain degree of common ground. It is highly likely, as I previously hypothesized, that this contemporary center would have had a museum, in other words, a fixed collection, while also sharing research, educational, and promotional functions that would have energized the project. It is, moreover, likely that attention directed toward such a center would have implied taking away some of the contemporary collection from the Fine Arts Museum and incorporating it into the new institution. This, of course, would have implied a significant loss of identity for our museum as a result of purely economic reasons.

Prior to all this, the artistic attention of the Fine Arts Museum had been directed towards a *Kunstshalle* that the Basque Autonomous Government and the Provincial Council of Bizkaia created in 1991. It took the name Sala de Exposiciones Rekalde (The Rekalde Exhibition Hall) and enjoyed ample physical space and an economic endowment far superior to that granted our museum to organize its exhibits. It is located quite close to both the Guggenheim Museum and the Fine Arts Museum, in such a way that it forms, together with these two institutions, an almost equilateral triangle. The Rekalde Exhibition Hall was able to organize important exhibitions while enjoying the dual financing of the Bizkaia Provincial Council and the Basque Autonomous Government. For example, the first exhibition of masterpieces from the Guggenheim in New York was organized there. This was presented to the Bilbao public in 1995, before the building had been completed, and part of this collection was exhibited simultaneously in the Fine Arts Museum. Later, however, the Basque Autonomous Government abandoned the project, and it remained exclusively under the control of the Bizkaia Provincial Council. Despite this setback, though, the Rekalde Exhibition Hall continues to function and organizes many interesting exhibitions, several of them oriented toward new forms of expression, buildings, videos, and so on. That said, they did consider closing it down once the Guggenheim opened. There was also, on one occasion, an attempt to annex it to the Fine Arts Museum, but it didn't work.

All this demonstrates the interconnections between the different cultural organisms that exist in Bilbao and the recurring ideas of amalgamation and independence. Effectively, this is a question of the existence of two contrasting opinions: planning interests that justify their perspective on the principle of more centralized management and a supposed

optimization of resources against a liberal vision more inclined toward multiplicity and the free development of each organism, even at the risk of overlapping, repetition, and greater costs.

Now we can't even conceive of any potential taking away of our contemporary collection by the center of contemporary art that never was. This threatened to take the Fine Arts Museum back to its pre-1945 situation, when the Museum of Modern Art was still independent, that is, to suffering a temporal limitation on its collecting and activities and losing contact with current developments in art.

The Fine Arts Museum was born a century ago with a clear, although not sole contemporary vocation. Many of the paintings that it acquired early on were originally done just a few years earlier. I have already stated that it had the support of working Basque artists, whose work formed part of the museum's collection from the beginning. When the museum bought one Gaugin painting, for example, the painter had died just sixteen years before. And this tendency has been maintained ever since, because none of the directors throughout the museum's history ceased in their conviction that the purchase of current art should be encouraged.

With a range as wide as the history of art, for the Fine Arts Museum of Bilbao there is an inevitable overlap with any other art museum. Within the Basque Autonomous Community, its interests overlap with two in Vitoria-Gasteiz—the Museum of Fine Arts and Artium—together with San Telmo in San Sebastián and, more closely, the Guggenheim in Bilbao. All these museums are subject to strategic planning by the Ministry of Culture in the Basque Autonomous Government. At present this government administers a Law of Museums that appears to favor a link between the various institutions through an interrelated hierarchical framework. I won't address here whether there will ever be a future planning strategy on the part of the cultural authorities that addresses museum content in such a way as to establish temporary boundaries, although such a strategy is theoretically possible. However, the special nature of the Guggenheim Bilbao, its uniqueness and isolation from existing museum connections, has enabled it to avoid for the moment any risk of interference with the contemporary section of the Fine Arts Museum. Initially this unique quality stems from the fact that the Guggenheim Bilbao forms part of an already existing international museum, or museum complex, with precisely defined aims and objectives, together with a specific collection. It also constitutes a wider project that goes beyond not only the approach of the Bilbao museum, but even cultural considerations. The uniqueness of the Guggenheim Bilbao's character has been maintained through many aspects that have been, at least up until now, impervious to joint action with the Fine Arts Museum. Later I will explain in which aspects this has been the case.

This does not mean that it hasn't already had some influence—for example, its legal model and many dimensions of its management have been looked at and even copied, and museum behavior is increasingly being judged according to the behavior of the Guggenheim Bilbao. One question, for example, that has come to the Fine Arts Museum from

the Guggenheim Bilbao is that of the aforementioned legal aspect. The Fine Arts Museum was born under the patronage of the Bilbao City Hall and the Provincial Council of Bizkaia and governed by a board named equally by these two institutions. This was the case until 1987, when it became a limited company governed by an administrative board, and in 2002 it became a foundation governed by a board made up of its three institutional owners together with various private sponsors: banks, private and public media interests, the Bilbao subway, a large local department store, an electrical company, and a private philanthropic foundation. The input of these private sponsors has allowed for greater financing, to such an extent that public institutions now contribute 60 percent of the finances (a figure from 2003). The presence of private sponsors, however, should still be considered a new phenomenon for our museum, especially when one realizes that the Guggenheim Bilbao has thirty-one sponsors, while the Fine Arts Museum has only nine and self-finances itself to the tune of 70 percent. This same concept of significant self-financing, previously unheard-of in the museum world, derives from its specific organizational model.

That the Guggenheim, in universal terms, was and is much more than just a museum, and that it has had powerful economic support with which to carry out its project, is well known, and the public has sensed its spectacular impact extremely well. Indeed, the Fine Arts Museum—an institution cherished by the people of Bilbao, whose value they appreciate and feel proud of—has sixteen hundred members of its Friends of the Museum Service, while the Guggenheim has more than fourteen thousand. This observation is even more pertinent when one takes into consideration the fact that those sixteen hundred members constitute a high number compared with other Spanish museums and the overall population of Bilbao (around four hundred thousand people in the city itself, rising to nine hundred thousand if one incorporates its surrounding metropolitan area).

Here are some further statistics from the Friends of the Museum Service: In 1995 the service had 334 members, rising to 952 by 1999. That is, it almost tripled its membership during that time, while it has (again, in 2003 figures) risen to roughly sixteen hundred. In other words, during the period in which the Guggenheim has been open (since 1997), the Fine Arts Museum has quintupled its membership.

This growth in membership of the Fine Arts Museum has coincided not only with the birth of the Guggenheim, but also with a specific policy to attract people that did not previously exist. I'll continue to demonstrate recent developments through the use of statistics: Our permanent workforce between 1995 and 2003 rose from forty-one to fifty-three people, that is, by 30 percent. However, subcontracted employees during the same time—that is, cleaning staff, security guards, museum attendants, gift-store workers, and volunteers—rose from seventeen to thirty-three people, thereby doubling in number. During the same time period, the annual budget rose from $2.7 million to $7.1 million, thereby increasing more than two and a half times the original figure.

Furthermore, in 1998, the Fine Arts Museum embarked on a significant architectural restructuring with the goal of increasing overall floor space and improving communi-

cation between its interior areas, both across and between floors. In other words, this was a project designed to join the two existing buildings, as well to open them up toward the exterior and expose them to the previously mentioned park. This costly reconstruction was finally completed in 2001. Of course, all these changes in the Fine Arts Museum and the growth in its finances were clearly connected to the Guggenheim, and on the whole, the former benefited from the stimulation of the latter. These changes were, indeed, thought of as a complementary development—in the sense of improving the museum's options—that would take advantage of an already extant and obviously rich cultural tradition to aid, above all from a position of noncontemporary art, the Guggenheim's attractions and of course to help Bilbao transform itself into a city offering multiple high-quality services.

It has been observed that the Guggenheim put Bilbao on the world map, and it is certainly true that the number of visitors to the city has increased spectacularly. Obviously, as a result of this, the Museum of Fine Arts has experienced both quantitative and qualitative changes as regards people visiting the museum. The influx of both foreign and domestic visitors to our museum has grown, in the latter case due to the number of exhibitions supported financially by a greater endowment. The average annual number of visitors between 1992 and 1996 was 113,292. In 1997, there was a significant rise to 188,880 although this was not as a result of the Guggenheim's presence, because the Guggenheim opened on October 20 of that year and therefore would have influenced these figures only during the last two months. The reason was that there were two important exhibitions at the time: Obras maestras de arte español en el Museo de Budapest (Masterpieces of Spanish art in the Museum of Budapest), which attracted more than fifty-seven thousand visitors, and Del Vedutismo a las primeras vanguardias: Obras maestras de la colección Thyssen-Bornemisza (From Vedutism to the early avant-garde: Masterpieces from the Thyssen-Bornemisza Collection), which attracted more than sixty-one-thousand visitors.

In 1998, there was a 20 percent increase in visitors, and many people thought that this was due to people attracted to the Guggenheim, since this increase was mainly due to foreign or Spanish tourists. However, if one looks at the chart for the respective origin of visitors to the Guggenheim and the Museum of Fine Arts, one can see that the figures are the opposite of one another in such a way that among our visitors, between 80 and 82 percent came from the Basque Autonomous Community, while the remaining 18 to 20 percent came from Spain or abroad and were, indeed, attracted initially by the Guggenheim. For the Guggenheim, the opposite was true: 90 percent of its visitors were Spanish and foreign, while 10 percent came from the Basque Autonomous Community.

Previously, I referred to the impossibility of raising certain questions concerning the Guggenheim within the cultural context of Bilbao. We have just seen some other aspects in which this is the case. One might say that the Guggenheim's presence, even as just a project prior to its actual opening, invigorated the economic situation of Bilbao and encouraged political leaders and cultural promoters to think about other types of attrac-

tions. Let me repeat that two of the institutional heads of both management boards were the same. One should, furthermore, take account of the fact that, as I mentioned earlier, although the museum opened at the end of 1997, its physical presence had been increasingly felt for the three years prior to that date. Moreover, controversy emerged about the origins of its acceptance as a project and certain events—such as the aforementioned exhibition of masterpieces from the New York collection in 1995—took place that seemed to indicate the nature of the future collection. As regards the effect of all this on the Museum of Fine Arts, there was such a change in the figures between 1995 and 2003 that one must attribute to the Guggenheim an important degree of influence on this growth. The Guggenheim has been thought of as the flagship of Bilbao's rehabilitation, yet, taking account of its more or less direct form of influence, the involvement of the Museum of Fine Arts in this resurgence is also evident.

Formally speaking, there is only one regular (although minor) form of collaboration between the two museums, through the so-called "Bono Artean," a common entrance ticket that is sold in both museums at a reduced cost compared with what would be the total of two separate entrance fees. Furthermore, there also exists a joint campaign to publicize this reduced ticket that is organized by the Office of Tourism in Bizkaia. The remaining elements of a relationship between the two museums take the form of normal good-neighborly communication—for example, through the mutual lending of works for specific exhibitions—but above all they are mostly apparent in cordial internal relations that facilitate consultations and some jointly made decisions.

There are other dimensions to this relationship, although more specifically of a cultural scope and in particular, through the world of the plastic arts. Such dimensions usually come into play through the works of art owned by the Guggenheim, both in its global collection and what it is specifically acquiring for Bilbao, together with the work it exhibits, or rather, its exhibition policy. There is a widely held notion that the Guggenheim Museum favors the container over the content, that there is no balance between the building and the work it exhibits, although I don't personally subscribe to this theory. It is true that the overwhelming beauty of Gehry's architecture might steal the visitor's gaze and enthusiasm to such an extent that it detracts from the work on show. Yet overlooking the potential greater or lesser value of certain exhibitions, a variable that affects the Guggenheim just as much as any other museum, generally speaking, one must recognize the fact that the people of Bilbao have never had such an abundance of the highest-quality contemporary art so close to hand. Previously, before the arrival of the Guggenheim, it was an arduous task for those people in Bilbao, or indeed Basques as a whole, who were interested in seeing work by the great contemporary artists to see such work. Today, anybody in Bilbao can see first-hand a Picasso, Kandinsky, Klee, Mondrian, Rothko, or Kiefer without leaving the city. Another fact one should take into account when analyzing the content of the new museum is its contemporary-art character; above all, that of the most recent or radical works such as Arte Povera, Minimal Art, and Conceptual Art, which the Guggenheim has exhibited on several occasions. Without doubt, one of the main rea-

sons why the Guggenheim's contents have been underestimated has been the difficulty of widespread public assimilation of new artistic languages, including Cubism (despite it being a century-old art form), through a basic lack of education in recent or current developments. Indeed, this suffered an even greater historical setback through the enormous cultural isolation and reactionary nature of the forty-year old Franco dictatorship.

The immediate cultural importance of these contents, through the presence of such important artists, is undeniable. This has also served, naturally, to relocate before an enthusiastic although not expert public both Basque and Spanish art within the context of unavoidable universal references that before might have gone by unnoticed. This is a work of the highest cultural enlightenment, which Basque society has never been able to enjoy in such a social, direct, and dazzling way before.

Another feature of the issue before us here is the Guggenheim Bilbao's own collection. It is true that the Guggenheim was, to a certain extent, a heaven-sent museum at the service of a cosmopolitan network of visitors whose first task was to promote Bilbao's image and attract widespread sectors, and perhaps the investment, of an international public. It is also true that such characteristics gave it a most distinct socioeconomic reality and that its legal nature and management policy stood out before other museums to such an extent that even to this day, a great deal of its activity remains closed off to other cultural realities around it. Logically, of these many cultural realities, the most immediate one is that of the Museum of Fine Arts. This is due to the fact that, generically speaking, it handles the same kind of work and is the site where the most overlapping of activity can and indeed does take place.

The Guggenheim Bilbao Museum not only enjoys the same artistic resources as other Guggenheims in New York and Venice but, at the moment of its founding and indeed at the time there was a commitment to this, it began to amass its own collection. This collection was, of course, open to being used by the other branches, yet in any hypothetical dissolution of the current agreement, such work would remain the property of the Basque institution. This collection has been subsequently built up little by little and indeed it is still not very large, composed as it is of eighty pieces of art. These pieces, however, were very expensive, since they are the products of the highest-priced artists on the international market: among others, Rothko, Still, de Kooning, Motherwell, Rauschenberg, Serra, Kiefer, and Richter. However, it's not here where an overlapping of interests takes place, at least not in a repeated or worrying way. The budget of the Museum of Fine Arts does not allow for the acquisition of the previously listed artists. Such, let us say "American prices" are out of our reach. In fact, our museum's collection—except in the case of graphic art—is based (as I mentioned before) almost exclusively on European art, and therefore there is no repetition between the two locations, because the logical attention which the Guggenheim pays to American art does not contend with, but rather complements our own collection.

However the Guggenheim Bilbao Museum also pays attention in its purchases and exhibits to European art. Exhibitions, though, do not present a problem, because any pos-

sible repetition, whenever it might occur, is sparse. Moreover, as regards purchasing, and for the aforementioned reasons, one notices the greatest overlapping of interests in the field of Spanish and Basque art, both of which are economically more accessible. Here, then, the evolution of the Guggenheim's acquisitions might result in a certain overlapping of interests between the two museums. Since its inception, the Guggenheim Bilbao Museum opted to buy Basque artists, although in a selective way, focused on a generation of artists that had emerged in the 1980s, together with some works from the 1990s, artists who maintained some sort of connection to New York by living and working there. As regards Spanish artists, the purchases have been focused in an equally selective way, although devoid of any chronological boundaries. The fact is that now there are several names that one can find in both collections: Tàpies, Palazuelo, Barceló, Cristina Iglesias, Eduardo Chillida, Darío Urzay, Txomin Badiola, and Pello Irazu. This would not be worth commenting on, since at the end of the day, everything forms a common heritage and, paraphrasing Baltasar Gracián in contrary fashion, "lo bueno, si es mucho, mucho major [the good, the more there is, the better]," but for the fact that economic funding for the purchases of the two museums comes from almost the same source and Euskadi's (the Basque Country's) funds, specifically those of Bizkaia, are limited, above all at a time when not only museum, but other large-scale infrastructural projects have been promoted that are transforming the region. And I worry more about the Fine Arts Museum than I do about the Guggenheim, not only because it is my duty as its director, but also because our funding to purchase works is a lot less. In February 2004, the minister of culture in the Basque Autonomous Government announced the future purchase of Spanish and Basque art for the Guggenheim. In part, I was tremendously happy about such an event because it implied a greater possibility for disseminating Basque art, given the capacity of the Guggenheim to publicize its latest news and the names it would welcome. On the other hand, however, I thought about the conflict of interests and the maximal use of our own resources. I thought about the future Law of Museums, which the Basque Autonomous Government is preparing, and its interest in an overall coordination. The Guggenheim Bilbao seems to be sliding, along one of its tracks, toward approaching more closely the kind of art that is found on its doorstep. So now it does not seem so easy for me to predict what might happen as the result of the coming together of the two museums' framework or the problems that might, either implicitly or explicitly, derive from their proximity and a common, therefore redundant, legacy.

Part III

A BUSINESS PLAN

The Guggenheim Museum:
A Business Plan

HANS HAACKE

When doing a Google search of the keywords "Guggenheim Museum," I came across a German article. I inadvertently clicked the demand for an automatically translated English version. Beginning to read, I wondered whether this was indeed an article on the Guggenheim Museum, because repeatedly a "Mr. Measurer" was referred to. Then it dawned on me that the program had given me a translation of the name of a person I had once met, Thomas Messer, the director of the Guggenheim from 1961 to 1988. German-English dictionaries translate the common German word *Messer* normally as "knife." In the early 1970s, Mr. Messer was often alluded to as "Mack the Knife." The clever translating program had related his name instead to the German verb *messen*, to measure. He had thus turned into someone who measures and, acting on the results of this exacting occupation, takes measures—by implication then, a person who upholds standards and is at the cutting edge. What better way to characterize the predecessor of Thomas Krens, who has been Guggenheim director since 1988.

In many respects, Thomas Messer was a trailblazer for Thomas Krens. One of the last major endeavors under his aegis was an exhibition of Andy Warhol's *Cars*, a series the artist executed shortly before his death. It was a commission of portraits of Daimler-Benz automobiles, from the company's first motorized vehicle of 1886 to a test vehicle of 1970. The then-chairman of Daimler-Benz, Edzard Reuter, closed his preface to the exhibition catalogue by aptly noting "A company's encounter with an artist is as complex as the perfect presentation of perfect products."[1] In a seconding statement, the museum director paid tribute "to an artist whose achievement is based upon an extraordinarily acute sense of the signs of the time." He added: "Appropriately, the exhibition is sponsored by Mercedes-Benz."

1. Edzard Reuter, quoted in *Andy Warhol: Cars*, exhibition catalogue (New York: Guggenheim Museum, 1988), p. 6.

By the 1980s, Thomas Messer—like Andy Warhol and Messer's colleagues in other museums—had indeed "an extraordinarily acute sense of the signs of the time."[2] In a flier, the Metropolitan Museum of Philippe de Montebello had offered a hard-nosed business rationale for the corporate sponsors it was wooing: "Many public relations opportunities are available through the sponsorship of programs, special exhibitions and services. These can provide a creative and cost-effective answer to a specific marketing objective, particularly where international, governmental or consumer relations may be a fundamental concern."[3] The flier had the telling title *The Business behind Art Knows the Art of Good Business*

Nevertheless, when Thomas Messer bailed out in 1988 after twenty-seven years, the Guggenheim Museum was facing serious financial problems. In an interview with the *New York Times*, he gave his blessing to the forty-one-year-old Thomas Krens and assessed him as "an extraordinary young man of great equanimity, of tact, of force."[4] Attributing tact to the young man was perhaps a bit too generous. Less then ten years later, in 1996, Elaine Dannheisser quit the Guggenheim board in a huff: "Tom Krens is very arrogant, and his rudeness was just too much to take,"[5] she complained—and took her collection of contemporary art to the Museum of Modern Art.

But Thomas Messer was right in other respects when he praised the budding director's "force" and his "international propensity."[6] Krens's boast at the time of his appointment, that the Guggenheim "is the one museum in New York City that is a specialist in international outlook," followed a cool business logic: "I think there's tremendous future potential in that."[7] From the beginning, global expansion was an essential part of his game plan. Peggy Guggenheim had been persuaded by Messer in 1976 to bequeath her collection and her Venetian palazzo to her late uncle's Solomon R. Guggenheim Foundation in New York.[8] It significantly boosted the equity that Thomas Krens was about to wager in his global designs.

During his undergraduate years, he had majored in political economy and later earned a master's degree in studio art from the State University of New York at Albany. While teaching as an adjunct professor at Williams College in the 1980s, he went for a second master's degree—this one from Yale's School of Management, where he won praise from one of his professors, Martin Shubnik, an expert in mathematical institutional economics and the author of *Game Theory in the Social Sciences*. When asked about his student, Shubnik said: "Without exaggeration, I can say that Tom has the mantle of P. T.

2. Thomas Messer, quoted in ibid., p. 7.

3. *The Business behind Art knows the Art of Good Business*, leaflet, (New York: The Metropolitan Museum of Art: mid-1980s), n.p.

4. "Guggenheim Names New Director," *New York Times*, January 13, 1988, p. C13.

5. Martin Filler, "Speaking Her Mind About Art, and Giving It," *New York Times*, September 28, 1997, Arts and Leisure Section, p. 35.

6. "Guggenheim Names New Director," *New York Times*, September 28, 1997, Arts and Leisure Section, p. 35.

7. Ibid.

8. In 1986, the Guggenheim Museum bought the American pavilion of the Venice Biennial for $30,000. Repeated attempts by the museum to determine the official exhibition program of the pavilion have run into strong resistance and have not succeeded.

Barnum on his shoulders, and I regard Barnum as a very serious fellow. Tom is proba-
bly the greatest seducer in the business."[9]

Krens did not succeed in seducing the trustees of the San Francisco Museum of Mod-
ern Art to appoint him director of their institution. "We were scared to death by all his
talk of flow charts and spreadsheets and computers and strategies. He never mentioned
a work of art once,"[10] *The New Yorker* quoted one of the trustees. The Guggenheim
trustees, however, were not frightened by his management lingo. Facing the task of tack-
ling the financial disaster they had been presiding over, they were eager to be seduced by
a full-blooded go-getter with a business plan. The culture of the Guggenheim board, head-
ed for decades by Peter O. Lawson-Johnston, was quite compatible with Krens's outlook.
Peter O. Lawson-Johnston is a son of Barbara Guggenheim. He is still involved today
with the significant mining interests that the branch of the Guggenheim family to which
he belongs has held around the world. (In U.S. relations with Chile during the
Allende/Pinochet years, its El Teniente copper mine in the Andes played a critical role.) His
political leanings may be deduced from his being a director of William S. Buckley's con-
servative journal *National Review*.

The Guggenheim board had signed up a gambler. There is some doubt today
whether the disciple of a Yale economic game theorist was, in fact, a good bet. It is only
fitting that Krens eventually opened not only one, but two Guggenheim branches at a
Casino in Las Vegas in 2001, one of which closed after eighteen months and just one
exhibition. As the saying goes: You win some, you lose some.

A year after his appointment, Krens wanted to demonstrate to the world that, in spite
of his lack of curatorial experience, he was qualified to mount an exhibition filling Frank
Lloyd Wright's spectacular automobile salon turned museum. The neophyte's 1989 Refig-
ured Painting: The New German Image, 1960–1988, however, did not gather kind
reviews. Krens had to write it off as a loss. Perhaps he had been too absorbed—as he
would be many times later—by building and expansion projects: the renovation and the
addition of a boxy wing to the spiral of the uptown museum and the opening of a new
branch in SoHo, designed by Arata Isozaki. With a sense of measure for the Solomon R.
Guggenheim Museum Foundation's limited resources, Thomas Messer had prepared a
far more modest plan than his successor. A $54.9 million bond issue in 1990 was to
finance Krens's more ambitious ventures.[11] Its debt service has been plaguing the muse-
um ever since. It has, in fact, governed Thomas Krens's peripatetic scouring of the globe
for rescue from what, in economic terms, has turned out to be his original sin. In 2002,
his expense account was larger than that of the director of the Museum of Modern Art.[12]

The construction project by Gwathmey Siegel and Associates was to take eighteen
months and cost $40.3 million. It lasted twenty-six months, and with a cost of $57.9 mil-

9. Martin Filler, "The Museum Game," *The New Yorker*, April 17, 2000, pp. 96–105.
10. Ibid.
11. Andrew Decker, "Can the Guggenheim Pay the Price?" *ARTnews* (January 1994): 142–49.
12. 2002 Income Tax Return of Solomon R. Guggenheim Foundation, Schedule 13, Part V.

lion it went over budget by $17.7 million. The SoHo branch had a cost overrun of $4.6 million. In 1994, four years after the bond issue, the museum faced annual interest and principle payments of over $6.5 million.[13] And by 1993 the $10.5 million operating budget of 1988 had risen to a projected $23 million.[14]

The museum was closed during construction for about two years. As a consequence, it derived no income from entrance fees, retail sales, and the rental of its spaces. When the SoHo branch opened in 1992 (behind schedule), to reach the galleries, one had to traverse a museum gift shop that occupied almost the entire ground floor. The Guggenheim had commissioned and marketed a great number of objects made in the style of works in its collection: ties, shopping bags, scarves, mobiles, dolls, and a variety of knickknacks, most of them hardly in line with the museum's declared mission to educate and promote excellence. A grandson of Joan Miró put an end to selling derivatives of his grandfather's images.

In a 1994 *ARTnews* article that quoted in its title a deputy director of the museum saying "It's Tight Right Now," Robin Cembalest reported that several exhibitions had to be cancelled or postponed—souring relations with cooperating institutions—and that the museum had cut 10 percent of its staff and had fired all of its librarians.[15]

Krens asked his remaining staff to become engaged in a drive to increase museum membership. Ruefully, he declared: "I'd rather that the museum was only about art. But that's the situation that doesn't exist. So therefore we have to do whatever we can to maximize our revenues."[16]

In 1990, at the time of his building spree, the Guggenheim director acquired Count Giuseppe Panza di Biumo's collection of 300 Minimalist and Conceptual works for a reported $30 million in a gift-purchase.[17] He raised the funds for this purchase by selling at Sotheby's a Chagall, a Modigliani and an important Kandinsky for $47.3 million.[18] Again in 1999 and 2000 $15 million worth of artworks were deaccessioned, and $10.1 million was deposited in a restricted fund of its endowment. The Association of Art Museum Directors asked the Guggenheim to explain this move in light of the AADM's code of ethics, which prohibits income from the sale of artworks to be used for anything other than the acquisition of other works. The Guggenheim's deposit in a newly created restricted art fund helped the museum meet a critical requirement of the letter of credit stating the terms and conditions for securing its bonds. The letter, since 1997 with WestLB, stipulates that by June 2001, the museum's endowment was worth at least $35 million, and that it was to be increased thereafter to $52 million.[19] The original bond issue in 1990 did not provide

13. Decker, "Can the Guggenheim Pay the Price?"

14. Ibid.

15. Robin Cembalest, "It's Tight Right Now," *ARTnews* (May 1994): 41.

16. Decker, "Can the Guggenheim Pay the Price?" p. 146.

17. Carol Vogel, "As Guggenheim Adjusts, Pinch Is Felt Elsewhere," *New York Times*, February 24, 1994, Arts and Leisure Section, p. C16.

18. Robin Cembalest, "The Guggenheim's High-Stakes Gamble," *ARTnews* (May 1992): 84–92.

19. Kelly Devine Thomas, "Following the Money," *ARTnews* (January 2004): 45–46. In 1998 it reached $56 million. Krens dipped into the endowment to cover operating expenses. It has shrunk to $45 million, New Yoork Times, January 20, 2005, p.A 1. 21.

for the collection to serve as collateral. However, over the years, suspicions repeatedly arose that in case of default, there does exist an indirect link. The ADDM is now raising this question again. It is the first time that the association has investigated a member.

In the early nineties, Krens brought new-moneyed members to the board of trustees. Real estate developer Samuel J. LeFrak made a gift of $10 million. His expectation that the LeFrak name would appear on the façade of the museum together with that of Solomon R. Guggenheim was thwarted by the New York City Landmarks Preservation Commission.[20] Instead level 5 of the rotunda and annex are now called The Honorable Samuel J. and Ethal LeFrak Galleries and Sculpture Terrace. The billionaire Ronald O. Perelman also gave $10 million and became president of the board in 1995, succeeding Peter O. Lawson-Johnston, who had been president since 1969. As the man behind Revlon, next to the two Lauder brothers, Perelman is the third cosmetics executive at the top of boards of trustees of major New York museums. Ronald Perelman's buyout artistry as chairman and CEO of a diversified holding company with investments in consumer products, entertainment, and financial services got him frequently into the news. But he also got coverage for his generosity to both Democrats and Republicans,[21] for offering Monica Lewinsky a job at a critical time, and for a messy custody battle.[22] Articles in the *New York Times* about his shifting fortunes were often illustrated with photos in which he posed at the Guggenheim Museum. When he pledged an additional $20 million in 1998, the ground level of the rotunda was named for him. But he was trumped by Peter B. Lewis, the head of Cleveland-based Progressive Corporation, one of the largest auto insurance companies of the United States. Lewis gave $50 million, provided the board made him chairman, above Perelman. The board looked at the figures. Peter Lewis became chairman—and Perelman resigned.[23]

In the late 1980s, Thomas Krens began his high-stakes gamble of global expansion that he hoped would shore up the museum's troubled finances. He had his eyes on Berlin's Martin-Gropius-Bau for a joint venture. However to no avail. His plan for a Guggenheim branch in Salzburg, to be built by the Austrian architect Hans Hollein in a mountain, also did not come to fruition. Hollein's son worked with Krens in New York for a number of years and is now director of the Frankfurt Schirn Kunsthalle, succeeding Thomas Messer in that position. Like an early attempt to get a foothold in Moscow, adding the Dogana at the entrance to the Grand Canal in Venice to his empire did not pan out. Nor did the feelers he sent out to several cities in Spain lead to a breakthrough.

But, unexpectedly, in 1991, Thomas Krens landed a spectacular coup in Bilbao. It funded the $100 million construction of a museum building by Frank Gehry, an adaptation of the architect's design for the Walt Disney Concert Hall in Los Angeles, which was realized only much later. The Basques also made available $50 million for new acquisitions

20. "Clash Over Name Puts Museum Gift in Doubt," *New York Times*, December 17, 1994, p. 13.
21. Wayne Barrett, "The Man behind the Job," *Village Voice*, February 3, 1998, p. 37.
22. "Billionaire's Custody Hearing Must Be Open, Court Says," *New York Times*, December 5, 1998, p. B2.
23. Deborah Solomon, "Is the Go-Go Guggenheim Going, Going …," *New York Times Magazine*, June 30, 2002, p. C36.

and agreed to subsidize the museum's annual $12 million budget. And they paid Krens $20 million in cash up front.[24] The Guggenheim Museum, in turn, was to lend its brand name and works from its collection and to pass through Bilbao shows it had organized elsewhere. It was given complete control over programming and acquisitions for the Bilbao collection.

I was one of those who believed that in this deal, the Basques could only lose and the Guggenheim could only win. Both parties were desperate. Once-prosperous Bilbao was crippled by the closing of the steel plants of Altos Hornos de Vizcaya on the Nervión river and the demise of attending industries and its formerly busy port. Compounding its economic plight was the reluctance by

Student wearing Guggenheim T-shirt in the streets of Bilbao, 1994. More than just a collection or even a building, the Guggenheim is also a marketable product.
© Hans Haacke/Artists Rights Society.

investors to risk their money in a region wracked by ETA violence. The Basques hoped that the importation of the Guggenheim Museum's cultural capital would promote urban development, give Bilbao a positive image, attract tourists from all over the world, and thus be a boon to the local service industry. It now appears that the Basque government had indeed made a profitable investment—thanks, no doubt, to the extraordinary attraction of the glittering structure of Frank Gehry that was parachuted into Bilbao. Whatever one may think about its suitability for the presentation of artworks and its ranking in the pantheon of architecture, it appears to perform the economic and the political purpose for which the Basque government spent considerable amounts of taxpayers' money. Phillip Johnson's comment, "When a building is as good as that one, fuck the art,"[25] may be translated into the economic terms of today's culture and tourist industry: "If the money is right, fuck the art." Even though a Basque audit in 2001 discovered a construction cost overrun of $16.5 million and alleged that the Guggenheim in New York had

24. "The Basques Get Modern," *New York Times*, June 24, 1997, pp. C1,10.
25. Allan Schwartzman, "Art vs. Architecture," *Architecture* (December 1997): 56–59.

paid higher than market prices for its acquisition of artworks for Bilbao, the Basque government nevertheless planned to contribute another $30 million for further acquisitions.[26] The appearance, internationally, of a big popular success also burnished the brand name of the New York mother, thus making her attractive for more suitors from around the world, whom she desperately craved. This may, for example, have been a reason behind Enron's sponsorship of Frank Gehry's retrospective at the New York flagship. The strategy of franchising the Guggenheim name and sending the collection on the road to bring in much-needed cash was given an important boost.

Within a month of the Bilbao opening, a joint venture with the Deutsche Bank came to fruition in Berlin. Krens had approached the bank a year earlier. He quickly came to an agreement with Hilmar Kopper, the bank's president since 1989 and now the chairman of its supervisory board. Both businessmen understood immediately the benefit each could derive from opening a Guggenheim branch in the bank's regional headquarters Unter den Linden. They fused the names of the two institutions, calling the franchise Deutsche Guggenheim. The terms of the contract in Berlin remain a closely guarded secret. However, it is fair to assume that one of the largest banks of Europe made a worthwhile offer in exchange for the cultural veneer and the image of international sophistication associated with Frank Lloyd Wright's iconic Guggenheim Museum. Hilmar Kopper gave a convincing business rationale in an essay for the book *Das Guggenheim Prinzip*: "Deutsche Guggenheim Berlin is an advertisement for Deutsche Bank's global expertise, quality, and innovative potential."[27] Kopper was equally frank when he explained in 1995, at the occasion of the Deutsche Bank's establishing a Foundation for Culture: "Whoever gives the money, controls."[28] In effect, he spoke for all corporate sponsors. As in Bilbao, Guggenheim-generated exhibitions pass through the Berlin branch. Because of a lack of funds in New York, some even originated at Unter den Linden. While Jeff Koons had supplied a ten-year-old flower puppy to Bilbao, for Berlin, he produced a new series of images with the appropriate title *Easyfun—Ethereal*, which, in Thomas Krens's words, "reflects deeply upon the complex concerns of Western culture."[29]

This evaluation of *Easyfun—Ethereal* and the attendant financial rewards may have been behind the most spectacular curatorial endeavor of Krens, a 1998 exhibition with the ambitious title: The Art of the Motorcycle. It filled the entire rotunda and drew unprecedented crowds to the museum. It was a box-office hit. BMW was the sponsor of the extravaganza. In a press release the company explained: "BMW's contribution to this exhibition … goes far beyond the mere provision of objects—BMW is dedicated, rather, to the combination of art, culture and technology in the more general sense. For this exhibition corresponds perfectly to the Company's motivation and commitment to culture:

26. George Stolz, "The Guggenheim Gets Audited," *ARTnews* (May 2001): 98.

27. Hilmar Kopper, "1+1=3: Das Deutsche Guggenheim Berlin," in *Das Guggenheim Prinzip*, ed. Hilmar Hoffmann (Cologne: DuMont Buchverlag, 1999), pp. 56–67.

28. Hilmar Kopper, "Die Kultur und das Kapital," Munich *Süddeutsche Zeitung*, May 18, 1995, p. 13.

29. www.deutsche-bank-kunst.com/guggenheim/alt/english/info/krens_essay.htm.

BMW wants to make a contribution towards new perspectives of the works, towards a new perception of everything around us."[30]

In the same year, an earlier and ongoing relationship with the German/Italian men's fashion house Hugo Boss was complemented by a Gucci-sponsored event with women staged by Vanessa Beecroft. For two hours, fifteen female models were showing off Tom Ford–designed Gucci rhinestone bikinis and high-heeled shoes. An additional five models were stripped bare by Beecroft, wearing nothing but Gucci shoes.[31]

In 2000, this baring of all had a full-dress sequel: Giorgio Armani, curated by the Arte Povera expert and founding director of the Prada Foundation, Germano Celant. The allegation that Armani's pledge of $15 million to the Guggenheim had something to do with this venture is strenuously denied by the museum.[32] The show's official sponsor was *In Style* magazine, a Time Warner publication. The lavishly appointed fashion showroom on Fifth Avenue and later also at the Guggenheim Bilbao were both designed by Robert Wilson, as were the halls of the Neue Nationalgalerie in Berlin when it played host to the roving Armani extravaganza.

The Art of The Motorcycle, together with the Guggenheim Motorcycle Club, traveled to Las Vegas. In 2001, they were the opening attraction in one of the two new Guggenheim branches at the Venetian Hotel-Resort-Casino. The museum's director of communication, Ben Hartley, had fittingly clarified the museum's mission: "We are in the entertainment business and competing against other forms of entertainment out there."[33] The Resort-Hotel-Casino paid for the two Koolhaas-designed museums, made other undisclosed contributions,

Venetian Hotel-Resort-Casino, Las Vegas.
Art and gambling combine in the Nevada desert.
© Hans Haacke/Artists Rights Society.

30. *Presseinformation*, BMW AG Munich, November 20, 1997.

31 Patricia Bickers, "Marriage à la Mode," *Art Monthly* (November 2002): 1–4.

32. Herbert Muschamp, "Where Ego Sashays In Style," *New York Times*, October 20, 2000, Arts and Leisure Section, pp. 29, 32.

33. Ralph Blumenthal, "Painting by Numbers: My Renoir Beats Your Vermeer," *New York Times*, June 6, 1999, Week in Review, p. 6.

and let the Guggenheim share in the operating income—and the losses—at a 51 percent rate.[34] Accompanying the move to the gondoliers in Las Vegas, Krens had entered into two new partnerships with financially pressed European museums, the Kunsthistorisches Museum in Vienna and the Hermitage in St. Petersburg. Their ostensible common purpose is to mount shows from their respective collections in Las Vegas, Bilbao, New York, and in Venice (Italy), occasionally sponsored by Deutsche Bank. In addition, Krens signed an agreement with the Hermitage for developing joint projects in St. Petersburg. Next to the Hermitage's director Mikhael Piotrovsky, a key figure in this relationship is Vladimir O. Potanin, who was elected to the Guggenheim board in 2002. He is the board chairman at the Hermitage and also the chairman of the board of directors of a newly created Hermitage–Guggenheim Foundation. The inaugural exhibition of works from both museums in the Hotel-Resort-Casino, Masterpieces and Master Collectors, was sponsored by the Interros Holding Company of Russia, of which Vladimir Potanin happens to be the president. When Potanin was not yet forty years old, *Forbes* ranked him in 1998 the wealthiest man in Russia and the 186th wealthiest in the world.[35] Many questions have been raised about how the young man amassed such a fortune in less than ten years in the privatization of state-owned properties, a fortune that was estimated in 2002 to be worth 4 percent of Russia's gross national product. Belonging to his Interros empire are Norilsk, the world's largest producer of nickel and palladium and a major producer of platinum, copper, cobalt, and gold, as well as large banking and media interests, including the national newspapers *Izvestia* and *Komsomolskaya Pravda*.[36] They are considered to have played a role in Boris Yeltsin's election. Perhaps observing the fate of his fellow oligarch Mikhail B. Khodorkovsky of Yukos, Potanin is cur-

Guggenheim merchandise. Malevich magnets and Picasso cups tempt the Guggenheim visitor with their promise of bringing art into the privacy of one's kitchen.
© Hans Haacke/Artists Rights Society.

34. Kelly Devine Thomas, "The Guggenheim Downsizes," *ARTnews* (February 2003): 100–105.

35. Centre of Russian Studies (NUPI), "New Forbes' Assessment of the Wealth of Russian Tycoons," June 26, 1998. In its issue of March 15, 2004, *Forbes* ranked Potanin the fourth-richest Russian. Three oil tycoons had overtaken him. However, with $4.9 billion to his name, he moved up to position 85 in the list of the world's billionaires.

36. Sylvia Hochfield, "Oligarch at the Guggenheim," *ARTnews* (March 2002): 45. Raf Shakirov, the chief editor of *Izvestia*, was forced to resign on September 6, 2004, because he had published, on the front page of the newspaper, a harrowing photograph of a man carrying a wounded child out of a school in Beslan that had been attacked by Chechen rebels. Seth Mydans, "Grief in Russia Mixes with Harsh Words for Government," *New York Times*, September 7, 2004, p. A3.

rently viewed as discreetly supporting Vladimir Putin. His PR office made it known that he had donated one of four versions of Malevich's *Black Square* to the Hermitage. His answer to a reporter's question how much it costs to be a Guggenheim trustee was "$2.5 million spread over five years."[37] If true, it would be a rather modest entrance fee.

By the end of 2002, in spite of the global maneuvering of many years, the Guggenheim house of cards was close to collapse. Krens had recklessly leveraged the museum's future. Again and again he had to dip into the endowment to cover operating expenses. Peter Lewis, the Guggenheim chairman, read Krens the riot act. He publicly humiliated Krens and threatened to fire him if he didn't shape up. Lewis accepted part of the blame as board chairman. In exchange for giving an additional $12 million to pay outstanding bills and service the museum's debt, he demanded a drastic reduction of the budget to half of what it had been. Staff positions dropped from 391 to 181, major exhibitions were postponed, and hours were reduced.[38] In due course, the idea of another Gehry museum building in downtown New York was abandoned, as was an on-line commercial enterprise. Following the closing of the SoHo branch a year earlier, one of the two Las Vegas branches, the motorcycle showroom, was shuttered.[39]

Guggenheim Museum façade peeling, New York. The Guggenheim would seem to face an uncertain future. © Hans Haacke/Artists Rights Society.

37. Adrian Dannatt, "Guggenheim, Las Vegas: Gambling as sin—Rev. Rosenthal," *The Art Newspaper* (November 2001), p. 1.

38. Celestine Bohlen, "Chairman Gives the Guggenheim an Ultimatum, then $12 Million," *New York Times*, December 4, 2002, pp. B1. 6.

39. Citing "differences in direction", Peter B. Lewis resigned from the board on January 19, 2005. Since 1993 he had given the Museum about $77 million, four times as much as any other board member. He wanted the Museum to concentrate on New York and to bring its financial house in order, rather that continue trying to expand elsewhere. The board backed Krens. Attempts to open branches in Rio de Janeiro and Taiwan are stalled. A new venture is being explored for Guadalajara, Mexico. In 2004 the Museum held an exhibition titled The Aztec Empire. The board appointed William Mack acting chairman and president. Mack joined the board in 2003 together with Stephen M. Ross. Both are major real-estate developers. Carol Vogel, "Guggenheim Loses Top Donor In Rift on Spending and Vision," *New York Times*, January 20, 2005, p. A1; Robin Pogrebin, "Loyalty Prevails Over Money in Guggenheim Showdown," *New York Times*, January 21, 2005, p. B3.

The Guggenheim Museum's trajectory is full of ironies, from *Black Square* via *Red Square* to Venice—real and fake—with deep mining, the murmur of "The Spiritual in Art" and the roar of a motorcycle gang in the background.

There was a good deal of schadenfreude among the peers of the Guggenheim director. The adulating coverage he had enjoyed by the press earlier turned into sneering "We always knew it" commentary. However, boards of trustees and officials in charge of public moneys still consider him a guide. Less flamboyantly than Krens, but just as determinedly, many of his peers are expected to pursue similar strategies to turn cultural capital into monetary capital. Some museum administrators do so out of conviction. The effect on "The Good, the True and the Beautiful" to which they all have pledged their allegiance is either ignored or written off as collateral damage.

Business as Usual II*

...a series of notes

MUNTADAS

I have selected a set of images that reflect the speed of information and the velocity of consumerism.

The Guggenheim Bilbao is an exemplary illustration of the paradoxes and contradictions of cultural perspectives mirroring a capitalist society. And the problem is not isolated. It is a worldwide symptom of how culture and economics are interrelated. The question is whether this is an irreversible situation produced initially in the United States and exported elsewhere.

Lets remark on the interrelationship between business and culture in all our lives. In this regard, the representation of cities is a key field.

* My thanks to Nayda Collazo-Llorens, Andrea Nacach and Joan Olivar for their help with this article.

 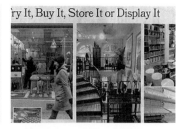

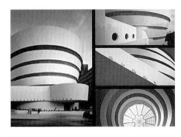

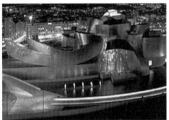

 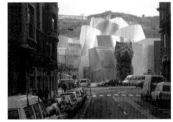

These are some references and personal observations that will emphasize some of the contradictions mentioned earlier.

First of all, in the summer of 1995, in the context of Intervenciones Urbanas in Arteleku, San Sebastián, a group of 25 people visited the city of Bilbao. We were trying to compare two very different cities: San Sebastian and Bilbao. The agenda included stopping at several specific locations. It included a visit to the Guggenheim headquarters and a talk with the museum director. The purpose of the visit was to get information on the various Guggenheim models, discuss the plan of the new building, and understand the entire museum project. The group included local and international artists, architects, critics, and social scientists. We did not get any answers. The responses were very vague and the entire process seemed very improvised. The local population didn't know what was happening and the cultural milieu was very angry.

The second reference has to do with the period before the opening of the museum. Major newspapers carried out interviews and opinion surveys regarding the importance of the Guggenheim. I remember receiving a call from a newspaper. My answer was "let's wait", anything that could happen in Bilbao was likely to be positive, the situation was so deteriorated, economically and culturally that any chance of making a difference could be positive. Years after we have seen that the results for the city have been evidently positive…but will they last?…or is it only an effect of architecture?

The third reference is an article by the New York Times' architecture critic proclaiming the Guggenheim Bilbao best building of the century. It was published before the museum opened. Before it had had any exhibit, it treated the museum in its formal aspects alone not its functions. His opinions were followed by many critics and celebrities who extolled the building.

These three aspects are symptomatic facts: the project itself, the media, and the architecture. They highlight key issues that emerge as the tip of the iceberg.

As a final comment, I will say that "site-specific" and "context-specific" are notions that have been applied to many contemporary projects by many artists and social scientists. Maybe we should now use the word "time specific" and talk in terms of expiration dates. In relation to works of architecture, maybe we should consider their expiration before they become ruins. In part, because the quality of present construction is so poor and its complexity so ambitious, we should consider the concept of permanence or temporality as well as its relation to cultural consumption. When we qualify something as site-specific or context-specific we are in fact implying it is time-specific. And I think that time-specificity makes us understand certain things such as hidden agendas for political and economical perspectives or a confrontational and critical position on the urgency of our times.

Sleeping in Bilbao:
The Guggenheim as a New Cultural Edsel?

SERGE GUILBAUT

I feel totally humbled and helpless by the task at hand. To write on the Bilbao-Guggenheim connection after Joseba Zulaika's thoroughly and absolutely fascinating and convincing book, *Crónica de una seducción*, is, I feel, like trying to teach Matisse how to paint. It seems that Professor Zulaika has covered all the angles of the museum, or rather, in this particular case, all the curves of the problem. All I can do, I think, is to dig, maybe not deeper, but underneath this story, to talk about its archaeology, so to speak. I will talk about a kind of parallel history: other attempts by cultural institutions, such as the Museum of Modern Art in New York, to project out toward the periphery their essential belief systems or aesthetic constructions during periods of political and social tension. I will attempt to trace an important trend, which began during the Cold War (MoMA) and morphed into something else (the Bilbao Guggenheim) during an era associated with a certain kind of postmodern culture, an era that I believe ended with the events of 9/11. Let me explain.

The twenty-first century did not start with a bang, but rather with a cash register ring. We have been told that this new century—without walls—should be a brilliant one due to liberal, global economies and the democraticization of a stock market fuelled by new virtual technologies. Paradise was supposed to be reachable, if only free rein would be given to neoliberal (free-market) propositions. If only all nations understood this and were willing to toe the line, everybody was supposed to benefit from the exercise. The trickling down would be luscious. There is a contemporary idea that says that since the collapse of all the world's walls and the tremendous success of the free-enterprise system, humanity has finally entered into a brave new world where communication, thanks to technology, has been made easier. This, in turn, has created a smaller world open to those free exchanges so beneficial for the global planet, making the Disney song "It is a small world after all!" finally believable.

It is true that the end of the Cold War generated an incredible amount of overly opti-mistic, if not naïve statements about the newly discovered freedom. The Cold War was constantly reconstructed as a post–World War II moment, George Bush senior was attentive to this situation by announcing after the first war in Iraq that we were con-fronting a "new world order," which he quickly amended by using a softer expression, less associated with authoritarian regimes, "the next American Century." This motto of course recalls a very successful term, "The Great American Century," concocted by Henry Luce in a *Life* magazine article in February 1941,[1] and played a similar role. In 1941, the idea was to encourage the American public, still attached to isolationism, to get involved in a war that—despite a general reluctance—would be very beneficial for the eco-nomic future of the country. This replay by the first Bush administration was important because the United States was in the process of reaping the profits of its technological vic-tory over the Soviet Union and Iraq and had become in the meantime *the* global power, the principal economic and military power in the world and even more powerful than after the World War II, when power was shared with the Soviet Union.[2] Nothing seemed, then, to oppose the U.S. vision for a new world organization, an organization constructed according to the wishes of conservative America. To cite a contemporary example, at the end of the first Iraqi war George Bush senior frequently alluded to the necessity for the United States to continue its moral quest around the world, for Americans to do what was right, moral, and just because they were Americans.

What is particularly striking here is that plans to build a museum in Bilbao by the Guggenheim Foundation were carried out simultaneously with the beginning of the Gulf War in 1991. Even more surprising is that, in 1996, just as the U.S. policy of contain-ment (in effect since 1947) was giving way to the larger idea of transnationalization, the new museum in Bilbao opened its doors. This does not, of course, imply any conspiracy behind these simultaneous events. It merely reveals just how in tune the Guggenheim real-ly was with the new post–Cold War situation and just how quickly Thomas Krens under-stood that time and speed are vital new ingredients in foreign cultural policy. For the first time in its history, the Guggenheim Foundation was faster off the mark than MoMA in New York, an organization that, since its inception, had traditionally been ahead of the international game. For this reason, a glance at the history of MoMA's international post-war activity will help us to understand and put into perspective the important meaning-ful move of the Guggenheim to Bilbao. In a sense, the initially successful strategy of MoMA after World War II, coupled later with its increasing inability to relate to new international conditions, gave way at the end of the century to the Guggenheim solution. This essay will, then, be a sort of archeology of this important transformation.

Although the Frank Gehry building has been analyzed so much and so closely by now, and although it is its design that energizes the press and crowds, the Guggenheim's

1. Henry Luce, "The American Century," *Life*, February 7, 1941, pp. 61–65.
2. See Noel F. Busch, "Nelson A. Rockefeller: As Coordinator of Inter-American Affairs, a Celebrated Young Heir Runs a Much-Discussed and Increasingly Important Washington Bureau," *Life*, April 27, 1942, pp. 80–84.

program or long-range vision is also an important aspect of the architectural project, something that MoMA was one of the first American museums to understand with regard to its own building. Contemporary culture is generally important for creating and sustaining the international image of a country, and it was particularly crucial at a time (the 1940s) when the United States was recognized as both a military force and a consumerist culture, yet without much cultural capital. In other words, MoMA, as an institution, was at this time thinking about life after the devastating effects of the atomic bomb. As a result, New York proclaimed itself the defender and protector of contemporary Western culture in all its aspects (art, film, design, and so on). Indeed, it was ready to take charge of the cultured world by protecting it from the new and dangerous philistinism of the Soviet Union. The type of modern art defended by MoMA and its patrons the Rockefellers thus gradually became an important weapon in the middle of the Cold War: MoMA's building was to be a kind of temple of freedom—a temple of freedom that was, however, not accepted by large sectors of an American public still in love with premodern representations.

Franchising MoMA: A Vision for Latin America

It all started after World War II, when the president of MoMA, Nelson Rockefeller, thanks to his Latin American contacts established during the war (where he was effectively fighting fascism through the Inter-American Affairs group),[3] decided to help modernize Brazil and its culture by bringing modern art to the continent. Rockefeller was possibly the first person to understand the importance of culture for America's political penetration in foreign lands. An article in *Life* magazine dating from World War II clearly made the point that a comprehensive project of this kind in Latin America was crucial to safeguard the entire continent at such a time of conflict, despite some misunderstanding on the part of an uninformed public:

> Rockefeller's outfit has been widely ridiculed on the grounds that it represents a kind of incorporated international Mayris Chaney [a Ginger Rogers–type dancer]. For some of the ventures which occasion these rebukes, like the good will tour of official Washington's favorite movie actor, Douglas Fairbanks Jr., the coordinator's office was not primarily responsible. Others like the streams of exchange scholarships, traveling exhibits of paintings and invitations to Brazilian artists to visit the U.S., have more point than is usually apparent to the U.S. public. The fact is that pianists, painters and professors occupy in many Latin-American countries the kind of prestige accorded in the U.S. only to pugilists, dipsomaniacs or crooners… It now appears that Rockefeller has accomplished more in a year and a half than Herr Goebbels did in a decade, and his organization stands as a convincing refutation of the theory that the Germans are the only people who know how to apply politically the kind of common sense that U.S. businessmen invented.[4]

3. Ibid., pp. 87–90.
4. Ibid., pp. 80, 88–89.

Rockefeller's goal had for years been to try and develop a series of MoMA franchises all over Brazil. After the war (and the defeat of fascism), it was important to give established (and friendly) groups the cultural weapons they needed for the new war taking shape there between capitalism and Communism. But things were complicated, because the United States did not have a strong base in Catholic, predominantly Spanish-speaking Latin America. In fact, together with Spain, France was far better established there due to the historical importance of French culture. This is why Rockefeller realized the importance of introducing modern art into Brazil, a Portuguese-speaking enclave and therefore slightly different from its Spanish-speaking neighbors. This led to what might be termed the first Franco-American "misunderstanding" of the Cold War era.

In November 1946, Rockefeller was busy preparing for an important trip to Brazil in order to extol the values of the American way of life and culture. Two days before leaving, and as a kind of afterthought, he had an idea that would have important consequences. He asked his secretary and MoMA's Dorothy Miller to go on a buying spree among New York's modern galleries so he could arrive in Brazil with the latest paintings from the American cultural capital. His plan was to donate these pictures, mainly by young and upcoming artists, to the country as gifts, or rather as enticements, as an example for Brazilian collectors to follow, thereby initiating a drive in the country to buy modern and contemporary art. It was also understood that, in so doing, they would also naturally buy the entire modernist ideology of progress, youth, and "freedom." Rockefeller took ten pictures to Brazil. They were, it was stressed, all (including those done by Europeans) made in the United States, so as to emphasize the creative power of the American soil. In a letter of November 1946, MoMA even suggested to Kneese de Mello that it envisioned lending Brazil an exhibition, entitled What is Modern Painting? and prepared by Alfred Barr, that was ready for export and designed to "advertise" modern art.[5]

What the defense of modern art—even in its most radical form—meant in global terms was, in Rockefeller's mind, the liberation of the progressive spirit. This was, from early on, the drive that propelled Rockefeller. Even as late as 1949, he was still trying to convince *Life* magazine's philistine Henry Luce to lend his support to Abstract Expressionism, describing it to him as truly "free enterprise painting."[6] Seen from New York, Western culture, struggling against the potentially widespread appeal of Communism among working classes, had two paths from which to choose: modern art, signifying the embattled individual thrusting forward toward liberation in a fluid and open society, and realist art, representing predetermined aesthetic patterns and propagandistic messages in support of a monolithic and closed socialist society.

Despite this active involvement, Rockefeller was shocked to hear that a new Museum of Modern Art was actually in the process of being organized in Brazil; by of all peo-

5. See Alfred Barr, introduction to What is Modern Painting? (1943, rev. 1945, 1946, 1949, 1952, and 1956; New York: Museum of Modern Art, 1975).

6. Nelson Rockefeller to Henry Luce, March 24, 1949, Alfred Barr papers, roll 2171, Archives of American Art, Washington, D.C.

ple, Léon Degand, a Belgian art critic based in Paris who worked for the French Communist newspaper *Les Lettres Françaises*. Were it to succeed, it would bypass all his efforts over the years. Rockefeller's disappointment was short-lived, however, because this particular experience fizzled out after enormous problems plagued the experiment. Chaotic organization, cultural misunderstandings, and passive Brazilian resistance were some of the difficulties encountered by Degand, who went back, defeated, to France with all the abstract pictures he had originally brought with him to Brazil.[7] What this episode demonstrates, though, is that after the war, both France and the United States understood that high culture is an important part of international politics and that the dissemination of modern art is a sure sign not only of identity, but also of power and influence, like a kind of soft neocolonialism. That is what was at stake in this failed invasion of abstract art in Latin America.

Later on, as the Cold War intensified in the 1950s, MoMA took over the dream and managed to develop the cult of the abstract already present in Brazil, launching the São Paulo Museum of Modern Art, together with several other franchises in Rio and Belo Horizonte.[8] Until quite recently, then, MoMA in New York was closely in touch with contemporary cultural production in Latin America and elsewhere and was quite successful in presenting its own contemporary aesthetic choices and values as universal, the way Paris used to do. For the last forty years, in fact, MoMA has to a large extent had the power to define the West culturally and to articulate deeply cherished Western values in the face of Communist attacks: individualism, modernity, originality, and historical linearity.

Post–Cold War Excitement

The post–Cold War world has, to some degree, at least on the surface, led to changing roles and strategies in the large Western museums. The multiplication of cultural sites from which artists can now speak, the diversity of cultural production being seen, the competition among voices in a world that Paul Virilio calls the "Babelian supérieur,"[9] defines a cultural landscape that has been, during the last few years, unrecognizable and not easily acceptable to MoMA. But what has also been interesting lately is the effort made by this museum to reshape or redeploy itself in a desperate attempt to respond to the new situation, as it did in the past, through the renovation of spaces. In the past, MoMA always tried to portray itself as a lively place, not only in contact with the latest trends in modern life, but even more importantly, as a space where cultural history was made, where good taste was developed and even taught to children in the museum basement, as

7. See my "Dripping on the Modernist Parade: The Failed Invasion of Abstract Art in Brazil, 1947–1948," in *Patrocinio, colección y circulación de las artes*, XX Coloquio Internacional de Historia del Arte (Mexico: UNAM, 1997), pp. 807–17.

8. For a brilliant discussion of the relation between the U.S. and Latin America, and in particular Argentina, see Andrea Giunta, *Vanguardia, internacionalismo y política* (Buenos Aires: Paidós, 2001).

9. See Paul Virilio, "Le complexe des médias," in *L'Art du moteur* (Paris: Galilée, 1993), p. 35.

it had been since the 1940s. Education was always paramount in MoMA's lingo and often was seen as liberating, as providing the opportunity to experiment, to become part of the new, to understand new structural developments in the modern cultural world. Its aura was such that by the late 1960s, MoMA was actually capable of convincing the Western democracies that modernism was the essence of contemporary culture. Many called this discourse propaganda, because it tried to impose internationally a series of self-serving, essentialist ideas cooked up in midtown Manhattan. During these very turbulent political years, it especially promoted the importance of individualism versus community and the strength of American production, as well as American leadership.

In facts, thanks to its clever strategy of communication (films, books, catalogues and international diffusion), MoMA was fast becoming the arbiter of taste, the traffic controller of a flux of images circulating across the international psyche, purveying U.S. obsessions. The role played by MoMA with delight and shrewdness was in many ways one of protector of the national soul in times of drastic changes during the Cold War and the guardian of an endangered species: modernism. As a result, the museum both championed and preserved some glittering remains of a rapidly passing tradition, holding on to a type of culture that the fast-encroaching industrial and commercial world seemed to erode a little more with each passing day. MoMA's role was not only to be an example, but also a sanctuary, a kind of a Jurassic Park for art, or a zoo for disappearing styles. The museum was a resting place for struggling modern representations and a sanctified, immaculate space where tired minds could be revitalized by the celebrated, powerful new icons, connected with the great past through an umbilical cord of cold concepts. The "Modern" was the land of plenty where the new elite could find an image of themselves for a future free and rich America.[10]

However, MoMA quickly recognized that this modern world was such a vast land, and so full of dangerous misguided directions, that modern "man" needed a map to save him the embarrassment of becoming lost in this artistic Tower of Babel. This device was conveniently provided by Alfred Barr, Jr., and has become known as the famous "Barr chart," an elaborate scheme of the development of modern art movements that looked like the genealogy of a royal family of modern art, although purified of its bastards. He designed it with all the care of a general designing a battlefield map (he even first thought of it along the lines of a torpedo), or a pre-electronic system, with all the connections established in order to create clean paths through a mountain of rejects, aborted experiments, deliquescent solutions, or politically incorrect trends. For a long time in the United States, this map served as a kind of intellectual crutch: Nobody could experience the museum without it. Barr held the Ariadne thread: He was the guide *maximus*. Yet this aesthetic stubbornness, which for so long was seen as a sign of visionary know-how, ultimately came to be regarded as a nostalgic *arrière-garde*, a kind of defensive battle to regain or protect

10. See the important study by Frances Stonor Saunders, *Who Paid the Piper? The CIA and the Cultural Cold War* (London: Granta, 1999).

old turf that was increasingly regarded as irrelevant in the 1990s, even if still gorgeous, like so many discarded relics in a flea market. The modern had become classic, the sacred transformed into curios. This is not to say that MoMA was ever really anticlassical or really defending angry young artists in their desire to destabilize the status quo. In fact, its strategy had always been the reverse, that is, to defuse calls for disruption or subversive elements, transforming rage into poetry, revolution into resolution. That was exactly the point Pablo Picasso had already made in 1948 when, to the dismay of Alfred Barr, Jr., the Spanish painter refused to sign a petition prepared by MoMA that insisted, contrary to the diatribe launched by right-wing U.S. demagogues such as Senator George A. Dondero of Michigan, that modern art was not subversive, but merely enlightening. Picasso, his wife Françoise Gilot later recalled, could not agree with what to his mind was such a castrating statement. Instead, he had to agree, in a very ironic way of course, with Dondero, thus proving that he was, indeed, subversive and dangerous. That was his only role and purpose in life.[11]

Thus the role of MoMA had been to support without question the Manichean Cold War world: a clear, clean world, a phantasmagoria world of styles and forms in touch with the internal history of ideas, but with a pathological fear of direct and visible involvement with the social and political affairs of the moment. I use the expression "fear of direct and *visible* connection" because what is fascinating about the history of MoMA is just how much the museum was involved, often courageously, with the affairs of the world, promoting, it is true, only certain views, a certain understanding of the world, a view closely connected with its own interests, not specifically as a museum, but as a representative of a daring and liberal entrepreneurial class in contradistinction to older, more traditional institutions like the Metropolitan Museum, with which it was, for a long time, competing for endowment dollars.

In the eyes of MoMA, detachment from the everyday was the condition for quality culture or an elevated status, despite the often contrary positions elaborated by artists themselves, including its heroes like Pablo Picasso, Clyfford Still, Jackson Pollock, and Mark Rothko. This idea of the severance between modern culture and the everyday was crucial to maintain. Modern art, so the discourse went, was above the everyday, yet in its deepest sense it was to epitomize all that was most trenchant in modern culture. MoMA was trying to isolate and promote a positive culture of energy, freedom, modernity, force, and clarity: a modern art for a modern age, an optimistic, individualistic culture in touch with the "real American soul." That is why Rockefeller, already in 1946 as we have seen, tried, with mixed results, to encourage Brazilians to create Museums of Modern Art in

11. Françoise Gilot and Carlton Lake, *Life with Picasso* (New York: McGraw-Hill, 1964), p. 197. Here is Picasso commenting on Alfred Barr's telegram: "The point is, art is something subversive. It's something that should *not* be free. Art and liberty, like the fire of Prometheus, are things one must steal, to be used against the established order. Once art becomes official and open to everyone, then it becomes the new academicism. . . . How can I support an idea like that? If art is ever given the keys to the city, it will be because it's been so watered down, rendered so impotent, that it's not worth fighting for."

São Paulo, Rio, and Belo Horizonte, duplicating MoMA's in order to jump-start Brazil into a sense of economic modernity and free-enterprise energy.

Modern art, then, was seen as one of the most precious allies of enlightened entrepreneurs. Brazil and Argentina, thanks to these efforts, subsequently embarked on ambitious programs of International Biennales geared toward the presentation of abstract art. MoMA understood the importance of Modern Museums for the creation of alliances between elite groups in the Western Hemisphere and started a large international program (financed by the Rockefeller brothers' fund) devoted to the defense and promulgation of not only modern art, but also of U.S. cultural production in Europe, India, and Latin America. Modern art, an important sign of individualism, creativity, and freedom, was rushing like brushfire all around the world to fight Communism (a traditional and powerful myth still at work today in certain circles.) Consequently, through to the end of the twentieth century, MoMA stood as an emblem of free Western creativity, like another version of the Statue of Liberty.

The Modern in Crisis and the Collapse of Certitudes

In 1997, confronted with a so-called "postmodern" situation advocating many of the very positions MoMA had fought against for so long, it decided to respond to an aesthetic offensive that was getting out of its regulating hands. For so many years its role had been to protect the boundaries of what was then considered modern culture and its icons, but in the 1990s, the institution was reacting to the apparent total disintegration and disaffection not only of modern form, but also of the modern paradigm. The local, the personal, and the political were replacing the universal community. How would MoMA respond to the enormous pressure and output from antimodern or nonmodern productions in both high art as well as popular culture? How would MoMA react when the illusion of harmony and universal understanding on which its ideology had been based was being defeated by a general realization that cherished canons had imploded? The fragmentation of discourses and anarchic explosion of voices became the dominant manner through which to participate in a culture profoundly decentered and multifaceted, a culture totally alien to the modern museum.

MoMA's reply to this change has been strange and particularly amusing in its protective response: Today, under a cool project devised by a cool architect, MoMA is recycling its past. Realizing this decline in auratic power at a time when its very name triggers images of linear and repressive thinking, MoMA has reacted by retracting itself into its shell, into its glorious past. Yet this is a retraction has been paradoxically represented physically by a beautiful and dignified "extension," which ultimately was not so much an extension as a form of retention.

Faced with this new crisis (for the institution), MoMA's first reaction was a classical one: to build another wing in order somehow to signal life and simultaneously to try to contain some of what did not actually conceptually fit into the original building. The Modern extends its wings (so to speak) so as to reach out and try to present new types of

visual production often at odds with MoMA's own historical interests. However, this seems to be a reaching out that operates more as a suffocating embrace than as a liberating accolade. This strategy, a way to protect the museum's history, displays and controls, what, in fact, has always been anathema to the institution. It's a way for MoMA to digest what has been for so long unacceptable, but what has painfully become so overtly present in the 1990s. Postmodern art in its diversity and irony was difficult to accept but not to integrate. Nevertheless, despite this cosmetic move, nothing has really changed in the institution.

The contemporary today (meaning, the heterogeneous) is cleverly included in small exhibitions featuring popular young artists in order to give the illusion that the museum is still alive and kicking while, in fact, it is only vibrating with a kind of Brownian movement, prolonging the fantasy that it is breathing the *air du temps*. In fact, it reacts now only to artificial and automatic stimuli and reflexes. This mechanism of survival is the reason given by the trustees for the construction of the new wing. Indeed, the new building program is being carried out in order, as the text on the MoMA Web site makes clear, for it to be a "dignified" space, meaning I suppose, a site where the architecture provides a space where the onslaught of contemporary productions (not only modern masterpieces anymore) are controlled, nicely profiled, well behaved, and dignified, rather than Disneyfied.

For MoMA, being a "dignified" place is the only way the museum can still believe in the illusion of detachment from a consumerist culture oozing everywhere even under the tightness of a gorgeous skin (like an *X Files* virus), as one can witness by visiting the bazaar of the new Louvre in Paris, where one passes without really realizing, from the well-designed space of retail to the similarly well-presented space of cultural heritage and masterpieces. MoMA's project uses a dignified architecture whose role could be perceived as that of an overarching thick blanket, deafening the cacophonous sounds of the everyday and the contemporaneous blaring outside, but also smothering it, a difficult thing to do when one is confronted everywhere with a contemporary culture that mixes genres. Consuming art, culture, and products has now become an unproblematic effect of postmodern living. In Madrid, for example, contemporaneity means that museums and shopping malls have the strange habit of looking furiously alike and, indeed, are advertised in similar ways in tourist pamphlets.

MoMA, with its new extension responding to this new situation, is caught in a double bind. It needs and wants to react to the present cultural situation, but its built-in reaction is too closely linked to its previous practice, used before the explosion and diversification of the art world. Today, in a world that has embraced globalism, it is problematic, to say the least, to build new borders, frames, extensions, or whatever the word or concept might be. Today, when emptied factories are recycled as museums of contemporary creations, when entire cities are transformed into artworks, it seems clear that it will be impossible for the MoMA extension to work, to respond adequately to this new situation, or to satisfy anyone but those already under the academic spell of MoMA's modernism.

Under globalization, MoMA, like many other organizations, has tried to extend itself, but cannot reach far enough. The new building chosen (designed by the Japanese architect Yoshio Taniguchi, thereby proving the international vocation of MoMA) only reconfigures the past by cleaning it yet again. The new wing's role in this version is actually protecting the original space, returning it to its origins, framing it by embracing itself, so to speak. Famous structures of the past, from 1939 onward (those of Philip L. Goodwin and Edward Durell Stone and Philip Johnson) are thus protected and reconfigured in an ever-growing unit. This layered architecture of MoMA in the center of Manhattan fittingly recalls the similar piling up of diverse historical structures, one on top of the other, in a recently unearthed ancient temple site in the center of Mexico City. There, each historical building, each level, is protected by a larger covering structure that preserves past, useless, but sacred constructions, extending out from the original sacred temple located at the heart of the large, overbuilt complex and on into the contemporary period. MoMA as a sacred, self-protective temple is a fitting metaphor for such a disappearing power.

Neo-Imperialism and Tourism

Other American institutions under similar strain have understood that in the new open cultural space, museums have become corporations in the business of profitable tourist attractions, with the added bonus of providing national propaganda Their enormous collections (and accumulated cultural power) are lent to outposts in a culturally hungry and tourist-hungry world. Like fast-food corporations, in order to profit, museums need many satellites and franchises to invade "empty" national and international cultural spaces, in SoHo, Berlin, Bilbao, and so on. As a result, when will we start to talk about cultural obesity, I wonder?

The Guggenheim Museum, despite outcries, has succeeded in making its passage into the twenty-first century with a clearer understanding of the logic of hypercapitalism, in a world where the United States, despite its many weaknesses, has become the unopposed world power. In this context, the Guggenheim has understood something that MoMA has not been able to grasp: Today, brashness is not only acceptable, it is actually demanded. It is understood that it pays auratic dividends to build a franchise in other lands, to show not only that your own culture is universal and hegemonic, but also that your foreign implantation helps the economy of other, weaker countries through cultural tourism: a kind of new royal and international charity, to give "culture" on a titanium platter, for the pleasure and curiosity of travelers who can stop and marvel at the extraordinary architecture on their way to the other famous mystic shrine: Santiago de Compostela.

To expand abroad, in a kind of ironic outsourcing (presenting the Guggenheim's American art collections) is the contemporary way of using culture as a complement of international policy. MoMA on the other hand, preferred to stay home and bring the tourists onto its site through the Dorset Hotel built on its doorstep. The New World colonizing the old one could be a good metaphor for this process, if it was not again so savagely and arrogantly done. Like Disneyland propagating its own particular "Destroy"

brand (as the French say) all over the place, high art is now used as the flip side of Hollywood films.

And so it goes, a kind of remake of the Cold War period but with a twist. All those surreptitious strategies carried out in the 1940s by MoMA to try to influence the West's notion of itself by launching copies of their own museum structure in Latin America are all now obsolete. One does not, as was the case during the Cold War, use foreign capitalist institutions to infiltrate the country. Today, we use the Trojan horse system: One simply parachutes into Spain a factory, keys in hand—or rather, a museum with "everything in it." The Bilbao Guggenheim is the first potlatch-cum-museum, a museum that functions like a momentous gift, but a gift so huge that it can never be repaid in similar terms. The gift here functions as a paternalistic universalism that becomes, for this simple reason, an important factor in the subjugation of local cultures and their "processing"—in the sense of processed cheese—into a bland global cultural production. The payback comes, of course, not only in cash, but also through admiration of the donor's way of life and its capacity to gather such a large amount of symbolic power. To be on the tourist map is now enough to bring smiles to the faces of city administrators with short memories.

What the Guggenheim has also understood is that the packaging of an artistic institution is crucial. In New York, Frank Lloyd Wright's museum was at its inception an eye-catcher, part castle/fortress and part fairytale construction. But by the 1990s, the usefulness of the construction was superseded by the need to escape the city and go international. Remember when one visited the museum's collection in New York? One would go along the ramp, stopping in front of pictures detailing the rise of modernism, like so many relics in the Chartres ambulatory, and reach the top of the edifice in an almost aesthetic orgasm with the Abstract Expressionist painters gathered under the beautiful glass ceiling. The thrust of the ascension in the late 1990s could not stop there and, like Paul Klee's angel of the apocalypse, one was sucked in and thrown out far away in the wide world, to Bilbao, to the ruins of industrialization, ready to be recycled into a tourist Mecca.

The Guggenheim Museum in Bilbao was, then, a powerful metaphor for the way to do cultural business in the late 1990s, of how to function in the new global economy. Recycling the hegemonic ideas provided in the 1950s and 1960s by MoMA to an American public eager to see its accession to the international/universal art world, the Guggenheim at the end of the twentieth century tried to export its downtown New York culture, like cars or fashion, all around the world. People had to be informed, up to date, aware, retrained, recycled intellectually, and good looking, like an Armani mannequin.

That's one of the roles of the Bilbao museum. The cultural plant (the entire idea is copied from contemporary industrial practice) is transported in foreign lands. Museum branches are scattered through Europe in the way Leo Castelli dreamed of doing in 1964, at the height of U.S. optimism, with his string of private galleries around Europe. The small individual entrepreneurial strategy represented by Castelli has today been replaced

by the powerful institution of the museum, an institution projecting to the public a potent aura of truthfulness, rather than being just a crude business enterprise.

Copying and mixing both strategies, the museum's sacral and serious nature and the brashness and daringness of the private gallery, the Guggenheim offers and imposes on foreign lands a modern culture specifically designed in the pages of U.S. catalogues and magazines. It's the same old movie, the same rerun, the same plot used by MoMA in the 1950s, but the image has been enhanced, colored by the spirit of enterprise. As happened during the Marshall Plan era in the 1940s and 1950s, the host government is asking for it, so to speak. Bilbao facilitates, for local, internal reasons, the installation of U.S. cultural production on its walls. If in 1950s Paris it was the desire of the French establishment to combat Communism that made this alliance crucial and viable, today it's the lure of economic help, and the danger of ETA, that pushes Bilbao to deal with the Guggenheim.

On the other hand, if in the 1950s the cultural terrain was the prime place for ideological battles against Communism, today, such a move by U.S. culture has to be seen in relationship to the new world order in which Europe has become an open field where competition can develop without fear of internal Communist Party alliances. The battle for the mind of Europe at the turn of the century was open, but it was a tough one. The Guggenheim Museum in Bilbao seemed to have been a first, beautiful salvo. This battle has already pitted against each other two very different types of societies, represented by their cultural productions (film, literature, and art). But the intense debate in Europe about ways to minimize this "Americanization/modernization" (also known as "Californication," following the famous hit by the Red Hot Chili Peppers), an Americanization that functions like a Trojan horse or, rather, like those containers filmed by Spielberg in *The Empire of the Sun*. In this film, freedom comes to the embattled, starving prisoners in a Japanese military camp from the sky in the form of parachuted containers crashing onto the ground in front of their wide eyes. These boxes, splitting on impact, open up and bleed out their luxurious contents, made up of a glorious amount of consumerist goods, cookies, candy, cereal boxes, Coca-Cola, paper towels, and so on, a beautiful Pop Art–like fireworks of U.S. commodities. At the Guggenheim, Minimal Art is parachuted in, but for maximum impact, as well.

Post-9/11 Guggenheim Bilbao

The Bilbao Guggenheim symbolizes the pre 9/11 world, a world still following the old schema, where the art world had been happily and savagely "deterritorialized," opened up, hybridized, decentered, decolonized, and diversified in order to offer a wide array of possibilities, where "flexibility" had become the word of choice for this new, redesigned planet in which the contemporary art world had, in fact, become a kind of gigantic aesthetic supermarket. The art world, through its many institutions has given us a wide variety of products (as art criticism demonstrates), many with new and improved exotic flavors. But what we often get is an art that is calibrated, even in its excesses, an art for all seasons, the way our Western markets manage to give us tasteless strawberries all year long. Art

is everywhere, emanating from all four corners of the globe and creating an international rainbow of tastes and looks giving us lots of good feelings. This, I am sure, is felt as a great thing to those many artists who now have a chance at an exposure they could never have dreamed of before. This idyllic image seems to be quite interesting until it becomes clear that such dissemination often becomes another form of dictatorship through sameness, paradoxically leveling all differences, processing peripheral products through the same but refocused centralized gaze. Faced with this situation of excess, of global supermarketing, one can already see the appearance of something one could call "Boutique art," a type of art production detached from the mass market, but also different from the old avant-garde strategies. This time, boutique art, having lost any sense of critical utopia, targets very specific constituencies through depoliticized but, I am afraid, often cynical productions.

It is true that the fall of the Berlin Wall and the end of the Cold War syndrome has opened up the world to the exchange and journey of ideas, products, and art, spawning a series of optimistic pronouncements about what are in the end demagogic possibilities of universal communication and "reconciliation." Nevertheless, this mobility or fluidity is never disconnected from the diversity of economic and social realities. The proliferation of international biennales around the world might be taken as a sign of this positive global transformation, but this phenomenon, I feel, is a mixed blessing. This proliferation can herald the participation of a usually excluded country in the concert of nations. Sometimes this can be a strong signal, such as that sent out by the Johannesburg Biennale after apartheid. Yet simultaneously, such proliferation can also announce the loss of specific identities or the erasing of particularity in order to have a share in coveted international capitalist/Western "contemporary" values. Biennales are rapidly becoming like supermarkets, window dressing for subaltern cultures unable to produce a healthy and powerful day-to-day art market. Biennales have become the last, ultimate space where, as in the Olympics, a community or culture can show off its production and have the illusion of full international participation while, in fact, often only providing products fitting international patterns. Biennales have become processes of entering into the dominant fold, consciously hoping to fit neatly into international demands, as well as into international cultural tourism. There is no denying that they provide a much-needed platform for exchange, but this is bestowed at a price.

This new fluidity, this free exchange of ideas between cities, this incessant traveling by artists and curators, is part of a race whose purpose is to offer new possibilities to artists and intellectuals who are usually locked up in their decentered places. To be out of place today (on the margin, hybrid, and so on) is often considered "in."

The price to pay for this is the illusion that centers do not exist anymore, that the world is one, where exchange is encouraged, open, and rewarded. It is true that central institutions have changed their strategies and certainly are visibly less arrogant. They have become suave and well mannered, but they are still able to determine choices, maybe even more so than before, due to their technological retooling. In fact, financial and edi-

torial power is still managed by the same few First World centers. They still possess the all-powerful system of distribution—art magazines, criticism, newspapers and TV. They produce the word, the text without which the "art" does not really exist, is not visible or seen. What has changed is that centers now also have antennas everywhere, searching for new products. The Guggenheim Museum, the best example of this trend, is using its artistic and auratic surplus to reach the world outside New York in a kind of artistic blitzkrieg.

In the last few years, it has been popular to talk about resistance, about modes of displacement able to mount a counterattack against these trends. Again, the integration of the other in a global system, an integration that has been successfully, if paternalistically, achieved is not at issue here. What still is, however, is the possibility of constructing a structure, a way of saying, in which artists can develop critical attitudes in front of such a monumental leveling machine. If it seems that the inside/outside dichotomy has been resolved, it is only an appearance or a wish by some who would like to see the colonial or neocolonial problem resolved or forgotten. In fact, those differences still exist, with maybe even more presence and force, in the art world. Isn't it time to make visible, to insist on differences among all those people flying around, moving without apparent reason in the postmodern fluidity? Isn't it time to differentiate between the salesperson of art and the political and cultural art critic? Isn't it time to be able to discover differences between the tourist, the art *flâneurs*, and those nomads described and theorized by Deleuze and Guatarri? In the midst of all those travelers exist people who actually do not get fixed by a type of system well trained to control immigrants, but uneasy when confronted with an unpredictable nomad. The nomad is constantly shifting gears to appear in different unexpected places in order to produce local actions with locals on local borders where microcultures can be destabilized or reempowered. The word itself calls up images of colonial spaces, of uncontrollable behavior, mobility, and wicked smartness. Nomads also, like gypsies, have an image, and the Situationists have insisted on this, which announces a deliberate incursion of nature into the fabric of urbanity. It implies a lack of civility, an unruly conduct made to derail the new systematization. It is true that this metaphor carries with it some colonial concepts, anxieties, and Romantic images, but at the same time, it brings the unconquerable into the heart of stable and secured modern urbanity.

This concept of nomadism still seems to be feasible when one realizes that postmodern theories have already been institutionalized in art schools and transformed into slick intellectual advertising come-ons. In a recent article, Elizabeth Legge asks if theory has not become "a paradoxically instrumental, shallow-making, and formulaic component of the art, rather than a truly corrosive critique. Does theory provoke the playfully pernicious hybridity envisioned by Homi Bhabha, or, as Aijaz Ahmad has more skeptically argued, does it instead become a 'marketplace of ideas' in which to shop."[12] Shop yes, but let's not

12. Elizabeth Legge, "Reinventing Derivation: Roles, Stereotypes, and 'young British art'," *Representations* 71 (Summer 2000): 1–23.

do it like Duchamp or the Surrealists, at the flea market. Today, let's do it at a select boutique. Today, it is understood that commerce, fashion, and art are all symbiotically intermeshed. The Guggenheim had a museum in Las Vegas, Prada has a museum-cum-space in Milan and New York. Koolhaas, the trendy architect, announces that, "shopping used to be an autonomous entity with its own metabolism. But over the past twenty years it has infiltrated almost every other activity known to man. Airports, churches, universities—it has become impossible to disentangle and separate the fate of these entities from shopping. They support each other, and you don't know where one ends and the other begins." And Germano Celant, Prada's curator adds: "In the end, it all fits together: art, fashion, architecture, design—even shopping. It's all theatre, really. A modern spectacle for a modern world."[13] So let's go shopping and be merry.

Much like old-fashioned colonialism, although this time using a feather rather than with a stick, international museums such as MoMA and the Guggenheim have been framing their discourses with ideas of freedom, decentering and talking to the masses with blockbuster, mindless presentations—the Cézannes, the motorcycles, and the Armani clothing. Recently, a famous European curator was advertising an exhibition by saying that all she wanted to do was produce a beautiful show, so beautiful that it would "knock our socks off." Personally, I've had my socks knocked off so many times lately that I have now got cold feet about all those flashy and often empty displays. Looking of late at several failures of the global adventures of the Guggenheim concept and system in the world, one has to wonder if again this institution is not right on top of the situation, acting as a litmus test for new times. In the last few years, the Guggenheim seems to have run out of steam, closing one project after another, its outreach shrinking while exploding trains endanger world tourism. When one realizes that the franchise notion itself is in trouble, having obviously been kidnapped by al-Qaeda, one wonders if the Bilbao concept is not going the way of the famous Edsel car—a great idea at the wrong time, and subsequently laid to rest. Under violent international pressures, is the beautiful and sensual Guggenheim in Bilbao, like the Edsel, ready to be put to sleep and fade from our memory? Well, don't worry, *Sleeping in Bilbao* is also a very good title for a Hollywood film.

13. Koolhaas and Celant are cited in Patricia Bickers "Marriage a la Mode," *Art Monthly* 261 (November 2002): 1–4.

Desiring Bilbao: The Krensification of the Museum and Its Discontents

JOSEBA ZULAIKA

Let me start with a confession. I was one of the critics who chronicled the glaring ironies and asymmetries of the initial deal between New York and Bilbao.[1] The criticism was largely prior to the creation of Gehry's architectural landmark and its stunning success in revitalizing Bilbao. Later I had to reconcile my initial criticisms, which I still maintain, with the larger picture of the museum's epoch-making transformation of a postindustrial city. While celebrating the transformational power of architecture among ruins, I felt as if I were suffering what is known as the Stockholm syndrome—the captive who in order to survive ends up believing in the cause and goodness of his own kidnappers. Writing about Bilbao forces me, therefore, to confront not only my own ambivalences, but the many complexities, uncertainties, dilemmas, and even scandals of a franchised museum.

I am going to focus on the transformation of the museum as an institution as the result of director Thomas Krens's Bilbao experiment. I am coining the term "Krensification" to describe its historical novelty. Without further ado, let me sum up its key defining tenets. A Krensified museum is: *1) a franchised, global institution; 2) that relies on the politics of seduction and gambling; 3) while taking advantage of the dynamics of gentrification and emblematic architecture among ruins; 4) by skillfully using the media to produce spectacular images and tourists' desires; 5) driven by blockbuster exhibits that require more than simply art; 6) while provoking strong reactions from the art world of the host city; 7) following a politics of building promoted by local politicians; 8) which translates to the museum New York's culture of the auction houses as well as Wall Street's cycle of boom and bust.*

1) Franchised Asymmetries in the Name of Globalization

"Bilbao? Are you crazy?" This was Krens's reply when he was first told about the city's interest in a Guggenheim. He was at the time looking for a European capital for his muse-

1. Joseba Zulaika, *Crónica de una seducción: El museo Guggenheim Bilbao* (Madrid: Nerea, 1997).

um's modernist collections. After several failed attempts in Europe and later in Spain, Krens was told of Bilbao as a possibility. He laid down a precondition that took by surprise his own advisors: There should be $20 million on the table as a prepayment before he considered Bilbao. The initial fee was a minor part in the overall scheme, but one whose symbolism nobody could miss. It was the franchise fee. It was a first in museum history. Krens himself had not brought up such a demand in previous negotiations with other European cities. The franchise fee signaled the complete programmatic and conceptual dependence of Bilbao on New York. The very name of the new museum, "Guggenheim Bilbao," was a recognition of the artistic identity and the location of the new transnational hybrid.

Krens visited Bilbao in April 1991. He demanded absolute secrecy and the signing of an agreement by the end of the year. Any rumor that a deal with the Guggenheim Museum was being cooked up was steadfastly denied by Basque officials, even when the *New York Times* had reported on October 2 (the day that a secret preliminary agreement had been signed in New York by both sides) that the negotiations were down to the final details. So imperative was the need for secrecy imposed by Krens on his Basque nationalist counterparts that not even their regional government partners, the Socialists, knew about it. When it was signed on December 13 of that year, the public had not been told until the last minute, thus preempting any discussion of the project. The following week, the Basque Parliament asked for a copy of the agreement to find out what had been signed. Never mind that, according to estimates at the time, the project was going to require 80 percent of the Basque funding for all museums indefinitely into the future.

Although the locals had been wisely kept in the dark, there was, however, the presence of international players during the signing, particularly the Italian minister of foreign affairs, Gianni de Michelis, who acted as the master of ceremonies. What had happened was that by November, Krens had realized that the Basques were still wavering and that "out of despair" he had to call his Italian friend to save the entire project. When I interviewed de Michelis about his meddling in Bilbao's affairs, he summed up by raising one hand while saying "the Guggenheim" and lowering the other, while pronouncing "Bilbao." That was the relationship between them. There was not much to add—except perhaps to say a word about de Michelis himself. He was at the time second only to Bettino Craxi in the Italian Socialist Party and, besides being Krens's soul mate in a passion for grandiose intercontinental cultural projects and the most committed European politician in favor of cultural "globalization," a few weeks later would make international news for being at the center of an Italian political scandal, ultimately being charged on eighteen counts of corruption. As a final note, it was a Friday the thirteenth and the day of Saint Lucy, the third-century virgin and martyr who, according to legend, had offered her beautiful eyes on a tray to a suitor who was in love with them, a perfect allegory for Basques telling Krens: "Please, lover, take our eyes. See for us. Show us the world of art and museums." During the solemn signing ceremony, de Michelis gave a speech likening the Bilbao agreement to a cultural equivalent of the military organization NATO.

Thus, at the outset, the most salient feature of Krens's Bilbao model was the systematic way in which he exercised strategic and intellectual control of the entire operation. The premise that the host city pays all the bills while the Guggenheim runs the show is but one aspect of the asymmetrical relationship. One only has to read the secret "Constitution" to get a sense of the agreed-upon imbalance: Bilbao's obligations include the reimbursement to the New York Guggenheim "for all internal and external costs and expenses incurred by SRGF in connection with the preparation of this Agreement and the performance of its obligations hereunder." Regarding the Guggenheim, it states: "As operator of the Museum, SRGF shall have the exclusive right to determine the planning, development and operating policy, standards of operation, content and art programming and all other matters affecting the management and operation of the Museum." It is simply the "one hand up and the other hand down" logic of Krensification described by de Michelis. "The Basques are coming to eat from my hand. I can't believe it!" Krens bragged to his staff. It summed up his total control of the situation. Welcome to the global politics of culture.

Central to such politics is that such conspicuous asymmetries take place under the cloak of "democracy" in action. What from the local viewpoint is perceived as a mockery of democracy, from the global perspective is international cooperation. An exhibit of Gehry's works at the Guggenheim emphasizing Bilbao was, for example, entitled Gehry's Vision of Renovating Democracy. In the Basque case, wasn't it all governed after all by a solemn agreement that Krens labeled "The Constitution"? For one thing, this so-called "constitutional" text had an built-in clause of secrecy. After the signing, when more than four hundred Basque artists and intellectuals presented a letter protesting the deal and requesting a copy for public scrutiny, it was refused on the grounds that it would violate the clause of secrecy. In other words, the "Constitution" was fully binding, but secret. The Basque public of 2.2 million that, with a 25 percent unemployment rate at the time, was financing the project to the tune of $100 per person, was not allowed to read it.

But what is most remarkable here is not some sinister imperial ploy plotted from New York. It is rather the willingness of the hand below cheerfully to accept what the hand above will decide for it. Intellectually and artistically this might be disastrous, but commercially it made perfect sense. The worldwide echoes of Bilbao's resurrection proved Bilbao officials right. It was shrewd of them to accept Krens's mandated asymmetries in exchange for access to the international artistic community centered in New York while hoping that this would be a preamble of access to Wall Street. At the other end of the deal, the striking thing was that the financially strapped New York museum, unable to pay the bills of its expansion and restoration, needed for its survival a city as desperate as postindustrial Bilbao. New York, in fact, depended on Bilbao as much as Bilbao did of New York. Both ends needed each other under the banner of globalization, but the museum could materialize only under a structure in which, amid such a shining partnership, one side took full control while the other willingly accepted franchised dependence.

The franchising of the museum comes in the end to a quantum leap in conceptual and symbolic terms. Krens's historic novelty signals the era in which a New York museum director is also in charge of a branch four thousand miles away on the other side of the Atlantic. It means that architectural designs, museum programs, art exhibits, art purchases, and the entire management of museums can be Manhattanized, McDonaldized, and marketed across the world from New York.

2) The Politics of Seduction and Gambling

It was already midnight, and a euphoric Krens had drawn out for me the history of how he had coaxed the Basques into signing a deal with him. With empty wine bottles and leftover sushi scattered over the large oval mahogany table at his Fifth Avenue office, at one point he summed it all up with the confessional sincerity of a lover: "Seduction: that's my business. I am a professional *séducteur*. I don't earn money, but I raise it, and I do it by seduction. I make people give me gifts of twenty million dollars [Bilbao's franchise fee]. Seduction consists in that people want what you want without you asking for it. It is a transference of desire. I am in a way the greatest prostitute in the world."

Krens's primary self-definition as a "*séducteur*" was not a mere *boutade*, a witticism. In one of his rare texts, he wrote of "the most vital function that a museum can provide: which is its capacity to give space to seduction by incongruity."[2] Seduction is about promises, language, self-referentiality, belief, temporality, challenge, and power. The asymmetrical relationship of a Krensified museum gets structured in a way that systematically allows one part to control and if necessary manipulate to its advantage the very terms of the relationship. Crucial aspects of such dependence consist in having to rely on such intangibles as belief and trust, in shouldering one-sidedly the economic risks of the project, or in being forced to accept tastes and definitions regarding art and culture.

The seducer's basic statement is one of promising. Don Juan is the literary embodiment of the perversion of seductive promising. He uses language performatively not in order to know or inform but to *do,* not as a field of knowledge, but as a field of enjoyment.[3] All the seducer is doing is play on the self-referential property of language and, even if he has no intention of keeping his promises, strictly speaking, he is not lying, either. In Krens's words, it is a matter of making others desire what you want them to desire. In short, the skilled seducer creates the demand, surreptitiously, for the product that he will then supply. What Krens effectively promised Bilbao officials was, besides access to New York's glamour and the stock market, to make them partners in his global adventure.

The seducer requires a believer. Soon a discourse unabashedly requesting "faith" from the citizens and the necessity for bold approaches and risky challenges became commonplace among Bilbao's editorialists. "It is like playing in a casino," the municipal official

2. Thomas Krens, "Museums and History: The Dynamics of Culture in a Postmodern Era," in *The Guggenheim Museum Salzburg: A Project by Hans Hollein* (New York: Guggenheim Foundation, 1990), p. 56.

3. Soshana Felman, *The Literary Speech Act* (Cornell: Cornell University Press, 1983), p. 27.

in charge of Bilbao's urban planning conceded to me. A mythical "future" demanded faith, risk taking, and any sacrifice in the present.

A key aspect of Krens's politics of financial seduction consisted in playing at New York's auction houses with Basque taxpayers' money. This required a simple redefinition of money that comes close to the gambler's, whose central premise is the utter disregard for the reality of money. Whether you win or lose, money per se doesn't count. It is just a way of keeping score, a mere ticket for performance, fun, and pleasure. Thus, the money spent in gambling, playing the lottery, bidding at an auction, or investing in the stock market is never really "expensive." The very idea of "cost" was ridiculed by the Bilbao promoters of the museum. The expenses were rather a "strategic investment," never a "subsidy." Subsidies were those funds expended on local culture, which now required a "catharsis." "Money is not important," Krens told me. "The important thing is that now we know that transnational museums are viable," he added. What he had done was to create a new patent, invent a new museum.

Adorno observed at one point that the curse of casinos and museums is that they can never lose. Krens is intent in replacing the analogy between the two institutions by substituting a new type of museum in which the casino rationality becomes the dominant one, but with a clever switch that makes it perfect for him: You take care of the money, the belief, and the risk from home, while I place the bets and enjoy the ride where the action is. Thus, the final purpose of the Krensified museum is to remove any risk of a loss and to certify a win-win situation where it really matters, in New York.

Yet the trick is that the other side comes out a winner, as well. This is where seduction's semantics of promise, belief, and desire play the crucial role. The ordinary premises of a merely economic transaction are replaced by others that are closer to what anthropologists call systems of symbolic exchange. A favorite example is the ritual potlatch, consisting of a long ceremonial process in which various individuals engage in the competitive destruction of their possessions. The catch is that the more you waste, the more prestige and power you earn. Here the symbolic economy is maybe as significant as the actual economy. Embracing a similar logic, Bilbao, in its strategic planning of the mid-1990s, devoted as much money to the symbolic economy of the Guggenheim as to the expansion and renovation of its harbor, still considered its main economic artery. It was a shrewd decision that soon paid off.

This did not entail, however, that Krens would be content with the mere token money of the gambler or the symbolic benefits of the believer. He demanded real money, and really soon. You go with belief and ritual, he was de facto telling the Basques. I will take the money to the New York museum and the city's auction houses. The point to underscore is not merely that money has become the driving force, even the central idea, behind art and architecture. What the Krensification of the museum shows is the central role of the global politics of seduction in creating basic power asymmetries by means of providing the semantic redefinitions of what value, art, and money are in the dominant postmodern culture.

The beauty of this culture of global seduction, as illustrated by Bilbao, is the accommodation it can provide by simultaneously promising hard cash to one partner and symbolic cash to the other, allegedly turning both sides into winners. This politics of cultural and financial seduction permeated by the psychology of the auction house, at the nexus between the museum and a casino, history and belief, aesthetics and gambling, is a key dimension to the success of the Krensification of the museum.

3) The Logic of Gentrification: Architecture among Ruins

If the Krensified museum was going to experiment with Bilbao as a casino, the good news was that Krens and the Basques had hit the jackpot. The entire world could hear the ring-ding-ding of the slot machine. The jackpot was, of course, Gehry's much extolled masterpiece in the abandoned docks on the Nervión river's ruined left bank. And the merit for bringing him was almost exclusively Krens's.

Gehry and his building were not per se a condition for Krens's grand scheme of an intercontinental institution. Still, the building reveals a key component in the Krensification of the museum—the adoption of the logic of gentrification. This logic, put simply, establishes that ruination is a precondition for reinvestment and that the potential value is measured by what the experts call the "rent gap"—the gap between the actual values of land and property compared with their future values after gentrification. Thus, ruination (of obsolete technologies, neighborhoods, factories, buildings, cultures, and so on) becomes a requisite for further reinvestment and renewal. This has always been a significant aspect of capitalist progress, only accentuated by its latest postindustrial phase in cities such as Bilbao. The way Krens incorporated this logic was by stumbling upon a city in which the gap between present ruin and future glory would be at the maximum. Had he established his grand franchise in Venice, Vienna, Madrid, Paris, or New York—all of them much coveted by him—the gap between ruin and glory could not have been nearly the same.

Bilbao is fabulously rich in ruins. The reason is simple: The heavy iron and steel industries over the ten-mile strip of the left bank of the river, the magnet of Bilbao's economic miracle for over a century, became obsolete and had to be closed down in the 1980s. The famed blast furnaces, or Altos Hornos, enormous steel structures of complex architecture, the pride of the entire industry, were suddenly rusty phantoms soaring within the ruined landscape, bespeaking desertion and drama for the tens of thousands of families that were supported by them. When Krens was knocking at the doors of Bilbao's treasury, in the municipal area of Bilbao alone, a small section of the left bank, there were fifty-two industrial ruins that occupied forty-eight hectares of land when I did my fieldwork in the late 1990s. The next town of Baracaldo on the same strip had another twenty-five industrial ruins occupying 100 hectares. In the next one, Sestao, one-third of its entire soil was occupied by sheer industrial ruins. And so on. The Benjaminian view of history as a process of decay and ruin could hardly find a more startling site.

Not only were the factories in ruins, but the cheap urban constructions built next to them were also derelict. Bilbao's urban network and communication infrastructures were

sorely in need of repairs and expansion. Finally, the demographic decline was about 20 percent between 1975 and 1995.

When in the late 1980s Krens was looking for a grand European capital for his flashy museum, he was still unaware that the gap between what he was offering and what those capitals already had was not dramatic enough for them to yield to his wishes. Experience soon taught him that a ruined city in desperate economic need was his best bet. They would comply with all his demands. Bilbao taught Krens the crucial lesson that the logic of gentrification could provide an essential ingredient of his new transnational museum.

The closing of big industries and shipyards was welcomed by the planners of the new Bilbao. It gave them full freedom to dream of an entirely new city. Major projects of urban development were designed to offset the areas most ruined by the dramatic changes. Renovated infrastructures, such as a subway system and a new airport, were much in need.

Above all, ruins call for new architecture, new beginnings, and a new era. The creation of a new city and a new society must start by building a new architecture that will embody its dream. Gehry's building began to take shape as Bilbao's entire valley of ruins was beckoning for an architectural apparition. Gehry delivered what Krens had asked of him: a building that would make visitors fall to their knees. His Bilbao Guggenheim became an instant landmark and made of Bilbao a mandatory destination point for architecture and museum lovers. Bilbao had not received such a gift since the first blast furnace, run on British coke, was built in 1872. The transition from the ruin of Altos Hornos to the architectural glory of the Guggenheim synthesized the economic rupture as well as historical continuity in Bilbao's tradition of self-invention. Never before had Bilbao been as conscious of the politics of building. Suddenly, everything else took backstage to the politics of star architects, international media attention, and the postmodern culture of late capitalism's virtual village. The dreamed transition from the smoky industries of steel manufacturing to a service-dependent and high-tech economy needed a powerful signature building, a flagship image, and Gehry provided it.

Gehry's undisguised love for Bilbao owes a lot to the city's postindustrial desolation. Indeed, he has said on countless occasions that a tough city such as Bilbao, surrounded by green hills, is his "idea of paradise." His celebration of Bilbao's tough "aesthetics of reality" could be opposed rhetorically to his Los Angeles concert hall's Disneyfied aesthetics, yet both buildings obviously belong to the same family of designs.[4] Upon his completion of the Guggenheim, Bilbao's urban planners decided to gentrify its surroundings, turning the waterfront into a green garden. Gehry hated the idea of destroying Bilbao's "toughness." "I feel like a spurned lover," he told me, recounting how Bilbao's officials had not responded to his offers to build and urbanize the area further.

4. See my "Tough Beauty: Bilbao as Ruin, Architecture and Allegory," in *Iberian Cities*, ed. Joan Ramon Resina (New York: Routledge, 2001), pp. 1–17.

In short, decay and ruination is what Bilbao experienced industrially and urbanistically. This historical reality is essential to grasp the transformational power of its new architecture. The much hyped tale of the Guggenheim's "miracle" took life from the mythical story of a city's resurrection soaring as an *ave fenix* from its ashes. Gehry provided the architectonic pleasure dome for the gentrifying logic of urban planners and its application to the museum by Krens.

Bilbao provides a grand example of architecture as ideology and spectacle. Its premise is that once public funds have been invested in architecture, it will equally benefit all social classes. The building has become in its own right the founding work of art at the Bilbao Guggenheim. It is almost a cliché to say that the building is far more interesting that its contents. The new technologies, the tourism industries, and the mass-media version of culture have fostered the emphasis on architecture as spectacle. The Bilbao Guggenheim has become the most successful "emblematic" building in the world. As is often repeated, "it has put Bilbao on the map." The lesson to learn from Bilbao is that flagship architecture can be a most powerful tool to market and sell a city. By reducing it to a pervasive image, the city becomes part of the global imagination. But the larger lesson is that a Krensified museum, aware that it can no longer rely principally on its art treasures to attract visitors, has embraced openly the voyeurism of spectacular architecture as its trademark.

4) Miracles and the Media, Spectacles and the Tourist's Desire

A month before the opening of the museum, on the cover of the Sunday *New York Times Magazine* there was a glittering photo of the new museum with a caption that read: "The word is out that miracles still occur, and that a major one is happening here. Frank Gehry's new Guggenheim Museum won't open until next month, but people have been flocking to Bilbao, Spain, to watch the building take shape. 'Have you been to Bilbao?' In architectural circles, the question has acquired the status of a shibboleth. Have you seen the light? Have you seen the future?"[5]

The words were taken from Herbert Muschamp's article inside the magazine entitled "The Miracle in Bilbao." The titanium skin's silvery palette of cold, grayish tones appeared in the spectacular cover photo drenched in the torrid, golden, crackling flames of sodium lamps and photographic coloring (the trick, I was told by the Guggenheim photographer, was to take the shot on a rainy night, with daylight film and long exposure). The glowing, yellows, whites, and golden colors reminded one reader of "a major meltdown of a nuclear power plant."

This evocation of Moses facing the Promised Land signaled the beginning, in the mass media of dailies and talk shows as well as architecture magazines, of a discourse celebrating the apotheosis of the architect as savior and master artist. Postindustrial and marginal Bilbao had simply been, according to the new discourse, the lucky spot where

5. *New York Times Magazine*, September 7, 1997.

the Virgin had appeared. The *New York Times* continued with articles on "Bilbao's Cinderella story."[6] To the too obvious power asymmetries Krens had enjoyed and written into his "Constitution," now the international press added the condescending view by which Bilbao and New York belonged to such different planets that only miracles and magical Cinderella stories could bridge the encounter between the poor provincial girl and the New York prince.

A revealing dimension of Krens's many Guggenheims is that they may exist entirely as media creations. Still, their reality is as powerful as if they were actual buildings. Who has not heard of a constellation of Guggenheims around the world? When the journalists are pressed to list them all, they come with a list of four or five, plus a dozen new projects here and there. Since Bilbao, a month scarcely went by without news of a Guggenheim franchise being considered somewhere. The fact is that there is only one building, in Bilbao. But even Bilbao's reality seems dwarfed by the news of dozens of Guggenheim franchises to be built all over the world. Krens's franchise exists only in one marginal European city, yet the Krensified museum exists everywhere in the media and in the desire of every city to have a sample of the elusive thing itself. This stunning presence by absence, desire by lack, is one of the hallmarks of the Krensified museum.

The result of all this is of course a "miracle." After being inaugurated by Muschamp's paean in the *New York Times*, the "miracle in Bilbao" theme became commonplace in the media. It generated a new auratic discourse that combined the old aesthetic values of the "genius" architect, the beauties of the design's powerful allusions, and their consequences in terms of urban renewal while adding the new virtual possibilities of computer programming and information engineering.

All of this has been a godsend for Bilbao. Bilbao being the alma mater of the newly invented museum, the only real image to hold its questionable reality, the desire for the Krensified museum turned squarely into the desire for Bilbao.

Is there anything we should worry about in such Krensification of cultural desire and its translation into the religiously hyperbolic discourse of miracles? Miracles are blinding: What they hide are the historicities and cultures in which they take place. Not surprisingly, the only person Muschamp found worthy of talking to in Bilbao was Gehry himself. Forget about the bean counters, but shouldn't the architecture critic enquire about something of the city's architecture or its artists, much praised by Gehry himself, or even perhaps something about the industrial history of Bilbao? In a clear act of the return of the repressed, the picture on the magazine's cover was more of a blast furnace than the pallid building of Muschamp's everlasting love. He had of course more relevant things to report, as indicated by his declaration that the building was in fact "the reincarnation of Marilyn Monroe." It was this American sense of freedom, which "likes to let its dress fly up in the air," that captures the essence of Gehry's masterpiece. Anyhow, you must "recognize that Bilbao is a sanctuary of free association. It's a bird, it's a plane, it's Super-

6. See, for example, Warren Hoge's "Bilbao Cinderella Story," *New York Times*, August 8, 1999, p. 14.

man. It's a ship, an artichoke, the miracle of the rose," miracles that for Muschamp take place in a contemptible city that reminds him of war-trodden Bosnia. All the critic cares about is discerning "American art and architecture" amid Bilbao's rubble. What he sees in the building is the auratic miracle of "a Lourdes for a crippled culture," that is, the salvation of *American* culture.

And what if the natives themselves end up believing the miracle talk? The fact that half a million pilgrims have been added to local tourism will be enough to vindicate the reality of the miracle. Factors such as that it is being financed by taxpayers' money will not even be taken into account.

World cities are for Krens what women are for Don Juan: useful accessories to satisfy his fantasies of power and conquest. What matters to him is that they all desire him. News of various cities, in Brazil, Argentina, and elsewhere vying simultaneously for Krens's attention has been frequent. These cities don't want what used to be called a museum, a building devoted to something as passé as merely hanging paintings on its walls. They want something else, a Krensified museum, a sexed-up building that will turn on the desire of the masses and that will *also* be a museum. What really matters, however, is what is *not* merely a museum, what goes beyond art per se.

We might recall Lacan's famous formulation, "La femme n'existe pas" (The woman does not exist) or Magritte's famous pipe with the caption "Ceci n'est pas un pipe" (This is not a pipe). Krens the seducer, in order to achieve his "transference of desire," their wanting what you want without their realizing it, had to speak in such terms to dematerialize his museum. Krens's many museums exist nowhere, yet the Krensified museum and its desire by every city becomes the overriding reality in the world of museums. Unless you visit Bilbao, such a dematerialized museum has no reality. It cannot be described except in the ubiquitous representations of the international media. Krens's ultimate power consists in this surplus of global franchises that exist nowhere. But that is precisely what an unending desire needs, a reality that in the ends does *not* exist. In other words, Krens must offer a museum that is *not* a museum, yet that is *also* a museum. Besides a theme park, a tourist attraction, an architectural landmark, a flagship project, and so on, the Krensified museum is also a museum.

5) Art Is Not Enough: Driven by the Blockbuster Exhibit

In the good old days, museums were thought to be repositories of art collections religiously visited once and again by museumgoers. They were the "permanent collections." With Krens, these collections are still part of the museum, but no longer the real thing. Let the New York critics sound the alarm at the prospect of their beloved art collections globetrotting amid the museum galaxy's many franchise venues. For Krens, they became essentially a backup for what is truly "sexy": the blockbuster exhibit. Krens in no way wanted his art's aura of timeless universal work to evaporate, for how else could he make his case in Sotheby's or in Bilbao, but his museum would certainly not handle it with kid gloves as untouchable sacred merchandise. He needed the collections as his company's

stock so that he could put a monetary number on their value and make things happen. The permanent collections were on the back burner, providing a brand name and a complimentary asset to what was truly important: spectacular architecture, the blockbuster exhibit, and flashy media reportage. Fixed values and permanent collections were somehow the antithesis of a truly postmodern, globalized, Krensified museum.

The blockbuster requirement means that any exhibit under half a million visitors is a failure. But who can attract so many museumgoers? Certainly no local artist. Not even most consecrated modernist, minimalist, or pop star. The question may go further: is art per se really enough to attract large numbers of visitors? We just need to look at the Guggenheim's biggest success: the motorcycle exhibit (sponsored by BMW). Later, the Guggenheim organized a retrospective of the fashion designer Giorgio Armani. Wright's rotunda added luster to Armani's ball gowns, pantsuits, and tuxedos (after Armani contributed a $15 million donation to the Guggenheim.)

The point is that the aura of art per se doesn't seem to be enough to create long lines at the museum's entrance. Of course, Krens would prefer if art kept that power of attraction. But if not, he has to find a way to bring people to the museum. If he has to do it by spectacular architecture, so be it. If the museum has to conform to the definition of "theme park," it is all for the sake of art. If he has to make the world know about his museum by it serving as a backdrop for Agent 007's film *The World is Not Enough*, why not? Art in the traditional media of painting and sculpture is simply one more element contributing to the final product—the Krensified museum as theme park—and increasingly losing relevance.

Art is still crucial to the entire adventure, of course. Don't forget that a Krensified museum is *also* a museum. But one wonders to what extent art's relevance is measured, in a Krensified museum, by its contribution to the promotional pitch of the global phenomenon. Benetton's ad campaigns can be taken as the perfect model for promotional culture in the postmodern era: Insist that you are selling great art and social responsibility, even if the only real goal is to spread your name and make profits. Such "transgressive" use of great photography and social discourse made Benetton wealthy. Krens also likes to proclaim that "transgression" is his most proper style. And the question arises as to what extent architecture, art, photography, and the media are structured in his overall Guggenheim design as Benetton-like promotional devices to propel his grand global adventure.

Las Vegas was the perfect place for the museum as theme park, and Krens made it happen. "The task is neither to resist nor to admonish the fetish quality of modern culture," wrote Michael Taussig, "but rather to acknowledge, even submit to, its fetish powers and attempt to channel them in revolutionary directions. Get with it! Get in touch with the fetish!"[7] The loss of seduction, not its excess, might be the real danger in the Las Vegasing of marriage (*Who Wants to Marry a Millionaire?*) or art.

7. Michael Taussig, "*Maleficium*: State Fetishism," in *Fetishism as Cultural Discourse*, ed. Emily Apter and William Pietz (Ithaca: Cornell University Press, 1993), p. 229.

There is a lot that Bilbao owes to Krens. First of all, it owes to him Gehry and his landmark building. And then, everything else, which is known as "putting Bilbao on the map": media recognition, tourism, urban renewal, economic recovery, and so on. But ironically, it is in the world of art that the consequences of Krens's "miracle" are most negligible. The blockbuster phenomenon is beyond the reach of the artist. Unless it is spectacular architecture, art is clearly not the real thing. It is at best a humble maid to the entire hoopla.

6) Murder in the Cathedral, or the Oteiza Paradox

I went to visit the old sculptor Jorge Oteiza, the man who with his art and writings has done by far the most to educate the Basques in the gospel of contemporary art. He is much admired by both Richard Serra and Gehry. As I entered his apartment to talk about the Bilbao Guggenheim, he cut me short: "Forget about writing and quit fooling around. Kill them. I will pay you." I looked at him startled. There was fury and madness in his eyes. A call to murder those responsible for the Guggenheim was his reciprocity for their admiration. He knew how to blandish scandal and total failure as his last weapons, but not everything was posturing. "Hate has overtaken me," he said bitterly while he stroked his chest with his hand. He was the artist who had written that you can sculpt only what you love. Now he was writing an essay entitled "Finally I Am an Assassin." Despite being in his nineties, Oteiza was refusing to die in order to be able to curse them. He had protested vociferously against what he called the new American Disneyfication of art. He no longer wanted to hear any aesthetic piety. Now he wanted the real thing—murder. Oteiza died last year, and recently I have been asked to contribute to a catalog for a retrospective exhibit of his work—yes, at the Bilbao Guggenheim.

This story concentrates on the bitter antagonisms and violence between Krensified global institutions and local artists. They are the ones who must rebel against the capricious value criteria and blatant asymmetries coming from the powers that be in New York or elsewhere. Oteiza's paradox consists in that while New York's world-class artists will consider him as their equal (Serra conceded to a reporter that he thought Oteiza was the greatest living sculptor, and Gehry called him one of the three or four fundamental artists of the century), the Krensified franchise museum will reduce him to a local artist whose value is seen as quite negligible.

But Oteiza is only one instance of this paradox. The same thing happened to the great Eduardo Chillida. Initially, when Basque critics charged that there would be no work by Basque artists at the new museum, Krens always countered that one gallery would be devoted to Chillida. But then he refused to buy Chillida's work. When the Guggenheim was about to open its doors in Bilbao, a snubbed Chillida had to complain in the Basque press that Krens was unwilling to purchase any of his work—purchases that, needless to say, would be done with Basque taxpayers' money. Krensification means that the museum mandarin from New York has the right to levy money for the purchase of art from

the host society and then spend these public funds of the franchised public the way he best pleases. If this implies humiliating the most consecrated local artist, then so be it.

But the key lesson for local artists to be learned from Chillida's case is something else. It has something to do with the repositioning of the artist as deserving a global or local audience. Chillida clearly belonged to the international elite art community when New York's Guggenheim exhibited his work in 1981. Then the Guggenheim purchased Chillida's work. But in the 1990s and in his home Basque Country, was he still a global artist whose work deserved to be collected? Krens decided that he was not. Suddenly, in the eyes of the Guggenheim, Chillida had become a minor artist unworthy of his interest. His work did not deserve the new museum's international space. When I asked Krens about it, his cryptic reply was that his modus operandi was to buy two works and receive one for free. In other words, Chillida was unwilling to bend to the Krensified museum's patronizing rules and had been punished for it.

The artist who did deserve a presence at the museum with a permanent installation, *Snake*, in the grand "boat" gallery was, of course, Richard Serra. The Bilbao Guggenheim was implicitly telling Chillida: You are now so local that you don't deserve us spending Basque taxpayers' money on your work. That money was good to buy work by Serra, Koons, Schnabel, and others, but not by Chillida. Basque money, under the control now of master Krens, had de facto demoted Chillida from his international stature. Later, under pressure, the Bilbao Guggenheim announced that it would, after all, buy some of Chillida's work.

The Guggenheim also bought the work of a few more "Basque" artists, although seemingly on one condition: that they were living in New York. One of them told me that the money they had been paid was *calderilla* (pocket change).

The plight of local artists is therefore one more crucial aspect we learn from the Bilbao Guggenheim. What essentially happens in a Krensified museum is that local representatives lose the intellectual control to decide what is valuable art, the financial control of their own resources, and the institutional control to promote a given art by purchasing or exhibiting it. Local artists become far removed from the centers that directly decide on the fate of their careers.

In the late 1980s, Oteiza had been asked by the then mayor of Bilbao to design a grand museum and cultural center for the city. After two years of work on the project, it failed, due mostly to political infighting between the Autonomous Basque Government and the mayor, who was forced to resign, as well as due to Oteiza's own clashes with the local officials. Almost immediately afterward, they embraced the Guggenheim Museum project that had been offered to them by Krens. It was then that an enraged Oteiza called for the murder of those responsible for the franchised museum. Gehry, to his credit, told a reporter that he understood Oteiza's murderous rage. But the logic of Krensification had put them all, members of the same international community of artists, at odds among themselves—Serra versus Chillida, Oteiza versus Gehry—by having to bow to an exter-

nal authority, embodied by Krens, that had final power over that community's direction and internal structure.

In short, Oteiza's paradox is that, while his work is lionized by Serra, Gehry, and Krens as world class, the Krensified museum they brought to Oteiza's home country clashed directly with Oteiza's artistic project. Yet once again, in one more telling case of the history of art's progress by deferred action, the other side of the coin is that now it is the Bilbao Guggenheim that will be responsible for promoting Oteiza worldwide.[8]

7) The Politics of Building: From Terrorism to New York

Cindy Crawford did not come for the museum's inaugural festivities after all. She had been at the top of the list of invitees, Krens told me, something that impressed him as the ultimate proof that Basques, caught between the defense of their ethnic heritage and modernity, had their priorities right. It was reported that she was scared of Basque terrorism. In fact, on the day of the inauguration ETA put a bomb in one of the flowerpots next to the Jeff Koons cyborg statue *Puppy*, made of 50,000 pansies, and killed a Basque police officer. Someone had been listening to Oteiza's unconscionable call to murder those responsible for the Bilbao Guggenheim.

The coda to the Oteizian "murder in the cathedral" theme has to do with the intimate relationship between Basque terrorism and the Bilbao Guggenheim. The expert at the city hall in charge of Bilbao's new urban planning, Mikel Ocio, put it most succinctly for me: "The Guggenheim is the revolutionary tax we have to pay for ETA." ETA coerces Basque entrepreneurs to pay a so-called "revolutionary tax" to support their organization. The analogy that the Guggenheim is the tax Basques have to pay to offset the negative consequences for being portrayed in the international media as terrorists goes a long way to explain why they have been so willing to go along with everything Krens wanted. Basques have had a long and successful tradition of joint ventures with international capital to exploit their mining and iron industries. These were undertaken in total parity and with the Bilbao business elite leading the ventures and benefiting the most from the profits.[9] Why now such a dependency in their agreement with Krens? This so infuriated Alfonso Otazu, Krens's first emissary to Bilbao, that he quit his collaboration in revulsion at the Basque compliance with Krens's every whim. We critics jumped into chastising Basque officials for their subservience.

Terrorism is a key reason why Basques felt that they had to bend over backward to make a deal with Krens. The Guggenheim was going to be the exorcism against the shameful taboo cast on the Basques by ETA. Faced with criticism, Joseba Arregi, the then minister of culture in the Basque Autonomous Government and a main negotiator with

8. See my "Oteiza's Return from the Future," in *Oteiza's Selected Writings*, ed. Joseba Zulaika (Reno: Center for Basque Studies, 2003), pp. 9–81, where I argue that the Guggenheim Museum can be seen partly as deferred action for Oteiza decades-long battle for the centrality of contemporary art in Basque politics.

9. See Eduardo Glass, *Bilbao's Modern Business Elite* (Reno: University of Nevada Press, 1997).

Krens, replied: "I negotiated in the name of a small country immersed in an economic crisis and with the problem of terrorism." One study determined that 85 percent of all international news about the Basques concerned terrorism. No greater public-relations achievement was possible than the replacement of this news with the extensive coverage of the Guggenheim in the international media.

A symbiotic relationship between terrorism and Krensification developed in the case of Bilbao. Both phenomena are crucial aspects of the globalization of culture and the media. De Michelis's point, when he declared during the signing ceremony in Bilbao that the Bilbao Guggenheim was the cultural counterpart of NATO, had a clear translation in the case of the Basques: The museum was their architectural response to counteract terrorism's negative effects on the Basque economy and tourism.

Trapped in between ETA's murderous folly and Madrid's political inflexibility, the Basque Nationalist Party (Partido Nacionalista Vasco, PNV), the majority power during the post-Franco period of the last twenty-five years, is unable to solve the endemic problem of terrorism. Its price in human lives and political chaos is immeasurable. But there is another public-policy dimension to it that greatly concerns Basque officials and that falls under the rubric of "image." The prospect of an internationally celebrated flashy museum takes on a new perspective when it is viewed as a bold adventure to transform such a negative image. The urgency of the endeavor explains why Basques did not mind the glaring asymmetries of a Krensified museum. Unable to develop a politics of pacification, they engaged themselves in a politics of building.

The operation required the transfer of sovereignty from the political sphere of the Spanish state to the cultural sphere of a New York museum. We cannot build our own independent state, but at least we can build a global museum—if only we surrender its final control to a far-away transatlantic power. From Krens's viewpoint, the greater the political independence of the Basques, the better. The only dependence required for Krensification is allowing the museum a totally free hand to undertake its *mission civilisatrice*. The lack of sovereignty that really hurts is the political one. Surrendering cultural autonomy in the name of globalization, a universal interdependence, is permissible.

The terrorist attack against the Bilbao Guggenheim on the inaugural day sent out the ominous message that an all-out war between Basque moderates and radical nationalists might break out. But ETA adopted a policy of not attacking the museum, which would have been an easy target for its own propaganda, although it would have jeopardized any international appeal it may have sought.

Krens built his grand Taj Mahal (an analogy he cherishes, the other two being the Pyramids of Egypt and China's Forbidden City) in such a "balance of terror." It is no small merit on his part that he gambled so much and that he convinced the board to accept his unlikely project. The result might also be seen as a combination of his museum's desperation, financially broke at the time, and the observation by David Ross, the then director of the Whitney Museum, that "Krens has two brass balls."

The Krensification of the museum is therefore symbiotic on a politics of building. Cities or regions in need of redressing their economic woes and national imbalances expect that a "Bilbao Effect" will do the job. Krensification promises media prominence and tourism to the cities. It does so, ironically, by actually taking away their autonomy. A significant aspect of such redress has to do with the loss of power of the traditional nation-states and the new configurations of state power emerging from subnational countries such as the Basques.

8) Auction Houses and Wall Street: The Nineties Culture of Irrational Exuberance

Finally, one must take into account nineties New York culture to appreciate fully the Krensification of the museum. When Krens made his appearance in New York's museum world in the late 1980s, his financial "strategies" were routinely compared to the "junk bonds" of Michael Milken and Ivan Boesky. John Richardson, for example, concluded his harsh portrayal of Krens observing that his "schemes can best be understood as a new kind of conceptual art: a combination, perhaps, of Boesky and Beuys."[10] Boesky was represented in the film *Wall Street* by the Gordon Gekko character. Gekko echoed Boesky with the celebrated statement that "greed is good." He boasted of his art collections having increased tenfold in value, and the film mixes the frenzy of stock market exchanges with the frantic buying and selling of art in the auction houses.

Gekko was the ironic incarnation of evil, but during the 1990s, he came to be seen as the pragmatic realist. This was also Krens's destiny. He was initially vilified by the New York journalists and art critics, but as news of a "miracle in Bilbao" took the *New York Times* and the architecture world by storm, his claims to being the museum's visionary savior solidified. Those of us who were critical of him from the Bilbao end were said to have been particularly foolish. If not for him, who else would have brought Gehry to Bilbao? Yes, he might have done it all for money and power, but so what? Somebody had to do the dirty job.

A key dimension to the Krensification of the museum has to be found therefore in its relationship to the nineties culture of what Alan Greenspan termed the "irrational exuberance" that took hold of Wall Street. As if to dispel any doubt of where the new global museum was being administered from, two months after the Bilbao signing, the Basque president, Antonio Ardanza, visited Wall Street with a simple task: to produce for the Guggenheim Foundation the $20 million check at the offices of Merrill Lynch. It was the franchise fee. A second visit by Ardanza to Wall Street would soon follow, this time to issue public debt. Basques seemed to be again at the epicenter of international finance, as they used to be in the past. What mattered was that you were in the Rolodex at Merrill Lynch.

10. John Richardson, "Go, Go, Guggenheim," *New York Review of Books,* July 16, 1992, p. 22.

Basque officials were, by self-admission, gambling in a casino, and their taxpayers' money, in 1992 and 1993, was the only fresh infusion of cash that allowed the Guggenheim to survive while carrying out its expansion and renovation. But in the meantime, it was Krens, the master gambler, who was the one truly experiencing the thrills of exuberance. He was actively involved in New York's Sotheby's auction house. If Basques were playing hardball in the politics of seduction under his leadership, Big Brother Krens had to show them the way. The mirages of promised financial bounty from the close association with auction houses and Wall Street was a crucial aspect of the new museum patented by Krens.

Nancy Sullivan concluded that what best defines the international community of art is "its proximity to the auction market, which is in itself based in New York auction houses."[11] Auctions recognize publicly the secretive decision-making processes between dealers and collectors. It is in the auction market where the success or failure of a work or career is decided. Krens has been a hero of this auction-based international art community. No other museum director had previously dared to auction off masterpieces from a major museum's permanent collection until he came along. And when the Basques signed a contract that handed him, in addition to the franchise fee, $50 million for new acquisitions, he wanted to spend it at Sotheby's. The Basque partners, who had established their own committee of experts, rejected the idea. But they could not control him, and the committee was soon dissolved as irrelevant. Krens was free from any semblance of control on his acquisition policy, and he went on purchasing works to which the committee had explicitly objected.

These were particularly bad years for New York's art auction houses,[12] and the Bilbao infusion could make a difference. It was also in an auction house (the Vienna Sotheby's) that Krens bought some works by the German artist Joseph Beuys for Bilbao, which, after being exhibited in New York, were found to be fakes.[13]

In short, a key to Krens's nexus between the museum and a casino, art and gambling, economy and belief, is the psychology of the auction house, a quintessential component of his global museum emerging from Bilbao.

There are obvious benefits to this globalizing of the museum in terms of collection exchanges and the sharing of the costs of expensive exhibits, as well as curatorial expertise. But, more importantly, there was the intangible dimension of sharing Wall Street's nineties culture of global networking, computer technologies, and financial exuberance. Key board members of the Guggenheim Foundation were immersed in that culture.

11. See Nancy Sullivan, "Inside Trading: Postmodernism and the Social Drama of *Sunflowers* in the 1980s Art World," in *The Traffic in Culture: Refiguring Art and Anthropology*, ed. George E. Marcus and Fred R. Myers (Berkeley: University of California Press, 1995), p. 257.

12. This was due partly to the earlier deceptive manipulations of international buyers. After the stock market crashed in 1987, Sotheby's had to fend off the fear of its effect on the art market by coming up with the trick of selling/donating Van Gogh's *Irises* at a very inflated price to bolster wavering sales.

13. See Andrew Decker, "Can the Guggenheim Pay the Price?" *ARTnews* (January 1994): 142–49.

Krens's international franchising was a stroke of genius that had made the Guggenheim the most attractive museum for global capital. This was recognized as decisive for their endorsements of the Krens's project by such tycoons as Ronald O. Perelman, chairman of Revlon and later president of the Guggenheim board, as well as an owner of extensive contemporary art collections, and his successor, Peter B. Lewis.

The point to consider here is the symbiotic relationship between Krensification and the Wall Street culture of the nineties and the extent to which the changes of success or failure in a Krensified museum are tied to the stock market's cycle of boom and bust. I mentioned earlier the notorious junk bonds, which were issued by distressed corporations and were of lesser credit quality, but still offered high enough interest rates to compensate investors for the risk of default. The point was for investors to borrow their way to prosperity, and buyouts financed by debt became the new corporate weapon. By underwriting junk bonds to low-rated borrowers who had been shut out of Wall Street, Milken and others made high profits. Some of the borrowers used the money to fund new acquisitions. Guess who was one of the people who most benefited from these junk bonds: Ronald Perelman, the deal maker whom Krens recruited for president of the Guggenheim's board in exchange for $10 million. Perelman, who began his career by buying his first business with $1.9 million in borrowed funds, ended up taking billions from Milken and launching a bid for the cosmetics giant Revlon.[14] This episode in junk bonds set the financial trend for the later 1980s. And the Guggenheim Foundation, whose board's president he was, would set the museum trend for the 1990s by enthusiastically supporting its Krensification.

Part of the mystique of the buyout artists such as Perelman consisted in the manipulation of debt, so that they would *not* use their own money. Krens became a fast learner in the art of expansion by issuing debt and doing business with the money of the host city. He began his tenure by requesting from his board a doubling of the $25 million that had been budgeted for the museum's expansion and renovation. Two years later, in August 1990, he issued bonds worth $54.9 million, which amounted to a 600 percent increase in the museum's debt. What would happen if he could not repay the debt? The art collections were there as collateral.

In the new financial culture of junk bonds and hedge funds, the traditional public corporation began to be viewed as an anachronism. In this new world of executives gone wild, everything was a "win-win" situation, a formula dear to Krens. Going to a casino to bet with somebody else's money was simply a free ride: Losses would not be his losses, and if it was a win, he was the one who played the hand.

In 1990, Michael C. Jensen and Kevin J. Murphy wrote in the influential *Harvard Business Review*: "On average, corporate America pays its most important leaders like bureaucrats. Is it any wonder, then that so CEOs act like bureaucrats?"[15] If anything, Krens is

14. See Roger Lowenstein, *Origins of the Crash: The Great Bubble and Its Undoing* (New York: Penguin, 2003), p. 10.
15. Michael C. Jensen and Kevin J. Murphy, "CEO Incentives—It's Not How Much You Pay, But How," *Harvard Business Review* 68, no. 3 (May–June 1990): 142.

the nonbureaucrat CEO. He has to spend several nights a week on an airplane. He is known for his passion for riding motorcycles in black leathers. Living up to the motto "Work hard, play hard," as soon as he descends from the airplane with his laptop and checks into a hotel, he is ready to put on his tennis shoes and go jogging. He is truly the entrepreneur who opened the world of museums to previously unknown adventures. He could not use the notion of the shareholders' value and play poker with their money in order to increase the ratings of their stock value for the quarterly earnings per share, but he did have the written assurance of a European society of 2.2 million taxpayers that would pay indefinitely whatever subsidy was required from them. He could not own and reap the multimillion-dollar stock options that became the new trend among the CEOs, but he did have control of the unparalleled symbolic value of his museum's art collections. In just one operation at Sotheby's, he made $47.3 million by auctioning Kandinsky's *Fugue*, Chagall's *Nativity*, and Modigliani's *Garcon with a Blue Vest*.

The 1990s was the decade in which the demise of the nation-state was much trumpeted. Academics were all for it. The era of big government was over, President Clinton declared. His consultant, James Carville, a White House insider, quipped that he would like to be reborn as the bond market. Krens was simply teaching the Basques and the museum world where the real power was: in Hollywood, in Disneyland, in McDonalds, in everything American, and particularly in Wall Street. Krens would simply update the famously stale atmosphere of the museums to the culture of the times, and he would do so by inventing a global museum "galaxy" of "McGuggenheims." The stocks were soaring in Wall Street, and what could be more of a "fact" than the huge profits of the bull years? Ultimately, the boom was based on faith, but who could resist the seductive promises of such historic growth? And you really didn't need to prove your value with assets. On the contrary, the rule setters in Wall Street "have decided to give premiums to companies that harbor the most profits for the least assets."[16] It was obvious that Krens's Guggenheim could not compete with the other big New York museums, but who else could compare to him in making more profits with fewer assets? He was the perfect guy for Wall Street.

Suddenly, everything appeared to be disposable and more dependent on the market. Even "the notion of a fixed asset became somewhat unfixed."[17] The very idea of purchasing a permanent collection appears suddenly outdated to many museums. It is the era of the blockbuster exhibit.

Computer technologies and the Internet became a crucial component of the boom years. The Guggenheim was showcasing in Bilbao the first architecture in which computer technology was deemed to be essential to the entire building process, despite Gehry's disarming reply to the journalists that "I don't know a thing about it; I can't even turn the

16. Quoted in Lowenstein, *Origins of the Crash*, p. 31.
17. Ibid., p. 32.

computer on." The Guggenheim virtual museum became a pioneering project to which millions of dollars were devoted.

Wall Street had become the final arbiter of everything, and the frightened executives felt compelled to allow it every decision. Why should the museums be an exception? Was there anyone so hopelessly out of touch who had not realized yet that what moved and shook the art was the wonderful alchemy of money called upon to make miracles? It only needed circulation and the anonymity of auction houses and the mechanisms of free markets. Wasn't value the command over subordinate peripheral people's labor and the magic of surplus that regulated the relation between the concrete particular and the universal? Rhetoric was all it needed for the circular power of money to mediate symbolically the concrete and the abstract, thus turning the museum, the press, and the department store into aspects of the same ideological system.

Number games were crucial to Wall Street's bubble during the 1990s and to the success of its emblematic companies such as Enron and WorldCom. They were aided in this by accounting companies such as Arthur Andersen. Krens is known for his knack of producing numbers favorable to his projects. After its initial support, his Mass MoCA project in North Adams, a precursor of Bilbao, was interrupted by the governor of Massachusetts when it was found that his numbers did not add up. Krens hired Arthur Andersen for his Bilbao and other project's feasibility studies. Inevitably, number games became central to validating the claims that Bilbao was a "miracle" and a "Cinderella story." The hotel industry, in particular, was there to prove it.

As it became painfully evident later, creative accounting and deception were an integral part of the Wall Street culture of the nineties.[18] Early on in the decade, the New York media savaged Krens for deceptive tactics. Andrew Decker reported, as an example, that in 1991, the museum had been closed and had had no earnings from tickets or from its bookshop. The salaries of the curators and the administrators had been paid, but the books showed no deficit. According to Krens's report to its board, the earnings had come from the honoraria of the itinerant show Guggenheim Masterpieces. Yet Gail Harrity, in charge of the Guggenheim's finances at the time, told Decker that the show had barely covered its costs. As was expected of a good CEO, Krens was simply cooking the books.

It is too easy to blame the lies on the CEOs. In a culture of seduction, you want to be seduced; in an economy of financial exuberance, you want the numbers game; in a period of reinventing a city, you want Cinderella stories to be told about you. It might simply be belief, but we like it. It was the culture of the times, and we wanted to experience it as long as we could.

There used to be clear distinctions between hard economic data and cultural fashion, between cash flow and stock options, between an actual business and a dot-com, between a museum and a theme park. Not any more. This might be just a bubble, but we liked

18, See for example Maggie Mahar, *Bull!: A History of the Boom, 1982–1999* (New York: HarperBusiness, 2004).

it. There was an old museum for the old economy. It was about time that we had a new museum for the new economy.

"There is no administration there," complained an art dealer in 1994 who was close to the Guggenheim, "there is nothing organized at all. They are in a constant whirl trying to pay the next bill."[19] The real thing was the Taj Mahal, Krens's global love museum, the archetypal pleasure dome of a lover's exuberant folly. It was "a heroic museum for a heroic painting," as he put it to me, in the hope that Picasso's *Guernica* would move to Bilbao. This was a far cry from what happened under Tom Messer, the austere director who had preceded Krens at the Guggenheim and whose main credential was that he knew about the history of art. Messer belonged to a previous generation of directors, methodical and understated, the administrator of a traditional institution, a generation that needed to be replaced by a new type—a vigorous, jogging, globetrotting adventurer who had never studied the history of art, but could experience a new franchise as the amorous gift of a prince succumbed to love. Passionate affairs, like market bubbles, might be transitory, but they are intense while they last.

Two things epitomize the end of this nineties culture of exuberance: Enron and 9/11. Enron became a sort of open laboratory in which, disdainful of traditional business, new plans were launched every year. Little attention was paid to the expenses: What mattered was the spirit of the stock market. Enron's many acquisitions left the company constantly starved for cash. There was concerted effort to conceal losses and inflate earnings. Enron's great success had simply been a public-relations phenomenon, that is, it successfully created the perception that its results were exceptional. Echoes of this corporate culture's taste for hype, bravado, deceptiveness, online technology, and accounting irregularities were frequently voiced by Krens's critics as well. Nobody was very surprised when the Basque National Audit Office found "an endless list of irregularities in the building and setting in motion of the Guggenheim Museum."[20] Such irregularities included the acquisitions of the works of art. The museum's organizational chart contemplated the role of an artistic director in Bilbao who would supervise the acquisitions. Krens had an easy solution to avoid such control: He never filled the post.

After 9/11 and the collapse of Enron, news of a 50 percent decrease in visitors to New York's Guggenheim and talk of "GuggEnron" surfaced. It was the cycle's turn for the bust. The critic Jerry Saltz called for Krens's resignation in *The Village Voice*, adding that, "The Trustees and board members who helped him twist this institution into a kind of GuggEnron should go as well."[21] Krens's November report to his board was that the annual operating budget would be reduced to half, from $49 million to $25.9 million. The Guggenheim SoHo outpost closed immediately. The Las Vegas Guggenheim awaited a

19. Quoted in A. Decker, "Can the Guggenheim Pay the Prize?" *ARTnews* (January 1994), p. 142.

20. I. Esteban and G. Carrera, "El Tribunal Vasco de Cuentas detecta irregularidades en el Guggenheim," *El Correo Español* (Bilbao), March 2, 2001.

21. Quoted in Deborah Solomon, "Is the Go-Go Guggenheim Going Going . . . ?" *New York Times Magazine*, June 30, 2002, p. 38.

similar fate a year later. Later, exhibits by Mathew Barney, Kasimir Malevich, and James Rosenquist were bumped from the 2002 Guggenheim calendar for lack of money. But none of these cuts would preclude Krens from continuing with his expansionist vision of planning a $680 million Gehry building on the East River in Lower Manhattan.

By the end of 2003, the bad news was coming from Peter Lewis, the chairman of the board. Discussing the new budget, he had told Krens: "Tom, either you go back and come back with a real plan, or we will have to talk about your leaving."[22] The staff positions were down from 391 to 181. Lewis complained that the annual spending in New York was "veering out of control" and warned of the dangers that an institution runs into when "you begin to believe your own press clippings." He did not want "daydreams" and demanded that no energy should be committed to the new downtown project. The headline "Guggenheim Drops Plans for Elaborate New Museum on East River" would soon follow. "The age of the go-go Guggenheim was over," declared the critic Michael Kimmelman, who continued: "Echoes of Wall Street … having mimicked the dot.com businesses of the era, with the hype about global networking, cutting-edge growth and a new economy, Mr. Krens's dream, like the bubble of the dot-coms, burst."[23] Deploring that the exhibition schedule was on life support, the critic wondered, "What is left when the go-go is gone?"

Bilbao's "architectural marvel" is the one thing that remains from "the insidious legacy of the 90s," together with the question of what a museum should be. In its January 3, 2003, editorial, the *New York Times* admitted that times had changed and that even if "for a time, in the 1990s, the Guggenheim looked like the brand to beat in the museum world," now that "many of these projects have shipwrecked," it was apparent that "the Guggenheim was sometimes running, like Alice, as fast as it could to stay in one place." The newspaper welcomed the rescaling of the museum to "make it possible to concentrate on the task of exhibiting art, rather than multiplying like so many Benettons." Art was again at the center of what a museum should be, as well as of how museum directors should be judged.

Wall Street's Enron-type collapse and 9/11 were the two events that thrust a dagger into the heart of the Krensified museum's bull. Krens's triumph and curse consisted in that he provided the personality needed to force his museum to ride the financial/cultural wave of boom and bust that Wall Street was to embark in the 1990s. In the process, he patented a new type of museum, the franchise model; he produced a new cultural variant, "Krensificiation"; and he provided a set of unique lessons to learn about the contemporary world of art, architecture, and museums.

22. Celestine Bohlen, "Chairman Gives Guggenheim Ultimatum, Then $12 Million," *New York Times*, December 4, 2002, p. A31.
23. Michael Kimmelman, "An Era Ends for the Guggenheim," *New York Times*, December 6, 2002, p. B37.

Part IV

THE LOCAL/GLOBAL DILEMMAS

Gehry's Bilbao: Visits and Visions

KEITH MOXEY

Gigantic in its proportions, boisterously cheerful in its radiant metal skin, rampantly over-confident in its soaring rooflines, aggressively playful in its expansive consumption of space, Frank Gehry's Guggenheim Bilbao rushes to meet the visitor with the same enthusiasm as does Jeff Koons's floral puppy sitting before it. Lavishing licks and wagging its exuberant tail, the structure spins before the visitor, waiting for breathless gasps of excitement and incredulity. Weaving and bobbing before your eyes, shimmering in undulating waves of metal and alive with reflections, the building seems to say, "Am I not the most spectacular thing you have ever seen? Was there ever a museum like me?"

What has happened to the institution of the art museum? What did it do to deserve this? How do we understand a cultural moment that seeks a building that is not so much a container for art objects as a pyrotechnic display of architectural virtuosity—a billowing circus tent, rather than a sober framework for the quiet contemplation of art? It is, of course, no novelty to associate this kind of building with the sort of apocalyptic thinking that speaks of the "end of art." The building, that is, seems to respond to a transformation in the way contemporary culture thinks about the concept of "art." Long gone are the days when recent artistic production was housed in functional buildings that bent over backward to erase their presence in the interest of displaying the contents located within them. Louis Kahn's building in Fort Worth and Renzo Piano's de Menil Museum in Houston, for example, would rather fade into the background than distract from the high seriousness of the art they contain. The modernist movement, with its agonistic relation to the culture that surrounded it, has not only been replaced by an art that is far more relaxed in its attitudes toward the hierarchies of value that inform the culture as a whole, but in its wake, museum architecture has moved from the periphery to the center of aesthetic interest.

The arguments that follow are intended as a reflection not so much on the Guggenheim Bilbao as a building, or as a specific institution, as on the cultural potential of the museum of global tourism. We can, perhaps, use the building itself as a metaphor of its

potential cultural function. Rather than reject out of hand the populist appeal of its shiny skin and seductive interior as spectacle intended for mass entertainment, I will argue that it can serve as a metaphor for the fluid and labile nature of aesthetic value. In particular, I believe that it is the building's "spectacular" quality—the way in which it relativizes the distinction between distraction and instruction—that constitutes its greatest strength.[1] Instead of condemning it for not aspiring to the artistic autonomy of high art, we can appreciate it for making an issue of aesthetic judgment—for the way in which it asks us to rethink the means by which we distinguish art from artifact.

There is little doubt that the Guggenheim Bilbao looks out of place in the context of the gritty industrial port of Bilbao, its gleaming titanium shell a striking contrast to the rusting railroad yards that surround it. Now that the industrial activity that once animated the area has stilled, the noise of the enormous building fills the vacuum. The industries that once exploited the iron ore of the Basque Country and that made Bilbao a shipbuilding center, have long since moved on. Since corporate logic dictates the pursuit of profit, once the mines had been exhausted and the wharves were left to ruin, the population that once lived off its activities was left to shift for itself. There is surely, however, little to wax nostalgic about good times gone by. There was nothing intrinsically valuable about the arduous, dirty, and dangerous unskilled manual labor that once informed life on this site.

Capitalism, of course, did not bring the Guggenheim to Bilbao, but rather provincial and city governments concerned about unemployment.[2] Taking their cue from some of the major economic developments of the twentieth century—the rise of the service industries and the growing importance of tourism—the municipal officials predicted that a major museum might generate enough visitors to the city that hotels, restaurants, and other retail merchants, would benefit from taking care of them. In developing this plan, they undoubtedly thought they could put private enterprise to work in revitalizing the city's economy.

If the shift to a service economy was one economic development of the last century that led to the proposal for the location of a new museum in Bilbao, another was the development of a new fully "capitalized" museum. The Guggenheim Museum in New York was the first to recognize the "logic of capital" in all aspects of its operations. Discarding earlier models of the institution that revolved around ideas of preservation and education, this museum consciously modeled its policies on those of a corporation. At various times the Guggenheim has been prepared to deaccession some of its most highly valued works of art to raise funds, organize exhibitions dealing with design and fashion that are not generally associated with the commitment to "art" with which museums of its kind are usually associated in order to attract a larger "box office," and finally to open

1. See Hal Foster, "Why All the Hoopla," *London Review of Books* 23, no. 16 (August 23, 2001) and "Master Builder," in *Design and Crime and Other Diatribes* (London: Verso, 2002), pp. 27–42, who argues the opposite.

2. For accounts of the history behind the project, see Joseba Zulaika, *Crónica de una seducción: El museo Guggenheim Bilbao* (Madrid: Nerea, 1997).

franchised branches in the United States and abroad in the hope of merchandizing its identity. One of the major debates surrounding the Gehry building and the Guggenheim collections displayed in Bilbao is related to the question of whether the authorities succeeded in putting capitalism to work for the benefit of the city or whether the capitalized museum trumped them by putting the city and its government to work for its own greater profit.

Following the lead of Fredric Jameson and other Marxist critics who view the process of globalization as the triumph of the multinational corporation,[3] Joseba Zulaika has argued that the Bilbao museum was a solution to a shortage of funds experienced by the Guggenheim New York.[4] Like any other corporation, the Guggenheim sought to raise funds by licensing its brand name. This feat was achieved by persuading the representatives of the Basque regional government that they could make use of the internationally recognized Guggenheim name if they put up the funds for the new museum and covered its operating expenses while allowing the American museum a share in the profits and permitting the New York museum's executives to determine the nature and quality of the works to be shown. Zulaika's narrative is one that characterizes the changing nature of the Guggenheim as the decline and fall of the museum as we know it and the consequences of its affiliate's construction in Bilbao as an example of cultural imperialism that has disastrous implications for the dignity and autonomy of the Basque people. Given the depressing nature of this tale, it is not surprising that the building itself, with all its sunny California cheerfulness, does not make an appearance.

Powerful and persuasive as this argument may be, I cannot help but wonder if this is the only story that we can tell about this new development in the history of the museum. It is possibly too early to tell whether the new museum is doing for Bilbao's tourist industry what the local authorities hoped it might, although first indications are that their expectations have been fulfilled.[5] More tourists now visit the Basque Country and Bilbao than ever before, and their presence has registered in local income as well as tax revenues. Whether this development has created enough employment in hotels, restaurants, and other retail stores, to provide a long-term solution to the city's industrial decline and high unemployment rate remains to be seen.

It is ironic that the assertiveness of Gehry's building, the way in which it calls attention to itself, should have given rise to so much critical comment, since it merely follows a tradition inaugurated by one of the most striking pieces of museum architecture of the twentieth century, Frank Lloyd Wright's Guggenheim Museum in New York. Is it because the sobriety and seriousness of the modernist rhetoric that was once deployed to guarantee the acceptance of the Wright building are no longer available to legitimate Gehry's, or is it merely a conventional suspicion of the new that has provoked this reaction? What

3. Fredric Jameson, "Notes on Globalization as a Philosophical Issue," in *The Cultures of Globalization*, ed. Fredric Jameson and Masao Miyoshi (Durham: Duke University Press, 1998), pp. 54–77.

4. Zulaika, *Crónica de una seducción.*

5. See the contributions of Javier Viar and Jon Azua in this volume.

is it about the spate of new museum buildings, the Guggenheim Bilbao being only one of them, that allows critics to dismiss them as a "fun houses?"[6] It is with this attitude that I would like to take issue.

My opening remarks about the playfulness of the building suggest something of the creative and imaginative manner with which Gehry has used aerospace software to mold and manipulate the titanium skin that covers his building. The soaring waves of shining metal, with their evocation of an enveloping circus tent, evoke the world of popular entertainment. The building itself implies that what lies within may belong in the realm of distraction, as well as that of instruction. The ire of the critics seems to have been directed at architecture they find demeaning to the status of the high art within. They see an incongruity between the inside of the structure, with its selection of the exalted artists of the Western canon—often presented in "white cube" installations—and the outside, with its frenzied and unabashed appeal to the ordinary passer-by.

Rather than bemoan the lack of relation of inside to outside, we can use it to articulate a vision of what might be the ambition of a new museum culture born of the needs of international tourism. Walter Benjamin argued long ago that one of the most promising cultural developments of modernity lay in the way in which the mass media allowed for the development of art forms that serve to distract working people from the trials and tribulations of their work-a-day world.[7] Where and when do distraction and entertainment become education and instruction? The impossibility of finding a definitive answer to this question offers us an opportunity, rather than an obstacle. In the absence of clear-cut criteria by which to evaluate works of art, in an age that recognizes that differences between classed, gendered, and ethnic subject positions and in the context of an ever-increasing awareness of the distinctions that mark global cultures, *the museum is transformed into a place where aesthetic questions should be asked, rather than answered.*

It is unlikely, however, that this goal will ever be realized at the Guggenheim Bilbao, in whose program planning artistic "quality" has been unadventurously identified with the canon of Western modernism in such a way as to preclude experimentation.[8] Nevertheless, it is possible to see the potential for a radically different visual fare. Whereas the sobriety of the museum's traditional buildings once served to separate the seriousness of high art from the world of everyday life, their current populism seems now to blur that distinction by transgressing the barriers that once equated aesthetic sensibility with privilege. Rather than serving as a tool with which to distinguish and exclude—rather than serving as a means of naturalizing class and cultural identity—the idea of the aesthetic can become an instrument with which to think.

6. Jed Perl, "Welcome to the Funhouse," *New Republic*, June 19, 2000, pp. 30–36.

7. Walter Benjamin, "The Work of Art in the Age of Mechanical Reproduction (1936)," in *Illuminations*, ed. Hannah Arendt (New York: Schocken, 1968), pp. 217–51.

8. Mark Rectanus, "New York-Bilbao-Berlin and Back: The Global Museum and Cultural Politics," *European Studies Journal* 17 (2000): 41–66.

The museum of global tourism has the potential to ask those who participate in cultural exchange to consider what is at stake in that process. The traveler might be confronted with the need to recognize the alterity of the cultural circumstances into which he or she has ventured. Rather than encounter the dominant narrative, the visitor can be offered alternatives—exhibitions and works that serve to relativize the story of Western modernism and to call it into question. Reference to the local artistic traditions of the Basque Country, including the work of its contemporary artists, would be an indispensable part of this endeavor. The continuing importance of aesthetic issues in this context may lie in what they enable us to discern about our own artistic traditions. If the nature an aesthetic decision is acknowledged as intimately related to the cultural location in which it is articulated, we may be able to understand the mechanisms that impel us to make such distinctions in the first place.

It is the populist shell of the Gehry building, rather than its more staid interior, that offers us as a way of thinking about the role of aesthetics in the tourist museum. The appealing and accessible nature of the architect's design, however, should not be misunderstood as a metaphor for a mindless celebration of any form of cultural creativity. The Adornian paradigm, according to which aesthetic value is attached to those works that question and challenge the commodity culture in which they are produced, is far from being the only critical position from which the production of art can be evaluated. The issue of social class is only one of the criteria by which the distinction of art from artifact may be undertaken. As Joan Scott has put it, "When class becomes an overriding identity, other subject positions are subsumed by it, those of gender, for example, (or in other instances of this kind, of history, race, ethnicity and sexuality). The positions of men and women and their different relationships to politics are taken as reflections of material and social arrangements rather than as products of class politics itself; they are part of the 'experience' of capitalism."[9]

While the plight of the disadvantaged and powerless might well be of central concern to many of those assessing the role of the institution called "art" in a capitalist culture, others will have other forms of injustice to address. For some, it will be the status and social role of women; for others, the cultural organization of sexuality and its condemnation of practices deemed "deviant." Others still will be concerned with the social construction of ethnic and national identities and the manner in which these are used to discriminate against and to disempower certain sectors of the population. The historical moment in which we live offers us a variety of critical perspectives that respond to the particular political agendas of different identity formations. Rather than try to enumerate or list them, I would rather emphasize the impossibility of doing so. The very vitality of the creation of aesthetic value will depend on its capacity to engender new and different ways of looking at the world that correspond to points of view that have not hitherto been articulated.

9. Joan Scott, "The Evidence of Experience," *Critical Inquiry* 17 (1991): 785.

If identity is understood as a process, rather than as a condition, if it is conceived as something that is forever in formation, then it becomes possible to regard aesthetic value as something protean and metamorphic, rather than as something to be established on the basis of predetermined values. Theorists of the globalization process, students of the cultural changes that accompany an increasingly integrated market economy, such as Nestor Garcia Canclini, offer us new models with which to reconceive the criticality of the aesthetic by dwelling on the particularity of individual response. Against Jameson's view that globalization leads to ever-increasing degrees of standardization and homogenization, Garcia Canclini argues that it results in fragmentation and recomposition.[10] While not denying the baneful effects of capitalist operations in the developing world, he envisions the role of the consumer in such a way as to make him or her an active player in the life of culture. By fetishizing the act of consumption, the capitalist system actually promotes a creative process of identity formation. Consumption, Garcia Canclini claims, is the location in which individual creativity and enterprise are exercised. Far from being at the mercy of market forces, it is in the maelstrom of capitalist competition, the battle of the brand names, that the consumer has an opportunity to exercise his or her powers of agency in making the decisions that shape and define identity: "It is in this sense that I propose reconceptualizing consumption, not as a mere setting for useless expenditures and irrational impulses, but as a site that is good for thinking, where a good part of economic, sociopolitical, and psychological rationality is organized in all societies."[11]

Transposing this model into the realm of the aesthetic, I suggest that our encounter with works of art can also be viewed as part of the process by which identities are formed. The metaphor of consumption affords us a way in which to conceptualize the aesthetic experience. As in Judith Butler's concept of performativity, consumption involves both what is culturally prescribed—the response to the expectations created by marketing—and what is enacted—the way in which these prescriptions are interpreted and manipulated by individuals acting in the marketplace.[12] Aesthetic choice, the distinction of artifact from work of art, involves both dimensions of performativity: It is both determined by tradition and liberated by the arbitrariness of individual agency in its historical specificity. By means of the identifications offered by the cultural ideals involved in aesthetic choice, in the intense psychological and phenomenological interaction between subject and object, convention and desire mingle so as to provide individuals with a contingent sense of identity.

Garcia Canclini's view that consumption is something that is "good for thinking" offers us a model for considering the kind of cultural work that goes into the construction of a notion of aesthetic value. Among the concepts deployed in his analysis is the

10. Nestor Garcia Canclini, *Consumers and Citizens: Globalization and Multicultural Conflicts*, trans. George Yudice (Minneapolis: University of Minnesota Press, 2001), p. 3.

11. Garcia Canclini, *Consumers*, p. 5.

12. Judith Butler, *Gender Trouble* (New York: Routledge, 1990).

notion of "complicity." He argues that while the consumer has the power to choose among commodities, he or she also supports the system of production by tacitly accepting at face value the qualities attributed to the product by the manufacturer. The sphere of consumer agency in a capitalist economy is necessarily a severely restricted one. If we apply the idea of complicity to the realm of aesthetics, substituting artistic tradition for the goods available in the marketplace, we can understand the hold of tradition on our customary response to works of art:

> Instead of seeing in consumption the docile echo of what cultural politics or some perverse manipulation wants to do with the public, we have to analyze how its own conflictive dynamic accompanies and mimics the waverings of power. Is not hegemony made up of this type of coincidences and complicities between society and the state, more than the imposition of the latter on the former? Is not this complicity, attained from relatively different positions, the key to each acknowledging the other and feeling mutually represented? Is not this complicity … one of the cultural secrets of the political regime's stability?[13]

The hegemony of traditional aesthetic values, the dominance of an accepted canon, is thus the product not only of the power of the cultures that have created and supported it, but also of our own complicity as "consumers." If the Guggenheim Bilbao plans to exhibit the great works of the modernist past enshrined in its New York headquarters, then it is not just because this is what the administrators think is appropriate for a museum of this sort, but because the tourist has been led to believe that this is what he or she should expect. Far from enjoying the guarantee of a universal aesthetic judgment, the canon must be reconceived as part and parcel of our cultural tradition, one whose power derives from our identification with the culture to which we belong. The fascination as well as the seduction of tourism surely lies in the way in which an encounter with another culture allows us to think about naturalized dimensions of our own. In a classic analysis of the tourist industry, Dean MacCannell suggests that the recognition of difference may be one of the most important aspects of the tourist experience:

> If the tourist simply collects experiences of difference (different peoples, different places, etc.), he will emerge as a miniature clone of the old Western philosophical Subject, thinking itself unified, central, in control, universal, etc., mastering otherness and profiting from it. But if the various attractions force themselves on consciousness as obstacles and barriers between the tourist and other, that is, as objects of analysis, if the deconstruction of the attraction is the same as the reconstruction of authentic otherness (another person, another culture, another epoch) as having an intelligence that is not our intelligence, then tourism might contribute to a utopia of difference.[14]

In visiting Bilbao, however, tourists will not be asked to encounter the alterity of Basque artistic culture, regardless of how that may be historically constructed, but rather

13. Nestor Garcia Canclini, *Hybrid Cultures: Strategies for Entering and Leaving Modernity*, trans. Christopher Chiappari and Silvia Lopez (Minneapolis: University of Minnesota Press, 1995), pp. 102–3.

14. Dean MacCannell, *The Tourist: A New Theory of the Leisure Class* (Berkeley: University of California Press, 1999), p. xxi.

the dominant narrative of Western European and American modernism. In doing so, they, and we—insofar as we have all been and will continue to be tourists—become complicit with the forces of capital that are eager to disseminate that narrative for profit. The existence of this canon is supported by our need for order—a product of the desire to naturalize the assumptions that motivate our behavior, as well as our reluctance to look around the edges of a culture that forms our conception of what is valuable and that gives our lives their meaning. Garcia Canclini thus offers us a dynamic model with which to understand the complexities of the interactions that take place in our encounters with works of art. What happens in Bilbao cannot simply be condemned as a capitalist conspiracy. It must also be evaluated in terms of the cultural identifications it both enables and denies.

A second approach to the ongoing process of globalization that may help us conceive the role of aesthetics in the age of the tourist museum is found in the work of Arjun Appadurai. For Appadurai, the most important development of our time is not the increasing integration of economic markets, but rather the means by which humans cope with their new circumstances. It is to cultural creativity, and specifically to the role played by the imagination, that he turns his attention. In making imagination the indispensable tool with which complex economic, social, and cultural changes are negotiated, Appadurai offers us a way of conceiving of the role of aesthetics. The following passage is quoted with an eye to its implications for aesthetic judgment:

> The image, the imagined, the imaginary—these are terms that direct us to something critical and new in global cultural processes: *the imagination as a social practice.* No longer mere fantasy (opium for the masses whose real work is elsewhere), no longer simple escape (from a world defined principally by more concrete purposes and structures), no longer an elite pastime (thus not relevant to the lives of ordinary people), and no longer mere contemplation (irrelevant for new forms of desire and subjectivity), the imagination has become an organized field of social practices, a form of work (in the sense of both labor and culturally organized practice), and a form of negotiation between sites of agency (individuals) and globally defined fields of possibility.[15]

This passage, with its repeated references to the image and imagination, is rich with ideas that are relevant to the process by which art and artifact are distinguished from one another. Fantasy, for example, is no longer discredited by its allegedly dependent or inferior relation to reality, the ideas by which humans organize their lives are not secondary to the economic circumstances in which they find themselves, and fantasy is neither identified with the life of the cultured classes nor is it exclusively a dimension of the appreciation of elite art. Fantasy is as necessary a part of social life as any other, and it is where an individual has an opportunity to exercise some power of agency in determining his or her place vis-à-vis the dominant hierarchies of artistic value.

15. Arjun Appadurai, "Disjuncture and Difference in the Global Cultural Economy," in *Modernity at Large: Cultural Dimensions of Globalization* (Minneapolis: University of Minnesota Press, 1996), pp. 27–47, 31.

Works of art have an important role to play as a means by which we make sense of the cultures of which we are a part. The Guggenheim Bilbao shirks the opportunity to use such works in shaping transcultural communication by an exhibition and acquisition policy that naturalizes the Western canon. A future museum of global tourism could effectively take the opportunity to draw attention to the incommensurable differences that characterize aesthetic response in different cultural contexts. In other words, rather than present works of art as if their value were established and universally recognized, they could be presented in such a manner as to allow the viewer to think about the circumstances that enabled certain artifacts to be recognized as "art." Rather than naturalize the encounter with works of art by displaying them as part of the unquestioned fabric of artistic culture, they could be exhibited in a way that enables the viewer to appreciate the values responsible for their inclusion in the hallowed space of the museum.

The Basque artistic tradition affords striking means by which such considerations could dramatically be brought to consciousness. By enabling and encouraging the visitor to understand the local significance, for example, of the work of such artists such as Eduardo Chillida and Jorge Oteiza, as well as their relation to contemporary sculpture in Europe and America, the museum would inevitably enhance and enrich the visitor's aesthetic response. The museum can make the viewer aware of the existence of two "aesthetic communities." Whereas the received story of the development of modernist abstraction is associated with an international elite, another story is inseparable from the history of the Basque community. In one, the abstract sculptures of Chillida and Oteiza are a manifestation of a historical moment in which abstraction attracted the interest of artists in a number of different countries. In the other, the abstract forms of these sculptors represent an attempt to formulate a Basque national identity. In one, the resemblances between the works of the two artists are more important than their differences. In the other, their differing attitudes toward the politics of Basque nationalism means that their differences are more important than their similarities.[16] The location of these Basque artists within the dominant narrative of modernist sculpture must inevitably be adjusted and reevaluated in the light of their place in another history. That is, their activity belongs to two histories that overlap, but do not coincide. Contrasting the dominant story with the local one makes it possible to understand the extent to which aesthetic decisions are context dependent and historically contingent. The limitations of the grand narrative become all too obvious when contrasted with the deeper and more subtle appreciation of Basque art that is sparked by a detailed familiarity with the politically charged circumstances in which it was created.

Like Garcia Canclini's, Arjun Appadurai's approach to the issue of a globalized capitalist economy is marked by a complex and positive theory of consumption. Rather than

16. Sabine Maria Schmidt, *Eduardo Chillida: Die Monumente im öffentlichen Raum* (Mainz: Chorus Verlag, 2000); Anna Maria Guasch, *Arte e ideología en el País Vasco, 1940–1980: Un modelo de análisis sociológico de la práctica pictórica contemporánea* (Madrid: Akal, 1985).

subscribe to a reductive view of the commodity as the conclusion of a process of production that determines its subsequent fate, Appadurai sees it as an object that animates a complex set of exchanges. Far from being mechanical and constant, the desire for commodities "emerges as a function of a variety of social practices and classifications."[17] Exchange is a political process in which the contest of values that determines the price of an object always exhibits the hierarchical structure of power that frames the transaction. Transposing, once again, this discussion into the realm of the aesthetic, the work of art is only an artifact until it enters a system of exchange, and once there, the ideological agendas of those taking part in the transaction become manifest as they determine how it should be ranked on a scale of cultural value. Furthermore, the institutional context in which the work is defined as art is itself susceptible to transformation by means of the process of exchange. In the crucible of the marketplace, or the politics of museum exhibition, the values of convention and innovation precipitate as they fuse and meld in the creation of something new. Like the market, the museum itself experiences change and transformation as works continue to be evaluated and reevaluated in the course of time.

All discussions of artistic worth take place in the context of established protocols about which objects are to be considered valuable and which are not. Aesthetic choices become problematic when the conventional boundaries that distinguish art from nonart are violated in one form or another. In such instances, the criteria that support the established position can either be maintained unchanged—so that the object is rejected and excluded from the accepted canon in the interest of tradition—or these values can be adapted so as to allow the canon to be expanded and, in the process, transformed. Appadurai draws attention to the fact that challenges to the status quo depend on the concept of agency. Not every member of a culture will subscribe to its dominant values with the same intensity, nor will the individual evaluation of objects coincide. It is in these debates that the interests of differing cultural identities have an opportunity to make themselves felt.

The value of these theories of the persistence of personal agency in the context of ever more integrated global markets for our understanding of the new institution of the tourist museum lies in the way they draw attention to the role of individual response in the realm of aesthetic judgment. Rather than dismiss the whole enterprise of the Guggenheim Bilbao on the basis of its links to capitalism, it may make more sense to consider the ways in which we can rethink its purpose. The models of consumption offered by Garcia Canclini and Appadurai suggest that the museum experience may be more complex than we have hitherto imagined. Like the consumer in the marketplace who uses his or her buying power to construct an individual identity, the museum viewer uses the artistic experiences offered by the museum to articulate his or her own cultural ideals. The cultural power ascribed to works of art by tradition encounters the power of individual pref-

17. Arjun Appadurai, "Introduction: Commodities and the Politics of Value," in *The Social Life of Things: Commodities in Cultural Perspective*, ed. Arjun Appadurai (New York: Cambridge University Press, 1986), p. 29.

erence as visitors respond with varying degrees of intensity to what they see. Whereas the Guggenheim Bilbao offers the tourist the dominant narrative of Western modernism, a story calculated to reinforce the social attitudes of a privileged few or to offer a universal idea of value to which all are expected to subscribe, the opportunity exists for a radically different kind of programming, one that would educate the tourist as well as the local resident to think about the circumstances of his or her own cultural displacement.

In Gehry's building, it is the exterior, with its promise of spectacle and distraction, that offers us the most powerful means of conceptualizing the new tourist museum. It is inside its promise of excitement and its invitation to fantasy that the idea of the artistic ambition can most fruitfully dwell. It is here, rather than in the "white cubes" that recite the familiar stories of modernism triumphant, that we can most usefully discern the unfulfilled potential for future museums. By focusing on the role of consumption, rather than of production, theorists of the globalization process, particularly Garcia Canclini and Appadurai, allow us to construe a role for the aesthetic after the "end of art." As we become more aware of both the provincialism of traditional theories of aesthetic judgment and the parochialism of the allegedly "universal" narratives customarily used to buttress the Western canon, these scholars offer us creative new approaches with which to think about the relation of art to artifact. By providing us with a positive approach to consumption, these authors allow us to consider the mechanisms of identity formation that are inextricably embedded in the process of aesthetic judgment.

What died with the discreditation of artistic modernism was not so much the possibility of discerning aesthetic value, but a universally accepted theory of its determination. In the face of a spectrum of artistic production that has often been excluded from aesthetic consideration, and without a theory of history to allow us to define the concept of "quality," these theorists suggest that the criteria of aesthetic judgment may be more various than we previously thought. Indeed, the potential for a museum of tourism lies precisely in drawing attention to the multiplicity of cultural axes to which the distinction of art/artifact responds.

Far from leaving us without a means of making decisions about artistic quality, however, these theories of consumption emphasize the importance of personal response, rather than economic determination, in the definition of what matters. As our subjectivities meet and metamorphose in the multicultural and multitemporal encounters afforded by the operation of multinational capitalism, these experiences will be mediated by identifications that must themselves be subject to continual revision. Global change serves to dramatize, rather than to naturalize, the politics of discrimination with which aesthetic decisions are inevitably identified. If, as Garcia Canclini insists, consumption is "good for thinking," then so is the aesthetic. If there is nothing fixed and permanent about the nature of demand, nothing stable about desire, then the nature of aesthetic values manifests the agency of individuals within parameters set by the cultural paradigms in which they operate. It is this context—in the museum of global tourism—that the values associated with different kinds of identity may be imaginatively constructed as they intersect and interact with one

another. In this place there could be, even if there is not as yet, an ongoing negotiation between the values of tradition, the structure of the inherited canon, and the forces of innovation and change. It is in such a museum that the fabric of our being, the naturalized values that have determined our attitudes to experience, might be challenged so as to be susceptible to reconfiguration and revision.

Global Museums versus Local Artists: Paradoxes of Identity between Local and Global Understanding

ANNA MARIA GUASCH

A little over a month ago a multimillion-dollar contract was signed between the New York-based heads of the Guggenheim Foundation and several Brazilian politicians concerning the project for a new Guggenheim museum in Rio de Janeiro, Brazil, in the Citade das Artes. Thanks to this project, according to the Brazilian politicians' official version, Rio would recover its former prestige and once again come to be known as "the Paris of the tropics."

There is no doubt, from what I have both seen and read, that the building designed by the French architect Jean Nouvel is a wonderful example of talent and cutting-edge technology, a new, Gehry-style tour de force. Yet how can one turn a deaf ear to all the criticism this decision has provoked? Namely, that it is a preposterous idea in an overpopulated city with serious infrastructural and poverty problems. If Guggenheim branches might seem to be appropriate in other contexts, even sources of pride, the fact is that in so-called developing countries, they might also evince, as a good part of the criticism points out, a certain sinister tone.

It is no surprise, then, to find out that in Rio, as was also the case in Bilbao, this decision immediately generated controversy. In both the city of *favelas* and the Ministry of Culture (headed by the singer Gilberto Gil) mayor César Maia's plaything has received all kinds of criticism: for its extraordinary cost ($250 million), its architectural quality, its disproportionate scale, its dubious value to the urban environment and, in short, for having absorbed resources that might have been directed toward other unfinished projects or indeed toward aiding the survival of more than one hundred museums and other cultural institutions in the city. The list of objections is long, and strong opposition to the museum (not only from institutions, but also from artists, activists, and politicians opposed to

mayor Maia) has even culminated in a legal suit claiming that it is too luxurious a project for a city in dire need of funding for education, health care, and other social programs.

And now that more than seven years have elapsed since the Guggenheim branch in Bilbao opened its doors, the Rio situation is scarcely coincidental. It essentially reproduces the same questions and controversy that it generated in Bilbao: Will a building resembling the set of an underwater world worthy of Jules Verne—a site that unites the two great formulas of the culture and tourist industries: the aquarium and the museum—help Rio's quest to be considered among the great constellation of world cultural and tourist centers? Will it help regenerate, using a model of prestige imported from abroad, a country with great potential, but continually frustrated and beset by a considerable problem of self-esteem? Of course we don't yet know. However, as pointed out in an article entitled "It Worked in Bilbao. Will It Succeed in Rio?" the only problem is that the inhabitants of Rio are not sure they want it, and as such, "Rio will lose."

At the core of what has happened with the Guggenheim *de nouvel* in Rio, and significant other themes to consider, are the following questions: Is it possible, in a neoliberal and neocolonial world dominated by global capitalism, for global conflicts to reconcile talent, international influence, and an ethically acceptable attitude? What happens to the model of a global museum, as in the Guggenheim case, when confronted by regional or different values or the emergence of the local and particular, as happened in Bilbao and is happening in Rio? Why does this global face of postmodernity decree that the best way to regenerate a city—turning it into an international tourist destination and a paradigm for innovative new architecture—should stem from a "global" museum?

The White-Box–Postmodern Museum

Museums that now have nothing to do with the white box of modernity or its denial by postmodernity[1] have lost their Eurocentric nature and, in a way similar to global exhibitions (Kassel, Venice, peripheral biennial exhibitions) have been consumed by "geopolitical anxiety." That is, they have been consumed by a nervousness provoked by contemplating both regional and identity values, as well as the emergence of local, particular, and smaller histories or micronarratives. Here, the "Guggenheim model" fits in.

The "Guggenheim model" breaks a long tradition of "museums of modernity" eager to demonstrate the best "international work" (represented, for example, by the New York Guggenheim and MoMA in New York). With the Bilbao Guggenheim, the "white box" museum as a container came to an end, yet so, too, did the idea of museums linked to great centers of power or major art capitals: New York (MoMA), Paris (the Pompidou) and London (the Tate), all museums dominated by "international" mainstream languages, a highly hierarchical and elitist vision, and a monoculture centered around an ethnocen-

1. *On the Museum's Ruins* was the title of one of Douglas Crimp's paradigmatic texts (Cambridge, MA.: MIT Press, 1993).

tric Western axis.

As early as 1976, in three articles published for *Artforum*, Brian O'Doherty described the modern space of the gallery as one constructed according to laws as rigorous as any employed in building medieval churches.[2] The underlying principle of such laws, according to O'Doherty, was that the external world should not penetrate this space: that windows should remain closed or even sealed, walls should be painted white, and ceilings should be converted into the sole source of light. Only then could art, free of everything external, take on its own life (what O'Doherty terms the "eye," discussed below). Works of art, like religious truths, would thus appear "untouched by time and its vicissitudes." Moreover, this condition of appearing "outside" or beyond time implied that the work would subsequently pass over into posterity. Art would therefore exist in a kind of eternal display, and this perpetuity would in turn safeguard in these exhibition spaces a symbolic status, an artistic posterity, an eternal or inaccessible beauty, and the qualities of a masterpiece.

Furthermore, these ritualistic spaces would function as a way of symbolically reestablishing the ancient navel that, in a mythological context, had on occasion been seen as connecting heaven and earth. And how did this white box deal with the presence of the spectator? To place oneself before a work of art involved, writes O'Doherty, a kind of absence of oneself in favor of the "eye of the spectator." Here he understands the term "eye" to be an incorporeal power that focuses only on formal and visual meanings. And by the term "spectator," he understands a type of shadow of oneself in which everything loses importance and is relegated to a second level with the exception of the "eye," understood as the "eye of the soul." Within the "white cube," we cannot laugh, eat, drink or sleep. We are there only in the condition (as in religious sanctuaries) of "spiritual beings," facing "pure forms" dominated by the eternal and the transcendent.

For modernity, then, the white box was the temporal complement of a monolithic kind of internationalism, a type of heroic supernatural phenomenon emerging out of the faultless ingenuity of the "West" and marked with a capital "I." However, for a postmodernity marked by the "ruins of the museum," the exhibition and the art center (*Kunsthalle*) transformed into the mythical imaginings of the nation as a sovereign political community. One only need recall how, during the 1980s, the Martin-Gropius-Bau in Berlin or the Royal Academy in London transformed—through exhibitions like A New Spirit in Painting and Zeitgeist (1981 and 1982)—into standard bearers of reevaluating a nationalist narrative that saw the nation as some kind of transcendent, continually reconfiguring whole.

The Global Transnational Museum

With the irradiation of the globalization phenomenon and its ideological supplement, liberal-democratic multiculturalism, and the emergence of a depoliticized global market (with a neutral reality, according to Slavoj Žižek), it was clear that for both the museum of

2. See the reprinted version of these articles in Brian O'Doherty, *Inside the White Cube: The Ideology of the Gallery Space* (Santa Monica: Lapis Press, 1986).

modernity and the nonmuseum of postmodernity, things were going to change, seemingly for the better.

Everyone was confronted with the necessity of recoding the concept of internationalism, although not only as a mere change of codes or with the addition of the prefix "new," but by transforming the object itself, beyond what would be merely a new façade or outer wall, as was the case with postmodernity understood as semblance or spectacle.

This was a situation in which, as contended by Michael Hardt and Antonio Negri in their *Empire*, there were now no centers of power or artistic capitals. "Where is the center?" they asked, in an empire understood as a new global form of sovereignty composed of multiple national and supranational organisms: "Where is the mainstream?" "Where is the capital?" And they were forthright in their answer: Where the power and money is, whether in Los Angeles or New York or in new "non-Western" global cities such as Johannesburg, Dakar, Havana, Shanghai, São Paolo, or Hong Kong.[3]

In a situation where, at least theoretically, there were no fixed frontiers, limits, or boundaries in a new "nonplace" cartography, Thomas Krens's idea of "theoretically" creating a museum model as a "*lingua franca*" was very clear.[4] At the same time that the "geopolitical" regime might now replace the terms "geography" and "identity" with "style," the "local" might now live equally together with the "international." This was a museum in the form of an "empty setting," an ensemble of abstract and atemporal forms that would be put into practice by narratives (roots) of place, by its particular metaphors and symbolisms. Finally, nothing would be surrendered to: The local would live on an equal footing with the international or global.

In this, Thomas Krens truly was a standard bearer. First, he conceived of this new museum model. Then he found (through atypical means) a peripheral city outside the mainstream, a city laden with but at the same time in search of new symbols for its self-affirmation. It was a city where people had spent a lot of time deeply thinking about its economic and cultural regeneration and had no trouble (at least its politicians had no trouble, in this "desperate" situation) in believing in the atypical project that presented a museum as the key to its salvation. And who knows? Bilbao, which has always cherished a certain (and at times shameless) grandiose vocation, might end up becoming the cultural capital of Europe. Indeed, Krens said as much in a 1994 interview for the newspaper *Deia*.

However, what Krens probably didn't comprehend was the "discursive nature" of place (Bilbao and, by extension, the Basque Country). Bilbao, for example, was not only a geographical point on a map (if at all possible, for Krens's purposes, a point with an airport symbol next to it), as was the case with so many English industrial cities (like Manchester) that all looked the same. It was a field of knowledge, an area of cultural exchange and debate or, as Lucy Lippard observes, a holistic vision of place with inter-

3. See Michael Hardt and Antonio Negri, *Empire* (Cambridge, MA: Harvard University Press, 2000).

4. In the world of art, Conceptual Art and Minimalism, of course, also have been lingua francas, not to mention franchises.

sections between nature, culture, history, and ideology—in other words, a text of humanity. Therefore, the place—and perhaps Krens did not understand this—was "a portion of land/town/cityscape seen from the inside, the resonance of a specific location that is known and familiar, the external world mediated through human subjective experience."[5]

Bilbao was neither a neutral container nor an emptiness at the margins of social interaction, but rather, as Lippard points out, a "geographical component of the psychological need to belong somewhere, one antidote to a prevailing alienation."[6] Bilbao and the Basque Country were and are, have been and will be, idiosyncratic and vernacular city, community and society. This was a society that, in very general terms and as María Jesús Funes observes,[7] suffered two opposing dynamics: one linked to technological development and the values associated with this development and the other the product of a traditional, almost premodern and pre-Enlightenment society in which symbolism was still very important.

To what premodern feelings am I referring? This mentality was characterized by a confusion between the private and the public. As such, outward-looking values were less important than those of family or the local fiestas, and there was an extremely strong sense of internal solidarity. The realm of expression, according to Funes, was the public square, neighborhood, and municipality. Thus, while civilization progressed toward an indiscriminate culture of the masses, the premodern vision of the world remained the construct of a more human scale, one in which an individual's capacities could more easily comprehend. Solidarity, mutual aid, and community were clearly established and did not dissolve under legal abstractions. There also existed a tendency to consecrate everything, from the language (Euskara, or Basque, a pre-Indo-European tongue) to the buildings. As a result, the power of small, yet significant symbols affected, on a daily basis and structurally, the ideology of Basque culture.

What Thomas Krens almost certainly didn't know was that the Guggenheim project could never be exactly the same in his initial European candidates: Venice (the first location he presented to the project's judges), Salzburg (where a plan existed to empty a mountain and install the museum inside the space, but which ultimately collapsed amid conflict between local and state administrations, despite the fact that models had been made of the project), or Vienna (much the same thing), nor would the project have been the same in Madrid, Seville, Barcelona, or Bilbao. Indeed, the latter was a city that, when negotiations began in 1991, would surely have been known to Krens only for its terrorist past and present. Bear in mind that when people began to hear about the project in New York circles, Krens had to withstand a hostile campaign by the American press, as demonstrated by an article in the *New York Times* arguing that Bilbao was the "Spanish Albania of the north."

5. Lucy Lippard, *The Lure of the Local: Senses of Place in a Multicentered Society* (New York: The New Press, 1997), p. 7.
6. Ibid.
7. María Jesús Funes, *La salida del silencio: Movilizaciones por la paz en Euskadi, 1986–1996* (Madrid: Akal, 1998).

In this way, from the point of view of the technological dynamic, a project like the Guggenheim might make sense, immersed as it was in a revitalization plan for the city of Bilbao after the demise of the industrial era and recasting it in an essentially service-based market—as, indeed, it was obliged to do by postindustrial capitalism in a developed technological region that possessed (among other things) a subway designed by Norman Foster and the Euskalduna Conference and Events Center. However, the traditional dynamic, the constant presence of premodern (rather than antimodern) sentiment that, for example, explained the persistent importance of strong religious feelings in the Basque soul (more along the lines of a prehistoric or prereligious spirituality, or stemming more from an aesthetic spirituality closer to Taoism or Buddhism than from confessional Christianity), the importance of race (from the founder of Basque nationalism, Sabino Arana), and the role of the language (Euskara) as an exclusive nucleus of Basque identity would also explain the "unsuitability" of the project. Globality encompasses, above all, a horizontal and simultaneous discourse while it maps its terrain, yet it crashes when confronted by local historical, anthropological, and mythical density, as is the case in Bilbao.

Opposition to the Guggenheim: "A Journey in the Desert"

Within this context, strong opposition to the project in Bilbao originally emerged. However, while such opposition still exists, it is at present quite minimal. The opposition can be explained both from an artistic point of view and especially from an ideological and territorial perspective. "It was like a long journey through the desert," observed the museum's director, Juan Ignacio Vidarte, on several occasions, while the architect Iñaki Uriarte had already claimed, in an article titled "Guggagression" in the (now defunct)[8] newspaper *Egin* that,

> this is a trick and the grave that the PNV [Partido Nacionalista Vasco, the Basque Nationalist Party, the moderate conservative and hegemonic party in Bilbao and the Basque Country], aware of the fact that in order to exterminate the soul of a people one only need destroy its culture, has prepared for Basque culture... Our society, the contributing citizens, haven't yet realized the magnitude of this catastrophe, both economic and cultural as well as one of self-esteem, of this enormous scheming swindle that we're all having to put up with. It was a low blow, a treacherous destruction of the development and dissemination of all the arts in cutting budgets, programs, grants, and all kinds of aid. It's the same kind of watershed that was produced by the pro-Franco uprising in 1936.[9]

On the one hand, one could sense at the time a feeling of surrender to an international culture with an American imperialist veneer. It was also believed that investment in

8. The radical Basque nationalist daily newspaper *Egin* was closed down by the Spanish police on the orders of the Audiencia Nacional (a special court dealing with terrorism and drug-related charges) in July 1998 for alleged links to ETA. These links were never subsequently established.

9. Reproduced in *HEIM* 31, October 12, 1997.

art was unprofitable. Indeed, at the beginning of the 1990s, the idea of a museum as a major engine of change still seemed strange. There was also a kind of territorial opposition based on the chosen system of priority. And if the gamble was purely an economic one, wouldn't it have been better to begin with a huge business center or mall? But if they were opting for art, why not choose other museum models closer to the concept of culture than to that of show, and above all in harmony with the local (Basque) and national (Spanish) artistic community? Neither was ultimately considered in the philosophy and scenography of the museum: Its three great symbols were ultimately Gehry's nonanthropomorphic design, Koons's dog, and Serra's snake.

The Basque arts community has launched numerous campaigns against the Guggenheim,[10] but I'd like to pay special attention to one that took the form of an exhibition entitled Prometeo encadenado (Prometheus bound). A few days before the official opening of the Guggenheim in October 1997, the show opened with works by 123 artists at the ARSenal gallery, an alternative space only a few yards away from the museum. The exhibition contained 155 works in different media—paintings, digital prints, postcards, collages, and assorted objects (music boxes, a Basque beret, doodles on napkins, Havana cigars, and so on)—but what really stood out was its festive, incisive, and ironic tone. It was reminiscent of a film that nearly forty years earlier had catapulted its director, Luis G. Berlanga, to fame with its particular version of Italian neorealist humor: *Welcome, Mr. Marshall* (1952). Berlanga used his fine irony to talk about the isolation that for the last two hundred years had defined Spain's international standing, only emphasized by Franco's dictatorship. The film also dealt with Spain's transformation into a semicolony and the shameful tendency of the "respectable" elites to side with whichever empire was ruling the day.

In the same way as Berlanga sneered at the Franco government's subservience to the Yankees with his brilliant, ironic gaze (the plot revolved around the high expectations raised by the Marshall Plan in 1950s Spain and the subsequent disappointment at its unfulfilled promises), the show in Bilbao sharply criticized the Basque government for having surrendered to yet another manifestation of "Imperial Power."[11]

As Serge Guilbaut points out in a very interesting essay,

> like Jean Cassou in 1952, Bilbao facilitates, for local internal reasons, the installation of U.S. cultural production on its walls. In the 1950s in Paris it was the desire for the French estab-

10. In an open letter to the minister of culture in the Basque Autonomous Government, Joseba Arregui, Jorge Oteiza compared the Guggenheim project to the same threat posed by a proposed nuclear power plant in Lemóniz (Lemoiz), Vizcaya (Bizkaia): "The analysis of economists with that of sociologists and architects has been published in numerous studies denouncing the barbarism of this Operation Guggenheim and multimillion-dollar fraud; no notice has been taken of them; they haven't made any difference. The rumors I related to Durana linked the Guggenheim project to Lemóniz. The threat that the nuclear plant represented is comparable to the threat of the Guggenheim to the cultural health of our country and to the energetic creativity and life of our artists and creators." Jorge Oteiza, "Se acabó el Guggenheim. Carta abierta a un consejero," *Egin*, May 13, 1993.

11. Joan Arnau, "Bienvenido Mr. Marshall: Vinieron y se quedaron," www.uce.es/DEVERDAD/ARCHIVO_2003/01_03DV01_03_30mrmarshall.htm.

lishment to combat communism which made this alliance crucial and viable. Today it's the lure of economic help which pushes Bilbao to deal with the Guggenheim. On the other hand, if in the 1950s the cultural terrain was the prime place for ideological battles against communism, today, such a move by U.S. culture has to be seen in relation to the new world order in which Europe has become an open field where competition can develop without fear or internal communist party alliances. The battle for the mind of Europe is open and will be a tough one. The Guggenheim Museum in Bilbao might well be a first beautiful salvo. The battle has already pitted two very different types of societies represented by their cultural productions. But the intense debate in Europe about ways to minimize this "Americanization/modernization" of the continent seems to have received its first blow with the arrival of the Bilbao Museum… The Bilbao Museum is the first major U.S. attack on this new war front, mixing all the traditional ingredients of power, influence, sympathy, status and emotion; U.S. dollar corporate power is displayed here in a very sophisticated way, reminding us of the potlatch tradition.[12]

This power was embodied in the figure of Thomas Krens, who in 1997 published a manifesto that he would subsequently repeat ad nauseam in interviews and inaugural speeches. I'll extract its principal points:

> In a postmodern world after the Cold War which invites democracy and dialogue, and which favors awareness and identity, cultural battles are more and more noisy…

> Within this context it is just possible that art museums, as we know them [the white cube], find themselves at a critical junction in the history of their development. That museums of the future won't retain the same formula that they have had for the past two hundred years is an obvious conclusion. One cannot deny that for some time now there has been a certain anxiety and precaution in the atmosphere. One could say that during the last ten years museums have been collecting candles, perhaps waiting for the apparition of new and more welcoming plans…

> … It was precisely at this moment that the Guggenheim dared to take the first, apparently bold, step of tripling its physical space in New York. It has embarked upon expanding the reach of its permanent collection; it has increased the number of special exhibitions; it has substantially strengthened its Venice museum and collaborated with governments and institutions to create new permanent museums abroad. The principal objective goes beyond the mere survival of the Guggenheim. The new Guggenheim must also be at the forefront of an evolving cultural project in its widest sense; it must construct great buildings; it must organize great exhibitions; it must collect and administer great works of art; and it must invent new administrative methods to foment and aid these creative activities…

> … Because the secondary objective which complements this is the need to safeguard the economic survival of the Guggenheim as a cultural institution. For this, the museum must situate itself in a position from which it attracts the most people possible, develops stable sources of working income that exceed its expenses…

12. Serge Guilbaut, "Recycling or Globalizing the Museum: MOMA-Guggenheim Approaches," *Parachute* 92, no. 7 (October–December 1998): 66.

… The Guggenheim was founded in 1937 to fulfill four main goals: to gather, preserve, interpret and present twentieth-century objects of visual culture. However, seventy years later the museum must adjust to the future; so as not to cease being a great institution it must define itself as a new and daring institution… With the inauguration of the Guggenheim Bilbao we have taken a giant step towards defining this future. When the new museum begins to operate within a context of museums in the United States and Europe, a new model of museum alliances will take shape… None of this would have been possible without the Basques, without their vision and leadership. In developing this new institution the Guggenheim has become Basque. Its hopes and aspirations are now ours; Basque culture will influence the program of the international Guggenheim in the same way that it will come to occupy an essential place within this new museum.[13]

Yet the Guggenheim did not become Basque, nor did Basque culture influence the international Guggenheim's program, and according to the official figures for visitors, there has been a greater and greater deviation between the museum and its location. Take the figures for visitors in 2003, for example: Since October 1997, 6.3 million people had visited the museum. In 2003, this figure was 875,000, 2 percent more than in 2002. There are more and more foreign visitors, making up 59 percent of the total (it is the Spanish museum second most visited by foreigners after the Dalí-Gala in Figueres, Catalonia). The numbers of national (Spanish) visitors have leveled off, and there has been a noticeable (some might say alarming) decrease in visitors from the Basque Country, which the museum directors don't officially measure as part of their statistics.

Let's now consider an analysis of, or commentary on, the program of both temporary and permanent exhibitions. As regards temporary (blockbuster) exhibitions, from 1997 to the present, there has been only one exhibition about a Basque artist: Chillida, 1948–1998, in 1999, and more recently another on one of the most valued Spanish painters in the international market—Manolo Valdés. Moreover, in a thematic exhibition—La torre herida por los rayos (Lo imposible como meta) (The Tower wounded by lightning [The impossible as a goal])—some Basque artists were included. As for the rest, there have been exhibitions on first-wave (Calder, Matisse, Degas, Picasso) and second-wave (Johns, Paik, Serra, Rosenquit, Rothko, the last two being advertised) avant-garde artists, as well as show-exhibitions (a history of motorcycles and the Armani collection) that could also been seen at its New York base. As regards the permanent collection, only two collective exhibitions have included Basque and Spanish artists, Arte Contemporáneo Vasco y Español in 1999 and Transparencias in 2003, including work by Javier Pérez, Cristina Iglesias, and Juan Luis Moraza.

As regards the blockbuster exhibitions, one could point out that in most cases (and of these the retrospectives on Robert Rauschenberg and Andy Warhol are clear examples), some of the key works that were displayed in New York were not brought to Bilbao. In other cases, such as that of Helen Frankenthaler, while in New York the exhibi-

13. Thomas Krens, *Guggenheim Magazine* (Fall 1997).

tion was presented during a moment dominated by exhibits by De Kooning, Gorky, and Rothko, in Bilbao, it appeared totally decontextualized and devoid of its original meaning.

We have seen that in the case of Bilbao, globalization breaks down in the face of the density of the local Bilbao. Here, paradoxically, the opposite has occurred: the global has not tolerated, but rather has suffocated the local (which is also international). As the Swiss architect Jacques Herzog argues, the Guggenheim in Bilbao is a cynical example of a global company's global behavior. And although it may be one of the best, or indeed *the* best, examples of Gehry's work, as a museum, it demonstrates a basic lack of interest, principally in the way that the work is displayed in those vast, empty spaces, without any kind of regard to the city or its people.

It is, remarks Herzog, like a foreign object deposited there for a while, like a piece of land artwork subject to processes of entropy, or as if the Smithsonian had rented, on a twenty-year lease, the Great Salt Lake for its *Spiral Jetty*—the time envisaged for nature to run its course and completely absorb the work. Curiously, the rental period on the Guggenheim Bilbao is also twenty years. And one day, in accordance with the Guggenheim strategy of presenting itself as a global brand, it would once again move on, instead of using art as an instrument of change, or something more in tune with the community of local artists. Ultimately, observes Herzog (and something with which I wholeheartedly agree), "art needs to be established in one place, and from there move to another place. One cannot import it as if it were a Starbucks. This is a model without any future, as the present crisis in the Guggenheim organization demonstrates; it's a coarse and stupid system, based solely on vanity."[14]

The Building: Site and Nonsite

From another perspective, and following Robert Smithson's reflections on site and nonsite,[15] Gehry's Guggenheim clearly seems to be a nonsite, that is, an all-purpose building that was originally conceived for the Walt Disney Concert Hall in Los Angeles and used as a testing ground in a (never ultimately realized) project for the Mass MoCA—a gigantic museum located in twenty-eight industrial buildings in North Adams, Massachusetts: "a kind of general experiment. The great show would take place in Bilbao." Gehry's building might also have been constructed in New York, if the Guggenheim's ambitious and aggressive, almost commercial plans for expansion had not been put on hold.[16] This, then, was a non site in constant tension and a continual self-affirmation against a specific site, Bilbao. Indeed, following the recent findings of Miwon Kwon,[17] one might characterize Bilbao as not only a physical (grounded, fixed, actual), but also as a discursive (unground-

14. Quoted in Luis Fernández Galiano, "Dialogue and Logo: Herzog Thinks Aloud," *Arquitectura Viva* 91, nos. 7–8 (2003): 125.

15. See *Robert Smithson: The Collected Writings*, ed. Jack Flam (Berkeley: University of California Press, 1996), pp. 144–56.

16. The early 1990s U.S. wartime economy claimed one of its first victims in the Guggenheim in the same way that it would claim another in April, 2003, when plans—drawn up by the architect Rem Koolhaas—to extend the Whitney Museum of Art were suspended. Apparently the victims of war are not all to be found in Baghdad.

ed, fluid, virtual) space—in other words, with an identity understood in both locational and conceptual terms.

Let's start by analyzing the building as a nonsite, that is, the building itself, which is undoubtedly one of the most beautiful(?) spectacular(?) or masterly(?) to come out of the Gehry factory. Gehry himself has recognized that the Guggenheim in Bilbao and its "idea of heaven" changed his life. However, rather than just list the superlatives associated with this architecture conceived as art, in which form dominates the structure and its function, let's consider it as an architecture labeled "deconstructionist," even though Gehry doesn't like this term, as an architecture that was born in a scrawl on a piece of paper, but that only sophisticated computer programs could transform into structures complying with the laws of gravity. This is a building that enjoys a certain unanimous pedigree among Gehry's colleagues—"the greatest building of our age," according to Philip Johnson; "a fantastic building," in the words of Sver xe Fehn (winner of the 1997 Pritzker Prize). "I was very moved by the creativity and poetic freedom that are implicit in its creation." "An extraordinary example of symbolic architecture," according to Terence Riley.

However, I have always thought that this building, in a shape resembling Gaudí's modernism and, going even further back in time, the Baroque tradition of Borromini,[18] was merely a screen building, a decoration inscribed on splendid scenography; the Abandoibarra neighborhood of Bilbao, next to a river, a (steel) bridge, and a valley and almost inventing a new genre of architectural sculpture or urban architecture: a "landscape of image." And all this was thought up closely in line with a spectacle-based society and cultural tourism.

I have always believed that here architecture operated as a pure and abstract form of experimentation. This is architecture that in its maximum state of sophistication and paroxysm reveals more about the architecture itself—the material, shape, and design—than about perception—in other words, about where it is located, what space it occupies, from where it is viewed, and who looks at it. Here there is no "innocent investigation," as Herzog states in reference to how an architect or an artist—he was talking about Bruce Nauman—engages those around him or her, trying to establish connections between the body and any material that might shed some light on how the world functions. Architecture is, therefore, not a tool of knowledge.

Moving on to another kind of reflection, if art and architecture are being transformed into political tools, as seems to be a sign of our times or our zeitgeist,[19] it is because they are closer to their emblematic or labeling component than to an investigation or explo-

17. Miwon Kwon, *One Place After Another: Site-Specific Art and Locational Identity* (Cambridge, MA: MIT Press, 2002).

18. Indeed, both Gaudi and Borromini clearly represent a classical Mediterranean artistic tradition. The connection between Gehry and Borromini has been pointed out by Kurt W. Forster: "If one examines historic architecture in search of buildings that might presage what Frank O. Gehry has been able to achieve, one is likely to pay attention to Francesco Borromini." Kurt W. Forster, "Frank O. Gehry Guggenheim Museum: Bilbao, 1991–1997," in *Museums for a New Millennium: Concepts, Projects, Buildings*, ed. Vittorio Magnago Lampugnani and Angeli Sachs (Munich: Prestel, 1999), p. 129.

ration sheltered in autonomy and in the white cube of the modernist paradigm. As Herzog points out, "as a European, I need investigation, freedom, dialogue, all those things that seem so ingenious in order to construct materials which form part of our culture." That's why I originally referred to the idea of unsuitability or inadequacy. I believe that a work such as Gehry's building makes sense only from the logic of modernity, as a masterpiece implied by its unique, original, and atmospheric nature. And one shouldn't believe that this is necessarily the case.

By Way of a Genealogy of the Problem

The project was originally thought up for the Walt Disney Concert Hall that opened in October 2003 in Los Angeles. And to tell the truth, with the exception of its material and scale, the sculptured shape of this organic-statuesque-metaphorical building, of this moving architectural object that defies Euclidean laws (thanks to use of the CATIA computer program),[20] is the same as in Bilbao. The original idea, "deconstructionist" curves that, as I will later argue, might have originated in the development of Oteiza's macles, or twin diamonds, presented at the Fourth São Paolo Biennial in 1957 and based on the persuasive power of images, was already foreshadowed in 1988, five years before the Bilbao process took shape, in the city of Los Angeles. However, as a result of budget problems, the project was put on hold for fifteen years. And when Gehry designed this exceptional building, sheltering in the traditional aesthetic values of originality, authenticity, uniqueness, authorship, and above all "aura" (so disputed by Walter Benjamin), he did so in relation to a metropolis: Los Angeles, and one of its main attractions, the Hollywood dream factory. The deduction is obvious: Following Marx (1852) and his famous argument that "history occurs twice, the first time as tragedy, the second as farce" in *The Eighteenth Brumaire of Louis Bonaparte*,[21] it seems clear here who occupies each role. Furthermore, as we all know, Bilbao is about as far removed from the Hollywood dream as one can get.

Another similar, although much more spectacular, project (another nonsite) would almost certainly have been built in New York, had it not been for the attacks of 9/11, which brought all cultural projects to a halt. The project would have been realized right where Wall Street meets the Hudson River, on three abandoned piers in the heart of the Financial District. The museum would have been twice the size of Bilbao's and would have attracted between two and three million visitors a year, generating $280 million in annual commercial revenue. Like Bilbao's, it would have been built from titanium (titanium as

19. The Biennial at the Whitney Museum of Art that opened in New York in March 2004 defined itself as the best thermometer of cultural zeitgeist—the spirit of the age—in the United States. Through a nostalgic recovery of the 1960s and early 1970s protest culture, centered on the figures of Robert Smithson and Zak Smith, political, psychedelic, and fantastic works of art were on display, projected in a postapocalyptic time following a cataclysm.

20. In Bilbao, as Forster points out, Gehry used programs that were developed for the design of airplane fuselages, but that in this case provided the matrix for the shaping of every part and the refinement of every element in the design and construction of the museum. See Forster, "Frank O. Gehry Guggenheim Museum," p. 129.

21. See Karl Marx, *The Eighteenth Brumaire of Louis Bonaparte* (New York: International Publishers, 1964).

an alternative to stainless steel because, according to Gehry, "it will survive in pristine condition for a hundred years"), glass and stone. It now only exists as only a model. Therefore, faced with so much "repetition," where are those traditional values of originality, authenticity, uniqueness, and authorship that a masterpiece of these dimensions implies?

First Conclusions

It seems obvious that the Guggenheim works from the perspective of a physical place—in a geographical and landscape sense—a good example, in fact, of site specificity understood in the traditional way and the complete opposite of what happened, at least from the governors' point of view, to Serra's *Tilted Arc* in the Federal Place. However, as a discursively determined site, it also seems clear that there is a lack of harmony, dialogue, and understanding. The truth is, I believe, that there is less and less sense in applying the qualifying word "masterpiece" to any old public or institutional building (there were such buildings before, by Le Corbusier and Mies, Louis Khan, and so on), but instead that one should look for the conceptual risks that architects have taken—defining their role in the public (and the political) sphere. Clearly, from this perspective, Gehry's Guggenheim begins to display its biggest fissures, its most obvious contradictions, and its most flagrant paradoxes and self-contradictions.

I believe that one of the greatest paradoxes or fissures is that a culture clash has taken place, something very close to the method of Romantic art, a Romanticism designed in the sum of its contradictions and paradoxes. It is a clash between the old and new Euskadi (Basque Country), between the presymbolic and the global, the postmodern and the modern, the West and the Indo-European, the classical and the prehistoric, and finally, between the traditional and the international.[22]

The German Neoexpressionists Anselm Kiefer, Georg Baselitz, and Jörg Immendorf recovered their roots as a temporal "continuum," as an aesthetic canon and as a constant anthropology of interpreting the characteristic Northern European world of art—a continuum that would incorporate a list from Mathias Grünewald to the Romanticism of a Novalis, or from the Danube School through to Ferdinand Holder. For Basque artists, that autochthonous sentiment of the particular and existential would find itself in prehistory, in the cromlechs—small structures composed of stones that form a circle of between two and five meters in diameter, *the* monument par excellence, empty and impervious to erosion by time. In the space of these small and sacred enclosures, empty and pure, the sculptor Jorge Oteiza saw the meaning of the void in the abstract vanguard.

22. As Jorge Oteiza argues, "We're experiencing the inflation of Greek art. It would never occur to us to mention anything more than our Arab heritage and, going back [further still], our Roman heritage, and one step further, our Phoenician heritage… Before the Arab, before the Roman, before the Phoenician, all Spaniards were Basque, if they recognize their original European roots… Today, I appoint Lascaux and Altamira—as a personal and conclusive discovery—to the empty statue of our Neolithic cromlech, for our recognition of the spiritual creative Basque." *Interpretación estética de la estatuaria megalítica americana* (Madrid: n.p., 1962), p. 29.

I do not believe, however, that Oteiza would have identified very much with the "warm and beautiful" titanium, accustomed as he was, like other artists of his generation such as Chillida, to living with iron and steel. We do know that, as with many artists of his milieu, he didn't like colossal works. Indeed, he commented on several occasions that very large statues are meant for cretins, people who feel themselves to be somehow bigger on viewing such work. However, what I am virtually certain of is that neither Serra's steel snakes, repeated ad nauseam by everyone (perhaps as franchise sculptures or lingua francas), nor the anti-anthropomorphic nature of the Guggenheim itself (whose metaphorical model is a fish) counts for a generation of artists—some painters, but mainly sculptors—who were schooled first in the Cubist and then in the Constructivist tradition, with the difference that here, this Constructivism was neither abstract nor purely rational, but rather planted its roots in a prehistoric past and in some of its most emblematic totems: the Neolithic cromlech and the cave.

Oteiza effectively sought in the cromlech the archetypal essential forms, such as the square, the cube, the circle, and the sphere, that appeared as "metaphysical boxes," in modules, macles, and polyhedrons, with which he sought the "liberation of energy in the Statue." This was the same radically experimental sensibility that made him write his "Propósito experimental" (Experimental proposal) of 1956–57[23] and that compelled him to create twenty-nine sculptures grouped into ten experimental families, constructions made out of Malevich units or cuboids in the polyhedron world, like the series based on the principle of mobility in the spherical world that won him the International Grand Prize for Sculpture at the Fourth São Paolo Biennial in 1957. These sculptures, which so fired Le Corbusier with enthusiasm (in the Oteiza Foundation's archive there is a letter of congratulations), like his "Propósito experimental," argued for a process of reductionism (similar to Malevich's) tending toward the elimination of the physical or corporeal nature of the sculpture, which, disoccupied and converted into a void, attained a "meta-aesthetic and transcendent" meaning:

> I reconsidered, following Malevich, a logic of disoccupation of space by the fusion of formal inconstant units, against the system of opening up voids through the fusion of great masses. But only now, a year after persevering and continuing with this experimental stage, have I managed to finish a correct understanding and calculation of the active and functional nature of the void. This void succeeds in breaking its relationship with formal material to the point of being independent, isolated, motionless, spiritually inhabitable and defined, aesthetically, by a formal dynamic, open, flat, and silent wrapping.[24]

23. The "Experimental Proposal" was the title of the text written by the artist to accompany his sculptures in the fourth São Paolo Biennial in 1957. It is published in English in *Oteiza's Selected Writings*, ed. Joseba Zulaika (Reno: Center for Basque Studies, 2003), pp. 220–44.

24. Jorge Oteiza, *La escultura contemporánea se ha detenido (carta abierta a André Bloc)* (Irún: n.p., 1958).

Oteiza thus freed the work from language in order to elevate the void aesthetically —a metaphysical void, within himself. For that reason, his *Metaphysical Box* series, his *Experimental Conclusion No. 1* and *Disoccupation of the Sphere: Experimental Conclusion No. 2* (1958), and *Homage to Mallarmé: Experimental Conclusion No. 3*, together with his sculptures shaped by metallic plates or sheets, have to be understood as a box or place where the sculpture—the empty space—is kept.[25] Moreover, with these sculptures Oteiza decided his process and work as a sculptor was finished, explaining the decision in an open letter to André Bloch in which he manifested a comparison between historical styles and his personal evolution.

Thus, after an experimental trajectory lasting twenty-five years, his sculpture reached a final, conclusive phase in much the same way as Mondrian's career did: "Very rarely does this happen with artists. It happened to Mondrian and now to me"—in other words, a final disoccupation of space beyond the limits of formal language. Yet if for Mondrian the integration of art and architecture implied the creation of an architectural space "without" the work of art, Oteiza recovered the work of art from the spiritual space of architecture. Oteiza himself wrote that, "in my conclusions, the work of art is recovered from the spiritual space of architecture—from the interior space like spiritual Furniture—or from an urban space like a metaphysical Insulator and private service for society, but with an art equal to zero (zero as a formal expression)."[26]

Some years later, Oteiza signed and sealed this end of art in a new text, *El final del arte contemporáneo* (The end of contemporary art, 1960) in which he argued that "contemporary art has ended":

> I am going to summarize my reasons for abandoning sculpture. The logical process is somewhat extensive, and on this voyage, in which I find myself as if I were inside a great statue that I previously knew only from outside, I have not found a free moment to devote to it. The sculptor, working within a new vision, does little more than construct a new memory. We finish the sculpture and begin to remember, forward, to live in a different way. Contemporary art has ended. Like everything that truly begins, it truly comes to an end. I am speaking aesthetically. As theory and experimentation. From a poetics, like that of Valèry, it will continue. That is, as a Romantic and popular exercise, as a secondary prolongation, which is what contemporary art is now.[27]

25. Pedro Manterola, "Cinco pasos en torno a la Pasión de Jorge Oteiza," in *Oteiza-Moneo*, exhibition catalogue (Pamplona: Pabellón Navarra, 1992), p. 23.

26. Oteiza, *La escultura contemporánea se ha detenido.*

27. Jorge Oteiza, *El final del arte contemporáneo* (Lima: n.p., 1960). Translated as *The End of Contemporary Art*, in *Oteiza's Selected Writings*, p. 259.

Anti-Guggenheim Discourse: Oteiza and the Alhóndiga

Oteiza is a key figure, seen from what Joseph Beuys might call a pedagogical-social-utopian point of view, both as a sculptor or architect-sculptor and as a social individual, for the construction of anti-Guggenheim discourse. Where the sculpture ended and an area of silence and elimination began, at this zero point of expression, is where the new man was born, one who, as he said, "returns to life, graduated for life," with a new and eternal freedom: ""I understood that I was left without a statue, but alive for the first time."[28] This final void meant that art no longer needed to continue exploring, that it had worked out a feeling for life. The artist was now no longer necessary within art, but rather in life. Within art, suggested Oteiza, artists had run their course, but outside of it they were essential. From here came the necessity of artists projecting their work into education, cultural agitation, and, definitively, into putting art at the service of life and the city. As Oteiza noted in *The End of Contemporary Art*, "In stating that I abandon sculpture, I mean that I have reached the experimental conclusion that it is no longer possible to add sculpture, as expression, either to man or the city. I mean that I'm moving on to the city—condensing all aesthetic knowledge into Urbanism and spiritual design—in order to defend it from the traditional activity of expression."[29]

Thus, Oteiza, through this work in an interdisciplinary space, together with a discourse that combined ideas about art, architecture, and urban design with notions of the public and social space of the city was the craftsman of what was going to be a grand cultural project for Bilbao, initiated in 1988, years before the arrival of the Guggenheim: a center of contemporary art and aesthetic investigation, the Alhóndiga Cube, a glass cube destined to be not a museum, but rather a multidisciplinary center of culture, contemporary art, and aesthetic investigation in a twenty-eight thousand-square-meter space (the same surface area as the Guggenheim, although it would have been much cheaper to build, given that it would have been built on municipal land, the Santiago Apóstol site). Oteiza's project, related to both his own *Metaphysical Boxes* and the architecture of Juan Daniel Fullaondo[30] (whose Minimalist arguments based on the existence of an empty space gave rise to a new shift of emphasis focusing on emptying architecture's center), rested on three elements: a glass-covered square eighty meters high that would function as a multipurpose hall, a completely opaque bridge building, and an open air square. In the same manner as Fullaondo did in his architecture, Oteiza conceived the Alhóndiga building as an ensemble of asymmetrical, sliding shapes, creating a dynamic equilibrium beyond the rigidity imposed by symmetry. And as in some of Fullaondo's projects (such

28. Jorge Oteiza, "Ideology and Technique for a Law of Changes in Art," Address for the Thirteenth International Conference of Art Criticism on Ideology and Technique (1964), in *Oteiza's Selected Writings*. p. 374

29. Oteiza, *The End of Contemporary Art*, p. 259.

30. Regarding Fullaondo's influence, see Jorge Oteiza, "Sobre la obra de Juan Daniel Fullaondo ¿Por qué tuvo Molly que vivir en Gibraltar?" in Jorge Oteiza, *Estética del huevo: Huevo y laberinto. Mentalidad vasca y laberinto. A Juan Daniel Fullaondo. En memoria y homenaje* (Pamplona: Pamiela, 1995), p. 17.

as his design for the Picasso Square in Madrid), Oteiza chose the emptiness of the center as a kind of perverted symmetry: The tension or duality between two similar objects that leave a disoccupied space between them was the major protagonist. "And obviously," argued Oteiza, "without that concept of duality the proposal for the Bilbao Alhóndiga Cultural Center would have been meaningless, where two gigantic cubes in two parallel blocks face one another, equal and different, separated and with their discontinuity accentuated by the bridge that, suspended over the public space of the street, penetrates them both."[31]

This was a complex that Oteiza himself christened an Institute of Comparative Aesthetic Investigation, insofar as it attempted to include all forms of cultural expression, a kind of art factory where an attempt would be made to stimulate cultural creation. It was said at the time that the Basque government rejected it for essentially political reasons. One should note that, once the initiative had failed, the Provincial Council of Vizcaya thought about using the building as a potential site for the Guggenheim Museum. The proposal was rejected, however, by the three architects invited to participate in the competition to design the new museum: the Canadian Frank Gehry, the Japanese Arata Isozaki, and the Austrian collective Coop Himmelblau, which had, by the way, designed a proposal in the form of a cube.

> The cube as an essential modular unit was a constant theme running through Oteiza's later work. Within his universe of geometric forms (not too far from spiritual reality and the higher service of Platonism), Oteiza turned over and over again to the box—stone or metal boxes in which the most important thing was to disoccupy the central void, revealing it as an active power. And if in these laboriously carved stone boxes the exterior facets protected an inaccessible and impenetrable hermetic interior, an interior that denies entry to the outside world, in his empty boxes, the sculptor stripped away the solids of his material. He literally emptied them and made them weightless in order to take possession of the space and make the void noticeable.[32]

Rafael Moneo wrote these words on the occasion of an exhibition dedicated to Jorge Oteiza in the Kursaal, in San Sebastián, in 2000, another space committed to art and culture. One of Oteiza's most emblematic works—and the most important part of the presentation—was the *Laboratorio de tizas* (Laboratory of chalks), the central essence of his sculpture, a materialization of his creative process that demonstrated how his research and experimentation displayed a strong metaphysical element. More than just sketches, here we saw notes, poems, drawings, writings, and reflections on Oteiza's thought, collected together on blackboards in amalgamated fashion and drawn from a lifetime's expe-

31. Ibid.

32. Rafael Moneo, "Oteiza," in *Oteiza*, exhibition catalogue (San Sebastián: Kubo; Kutxaespacio del Arte, 2000), n.p.

33. As the architect Rafael Moneo commented, "I wanted to use laminated glass to create a structure that blends in perfectly with the natural environment of the Urumea riverbank, an abstract, freestanding piece representing a total departure from traditional urban architecture."

rience: In fact, Oteiza frequently observed that he never spoke about what he previously knew, only about what he was, at any given time, getting to know.

This Kursaal in San Sebastián, composed of two gigantic abstract hermetic cubes coated with laminated glass in skinlike fashion, more than belonging to the city, actually forms part of the landscape[33] and is not only a space to exhibit, but above all a cultural space. And this is what, I believe, the Alhóndiga in Bilbao would have been. But such a utopia was not possible, and society fell victim to dystopia. In this case, by "dystopia," is characterized by what cancels out local differences, essential local identities, traditional models of knowledge, and the rich diversity of cultures, or what leads to cultural homogenization—at the end of the day, a greater control by the structures of power. It is characterized by the spectacle of the Guggenheim, this essence of cultural tourism, stellar architecture, massive public attendance, blockbuster exhibitions, and "sinuous and scarcely innocent curves." These—and here I would suggest a hypothesis that is difficult to resist—might be viewed as a postmodern interpretation of Oteiza's macles. I don't believe this is such a preposterous idea. The series of sculptures termed *Maclas* (Macles) was undertaken between 1956 and 1957 and was composed of stone and iron sculptures opened up to space through the fusion of their formal units.

Now, finally, Oteiza will be the second Basque artist—since the Guggenheim opened its doors in 1997—to be exhibited there in a temporary exhibition commissioned by Margit Rowell—another example of the global curator versus the local artist. And I hope that the Guggenheim machine, now without the artist who was allowed to come to rest in his museum and foundation, which opened in the Navarrese town of Alzuza in May 2003, does not present us with an Oteiza as an international artist devoid of the local, the vernacular, and the identity-based, nor that it presents him as an artist whose aesthetic and formal face is blended into a theoretical, didactic, political, anthropological, and, finally, utopian one.

The Franchise Museum:
An Instrument of Cultural Colonization

ERY CAMARA

The following reflections stem from a visit I made to the Guggenheim Bilbao in 2001, after the general meeting of the International Council of Museums (ICOM) and its Comité International pour les Musées et les Collections d'Art Moderne (CIMAM) in Barcelona. I was familiar with the controversy surrounding the Guggenheim and interested in the issue because of the number of innovations that it represented. I thus felt I had to experiment somewhat with this visit to clear up my doubts, or even raise new ones. The unusual aspect of this case was that it was a franchise museum supported by the Basque Autonomous Government, which had invested large sums of money and signed an agreement that remained largely unknown to most Basques. The control of information surrounding the negotiations and the agreement's clauses demanding secrecy from both sides ultimately meant that Basque taxpayers would be paying for something about which they hadn't even been consulted. In a recent publication by Mark W. Rectanus analyzing the transformation of culture into a sponsored industry, and specifically in the chapter dedicated to the global museum, the Bilbao case is presented as the perfect example:

> The Basque and regional Biscay governments essentially paid the Guggenheim to conceptualize, design, and oversee the construction of the museum and to administer it for a twenty years contractual period (which would be extended to seventy five years).

> ... The new museum in Bilbao was a good deal for the Guggenheim. The Basque and Biscay governments paid for all construction costs ($100 million) and ongoing operational expenses and also agreed to pay for all administrative and curatorial services provided by the Guggenheim... The Basque government allocated $50 million to acquire a new Spanish and Basque art collection. However, the best part of the deal (for the SRGF [the Solomon R. Guggenheim Foundation]) was a $20 million tax- free "donation" made to the foundation by the Basque government, which referred to it as a "rental fee" in exchange for loan privileges (access to six thousand works in the Guggenheim collection) and use of the

Guggenheim name for merchandising… The GMB [Guggenheim Museum, Bilbao] was granted exclusive rights in Spain to merchandise products related to the Guggenheim collection as well as the Bilbao museum's own holdings… In addition, the Basque and Biscay governments carried the sole financial liability for the GMB, an agreement almost identical to standard franchising contracts[1]

Without doubt, the Guggenheim clearly came out ahead in this transaction, because it managed both to begin circulating material that in the main had been confined to warehouses through lack of space elsewhere and to achieve an international presence in which almost all the risk had been taken by the local participants. As Michael Kimmelman argues, "all the deals made abroad by Krens implied money for the Guggenheim, but not expenses."[2] Moreover, to imply that the benefit derived from this negotiation was mutual was to overlook the activity and cultural influences organized by the museum itself, such as its exhibition policy. Everyone knows that the art exhibited by museums reflects a certain cultural vision obtained through constant revision. In this case, both the expansionist and visibility models that underpinned the Guggenheim philosophy, together with locating Bilbao as an obligatory visit for cultural tourism, were important. However, such aspects were not enough to shape the mission of this particular museum. The lack of transparency in these negotiations allowed other interests or priorities to intervene, and they almost certainly considered the cultural and museological aspects of the project irrelevant. For example, in an interview entitled "Our Relationship with New York Allows Us to Add, but Never Take Away," with Juan Ignacio Vidarte, an economist and the museum's director, one is left with the same ambiguous impression: "The Bilbao Guggenheim Museum operates, effectively, in a different way," contends Vidarte. "At root, it is based on an alliance between public institutions and a private institution, on a Basque-American collaboration and on an innovative operational model with several objectives that transcend the strict realm of museums. As such, it does differ from the prevailing tendency."[3]

What might such objectives, transcending the strict realm of museums and on which its difference is based, be? And why was this never clearly explained to the general public beforehand? It should be of no surprise that the museum's director is an economist who has little experience as regards art and culture. And if one thinks that the notion of incorporating a wide variety of objects in one museum is innovative, then they should take a look at any museology handbook to see that museums in general differ little from the "Museo Tutti Frutti," with its registered trade mark or elegant architecture.

To diversify one's offering according to criteria based on artistic, academic, or scientific quality is hardly at odds with the strategy of any museum facing a lack of financial

1. Mark W. Rectanus, *Culture Incorporated: Museums, Artists, and Corporate Sponsorships* (Minneapolis: University of Minnesota Press, 2002), p. 178.
2. Michael Kimmelman, "Un conquistador en el mundo del arte: Thomas Krens del Guggenheim," *Museum Internacional* (UNESCO) 51, no. 1 (1999: 54.
3. Juan Ignacio Vidarte, interview by Rafael Sierra in *Descubrir el Arte* 46, "El Efecto Guggenheim" (December 2002): 36.

and operational resources and donations. However, it should not be up to a bureaucrat to impose legally on us a mutation whose failure we can now see in other areas. Resistance to the introduction of Guggenheim affiliates in many cities, even after the success of Bilbao, reveals the extent of the disrepute associated with this expansionist museum model. Nor have economic conditions favored the financial success of the foundation, with partial shutdowns and the laying off of staff in some sites. One should, then, ask the following question: Why have opposition movements and demonstrations in other cities forced the local authorities to reject the project, but not in Bilbao? The natural answer would appear to be because of the secrecy of the negotiations. Was this the difference? It would be easy to go along with this answer, were it not for the cultural sovereignty of a people living next to an extremely controversial object. Is it really a museum? It is, if the building is its object and the works underpin its activity, a moving stock. Now everyone is looking at Guadalajara, the capital of Jalisco, in Mexico. The authorities in charge of negotiations there say that there is no turning back, as if the magic recipe were the perfect antidote to escaping social oblivion and all economic problems. A quick glance at the historical links between the Guggenheim family and the mining industry in Mexico during the Porfirio Díaz era would refresh the memory of all those ambitious businessmen and politicians, as well as everyone connected with the project, to prevent this new form of exploitation. For the moment, they have only just begun to undertake a viability study.

A quick look at the various museum typologies on offer today tells us that those that stand out are the ones that ostentatiously shout, "Look at me, I'm worth a visit in my own right!" For this fact alone, I find it hard to consider such a case as a museum, let alone the best type of museum. What is a museum for? To store, in a relatively modest way, an exceptional collection, or to establish an architectural milestone in which the content—whether extraordinary or mediocre—is secondary? A museum's functions are much more complex than just serving as a showcase. However, efforts to integrate museums into the competitive network of cultural institutions have lead them to make critical changes that are being increasingly noted. Kenneth Hudson's observation on this tendency is particularly illuminating: "What the museum is trying to do has become more important than what it really is. This undeniable tendency is interfering more and more with the definition of what the museum is and is perhaps rendering it more and more irrelevant."[4]

If both the exceptional nature of the museum space and its artistic dimension are relegated or made irrelevant, the process of urban homogenization and the blurring of the museum realm point more clearly toward a reification that guarantees mass consumerism and, probably, uniformity within this consumerism. The gradual conversion of the museum into a theme park like Disneyland, or a mall, inevitably leads to much speculation, not all of which favors the museum itself. As such, the demagogical manipulation of the term "museum" to disguise a certain reality or to hide a financial crisis should not

4. Kenneth Hudson, quoted by Marcia Lord, "Editorial," *Museum Internacional* 49, no. 4 (1997): 3.

be allowed to triumph. In the hands of bureaucrats, stock-market dealers, or politicians lacking vision, the museum can easily become a passing whim. If we adhere to the maxim that only negotiations and self-referential architecture define the function or meaning of a museum as regards the public service it carries out, the results are there for all to see: a questionable addition or a miracle that vanishes as the surprise factor gradually wears off.

Why such secrecy? An uninformed populace remained at a disadvantage in the appropriation of the institution as a screen on which power relations and decisions that (to a certain extent at least) affected their culture were projected. Or in the best-case scenario, one might have initially marveled at something that in the long run would have been to the detriment of local values. These irregularities, together with the reserve of the authorities in really addressing or refuting any cultural aspects that might have been derived from the project, provoked strong inequalities or asymmetries, as highlighted by Joseba Zulaika:

> We have already witnessed the first of the decision-making and power asymmetries that might be considered crucial in making the new cultural globalization viable: The locals have to pay for the work down to the last cent, but they have no right to be informed in order to have an opinion or make decisions. In other words, the whole thing was done in the name of democracy, but through the strict control of information, without even mentioning the right to make decisions, and imposed by a private company from New York that was going to take up 80 percent of Basque public funding for museums.[5]

One might add to these observations clause 6.2 (ii) from the general agreement, which states: "As regards the museum director, the SRGF will have the exclusive right to decide the operational planning, development and policy, the working norms, artistic content and programming, and all remaining matters that affect the administration and operation of the museum, in accordance with the commitment of the SRGF regarding the quality and content of the artistic programming."

The asymmetries in the agreement highlighted by Zulaika are disturbing in the sense that a foreign administration would, almost by remote control and for twenty years (and extendable to seventy-five), run a branch whose impact on culture and art was highly questionable. If it was simply a question of trying to make the city the same as any other fin-de-siècle metropolis or of proclaiming it an urban model for the twenty-first century, with this museum Bilbao certainly made a name for itself, through much hype, on the tourist and cultural map. Obviously, no other museum in Bilbao could compete economically with this affiliate, and therefore it was able (in a variety of ways) to blur or hide numerous other (and equally worthwhile) initiatives. Indeed, one cannot overlook the benefits that its presence in the city has engendered or the success of the building itself. How-

5. Joseba Zulaika, *Seducciones, asimetrías, globalizaciones: Las lecciones del Guggenheim* (N.p.: SITAC 2001; México: PAC, 2002), p. 156. See also, by the same author, the excellent work *Crónica de una seducción: El museo Guggenheim de Bilbao* (Madrid: Nerea, 1997).

ever, what is worrying here are the symbolic values that were brought into play. Simply stated, that Basques were not able to give their opinion about an investment that would affect their culture profoundly reflects a basic disregard for democratic values. Furthermore, to be satisfied merely with the immediate benefits generated by its presence and limiting this exclusively to statistics and money sidesteps the cultural dimension, the desirability of an exercise that emancipates, liberates, and forges in the individual citizen certain criteria of cultural sovereignty and self-determination in taking control of one's own cultural development.

As has been argued, the Guggenheim in Bilbao has set a precedent in that it functions as a Bilbao-New York hybrid whose modus operandi favors, on the one hand, the foundation's expansionist policy and, on the other, situates and gives prominence to the city, locating it on the international tourist circuit. Indeed, the lack of local control over this operation has allowed a private business to spread its values and influence in a field where urban dynamics stand out as new, exceptional, and renovating. That said, I also understand that the lack of adequate human resources in Bilbao's more general museology also meant that professional formation through the museum was a perfect means of introducing influences far removed from local concerns.

In an interesting study on Spain's new museums, Maria Ángeles Layuno Rosas considers the subject in the context of the country's post-1975 democratic era—in other words, based on a constitution that created a high degree of autonomous or local decision-making authority and therefore a certain cultural decentralization that favored the rise of cultural industries in which contemporary museums emerged. She contends that:

> one of the key factors in the political impetus of these cultural projects sometimes consists in redefining the city's image as an issue of political prestige and economic strategy. The economic consequences are centered on attracting investment that the introduction of the museum implies, thereby having an effect on the physical and economic regeneration of a city or area. The economic, urban, cultural, and image-related prosperity that was implied by bringing a museum from the prestigious Solomon R. Guggenheim Foundation to Bilbao was guaranteed for those in charge in the Basque Government, and from this starting point—and even at the cost of overstepping the mark in their investment—came the proposal to choose an imported model instead of a contemporary art museum created by their own resources.[6]

To risk investing in a warehouse composed of extraordinary architecture in which the cultural agenda was out of the control of local authorities revealed a choice that responded to other priorities. In effect, it was all about entering a competitive world without having the adequate resources or strategies and volunteering to take part in a world of simulation and fiction far removed from the world of art. I cannot resist comparing this introduction procedure favored by the authorities to a process of unequal competitiveness,

6. Maria Ángeles Layuno Rosas, *Los nuevos museos en España* (Madrid: Edilupa Ediciones, 2002), p. 13.

a cultural infiltration similar to the colonization of a relinquished symbolic space as represented by the museum. Where were the Basque initiatives in the whole affair? Taking account of every such possible proposal, they remained squarely on a secondary level. Taking account of the fact that Bilbao didn't have any collection that approached the vanguard nature of modern and contemporary art like that of the SRGF, one might ask why the people of Bilbao didn't build their own museum with an architect they themselves chose and rented the exhibitions they wanted, without giving in to a registered trademark that would dictate their likes for them. Had this been a curatorial proposal that might have saved the project from the expansionist vision of the Guggenheim, one might have judged it from another perspective. However, the exhibition program designed by Krens was essentially underpinned by a selection of masterpieces from the foundation's traveling collection, loans and acquisitions that left little space for other curators. And the sensationalism associated with the motorcycle and fashion exhibitions in attracting large numbers of visitors and big sales figures was more redolent of Hollywood-style entertainment and business than of a museum that was attempting to promote more serious, although groundbreaking, research and exhibitions.

I must admit to a certain ambivalence on first succumbing to the seduction of seeing the external part of the building. Without doubt, one's first physical encounter with the building, even after having seen many pictures, is dazzling. One has to congratulate Gehry, who broke down the border between sculpture and architecture with this work, a work that asserts itself in all directions and marks another sudden transformation of the museum into spectacle. Frank Lloyd Wright's Guggenheim and Renzo Piano's Georges Pompidou Center might be regarded as forerunners of this spectacular transformation.

During a visit, the seduction provoked by the transgression of the building forces one to see, through the architecture, the change that the museum's new functions imprint on its presence. This sensation is so powerful that no image rivals that of the building in promoting the city. Neither the collections nor the exhibits are remembered with the same intensity or frequency as the glistening curves of the building. The implications of the building for the organization of the museum's exhibition rooms are undeniably faultless in creating a diverse range of experiences within its spheres. The versatility or possibilities offered by its interior space allow a great deal of flexibility in adapting designs for particular exhibitions. However, during a visit, in every corridor or hall, the building reminds us architecturally of its presence through its artistic impact. It unfolds before us so magnificently that this celebration of the building can trouble someone who is attached to the idea of the museum as a discrete guardian of works that should be able to converse with one another without any external interference.

It appears that the building has inherited from its nineteenth-century predecessors—something that is appropriate in order to justify its basic functions, but at the same time that has also completely shrouded it—an excessive degree of glamour, similar to a makeover offered by publicity firms. In effect, then, its exhibition halls are wonderfully designed to show off their own attributes.

Spread majestically over the river, it shines, glitters, reflects, and shows off its charms on all sides. Both its interior and exterior are sites of communication, contrast, conjugation, and articulation that do not fail to surprise the onlooker. Its convulsed sinuosity rises, with a kind of frozen dizziness, toward a kind of subtle, flickering stillness, like the movement of a curled-up snake or the kaleidoscopic scales of a flapping fish. Like a flower woken up by the sun and revealing a multitude of silhouettes, it clearly conjures up the image of a great monument, a jewel-like sanctuary to exalt some higher power. Its very presence acts as a motor of change that is limited neither to its physical existence nor to its modus operandi, for it manages to generate culture—that is, it encourages changes in attitudes toward appropriating an aesthetic experience like that of culture, as if subverting the shape in which it arrived, assimilating both the art and the museum itself. Its titanium shell reflects, before all who visit it, the smile of Narcissus. It has itself been diluted by the reflections that pursue beams of light, glass, and metal. It undulates and swaggers like a tempting slogan of the new millennium city. As befits a principal source of the changes that have given new life to the river, it juts out and reclines like a ship whose unloading requires careful inspection so as not to regret later a possible humiliation in the exchange. It acts as a detonator of new practices and strategies of manipulation and speculation regarding culture within the framework of the globalized free market in which we live, as well as being a symbol of an attitude and a visibility that promotes both prestige and recognition. But at what price?

I understand the idea of the museum as a space of exchange, and the more balanced this process is, the more power and benefit for all parts. It's a long-term investment that qualitatively affects the emancipation of a society in that it has an infrastructure that favors a number of liberating experiences of knowledge before the world's patrimony. The spectacular nature of a museum, however, although it covers up and cleans a city's urban image, cannot transform an unavoidable reality into mere aesthetics or into a development project that infringes on discerning the differences between growth, popularization, and the right of access to culture that allows one to distinguish between quality and mediocrity. Exuberance in itself may have many qualities, but this alone does not define exactly a museum's mission. Indeed, the abuse of its enchanting virtues can keep a watch over and cloy on the substantial elements of a discourse.

I'm not trying to defend here the sterilized or orderly nature of the museum or to reject the idea of experimentation. On the contrary, I have attempted to analyze the quality of the franchise represented by the museum and to deduce from this kind of development and its results in Bilbao some conclusions surrounding its controversial aspects, leading me to ask: Why did Basques, a people renowned for their rich traditions and political determination to defend their millennial symbols of identity, suddenly see their cultural sovereignty mortgaged by their own governing authority when it accepted the introduction of a mechanism resembling the Trojan horse that for many years to come would be an example of perceiving, appropriating, and appreciating culture with which one might seriously disagree for many reasons?

Giving in to a seduction that might lead to alienating the meaning of art, culture, or a museum serving the wider community only opens a door to ventures whose priorities center on maximizing economic benefits, as well as political and cultural influence. In other words, this is to favor a development that might include a strategy of neutralizing the local, based on a regeneration strategy imbued with American influence, which is more and more dominant in cultural consumption.[7]

Although much has been said about the breaking down of frontiers in artistic genres or the need to redefine the artistic, undertaken as a means of recognizing the interactions and reactions that emerge in the sphere of cultural values, one can't expect just anything miraculously to become art or a cult object in the museum. Nor should the museum be transformed into an exceptionally well-designed "Musée Fourre-Tout" or "Museo Tutti Frutti" just to attract the masses, even if by doing so it frees itself of critical judgment or any exigency about its potential manipulation of artistic expression. Most members of the American Association of Museums, together with many critics, museologists, artists, and experts, do not support the expansionist Guggenheim model. Why is it so popular among politicians and economists? It's up to all of us to think about this new vision of the museum as a means of demystifying its paradoxes in order ultimately to discern and advocate a museology that, far from clamping down on experience, enriches us with it.

7. In "Against the Discursive Museum," in *The Discursive Museum*, ed. Peter Noever (Vienna: MAK; Hatje Cantz Publishers, 2001), pp. 44–57, James Cuno is very critical of how this new vision of the museum, curatorial practices, and the strategies favored by Thomas Krens represent an obstacle to the genuine experience of artistic expression, as well as the ideas and concepts associated with serious investigation. In a special issue of the *Revista de Museología*, published by the Spanish Association of Museologists and entitled "Arquitecturas para la mirada" (Architectures to keep an eye on, 1999), the debate about the dysfunctional nature of the Guggenheim as a museum (as in the case of the Museu d'Art Contemporani de Barcelona [MACBA]) intensified without undervaluing some of the symbolic qualities surrounding its foundation. In the issue, respected Spanish specialists expressed their opinions on the conflictive relationship between museums and emblematic or spectacular architecture in recent decades.

Part V

THE MASTERPIECE

Frank Gehry: Master and Commander

ALLAN SEKULA

[At the "Learning from the Guggenheim" conference, I showed rough cuts from a film in progress with the working title *The Lottery of the Sea*. The film is about the sea and port cities in the context of questions of sovereignty and democratic governance. I am working on another film in collaboration with Noël Burch, *The Forgotten Space*, which takes up the global cargo-logistics system and the mythologies of neoliberalism and free trade. Both films include segments on the architecture of Frank Gehry. The first film takes up the Disney Concert Hall in Los Angeles, the second the Guggenheim Bilbao. I have excerpted below an earlier essay entitled "Between the Net and Deep Blue Sea (Rethinking the Traffic in Photographs)," originally published in *October* 102, (Fall 2002), pp. 3–34, reprinted in Allan Sekula, *TITANIC's wake* (Cherbourg: Le Point du Jour, 2003). I have also included an exchange of letters with the director general of the Guggenheim Bilbao, Juan Ignacio Vidarte, published in *October* 104, (Spring 2003).]

Irrational Exuberance

Five or ten years ago, I was confident that the sea had disappeared from the cognitive horizon of contemporary elites.[1] Now I'm not so sure. The sea returns, often in Gothic guise, remembered and forgotten at the same time, always linked to death, but in a strangely disembodied way. One can no longer be as direct as Jules Michelet was in his 1861 book *La mer*, which begins with a blunt recognition of the sea's hostility, its essential being for humans as the "element of asphyxia." And yet Bill Gates buys Winslow Homer's morbid *Lost on the Grand Banks* for more money than anyone has ever paid for an American painting. Frank Gehry builds a glistening titanium museum that resembles both a fish and a ship on the derelict site of a shipyard driven into bankruptcy by Spanish government policy, launching a new touristic future in the capital of one of the world's

1. See Allan Sekula, *Fish Story* (Düsseldorf: Richter Verlag, 1995).

oldest maritime cultures. It was the Basques, after all, who probably discovered America, but they preferred to keep a secret and return without competition to the rich cod-fishing grounds of the North Atlantic.

Frank Gehry's Guggenheim Museum for Bilbao is a Los Angeles export product, a leviathan of California postmodernity beached on the derelict riverfront of the economically depressed maritime-industrial capital of the Basques. As such, it marks the first move in a projected campaign of economic "revitalization," tied, as one might expect, to land speculation and tourist promotion. Kurt Forster, who is Gehry's biggest defender and who has stressed the protean, vitalist aspect of the architect's fish buildings, has gone to some length to exempt Gehry's project from these sorts of vulgar and dismal economic associations: "with his buildings of the 1980s Frank Gehry returned to an architecture possessed of powerful corporeal qualities. He does not think of the volumes of his buildings within the confines of abstract space (which is also the space of economics); rather, he engages these volumes in intimate relationships with one another."[2]

The bad objects here are legion: abstraction, economics, and by implication, bureaucracy and modernism. The crypto-Baroque promise of redemptive embodiment—"corporeal qualities" and "intimate relationships"—is not unlike that offered by the virtual world of the Internet.

One can of course travel a short distance along the Bilbao riverfront to the big city fish market and see there evidence of the prodigious Spanish appetite for the creatures of the sea. Here the corporeal qualities of the fish that inspire Gehry are depressingly linked to the abstract space of economics: boxes of *merluza* (hake), previously caught in great quantity off the Iberian coast, now imported from Namibia.

But like James Cameron in *Titanic*, making sure that the diamond is tossed back into the drink, Forster wants to disavow and affirm the economic at the same time: Gehry "and his collaborators made use of programs that were originally developed for the design of airplane fuselages."[3] The fish is also an airplane, as the frequent references to titanium as an "aerospace material" found throughout recent writing on Gehry attest. The implied association of titanium cladding with the skin of advanced aircraft is somewhat inaccurate, since titanium is typically used internally, alloyed with steel for jet-turbine blades that must both be lightweight and capable of withstanding high temperatures. In fact, the most radical innovations in aircraft skin design have come through plastic-polymer composites, which are crucial to so-called "stealth" technology. In fact, titanium has become a metametal, a metal that *refers* to high-technology metallurgy, especially in luxury consumer products such as German-designed high-end autofocus cameras.

For Forster, as for Gehry, the main breakthrough at the level of architectural practice is the collapse of the laborious mediation between drawing and executed design. On

2. Kurt Forster, "The Museum as Civic Catalyst," in *Frank O. Gehry: Guggenheim Bilbao Museoa* (Stuttgart: Edition Axel Menges, 1998), p. 10.

3. Ibid., p. 11.

this point, Forster waxes utopian: "The age-old distinction between the hands that design and the instruments that execute has been overcome."[4] I would be delighted to see him deliver this argument with a straight face to the construction engineers and iron workers who painstakingly translated the plan into the skewed geometry of the steel structure that is ultimately obscured beneath the glistening convoluted surface. Forster concludes by lauding the Guggenheim Bilbao as a "a monument to the productive capacities that are now at our disposal."[5] In other words: a monument to the absolute hegemony of intellectual labor afforded by computer-based manufacturing.

Having photographed Gehry's building, I want to venture another sort of reading. For all of its acclaimed "vitalism," its primal links to the doomed carp swimming in Gehry's grandmother's bathtub in Toronto, the Guggenheim Bilbao is more accurately likened to a gigantic light modulator. It introduces a new level of specular reflectivity into a rather drab cityscape previously restricted to tertiary hues. In effect, what it imports to Bilbao is an esthetically controlled, prismatically concentrated version of the high specularity characteristic of the Los Angeles cityscape, the random and ubiquitous presence of shiny surfaces, glass, and metal ricocheting sunlight in an inhuman, migraine-inducing glare. For this benign and restrained version of American aerospatial enlightenment, for this lighthouse and control tower far upriver from the sea, the Basques, who pay all the bills for the museum, are entitled to feel grateful. Thus far, there are no Guggenheims planned for Hanoi, Belgrade, Baghdad, or Basra. For insights into the less restrained version of American aerospatial enlightenment, I advise the reader to see Hartmut Bitomsky's new film, *B-52*, about the venerable gray workhorse of the Pentagon.

By coincidence, one notices a certain corrosive potential. In the container transfer terminal on the downriver flank of the museum sit large cylinders of hydrofluoric acid, the extremely nasty agent used to dissolve and etch titanium and its alloys. This powerful oxidant is always a handy chemical for the aerospace industry, since it can eat away at metal without causing the heat fatigue associated with traditional machining. The touristic postcard is smudged somewhat by this reminder of Bilbao's lingering industrial kinship with Seveso and Bhopal. But there is no need to entertain apocalyptic scenarios: Much to the architect's dismay, the Guggenheim's titanium cladding is already beginning to stain and darken from exposure to the relentless marine atmosphere of the Bay of Biscay. Up close, the building is beginning to resemble the wreck of an old bomber, stained with the greasy residue of burned kerosene fuel.

Given this protean litany of resemblances, we can revise another old slogan, this one from a staple of 1950s American children's television: "It's a bird, it's a plane, it's … Supermuseum!"

4. Ibid.
5. Ibid.

Response to a letter from Juan Ignacio Vidarte

Los Angeles
March 17, 2003

To the editor:

I have to assume that the director general reads *October* with greater care and precision and less literalism when he ascertains that the contents are up to snuff.

It is perverse and pedantic to offer a chemistry lesson in response, but allow me to clarify my largely metaphoric play with the theme of corrosion. Titanium does indeed oxidize, and in fact, titanium dioxide is a principal ingredient of white paint. Titanium's fabled resistance to what we commonly think of as oxidation (the forming of metallic oxides with atmospheric oxygen) does not extend to higher-energy oxidation-reduction reactions such as those with halogen ions like chlorine, bromine, and fluorine. Thus, the hydrofluoric acid until recently transported in large cylindrical casks through the RENFE [the Spanish national railroad service] container terminal just next to the Guggenheim Bilbao is an excellent agent for violently "corroding" or oxidizing titanium metal. This strange proximity of a highly corrosive reagent and what metals suppliers now—in the wake of the building of the Guggenheim—like to describe as a "gourmet metal" stuck me as particularly ironic when I first photographed the museum in 1998. (Imagine a marble palace next to a pond full of hydrochloric acid.) My larger point is that titanium has come to stand for the illusion of eternal imperviousness to the elements and thus suits well the immortalist fantasies of contemporary elites. My comparison of Gehry's building to the B-52 bomber will I hope be understood by most readers to be nothing more than a flight of fancy on the theme of technological longevity and American military—industrial—architectural prowess. So now it turns out that a squad of cleaners has regularly to scrub away the accumulating grime from the not-yet-sanitized maritime-industrial air of Bilbao (I never described this grime as "corrosion"). Routine maintenance, perhaps, but nonetheless a tarnishing of the myth of the immortal metal that never rusts.

As for the director general's confident assertion that the "drab, industrial past" of Bilbao is now "gone" and that the city has been "radically altered" by the construction of the Guggenheim, I would simply ask if the substitution of services and tourism for a diversified maritime and industrial economy is necessarily such a good thing, especially when the jobs created or "maintained," once the construction boom is over, are often precarious and low-waged. Furthermore—although this is not a charge to lay at the doorstep of the Guggenheim—a coastal nation turns its back to the sea at its own and the world's peril, as the stunning incompetence and indifference to the *xente do mar* (people of the sea) of the Spanish national government in dealing with the ongoing *Prestige* disaster in neighboring Galicia demonstrates. (See my "Marea negra: Fragmentos para una ópera," in *Culturas* 34, weekly magazine supplement to *La Vanguardia*, Barcelona, February 12, 2003.)

In point of fact, Bilbao remains a maritime city, although these functions have large-ly moved away from the inner-city riverfront and thus from the lifeworld of the commercial middle classes and their invited guests. The container port—second, I believe, only to Barcelona in Iberian cargo volume—is now undergoing expansion at the mouth of the Nervión River. What have atrophied are the older, productive elements of the maritime economy: fishing and shipbuilding.

The symbolic function of Frank Gehry's architecture is to "refer" obliquely to the organic unity of this maritime older economy while celebrating at the same time its replacement by a new, flexible order of accumulation. (On the latter part of this point see Andrew Friedman, "Build It and They Will Pay: A Primer on Guggenomics," *The Baffler* 1, no 15 [November 2002]. Friedman cites Enron's sponsorship of the 2001 Gehry retrospective at the New York Guggenheim and quotes company president and CEO Jeffrey Skilling's praise for Gehry as an avatar of the "New Economy." This is praise that I am sure Gehry would like to forget.)

Gehry's nostalgia for seventeenth-century seafaring mercantilism is quite explicit. He has, for example, likened his Walt Disney Concert Hall in Los Angeles to the billowing sails of the merchantmen depicted in the maritime paintings of Hendrick Vroom. The fact that shiny silver models of such vessels constitute a variety of expensive kitsch, especially in Spain, seems to have escaped his notice.

The more elegiac and less frivolous lament for the demise of the industrial waterfront of the inner Nervión can be found in the giant slab of rusting steel incorporated into one face of the Euskalduna Conference and Concert Hall, just down river from the Guggenheim, designed by the team of Sariano and Palacio. And a more profound encounter between metal and the corrosive energy of the sea can be found in Chillida's remarkable steel sculptures on the rocky headlands at the mouth of the Bay of San Sebastián. Gehry's titanium fantasy needs Richard Serra to authenticate the architect's affinity for the maritime "industrial past" of Bilbao.

The director general's marshalling of positive economic indicators can be seen as a belated effort to fend off serious criticisms of the Basque government's subsidy of a cultural agenda and programming controlled and directed from New York. The key text on this new "franchise" model invented by Thomas Krens is by the Basque anthropologist and philosopher Joseba Zulaika: *Crónica de una seducción: El museo Guggenheim Bilbao* (Editorial Nerea, Madrid, 1997). This book cannot be purchased in the bookstore of the Guggenheim Bilbao, and interestingly, there is no English-language edition, although Zulaika has published a related textbook for his students: *Guggenheim Bilbao Museoa: Museums, Architecture, and City Renewal* (Center for Basque Studies, University of Nevada, Reno, 2003.)

Allan Sekula

Frank Gehry Is Not Andy Warhol:
A Choice between Life and Death

JEREMY GILBERT-ROLFE

When Richard Gluckman's Andy Warhol Museum was opened, the *New York Times* called Frank Gehry and asked him what he thought. He said he hadn't seen it, so couldn't comment, but he knew that it was not what Andy would have wanted. What Andy would have wanted would have been a Wal-Mart store, a big, flat rectangle with an appropriately huge parking lot and, inside, all of Andy's stuff laid out as in a shop, while outside, on either side of the doors, two glass-fronted coffins, stood upright, with Andy preserved in formaldehyde in the one and in the other the similarly maintained corpse of Jackie Onassis. What Andy would have liked is a building that was about what he was about: business as the business of art—as he put it himself—and the cult of personality. An architecture that was in any way exciting would have been beside the point from his perspective—I don't say it has to be from ours—because he was not interested in excitement of any sort that might take place through sensation, which is to say, through the body, but rather, or so one gathers, in irony.

Irony was what we got when the art world came to distrust sensation, which was part of the wholesale rejection of a—inevitably narrowly and tendentiously defined—modernism that had become the norm in the art world by the mid-seventies and that enshrined Warhol as the Christ to Duchamp's John the Baptist. With him it enshrined an attitude toward the visual arts that concentrated on the sign, rather than the surface, that read the work as a text, rather than asking questions about what seeing it was like. As I have noted elsewhere, this alteration in the art world's tastes was accompanied and largely fuelled by a reconciliation of Foucault with the Frankfurt Institute, which allowed Warhol to operate as the darling of hard-core rightists like his supper partners Alphonse d'Amato and Roy Cohn while being treated as a kind of involuntary Walter Benjamin by *Octo-*

ber magazine and large parts of the art-historical, curatorial, and shopkeeping establishment. It all depends on how you want to read signs.[1]

In his diary, Andy always identified the women whose portraits he painted by their source of income—the hog-belly-futures wife, for example—and that was also how they identified him: They got painted by Andy Warhol. It was hilarious, or something, that he made them look dreadful. They understood caricature and that it is a form of wit. The only variety of art-world life not mentioned in the diary is intellectuals. He never sees any. They love him for his irony, which some might find ironic in itself. For them, he recycles signs and, in that, exposes them in a way that permits us to be clear about how capitalism works. He is what we have after the end of art: an object emptied of aesthesis—with the end of art comes the end of sensation as the content of art—but filled with irony, which is to say, with an idea whose material context is all but irrelevant, except to the extent that it can point to something about the historical and cultural context, which is to be sure material, albeit in a way that manages to make our encounter with materials themselves secondary at best. Andy sort of stumbled on the thought that maybe he'd use the out-of-register as a kind of image. Suddenly that series of prints becomes an update of "The Work of Art in the Age of Mechanical Reproducibility." Viewed as participants in the demystification of the great allegory of production, it's splendid that the images used should be only minimally altered while being recycled, because this guarantees maximum epistemic consistency while focusing on how cultural meaning may be thought about as surplus value produced by a fetishized kind of labor.

Andy in his glass-fronted coffin outside a Wal-Mart museum is the perfect metaphor for much of what been internationally ubiquitous in art galleries and museums over the past thirty years. It is the art of the undead, in the sense that it is what one gets when everyone's agreed that art is no longer possible, and what it asserts is always and only that. Oddly enough, it is historicist while proposing itself as a permanent and irreversible condition. To take the case of another Duchampian artist, we do not yet have a criticism that will consider Sherri Levine and Walker Evans as two equally arguable positions on where meaning lies in regard to the photographic, and I think this is because of a reluctance to consider the possibility that we are now past the period in which we were able to take seriously the idea that art is over.

Thirty years is an extremely long time, and the apparatus of demystification has surely by now been thoroughly demystified itself. But even if it hadn't, it seems to me that Alain Badiou's refusal to accept that philosophy was made impossible by the Holocaust because that would mean that Hitler had won even though he lost on the battlefield applies just as well to art and its relation to capitalism or the other shortcomings of the socially constructed subject as we have tended to have it. I don't think it's been a period of slackening. I think it's a period of great diversity, although that is largely hidden from

1. Jeremy Gilbert-Rolfe, "Nietzschean Critique and the Hegelian Commodity, or the French Have Landed," *Critical Inquiry* 26, no. 1 (Autumn 1999): 70–84.

us by the uniform predilection for art after the death of art by the art establishment of at least two continents.

Materials themselves are never secondary in Gehry, and neither is sensation. He is not part of the Warhol's World of Death, not least inasmuch as he never took any notice of the idea of the death of art. In this respect and others continuous with it, there is an untimeliness about his work to which I'll return. When one presents Gehry with a material, he sees what it can do, rubs it against his face, tries to break it, has thoughts about the color and what kind of a surface it has. In my opinion, it's all about how to connect a material to a kind of movement or how to find a kind of movement in it, although he's much more likely to talk about color and texture. Either way, it's about how to get something going, to make the material contribute to architecture considered as an event.

Here we could of course compare Gehry's use of materials with Andy's and the out of register, but I think to do so only underlines the extent to which one gets a tiny bit in Warhol of what one gets a huge amount in Gehry. Andy never makes more than one move per work, and that's what people like about his work. Gehry's process is a constant search for more inventiveness, reconsideration, and refinement that clarifies rather than refines and where clarification can mean more confusion than was in the design the day before. It is a lively aesthetic that is precisely aesthetic: It tries to connect architecture with feeling as well as with ideation. It is not quite true that Gehry never noticed the death-of-art idea. He once had an argument about music with Helmudt Schmidt in which the latter insisted that nothing of consequence had been written since World War I or shortly afterward. Gehry found the idea that someone would think something couldn't be done that was as great as something already done quite unacceptable, but I think that was because he found it incomprehensible.

In thinking about what I was going to say here about the Guggenheim Bilbao, I found myself faced with a dilemma in that I got the distinct impression that the conference was to be about the Guggenheim and Bilbao, and while this rather suggests that one should have something to say about the building's effect on the town, I can talk only from the point of view of the building. Certainly I have something to say about the implications of dropping a quite large silver building into the capital of the Basque region, and the first thing I have to say is that the very implausibility of the idea thus expressed unites it with others that turned out very well in the end, for example the Eiffel Tower. I think such a comparison underscores the extent to which, in order to get an event under way, one has to perform a separation from things as they already are, which is almost frivolous—or just is frivolous—in that it is not reasonable, the reasonable being wholly confined by and a property of things as they are. The alternative is an art and architecture of socioanthropological signage, from Victorian classical columns to Michael Graves's ironic seven-dwarf caryatids at the Disney headquarters.

However, what I have always liked most about Gehry's work is its practicality, which for me is forever inscribed in the privately owned bank he built early in his career, which began as a two-story cube, but because the client's fortunes declined became first a sin-

gle-story building with a false front and then—as the client's fortunes declined further—ended up as a U-shaped single-story structure but still with a false front. I think his practicality extends from his attitude toward materials to questions having to do with the site, considered in more than one way, but including historically and in terms of the client and money. Everything that departs from things as they already are in a Gehry building happens despite or because of a careful consideration of them. The Disney Concert Hall is I think what it is because he not only lives in L.A., but had twenty-two years to think about the project and what it required. Doubtless the Guggenheim Bilbao would be different in some respects if he'd lived there instead of Los Angeles, just as it would have been a bit different inside if the director hadn't been Thomas Krens, but as it is, the museum is a convergence of titanium and the local stone—cultural signage incorporated into structure, as with the color blue—that will probably always be compared with the Disney Concert Hall because that came both before and after it and also because of the comparison I've already made.

Because I think of him as first and foremost a practical thinker, I have always found myself moving between what the building looks like and how it works, and I think that it isn't hard to demonstrate that most of what makes the buildings look good is inseparable from what they're supposed to do. It is quite true that these are inseparable from the start in that Gehry works from the outside in as well as from inside out, but one ought not to exaggerate or misrepresent what is at stake in his doing that. The outside is indeed a question of an ectoplasm, inherently and also in practice detached or at some distance from an internal structure that need have no direct correlation with the exterior. But it is as much a response to the program and the site as to any concern about shape or volume. The Guggenheim Bilbao lines up with the mountains. Its disposition seen from above is determined by the site both by the way it sits in it and by the way in which it crowds it by sitting in it. It's a matter of more than what is happening inside in regard to people moving between appropriately shaped rooms. The building considered as a container is also a big shape or concatenation of shapes, visible from afar and in Gehry's case always quickly becoming accommodating once one is close to them. One of the functions of the metal is that it allows voluminous mass to be present as light, if not weightless, and this has added to Gehry's ability to get buildings to take up a lot of space without overwhelming the people about to enter them.

The Guggenheim Bilbao is a good example of this, I think—the Experience Music Project in Seattle and the Disney Concert Hall perhaps better ones. Early examples are the Geffen Contemporary in Los Angeles and the Santa Monica Mall—and in a minute, I'll say something about how Krens squandered what it would otherwise have made possible. Unlike the other buildings I've just mentioned, you have quite a long time with the Guggenheim Bilbao in view before you actually enter it. You don't see them from a distance, except briefly from a car. Then they're right there up against the sidewalk. In fact, in the case of the Experience Music Project and the Disney Concert Hall, their façades are designed to activate the sidewalk at the juncture with the building to get one oriented to

the inside, and it may well be that one's first encounter with the building (other than the parking lot and the aforementioned glimpse) is of that bit of façade and the rest of the building curving away in several directions, none of them vertical. Likewise and also quite unlikewise, one might see the Chrysler Building from across the street and then you're in the lobby—it was always wholly above you from the start. When going to see the Guggenheim Bilbao, on the other hand, one can, as you all know better than I, walk toward it down a street, with it cropped by the buildings on each side until one breaks out onto the promenade. Once there, one is at first distanced from it and then brought into it down a long, slow movement that doesn't have one first overwhelmed and then gobbled up.

I want to say something about the way in which the Guggenheim Bilbao looks good, its relationship to Gehry's practicality, and the part both play in some of the controversy that surrounds his work. I think that what makes it look good contributes to its unpopularity. Not only is it pretty, but it's modernist, rather than postmodern, in the sense in which those terms are used in the discourses surrounding the visual arts, while at the same time it is of course quite unmodernist in every crucial respect except for its preoccupation with visual effect and self-assertive liveliness—which incidentally illustrates the bankruptcy of the way those terms are used. I see Gehry's work as caught inevitably but unfortunately in arguments to which it has a more subtle relationship than is perhaps normally described, but that are in any case not resolvable. On the one hand, he is what he is because his is a practical architecture that has invented, or however one wants to put that, a new kind of architectural form or look as the direct result of responding imaginatively to the California earthquake codes, which is another way of saying by being prepared to start somewhere else when it came to thinking about out of what buildings could be built. On the other hand, he is an American architect, and the consequences of that seem to me to be irresolvable. As soon as he started building in Europe, he was accused of attempting to turn first Prague and then Berlin into Disneyland, a charge with a different kind of resonance than accusing James Frazer Stirling of trying to turn this or that German city into South London.

In the face of such questions, I think the best one could attempt would be to raise some questions about the questions. I like the Guggenheim Bilbao. I think it's a good idea for the city to have an international museum built by a foreign architect, and I note the need to keep the desirability of internationalism apart from the repulsiveness of globalism in its present and foreseeable form. As a grandfather, it irritates me that toys are now the same all over the world, and bringing back a toy from anywhere is likely to mean bringing back a toy from Toys "ü" Us wherever it was one went, but I don't think either Frank Gehry or art as such, wherever it happens to have been made, are the same sort of sociocultural phenomena. At the end of this piece, I'll come back to how it seems to me that while globalism does indeed equal with Americanism, one must first separate Gehry from any definition of American culture as such. In other words, one must pay attention to his architecture's singularity, but then one must also—having granted that one need pay no attention to the idea that anything that comes from America is wicked, a proposition

that would retroactively ban jazz and rock and roll from continental Europe—think about how it is that American culture, however defined, presents a dilemma one can't avoid, not because it comes from America, but because it fits in everywhere, and people are uncomfortable with what seduces them. Given that a lot of the whole pleasure provided by the Guggenheim Bilbao has to do with how the building fits in by not fitting in, discomforts caused by its reminding one of things one didn't like about the current state of the world would seem rather to get in the way of one's enjoyment of it. I want to suggest that it does not present the same set of thoughts as those offered by the sight of a group of Europeans wearing blue jeans, drinking Coke, and lining up to see a Hollywood movie while denouncing American capitalism and foreign policy. Or that it shouldn't, and that if it does, one has missed something important, and that this is the case regardless of what one may think about the museum's exhibition program.

But first I want to say some things about the museum itself, specifically to say a little more about how it is lively and what kind of liveliness that is. This brings us back to Gehry's practical relationship with clients and through that to how his practicality is often overlooked in the service of one or another question about signage and appearance. While I like the museum, and think it introduces a kind of life into the city and the experience of looking at art that is in part unpopular because of its untimeliness, a function of what I've called its unmodernist modernism, I am aware of a couple of ways in which it could have been better. I only know about them only because Gehry told me.

In the original design, the atrium was supposed to be less elaborate than it now is and instead have flat walls on which art could be hung, and the big hall was supposed to be divisible or permanently divided into four. What we have reflects Thomas Krens's decisions, rather than Gehry's. Both have to do with giving the client what he wants, even though that reduces the building's usefulness, and I suppose both tell us something about what Krens wants. Reducing the usefulness of the atrium by encouraging Gehry to become more extravagant or expressive or whatever tells us that Krens wanted to hype the architecture as an event in itself—in doing so contributing to the contemporary tradition of relatively useless museum atriums of which the ultimate example is perhaps I. M. Pei's National Gallery addition: Not subdividing the large hall tells us that he's stuck in the sixties.

Had the atrium been less interrupted by detail that does, nonetheless, spell out much about the building as a whole in a very exciting way, one would have been brought up against art more obviously and quickly than one now is. It would have been Gehry and the city outside, Gehry quickly giving way to art once one got inside. As it is, it takes a long time to get to art not interrupted by architecture. Robert Rauschenberg's comment at the opening that they would just have to find art that could live up to the architecture was well put, but has more to do with the curatorial than the architectural program, and so does one's sense that it's made for big things. In practice it dwarfs big things. At the opening it dwarfed the Koons outside and the enormously long, but in there not particu-

larly so, Rauschenberg, while making the Serra look shrimpy as well as blatantly deriv-
ative.

But this has to do with the survival, in the museum world, of tastes formed in the
sixties. The Dia:Beacon is, one hopes, the ultimate or final expression of the position in
its purest form. The Dia:Beacon is a mausoleum meant to be a shrine to the proposition
that nothing ever happened that was as wonderful as the American art of the sixties, but
difficulties occur when the preferences of that decade determine how art in general will be
exhibited. In lots of areas of the art world, the adoration of the gargantuan as a virtue
has abated quite a lot since the end of the sixties. Koons's horrible dog bush is a con-
ventionally ironic debunking, wholly indebted to Warhol, of the art of the sixties. Its crit-
icality denies it the frivolity for which it is a substitute. Most of what he does is much
smaller and would be dwarfed by the large hall, like nearly everything else. Krens has
extended the literally academic preferences of the sixties—the academy considered big his-
tory paintings to be the most ambitious kind of paintings—into a program that sticks the
Bilbao Guggenheim with a big space that works only for works that require a big space,
which most contemporary works don't, and that is therefore born to some extent as a
museum for yesterday's art.

When I was there shortly after the opening, I didn't notice the Koons topiary outside.
The building simply took all my attention until sometime later. When I did notice it, the
thought that came to mind was that it wouldn't have done any better inside if it had been
in the big hall, because once inside it, one could only be aware of how everything that
went on in there would always be about managing to hold that space or not. As with the
art of the sixties, it suggests that what you should always be looking for in art is for it
to be assertive and in need of lots of space, either to overwhelm or subvert. Art that
requires another kind of space has a gallery upstairs. And of course there are other kinds
of things one can put in a large hall: objects that have no need of any particular kind of
space whatsoever, motorcycles for example, or conceivably any kind of recycled
socianthropological sign or object.

If his acquiescence and cooperation in the decisions regarding both the atrium and
the big hall remind us that Gehry is very matter of fact, or practical, about the extent to
which, unlike sculpture, buildings are the result of compromises, they also remind us that
in practice his original idea was usually, or in my experience always, better than the com-
promise.

Other than what I've already said about Krens's vision of the museum, I have little
to add to the debate about his drive to have the Guggenheim be a sort of Art "ü" Us of
contemporary art. The ambition seems reasonable in as much as it is in fact true that
one sees the same art in Los Angeles, New York, London, or Berlin and so one suppos-
es an international museum that acknowledges that would be an, as it were, natural con-
sequence. It seems like a best of times and worst of times situation that others will want
to discuss at greater length than I. I tend to look at museums' curatorial policies from the
perspective of an artist and critic and am bothered less by the blockbuster-for-box-office

requirement than by the problem of our having had thirty years of institutional critique that seldom takes into account, especially at the level of art production itself, the effect on the institution and the critique of their now thoroughly developed symbiotic relationship. However, that has little to do with the specific case of the Guggenheim Bilbao, although I think it has a lot to do with an art world that hasn't noticed that the one thing that hasn't changed is the model of art history that the curators and art dealers still use. But before I get back to what I have to say about the building, it may be useful to note that as far as the atrium goes, Krens's demand was the reverse of what Gehry more often gets from the client.

While the Guggenheim Bilbao's atrium is an instance of the client demanding excess at the expense of practicality, his rock-and-roll museum in Seattle has a less excessive roof than he'd planned because the client thought he was going too far, and one might also cite the case of the Founders' Room at the Disney Concert Hall, where members of the board asked for something and then decided they hadn't. Similarly, a lot of the criticism aimed at Gehry by critics, particularly in the newspapers, has accused him of impracticality in the service of appearance. But what's fanciful about Gehry's buildings follows from what's practical about them, especially regarding the question of what the building's supposed to do and be. His proposal for the Museum Island in Berlin was pilloried for what it threatened to do to that bit of the Berlin skyline, but if less attention had been paid to the conventions of nineteenth-century architecture and more to the logic with which Gehry responded to the task at hand, Berlin would have maximized the exhibition space available to the museums on that site in a way that had the full support of the people who worked in them. One of the requirements of the original program was that a busload of tourists should be able to go through all the museums in an efficient sort of way without disturbing any art historians who might be at work. I don't think the last part is in any of Krens's requirements, but don't know for sure. On the other side of the coin, the Founders' Room at the Disney Concert Hall is great because Gehry resisted pressure, and if the client hadn't got cold feet, Seattle could have had a building even more worthy of Jimmy Hendrix than it is, inasmuch as rock-and-roll museums are by definition not about restraint.

That said, I'll leave to others the particular questions that arise around Gehry having built a museum for a flawed program that is, nonetheless, a program designed to show everywhere what one finds everywhere and that, therefore, is I suppose, about a world in which people travel a lot and in which, because of the very conditions that facilitate and necessitate the travel, everywhere is the same. I expect that in the Roman Empire, one dragged oneself all the way from Syria to Germany and found people talking about the same poet, who lived in Alexandria most of the year. All along the way, one would meet local poets who were furious about it. All of them wrote the same kind of poetry.

Returning to the building, I don't think it's arguable that the Guggenheim Bilbao dominates the landscape in the sense of being a focal point or that in doing so it also orients

one to the landscape in a series of ways, of which not all are apparent from the viewing tower that comes with it. It is quite a large building that shines and in that seems weightless while being obviously metallic. As one gets closer, one sees that the titanium plates are very thin, like paper, and have been bent a bit in this and that way by the people who put them on. Then one is at the entrance and then inside and aware of the heaviness of the glass that's hanging around and the complexity of the series of moves through which Gehry adjusts the theme of curvature to the necessary one of verticality in the interior and particularly in the atrium. Where everything on the outside was thin, a great deal on the inside is thick or heavy, but when it's thick, it's a column altered by a skirt—a volume that is not solid, but contains air—or it's glass or a metal skeleton. The thinness of the titanium reinforces one's inclination to see the building in terms of movements, rather than forms, and inside, the material emphasis on a kind of qualified solidity encourages or prepares one for another kind of movement: the slow, but not directed movements that go with looking at art.

Responding to the less paratactic movements of the exterior, I said when I wrote elsewhere[2] that it's a complex building united by an almost continuous skin that holds together volumes experienced as the products of curving and intersecting planes. The sense in which one sees volumes as products of planes is the sense in which I think Gehry's architecture continues to be ectoplasmic in principle and emphasis—actually it is the double ectoplasm of the skirt, a surface not exactly following the outline of what it conceals and in that presents—in which weightlessness as a condition adjacent to thinness is promoted by the titanium's being thin, as well as silver. All architecture since the invention of steel girders is ectoplasmic to some extent, I suppose, in the way in which a skyscraper is a frame with an elevator shaft running up the center, but Gehry has always drawn attention to it by making the outer skin be something other than a reflection or extension of the interior, at least until one gets inside, when one realizes that the exterior has something to do with making the building do everything it has to do without fitting into a strictly rectilinear form, movement within movement, rather than stasis, being the goal, or at least that's how I see it.

To quote myself again while remaining with the skin, in the book I wrote with Frank,[3] I also noted the material properties that one takes in when walking around the building, which are, listed as sensations of surface and volume, silver as a property of metal; glass, which is also to say transparency and another kind of reflection than that found in the metal—in one light passes through or is bounced back, in the other it seems to be sucked in—stone; steam (courtesy of Yves Klein) and water; and blue as a property of paint, which is to say of a surface, as well as the of sky and the water, where it's a depth. I take seriously Frank's remark that the old modernist idea of truth to materials isn't much of

2. Jeremy Gilbert-Rolf (with Frank Gehry), *Beauty and the Contemporary Sublime* (New York: Allworth Press and the School of Visual Arts, 1999).

3. Ibid.

a stimulus any more, because there isn't much that one can't get a material to do if one has enough money. Given the huge role that our awareness of the materials he uses plays in our experience of his buildings, I think one has to pay attention to what he does with them, having decided that stuff about load-bearing capacity and so forth isn't where the building's idea can be found.

I have always seen Frank's work as being about lightness. I think his success has had to do with introducing the experience of lightness into big buildings. The ectoplasm activated by having a relationship to the interior that can begin as a relationship between the outside of the inside and the final outside provided by the skin, at its most dramatic in the Disney Concert Hall, has been a feature of his work from the first, but curvature allowed him to develop other relationships than ones of parallelism and complementarity. I've also said in more than one place that I think his introduction into architecture of lightness as a principle and phenomenon built into the thought of how the building should seem when one looks at it is as much as a function of the California earthquake codes as anything else, and it is there that one finds the absolute requirement that the building be a frame that can withstand some shock, with the surface hung on it an optional matter that must be thin and able to fall off in a crisis.

Frank became known for his use of chicken wire, but in my experience, the material that's most consistently been on his mind is paper. I've known Gehry since the seventies, and when explaining why the old modernist idea of truth to materials is unavailable to an architect living in an age when the only thing stopping one from recognizing almost any structure is money, rather than physics, he has always referred to paper as the basis of structure and to how if one can make a model out of paper, one can build it. I think the titanium and other metals he uses nowadays allow him to preserve the idea of paper. The idea of truth to materials has become another kind of truth about materials, and realizing buildings has become not a question of what loads materials will bear, but of extending the principle of paper into something more permanent and waterproof. In my opinion, or rather perception, because it is thin like paper, responsive to daylight, and describes a curve, the titanium covering is as much a plane as a surface, which is to say it is freed from mass as much as it is the outer skin of a mass. This is how and why I also see that lightness—a property of its being both thin and silver—as being connected to its correlative, mobility. The less heavy something is, the freer it is to move. The titanium seems to suck light in, introducing a level of indeterminacy unavailable in the local stone, which interacts with it, making everything that is not metal seem heavy. The contrast becomes one between marble and glass, with the metal taking the properties of both—density, reflection—to another level of intensity by seeming to be less substantial than either.

Gehry learned a lot in the sixties from artists whose own work subsequently became heavier, stodgier, and increasingly inert as his became lighter, more and more inventive, and all about movement. I certainly think one can relate the movements one finds in Gehry to general conditions of contemporary everyday life, which is above all that of a world in which we aspire to the weightless condition of the photographic image, rather

than to the more materially truthful surfaces of the images photography replaced, which were layered and approximate where it is thin and exact. I have twice mentioned the skirt as image and object and should suppose—have elsewhere proposed at some length—that how people walk and what they wear tells one something about the culture they inhabit, particularly at the level of the subject as an always already public image. As images, Queen Victoria and a girl in miniskirt are meetings between skeletons, musculatures, flesh, and clothing that constitute gestures and postures in combination and, as such, tell us a nearly everything we need to know about the differences between the nineteenth-century and twentieth-century subject as a social construct that everyone regards as a product of nature.

The skirt and its relationship to an idealized body is directly relevant the sense in which, if all architecture since the mid-nineteenth century is essentially ectoplasmic, Gehry gives the ectoplasmic a role in his work that links it to mobility and play and possibly to the frivolous. This is because the ectoplasmic is nowadays a matter of curvature and continuity, where once it was one of transparency and planes that gave way to other planes. Transparency and surface and interference with depth such as one may obtain with chicken wire undermine one's sense of solidity and stasis. Curves, in the masculinist categorizing of the properties of the beautiful and the sublime that Winckelmann instituted and in which everyone still seems to want to believe, including apparently the majority of feminist artists and art historians, are feminine and passive, where straight lines and sharp angles are masculine and decisive. I have suggested that one needs to substitute intransitivity for passivity and simple transitivity for the active as such in this equation, but only bring it up here because of what it suggests about curves and their lightness as the properties of a large public building surrounded by mostly shorter ones, mostly angular. In the distance and much larger are the surrounding hills, none of them particularly jagged.

Curvature goes to the feminine, and arguably one doesn't need Winckelmann to get one that far. Skirts are as close as a sheet of paper to embodying the idea of a plane that is only a surface and are inherently about movement. I'll not pursue the point, but it seems to me that there wouldn't be anything wrong if it were to be the case that it was through female dress and feminine form that architecture became infected with values that were other than bombastic and with an idea of the outside that wasn't straightforward because it had a playful relationship to ambiguity. In practice, Gehry stared at mediaeval carvings of folds in cloth when working on both Bilbao and the Disney Concert Hall, works in which drawing and carving get stone as close as it can get to looking soft and malleable. I take this, too, to be a function of his practicality. He begins with the building as a thing that has an outside. It's carved out of the outside inasmuch as what he began with when he built the museum we're discussing was the site.

I don't think it is a hyperactive building except in the hyperactive parts, but I think one sees it in terms of movement that both concentrates and deflects. It lines up with and responds to what's around it near and far at the same time that it takes light into its skin and becomes in places very complicated in terms of the barrage of sensations it sets in

play. Jerry Fodor recently and snottily defined phenomenology as philosophy that tries to think about the thinking that takes place before one starts to think, and I certainly think that it is as sensation that Gehry's museum has to be described. It has everything to do with why he insists that the finished building must exceed the drawing—in other words, that it must be more than the idea with which he started. In our book, I talk about Gehry in terms of Deleuze's Kantianism and his definition of sculpture—in *What is Philosophy?*—as an intersection, through molding and carving, of percept, affect, and cognitive person-ae—roughly speaking, time, space, and philosophical systems—but to describe the experience of looking at a Gehry building, one could also enlist Merleau-Ponty's idea of the flesh of the world, which begins with the interaction between the body and the atmosphere around it and extends to include all that is in the world, including the sociopolitical.

To which, in conclusion, I'll now turn.

I once gave a lecture at the Whitney Program in which a student, who has since become famous or notorious in a small way for a particularly excessive historically positivist theory of documentary photography, told me that the idea of looking good never came to his mind without him being reminded that capitalism prevents some people from enjoying the beautiful, even in the form of Kant's image of beauty, which is the flower and which I'd offered as an example of how there are circumstances in which historical contradiction may not be the theme that comes to mind or the source of a language with which to think about it. Gehry delivered a building that is fun to look at as long as it doesn't remind you of all sorts of things that you don't like. If it does, it will be difficult to see it at all.

There is no such thing as American architecture any longer. Gehry, Graves, Peter Eisenman, and Robert Venturi have very little in common, and he less in common with those three than they among themselves. Internationally, contemporary architecture probably owes less to an American precedent than do most of the visual arts because there is no equivalent in recent architectural history for the sixties, when everything in art did seem to happen in the United States. This would mean that architecture had been international for longer than the visual arts, which began to blend into one mass of multiplicity only around he middle of the seventies, having spent the previous forty of fifty years quite severely regionalized. But while it's silly to describe it as peculiarly American, the Guggenheim Bilbao is American in the more generalized way in which it stands for the placelessness of contemporary life as much as for anything having to do with Bilbao. Its presence connects the city to a world that is both happily and unhappily engaged in the loss of local identity, and that world is the placeless world of technologically advanced consumerism, the world of the telephone and the cable and jet travel in which every place is simultaneously present to all the others, united by a common economy, which itself is no more bound by constraints of place than architecture is by the limitations of materials. Everybody's happy because everyone wants to live the way Americans do. Everybody's unhappy because everybody hates America, and as life in Bilbao becomes indistinguish-

able from life anywhere else, it does so by surrendering to a condition perfected in the United States, albeit the European Union is struggling hard to ameliorate and restrain it.

Gehry is not a particularly American architect, whatever that would be, and even though what he says about architecture and democracy is very American in its desire to see pluralism as the basis of what a city should be, but I think he is specifically an architect of the placeless subject. And I think living in L.A. probably helped him to become that. The placeless subject is the subject that thinks in terms of mobility and of simultaneous movements and conditions of relationship to place. The contemporary person's essential and representative expression and prosthesis is the mobile phone. Los Angeles is a city of suburbs without an *urb* in a state where they tell you how to use your mobile phone on the first page of the Highway Patrol's driving manual. A Gehry building happens after and because the site and its history and everything that can be specified as belonging to a place are taken into account and then brought into contact with what belongs to nowhere. I see the use of local stone in Bilbao as the meeting between the place and the titanium, which comes from one of several other possible places. Others will perhaps want to see it as the appropriation of the local for other ends, and indeed there is a climactic side to the building's having exhausted the quarries. It depends on what one's attitude is toward nowhere. For some, perhaps, the quarries run out as Bilbao's identity disappears into the general appearance and habits of international capitalism. For others, equally, the building is an ultimate realization of Bilbao's interaction with the world in general. Mobility and lightness don't come from Bilbao and are also not properties of American or any other capitalism, and there doesn't seem to be a good reason why Bilbao shouldn't have a building made out of mobility and lightness. Or rather, if there were a good reason, it would not be as good as any bad reason that actually got the building built, because the project's success obviously depended on all sorts of claims being not taken as seriously as they might have been. Clearly, a decision was made to suspend too much talk about local traditions. The result was a landmark that, unlike most, actually is worth visiting.

But as the building focuses Bilbao around something that comes from somewhere else, so it focuses attention on the problems one may associate with the museum and the international culture that its program reflects. The art doesn't come from Bilbao, either, but rather from everywhere else. As such, it leads back to the world from which the tourist has just come, which makes it perfect for the placeless traveler, but for some will be iconic of how for the most part cities have no special reason to be where they are anymore. The usefulness of being on a river is a thing of the past. London fortunately made the transition from harbor to airport, Los Angeles can be anything that comes along, but cities founded on service rather than industry can be anywhere. The cultural and political questions raised by the building and, differently, by what it contains have to do with our now living in a world in which it doesn't matter what the local characteristics are, or rather, were.

As I said, I think one has to keep internationalism separate from globalism, and the Bilbao Guggenheim nicely illustrates the distinction, as well as and perhaps the political

issue in a certain way. Imagine the situation spatially, as an axis with at one extreme a building that is the sum of a concentrated attempt to reconcile the program with the site, the local with the indeterminately other, shapes and materials that both separate and unite the building with its context. In the middle, imagine a city that wants to connect with the global economy by becoming another tourist center. At the other end, envision a museum program that is part of an international franchise. The city wants a building by an internationally known architect, and it gets one that reorders the city and by doing so makes it more internationally known. The city now has at its center a building that connects it to a world beyond itself in the sense that that's not the only city that has a building of that sort. Inside the building is art that one can find anywhere.

The building's internationalism follows from wanting to do urban renewal with a good architect, the museum's from art similarly being nowadays the same sort of mix of things wherever it's made. They are not the same. For one thing, the building has room for the local, and the museum program really doesn't. To the extent that it does, there can only be a dialectical relationship of the local to everything else, while in the building, the local and what comes from everywhere else have a far more complex relationship to one another. It takes in the curvature of the river, it forms a relationship with the bridge, and it stands apart by doing so. Inside the museum, objects sit uncomfortably in a space too big for anything, including any number of Serras, as the local art world in any European city is likely to sit uncomfortably on a historical map still dependent, as almost no other trade is, on place. Art may be the same everywhere, but because you have to look at original objects and talk to people in person, it still has geographical centers. If the museum franchise is meant to promote the development of Bilbao as a place where artists choose to live, then it will be promoting art that has nothing necessarily to do with the city, because like contemporary capitalism, contemporary art doesn't have much to do with places—especially when it pretends to, on which occasions it is always invoking a universal of some sort. I think, for example, of Roni Horn's work on Iceland.

I have mentioned the doleful use made of Foucault and by the hagiographers of the undead as a style and worldview, and he it was who said that history has no margins in which to frolic. Gehry frolics at the center of history. His work is playful in the simple sense that it follows logic to its conclusion, including and especially at the level of what is possible in terms of what's already there by the time the elements have been placed in the order in which they need to be. It is an architecture of frivolity and willfulness in that there's no reason for anything out of which it's made to be what it is except that that is a way of realizing the program while providing one with a surprise—suspended glass, held on by magnets, that complements a weightless skin, for example. Frivolity marginalizes the historical by depriving it of the twilight in which it likes to fly, if not frolic, while practicality undercuts historicism: The alternative to an architecture of disorientation as reorientation is an architecture of quotation. As a practical matter, the city either renews itself or quotes itself. If the former, it will do so in response to the world as it now is and using the best materials that are to hand, not only the local ones. Its renewal will be a conver-

gence between itself and the current state of things. If the latter, it will become trapped in simulation, becoming more like itself than it ever was, Bilbao as what was once a port city but now has no foreign influences, a model of its own history without any room not just for frolicking, but for going in any direction but back, as when New York was with difficulty prevented from putting cobblestones in a historically rich district that never had them.

The political question posed by Gehry's museum is not about globalism, but about history and international culture. There is no political question about globalism that hasn't been answered, except for the questions that have to do with how one does anything about it from a local point of view. It is predatory and simultaneously inevitable, history intertwined with fate. Gehry's architecture offers international culture as an alternative to globalism: the possibility of singularity produced from a specific set of conditions and opportunities, continuity as a theme and concatenation as an organizing principle, architecture as a kind of thinking that can be done anywhere present in a building that can only be done in one place. It offers a building that is for that place, but from everywhere or rather anywhere else, which settles into the city, but at the same time perks it up, rather than mourning for its history or reinventing it for the same reason. Undoubtedly, art and architecture will reflect globalism as long as it's the prevailing ideology, but globalism is inherently destructive because it concentrates wealth, while art and architecture are productive to the extent that they make the world livelier, rather than the alternative. Gehry has perked Bilbao up and perhaps dragged it into a convergence with the rest of the world that it would otherwise have had every day only on the television, in a much less exciting and rewarding way. It is important that his building has as much not to do with Bilbao as with it, because it's supposed to be both central to the city and what connects it to the rest of the world. That's the sense in which it seems to me to have been good for the polis, regardless of whether it ever made any money by way of tourism.

Politics involves more than money. How unfortunate, then, that once inside it's the same old vale of art after art's death through which one must pass everywhere, the international house of certainty in which Andy frolicked and Koons now plays, where modernism as a tolerated ghost takes the form only of the large and heavy. Gehry and the city of Bilbao live in the present and conceive of a world in which things happen. The museum presents a world in which the same idea is repeated using a changing menu of objects. The building and the city's politics have to do with simultaneity and deferral on more than one level, while the museum is about how everything devolves into a question of being after and response to something else. But that is the situation everywhere and has nothing to do with Gehry or the Bilbao city council. It has to do with the politics of international culture and how it must find a way to think about the visual arts without insisting that we continue in a past we've long since seen through.

Architecture :: Sculpture

John C. Welchman

My aim here is to introduce some of the relations posed by recent artists, architects, and critics between the domains of architecture and sculpture. I don't intend my remarks to operate as some kind of latter-day paragon such as what made competition for preeminence among the arts so popular in the late Renaissance, nor—for reasons of space and focus as much as anything else—do I intend them as a contribution to the discourse of modernist utopianism in which painting and sculpture collaborate with architecture and design, collapsing their mutual distinctions in the name of a progressive future. Nor, again, is it my aim to take sides in what seems like an endless sequence of professional jibes as artists and architects measure the difference between their activities in a series of quips and put-downs. We all remember Barnett Newman's witty definition of sculpture as what you bump into when backing up to look at a painting or Marcel Duchamp's response to a question about the difference between sculpture and architecture, the answer being that "one has plumbing."

If anything, these dicta have become even more common with the rise of postmodern architecture and its aftermath and the emergence of a strand of thought—in which Frank Gehry, as we will see, is deeply implicated—that proposes a newly accelerated set of overlaps and interplays between sculpture and bespoke building. Arguing against this relation, for example, Rafael Viñoly joked that the difference between "big sculpture and architecture is the waterproofing." And Gehry himself chipped in when he noted that the main difference between sculpture and architecture is, simply, "the windows."

With these anecdotes in mind, perhaps we should commence a broader account of the relations between sculpture and architecture on site. Looking at the characteristically dramatic shots of the Guggenheim Bilbao with which we are all familiar, one of things we notice—although probably not at first—is the telling presence of two sculptures, equally theatrical in their own right, doing battle for attention at the entrance (Jeff Koons's *Puppy*)

and rear (Louise Bourgeois' thirty-foot-tall bronze and steel spider, *Maman*, 1999). These works are symptomatic of several relational registers put in negotiation between architecture as spectacle and sculpture conceived as supplement—or even pantomime.

First, the gigantism of the sculptures, their inflation of an animal and an insect to dozens of times normal scale, subtly confers a sense of diminishment on the building they preface: If we read it as we understand them, the Guggenheim itself is reduced to the scale of what they already are—large sculptures.

Second, we should note the particularities of these works: Both are zoomorphic, both represent real, recognizable creatures, one, the most familiar and saccharine of domestic animals, the other, an inhabitant of the dusty corners of domestic space. One is characterized by romping and innocent ebullience, the other, as in Redon's noirs, is associated in the Symbolist moment with darkness and fear—but also aligned by Bourgeois with the nurturing vulnerability of motherhood. Both bring with them, then, intimations of an utterly different order than that normally brokered by either architecture or sculpture. Neither discourse nor institution would seem comfortable with the casual banality of the Koons or the menace and finesse of the Bourgeois.

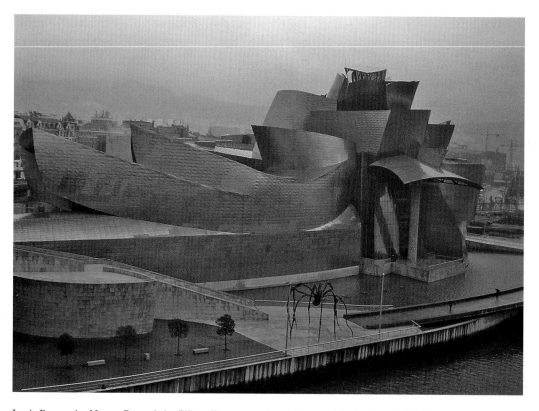

Louis Bourgeois, *Maman*, Guggenheim Bilbao. Elegance and populism combine in theatrical fashion at the rear of the museum.
© Cameron Watson.

In one sense, third, these animals stand in as the ironic endgame of the tradition of guardian spirits and hybrids that stretches back to the Egyptian sphinxes and the Lion Gate of Mycenae and forward to the grotesques of the medieval tradition located on portals or in the nooks and crannies of interior ecclesiastical space.

In another, they act as populist foils and vernacular embellishments lending the structure and the precincts they command a kind of folksy accessibility or carnival affirmation. And it's in this condition that they may be said to participate in the orientation of architecture with homespun Americana and street-smarts lite that was introduced into Gehry's projects through an encounter with Pop Art mediated by Claes Oldenburg.

Finally, the two-step sculptural bestiary that punctuates public navigation of the Guggenheim Bilbao is the whimsically deadbeat party of an antithesis between inside and outside that implicitly sanctions the "serious," mostly abstract nature of the sculpture displayed within the museum—emblematized most notably of course by the stringently non-mimetic work of Richard Serra—but also by that of Eduardo Chillida and others.

Koons's work, in particular, epitomizes the globalizing carnival that in the last decade has been license to do pantomime and minstrelsy in front of major museums or civic monuments. *Puppy* began life in Sydney, Australia, was exported for the opening of the Guggenheim in 1997, where it remains, and has also done duty in front of Rockefeller Center in New York (May–August 2000) and elsewhere—each of its appearances being accompanied by sustained media hoopla and fanfare. And Koons, of course, is not the only artist implicated in the redesignation of the museum precincts as amusement park or sideshow.

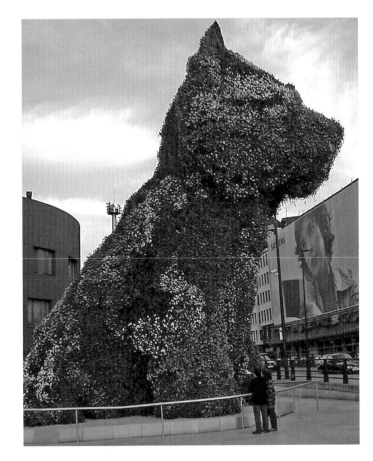

Jeff Koons, *Puppy*, Guggenheim Bilbao.
A folksy pastiche welcomes visitors at the museum entrance.
© Joseba Zulaika.

There are, however, many clear differences between the origins and implications of the sculptural works displayed in the precincts of the Guggenheim Bilbao. Bourgeois' spider has, in fact, recently been associated by Mieke Bal with the latest version of interstitial discursivity—postmodernism's reorganization of the paragon, if you like. For Bal, *Maman* emblematizes a domain of signification that conjoins not just the sculptural and the architectural, but also the dimensions of theory or critical reflection, historical genre, mythology, and biography that might weave them together. The spider, notes, Bal, "fits no genre or several: sculpture, installation, architecture. It relates to many currents of twentieth-century art, especially sculpture, but also beckons the baroque. Its contents and associations evoke social issues without being reducible to any one of them. It will doubtless become an icon of turn-of-the-century art."[1] Whether we agree or otherwise with the ambitious new zoning proposed by Bal, the symbolic mutations of Bourgeois's spider function in a domain quite remote from the decorative pastiche of *Puppy*.

I want to begin drawing out some of the wider issues in the relation between sculpture and architecture with a text from one of Frank Gehry's most cited and celebrated statements. "I don't know where you cross the line between architecture and sculpture," he famously remarked on the eve of the opening of the Guggenheim Bilbao. "For me, it's the same. Buildings and sculpture are three-dimensional objects."[2]

Gehry's insistence at the unveiling, or should we say, launch, of his most dramatic structure, on the shared conditions and boundaryless communion between architecture and sculpture has been one of the unswerving certainties of his shifting career. In a statement published nearly two decades before (in the 1980 edition of *Contemporary Architects*), for example, Gehry notes, quite forthrightly: "I approach each building as a sculptural object, a spatial container, a space with light and air, a response to context and appropriateness of feeling and spirit. To this container, this sculpture, the user brings his baggage, his program, and interacts with it to accommodate his needs. If he can't do that, I've failed."

In this, one of the earliest of his many conjugations of architecture and sculpture—pairings so numerous that in one form or another they dominate the popular reception of his oeuvre—Gehry situates the notion of a building as a sculptural object at the head of a concentrated minireprise of the nature of his enterprise. The sculptural approach to architecture presides over what appear as secondary, if necessary, functions of any building: as a "spatial container," a shell or shelter within which various activities may take place—dwelling, working, viewing; an organization of space infused with light and air (this definition is sufficiently abstract that it could be coupled with either the sculpture or container orientations); and as a "response to context," an affirmation of the codependency of a structure with its site, location, and their histories that it further defined

1. See Mieke Bal, *Louise Bourgeois' Spider: The Architecture of Art-Writing* (Chicago: University of Chicago Press, 2001).
2. Cited most recently by Sarah Milroy in "The Bilbao Effect, Art versus Architecture: Which Will Win Out?" Toronto *Globe and Mail*, January 24, 2004, p. R5.

with the invocation not only of a material or locative specificity, but of a kind of "appro-priateness" that Gehry links with emotion and spirituality in something like a latter-day deployment of the empathetic as a measure of architectural outreach.

Inverting—perhaps symptomatically—the initial ascendance of sculptural objectivity over spatial containerization, Gehry concludes this concentrated itemization by attending to a final condition of architecture that he locates in the interactive reception of the build-ing by an individualized user whose particular needs or programmatic orientations have to be "accommodated."

Gehry's commitment to a sculptural architecture, highlighted here and developed in quite nuanced, if sometimes inconsistent detail throughout his career, points us then to a founding orientation of his work quite distinct from the kinds of self-conscious theoriza-tion or working assumptions that motivated previous architectural regimens—functional-ism or commercial iterability, urbanism, civic, autocratic or religious monumentality, to cite only some of the most obvious cases.

But the relational question I am beginning to frame here is flanked by two converg-ing extremities that I want, for the sake of scale and focus, to foreclose. The first is an issue that alongside its implied double and probable other defined much of the discussion at the Reno conference. I'll pose it here in the simplest of terms as a series of questions: What is the relation between architecture and the aesthetic? And what contribution, dis-tinct or otherwise, to this relation has been made by Gehry's practice? I will argue that responses to these questions might best be accommodated if the sculptural is adequately situated as the crucial mediating term in the passage, if indeed there is one, from archi-tecture to the aesthetic.

The second issue is really a replay of the first, but in a different key, that of the main-stream reception of Gehry's projects, usually played out in the arts and editorial sections of regional newspapers between the announcement and construction of a local Gehry project. The latest of these can be found in the Toronto *Star and Globe* about a projected extension to the Art Gallery of Ontario,[3] but almost without exception, such discussions turn on the same repertoire of arguments and historical examples, locking them in a polarity from which few commentators seem able to escape, to pose the question of whether Gehry is designing a building in the service of its function or an artwork that by implication traduces and in effect spoils the former with an excess of the latter.

I don't want to suggest by any means that these questions are irrelevant, or even that either local or aesthetically generalized responses are somehow out of order. My task here is much more modest. I want to demonstrate that for different, but related reasons, the aperture of the polarity between locality, function, and the aesthetic is too great in these accounts and the resultant adjudication of one over the other may be, in the end, a false choice, falsely premised.

3. See Milroy, "The Bilbao Effect."

In what follows, I think through here several horizons of relationality according to which the practices—and effects—of architecture and sculpture have been either thought together or knowingly prized apart (and occasionally both at the same time). Largely because they so usefully summarize or allude to a considerable number of the relational aspects attended to by artists, historians, and critics, perhaps the best place to start is by returning to the texture of Gehry's own observations and opinions about the exchange between architecture and sculpture. But by doing this I do not want to ignore the important fact that many critics have followed Gehry's lead by anointing the architecture/sculpture conjunction as the foundation stone on which his success and celebrity are built. I'll cite just one example here (a couple more follow below). In her address on the occasion of the award to Gehry of the Pritzker Prize in 1989, Ada Louise Huxtable observed that Gehry's "explorations" "characteristically take place at the point where architecture and sculpture meet in anxious and uneasy confrontation; this is the difficult, dangerous and uncharted area that he has made his own."[4]

Here, then, are some strata in Gehry's wide-ranging thought on the terms and implications of a sculptural architecture. First, he notes on several occasions the relative separateness of architecture and sculpture, or at least that they may have different agendas, aims, and consequences. Nowhere is this more apparent that when Gehry is self-critical about the final effect of a sculptural or architectural element, as when he bluntly assesses his error with the copper "sculptural piece" for the Advanced Technology Laboratory Building at the University of Iowa, in Iowa City (1987/89–92), which, despite his intention to rhyme its material with "the copper of the Student Union," he simply "did wrong."[5] Even here, however, the sculptural is never quite sequestered from the architecture that governs it. The amplitude of Gehry's error is double that of a purely sculptural mistake: According to his mea culpa, the piece fails not only on its own terms, but also in relation to the relationship for which it strives—that of the site-specific repetition of its signature material.

The relatively traditional role of sculpture as an additive or supplement to the arena of architecture is attested elsewhere in Gehry's work: at the headquarters of the Progressive Corporation in Cleveland Ohio (1987 +), with the rooftop sculpture terrace programmed as a discrete element into the American Center, Paris (1991–93), or by the logic of adjacency, at the private home with guest house by Philip Johnson in Cleveland Ohio, where a sculptural work by Claes Oldenburg is set in the context of Gehry's building, or in the courtyard in front of the Fritz B. Burns Student Center at Loyola University Law School (1978 +), which is home to another Oldenburg sculpture, *Toppling Ladder with Spilling Paint*, added to the ensemble in 1986.

4. Ada Louise Huxtable, "On Awarding the Prize," at http://www.pritzkerprize.com/gehry.htm as of January 11, 2005.
5. Frank O. Gehry, *Frank O. Gehry: Individual Imagination and Cultural Conservatism*, ed. Charles Jencks et al. (London: Academy Editions, 1995), p. 42.

It's here, too, under the aegis of the traditional, that we might set out some of the numerous, more conventionally regulated encounters between Gehry and sculpture, which include his own sculptural works, such as the fish sculpture in Barcelona or his glass-and-wood sculpture *Standing Glass Fish* on view at the Minneapolis Sculpture Garden at the Walker Art Center and direct collaborations with sculptors, notably, of course, with Claes Oldenburg, but also with Richard Serra, with whom he worked on the design of two unrealized bridge projects, including one for Tate Modern in London and another for the exhibition Collaboration: Artists and Architects (Architectural League of New York, 1981), which envisaged a connection between the World Trade Center and Chrysler Building with anchoring elements of giant Gehry fish and a Serra pylon in the East and Hudson Rivers.

Gehry has also produced a sequence of exhibition designs, many of them for exhibitions of sculpture, such as German Expressionist Sculpture (1983) at the Los Angeles County Museum of Art, for which he built arguably his most traditional edifice, reconstructing a portion of a niche in a brick church façade to provide a simulation of what was probably the original location of an Ernst Barlach sculpture (visible in the background of several photographs documenting the show).

Occasionally, this normativity is knowingly traduced, set up as a setup, if you like, and nowhere more cunningly so than when Gehry wittily recalibrated sculpture—through architecture—as natural form in the garden of his own house after its 1992–93 renovation. Here, architecture takes on the pictorial role of the frame in order to serve as a special catalyst that produces nature as public sculpture: "I wanted to expose the beautiful specimen cactus in my garden to the public view. I wanted to present it like a public sculpture."[6]

In addition to these situations for sculpture as artwork or architectural extra, the sculptural is considered by Gehry, not as a discrete practice or regimen of specific objects, but as one of the many—and seemingly one of the most important—of the signifying effects of his architecture. Consider this observation about the Walt Disney Concert Hall in Los Angeles: "the building's orientation, combined with the curving and folding exterior stone, will present highly sculptural compositions as viewers move along." Gehry's comment collides several signal aspects of his thinking about the experience of architecture—to which we will return. These include movement and temporality, ascribed to the building itself, with its curves and folds, but also attributed to the perceptual sequencing of a visitor's itinerary, and the key notion of sculptural compositionality, a telling formula that will allow us to trace some strands in the history of the modernist theory of "composition" so vigorously disputed in vanguard art practice from the 1960s on—and crucial, I would argue, to the emergence of Gehry's signature practice.

6. Frank Gehry, in *Gehry Talks: Architecture and Process*, ed. Mildred Friedman, with an essay by Michael Sorkin and commentaries by Frank O. Gehry (New York: Universe Publishing, St. Martin's Press, 2002), pp. 38–39.

The sculptural effect that arises from architecture appears to develop from two different understandings of what exactly sculpture is in the writings and comments of Gehry and his associates. At one extreme, the sculptural is the product of concentrated or spectacular artlike assemblages of space and materials that lend to a building something that delivers it to an aesthetic condition beyond its function. It is in this sense that the headquarters for Vitra International, near Basel, Switzerland (1988/92–94) is described as "flamboyant and sculptural," or, in the same vein, that the nature of its "communal support areas … allowed them to take on richer, sculptural spaces."[7] As with many of Gehry's commissions, the correlation of the sculptural with the dramatic or the flamboyant does not emerge in isolation from other effects or different orders of association.

At Vitra, of course, the sculpturally avant-garde spectacle offers an enclosure within which, as Charles Jencks and others have noted, elements of design themselves, in the form of privileged items of furniture becoming sculpture, are isolated as singular, Platonic, and exemplary on their plinths and pedestals. Here, then, sculpture in its para-architectural disguise offers shelter for design made over as sculpture in its traditional incarnation.

The plural and antithetical operations of sculpture's agenda so vividly present at Vitra are apprehended as singularities elsewhere. One reading of the American Center in Paris, for example, pronounced it "slightly too unified, like a sculptural element," attributing this shortcoming to the fact that "it was not completed to Frank's design." The purportedly more conventional appearance of the center, driven by a Parisianizing plainness much remarked on by its critics, becomes another—here excusable—architectural error that is lent a palpable gestalt by invoking the discursive trope of the sculptural—defined in this instance by unadventurous homogeneity, stasis, and unity.

Yet again, however, we witness a designation driven by the ubiquitous and deceptive sculptural metaphor that ends up being turned back against itself. Robert Maxwell, for example, delivers as an approbation of one of Gehry's more whimsical buildings, the offices of the Chiat Day advertising agency in Venice, California, with its façade famously pivoted on Oldenburg's gigantic binoculars, virtually the same pronouncement that was offered as a rationale for the relative failure of the American Center: Chiat/Day, he affirms, is successful as architecture because it is "sculpturally unified."[8] The building succeeds, according to this account, because of its ability, measured and defined in sculptural terms, to digest and resolve the outrageous and outsized object—the very symbol of that technological optic devised to conquer space, bringing the far to the near—that administers its fearless symmetry.

It's clear that the final frontier of the sculptural metaphor deployed by Gehry arrives with that special organization of form and material—and its privileged "truth," long des-

7. *Frank O. Gehry*, pp. 49, 83.
8. Robert Maxwell, cited in *Frank O. Gehry*, p. 64.

ignated as the aesthetic. Gehry works out this aesthetic in generalized terms that confer on architecture the double premium of pictorial immediacy and sculptural order:

> Painting had an immediacy, which I craved for architecture. I explored the processes of raw construction materials to try giving feeling and spirit to form. In trying to find the essence of my own expression, I fantasized the artist standing before the white canvas deciding what was the first move. I called it the moment of truth… The moment of truth, the composition of elements, the selection of forms, scale, materials, color, finally, all the same issues facing the painter and the sculptor. Architecture is surely an art, and those who practice the art of architecture are surely architects.[9]

The recipe set out here is deceptively simple: Immediacy and raw construction admixed with feeling and spirit, articulated by composition (the key process that facilitates mobility and interrelation between discourses, as we will see), and set in motion by an originating "moment of truth"—all this makes architecture an "art." There is so much at stake here in every word, phrase, and assumption that I can respond to it only somewhat cheaply. Let me cite a ringing endorsement of Gehry's synaesthetic dream: We "share," notes one of the prefaces to the Guggenheim Museum's own exhibition, Frank Gehry, Architect (2000–2001), "Mr. Gehry's ongoing search for 'the moment of truth'—the moment when the functional approach to a problem becomes infused with the artistry that produces a truly innovative solution." I draw your attention to the "we share"—and to the correlation of artistry and the delivery of "truly innovative solutions." This preface was written by Jeff Skilling, president and chief executive officer of Enron. Cheap, perhaps, but telling nonetheless: If the ingredients of Gehry's recipe can be selectively stir-fried in a sauce that cooks the corporate books, then at least some of the dishes they produce may not prove all that savory.

Irony, chilling or delicious, aside, the question remains: Can we learn anything from this litany of iterations and outright paradoxes in the interleaving of architecture and sculpture beyond the obvious fact that reading one through the other is clearly desired, privileged, and even compulsive in the reflections of both Gehry himself and many, if not most, of his critics and commentators?

I think the answer is yes, we can. What might result from this inquiry will clarify something at least about the nature of current avant-garde architecture, about the relation between architecture and both the aesthetic and the social, and about the new forms of congruence, or codependence, between architecture, sculpture and painting, media, technology, and the public sphere at a moment when both the material and the conceptual separateness between these domains is fast diminishing.

I want to explore some of the historical, contextual, and theoretical conjunctions between architecture and sculpture that might help explain both the insistence and diver-

9. Frank Gehry, acceptance speech for the Pritzker Architecture Prize, at http://www.pritzkerprize.com/gehry.htm as of January 11, 2005.

sity of Gehry's own relational strata. I'll do this under two main headings that sometimes converge and occasionally conflict with his.

Compositionality

In my sketch of Gehry's negotiations between sculpture and architecture, I cited several occasions—most notably, perhaps, in his account of a visitor's dynamic experience of the Walt Disney Concert Hall—when architecture's sculptural orientation is aligned with the artistic effects of composition. Gehry's defense of composition in architecture has three main components. The first arises from the generalized association of composition with the aesthetic or the artistic—and its "truths." The second relates to the different realizations of compositional arrangement associated with various periods in Gehry's career—ranging from quasi-modernist singularity in the earliest works, (such as the Danzinger Studio and Residence, 1964–65, Hollywood, CA), through a syntax composed with modular elements or an assemblage of distinct geometries (as in the Team Disneyland Administration Building, ["cowcatcher"] 1987–95, Anaheim, CA), to the seething fractal and curvilinear forms of the Guggenheim Bilbao and after (the Experience Music Project, 1995–2000, Seattle, WA). The third is that noted in my leading example, a situation in which compositional effects arise from the complex perception of the building from constantly shifting points of view. Because versions of all of these understandings of the compositional were formulated—and disputed—in the development of the historical avant-garde, it will be useful briefly to trace their origins and development.

The interest in composition has a long history, dating back at least as far as chapter 7 of the *Poetics*, where Aristotle notes that "a picture, or any other composite object, if it is to be beautiful, must … have its parts properly arranged."[10] Aristotle's is perhaps the founding articulation of the theory of aesthetic composition that dominated Western cultural practice until the twentieth century. The correlation between beauty and the coordinated arrangement of parts was vigorously reinforced in the eighteenth-century Neoclassicism associated with the development of modernity. Here it was identified with the dominant theory of the aesthetic unity of the individual work proposed by German art historians from Johann Joachim Winckelmann to Erwin Panofsky—a lineage that culminated in the gestalt perception of the image as an organized visual whole. In another study, I proposed that certain powerful tendencies within visual modernism actively struggled with the inheritance and reinflection of this compositional tradition and that they signaled the intensity of their intervention in a complex discourse of compositionality that was refracted through the designation "composition" itself.[11]

The great pictorial compositionists, Wassily Kandinsky and Piet Mondrian, devised elaborate visual-textual systems for the articulation, respectively, of spiritual and utopian

10. Aristotle, *On the Art of Fiction: "The Poetics,"* trans. L. J. Potts (Cambridge: Cambridge University Press, 1968), p. 27.

11. See John C. Welchman, *Invisible Colors: A Visual History of Titles* (New Haven: Yale University Press, 1997), esp. chs. 6 and 8.

world orders. For both artists, the composition was a sanctified space, designated by a powerful word, whose cosignifications traduced the more restricted logics of earlier compositional orders. While they took on some of the aestheticist or formalist insistence on compositional self-reference, "arrangement," and decoration, such emphases were for them, merely points of departure. Visual forms, they claimed, must be intense and arranged, but they are always signs, and not just patterns. For Kandinsky, they were modernist allegories that filtered the communication of psychological states. For Mondrian, they were the environmental barcodes laid down for a visual adjudication of the future.

In his definition of a "Composition," Kandinsky puts almost his entire emphasis on the effects of sequential time, on accumulating investments and excruciating revision. He stresses that a "Composition" is the result of the formation of feelings "over a very long period of time" and that its forms are "slowly and almost pedantically examined and worked out." Unlike the Futurists, he was not concerned actually to represent sequential time or simultaneously serial instants. Instead a "Composition" arises as a *combination* of sequences, sketches, and preliminary ideas whose totality might be compared to a dimensional map of a complex psychological state. A "Composition" rectifies the superficial apprehension of the "Impression" and the provisionality of the "Improvisation" by offering a powerful, summary *representation of revision.*[12]

For Mondrian, the term "composition" functions not simply as a nonreferential title or handy tag, but as a sort of philosophical envelope for the social high seriousness of his whole pictorial enterprise. Almost continuously operative at the threshold of his move to noniconic abstraction. For Mondrian, the term "composition" became a privileged designation standing in for the progressive eclipse of the naturalistic visual sign. Once established as the nearly exclusive designation for his paintings, the theory and practice of "composition" are redolent of the goals and achievements actively sought out and italicized in his writings—the point of conjunction in a whole lexicon of "New Plastic" attributes—relationship, repose, rhythm, equilibrium.

In a position paper on the theory of Neoplasticism, Mondrian notes the centrality of the notion of composition to his whole undertaking: "[J]ust as in painting [so also in architecture], it is above all *composition* that must suppress the individual."[13] This is underlined in a manifesto of 1921: "It is through *composition* that the 'universal plastic means' must be expressed in continuously self-neutralizing plurality (and not by repetition 'in the manner of nature')."[14] The achievement of *compositional* order was the crucial goal of a theory and practice that sought to produce what Mondrian termed a radical "otherness" in respect of traditional artistic (or architectural) practice. Composition—the semimechanical dispo-

12. Wassily Kandinsky, *On the Spiritual in Art* (1912), in *Complete Writings on Art*, ed. Kenneth C. Lindsay and Peter Vergo, vol. 1, *1920–1921* (Boston: G. K. Hall, 1982), pp. 124–25.

13. Piet Mondrian, "Neo-Plasticism: The General Principle of Plastic Equivalence" (1920), in Welchman, *Invisible Colors*, p. 139.

14. Piet Mondrian, "The Manifestation of Neo-Plasticism in Music and the Italian Futurists' *Bruiteurs*" (1921), in Welchman, *Invisible Colors*, p. 154.

sition of plastic units into a "universal" order—had as its antithesis the inherited (Romantic) conception of artistic "individuality."[15] At its extreme, it approached the condition of "logic": "Is not art," asked the artist, "the *exteriorization* of logic?"[16]

Mondrian's utopianism, which makes painting the privileged emissary of the social utopianism to come as it delivers red, yellow, and blueprints for the design and architecture of the future, is met of course by Walter Gropius's version of aesthetic totality, with architecture now as vanguard, set out in the founding document of the Bauhaus in 1919: "Together let us desire, conceive, and create the new structure of the future, which will embrace architecture and sculpture and painting in one unity and which will one day rise toward heaven from the hands of a million workers like the crystal symbol of a new faith." Purged somewhat of this visionary breathlessness, Gropius would later elevate architecture as the proving ground for a healthy society: "A modern, harmonic and lively architecture is the visible sign of an authentic democracy." This journey of the compositional from a device that secures aesthetic singularity to the correlate of a successful social democracy is clearly crucial to my discussion—but raises issues far too broad to be taken on here.

Returning, then, to the historical avant-garde, while Henri Matisse defended the more cautious and circumscribed compositional pictoriality of the Ecole de Paris on the residual grounds of the figure, Kasimir Malevich deployed the same terminology to issue a withering attack on the attributes of body-form. He rails against the "allusive" "parody of life" that appears in "a face painted in a picture," asserting, near the conclusion of his essay on Suprematism that "You go into raptures over a picture's composition, but in fact, composition is the death sentence for a figure condemned by the artist to an eternal pose."[17]

In this essay, "From Cubism and Futurism to Suprematism: The New Painterly Realism" (1915), Malevich offers one of the first of what would be a wave of radical disaffections for the modernist notion of "composition" issued from the progressively militant and polarized ranks of the Russian and then Soviet avant-gardes. Indeed, the opposition between the virtues of "construction" and the decadence and futility of (bourgeois) "composition" would become one of the centerpieces of the elaborate art debates staged in Moscow and elsewhere in the late 1910s and early 1920s. Here, however, Malevich seems to imagine that constructive values are a greater and privileged set, containing and controlling a range of other "formal/technical" attributes, including what he terms "compositional beauty." Following the demise of the "laboratory art" experiments of Liubov Popova, Alexandr Rodchenko, and others around 1918 to 1921, all hints of composition would

15. The quoted words are those used by Z ("an Abstract-Real Painter," and thus a surrogate for Mondrian himself) in Mondrian, "Natural Reality and Abstract Reality," in Welchman, *Invisible Colors*, pp. 114–15.

16. Piet Mondrian, "Neo-Plasticism: General Principle," in Welchman, *Invisible Colors*, p. 143.

17. Kasimir Malevich, "From Cubism and Futurism to Suprematism: The New Painterly Realism" (1915), in *Russian Art of the Avant-Garde: Theory and Criticism*, ed. John Bowlt (New York: Thames and Hudson, 1988), p. 135.

be banished from the theory and practice of Constructivist-Productivist practice. "Composition" became a predicate of an outmoded "art" impulse, while constructed work was given solely to the design and production of things named only by their function.

Although raised to a flash point and finally incinerated by Kandinsky and Mondrian, compositionality did not cease to be a preoccupation for visual artists after the mid-century. In many ways, it remained the key point of investment and antagonism for all modernist art. It was also the most important point of calibration for avant-garde and neo-avant-garde disavowals or reinventions of formal order. And it is of course these destinies of the compositional that were inherited most directly by Gehry.

For the generation that succeeded the Abstract Expressionists, composition was an unwanted, although ambiguously contested sign of the false order and fastidious control of European modernism. Robert Rauschenberg was one of a number of artists working in the United States in the later 1950s and the 1960s who began a fundamental contestation of the precepts of ordered form, especially as they had been worked out by the School of Paris. Rauschenberg claimed, quite deliberately, to work "in spite of composition," substituting a theory and practice of collaboration, accumulation, and contingency whose operations are specifically mobilized against the deliberation, control, and order of the composition. "Painting is always strongest," he asserted, "when in spite of composition, color, etc., it appears as a fact, or an inevitability, as opposed to a souvenir or arrangement."[18] Like Willem de Kooning and Clyford Still, Rauschenberg opposed "the whole idea of conception—execution—of getting an idea for a picture and then carrying it out," although unlike them, his concern was for "*collaboration* with the materials," for a kind of spontaneous, chance-assisted interaction of factlike parts "combined," rather than "composed."[19]

In "Specific Objects," his strategically important discussion of the new object-based work of the 1960s, Donald Judd announced that his chief problem with painting was that it is unredeemably "spatial." It can never resist producing images of space; it is vestigially illusionistic; it looks like or intimates something else: In short, pictorial space is always *composed*, it has "qualities especially identified with art." Only Yves Klein and Frank Stella, in his opinion, produced painting that was nearly "unspatial."[20] During a broadcast interview with Bruce Glaser in February 1964, Judd specifically articulated a final departure from what Glaser termed "traditional compositional effects" and what Stella called "compositional or structural element[s]": "[T]he fact that compositional arrangement isn't important is rather new. Composition is obviously very important to [Victor] Vasarely, but all I'm interested in is having a work interesting to me as a whole. I don't think there's any way you can juggle a composition that would make it more interesting in terms of

18. Robert Rauschenberg, "Statement," in *Sixteen Americans*, ed. Dorothy C. Miller (New York: The Museum of Modern Art, 1959). Reprinted in *Readings in American Art 1900-1975*, ed. Barbara Rose (New York: Praeger, 1975), p. 149.

19. Ibid., p. 150.

20. Donald Judd, "Specific Objects" (*Arts Yearbook*, 1965), in *Complete Writings 1959–1975: Gallery Reviews, Book Reviews, Articles, Letters to the Editor, Reports, Statements, Complaints* (Halifax: Press of the Nova Scotia College of Art and Design, and New York: New York University Press, 1975).

the parts."[21] While he criticized key aspects of the compositional tradition, Judd, like Anthony Caro before him and others in the Minimalist scene (as we'll see in a minute), never quite dispensed with some of its central precepts.

Judd's concern was to redistribute compositionality in several registers designed to unseat the hegemony of modernist pictoriality. These included the consecration of household and industrial materials—Plexiglass, plywood, synthetic paints, and so on; an emphasis on gestalt totalities, rather than the syntax of parts; and a reorientation of the reception of the work through a circumambient perception dependent on bodies, movement, and time. Gehry is a legatee of this redistribution, not as it unfolds in the specific objects and thinking of Judd, but rather as it emerged interstitially between positions adumbrated in the late modernist, Pop and Minimalist avant-gardes, which themselves overlapped and conflicted.

Judd, of course, had no particular interest in addressing the extension of his compositional revisionism into the domain of the architectural. In fact, his view of building, so far as we can tease one out, tended to eclipse architecture per se in favor of a formal visibility of general "nonart" construction that establishes it in continuity with things specifically designated as "art."

As he puts it so forthrightly at the opening of a review in *Arts Magazine* (October 1964) of the Museum of Modern Art's exhibition Twentieth-Century Engineering (1964, curated by Arthur Drexler): "Dams, roads, bridges, tunnels, storage buildings and various other useful structures comprise the bulk of the best visible things made in this century." The world's "few good buildings," he continues, supplied by what he terms "real architecture," are "more specific than most of the engineering projects," but "most buildings," and most of what architecture achieves in the name of false "elegance," "are far inferior to engineering projects." Judd attributes this to the perverse liberation of engineering engendered in its domination by sheer commercialism and utilitarian drive—something that at its best gives rise to a cleansing simplicity of form that Judd calls "the plain beauty of well-made things." Writing as architectural postmodernism was in its incubation phase, Judd glimpsed three futures for architecture that, it could be argued, are all attempted in Gehry's work: first, the substitution for false, decorative "elegance" (the elegance, if you like, of brocade) of a kind of complexly elegant structural simplicity; second, the arrival of an architectural "invention" that could subvert the unyielding "barrenness" of the built environment; and third, and perhaps most important, (Judd quotes from the exhibition catalogue), something to replace the "lack" of a "political and economic apparatus that would facilitate a truly responsible use of our technology."[22]

21. Donald Judd, "New Nihilism or New Art?" Interview by Bruce Glaser with Frank Stella and Donald Judd, broadcast on WBAI-FM, New York, February 1964, and published as "Questions to Stella and Judd: Interview by Bruce Glaser, Edited by Lucy R. Lippard," *ARTnews*, September 1966), in *Minimal Art: A Critical Anthology*, ed. Gregory Battcock (New York: E. P. Dutton, 1968), pp. 154, 155.

22. Donald Judd, "Month in Review," *Arts Magazine* (October 1964), reprinted in Donald Judd, *Complete Writings 1959–1975*, pp. 137–39.

But once more we must not get carried away. I have to wonder whether Judd would have viewed the Guggenheim Bilbao, as he did the show at MoMA as "overly dramatic" and somewhat pretentious." I rather think he would.

Postmodern Sculpture

There is little doubt that a signal component of Gehry's architecture has been achieved in sustained relation to the work and ideas of successive postwar generations of late modernist, combine, Pop, installation, Minimalist and Earth artists who produced between them a startling new matrix for the production of artworks in three dimensions as well as a series of powerful reflections on the relations between sculpture and architecture, artwork and landscape, and institutional and public space. Many of these artists, such as Oldenberg, Ed Kienholz, Anthony Caro, and Serra have collaborated with Gehry and/or count among his friends. Others, including Gordon Matta-Clark, Robert Smithson, Dan Graham, and Hans Haacke made important, often more critical interventions in the reciprocal relations between sculpture, architecture, and their social or natural contexts.

Certain aspects of these relations can be generalized across individuals and movements, such as, for example, the interest shared by many of these artists in the deployment of cheap or everyday materials. "My artist friends," said Gehry, "people like Jasper Johns, Bob Rauschenberg, Ed Kienholz, Claes Oldenburg, were working with very inexpensive materials—broken wood and paper, and they were making beauty. These were not superficial details, they were direct, it raised the question of what was beautiful. I chose to use the craft available, and to work with the craftsmen and make a virtue out of their limitations."[23] Other components of what emerges as a complex tessellation of exchanges, influences, and deferrals were worked out with different emphases in the theory and practice of individual artists whose allegiances, clear from the names rehearsed above, range from variants of modernist formalism to thoroughgoing institutional critique. In what follows, I will look briefly at three formations of relationality between sculpture and architecture. All, I will argue, have had an impact on Gehry, and each will be rather crudely personified in a different kind of sculptor—one modernist, one Minimalist, one, for the sake of labeling, post-Minimalist: Anthony Caro, Richard Serra, and Dan Graham.

In a lecture on sculpture and architecture delivered at the Tate Gallery in London in March 1991, Anthony Caro sketches a relationship that with numerous emphases and inflections is fundamental to the generation that opened up new understandings for sculpture after Abstract Expressionism:

> [S]ince the Sixties, sculpture has not been far away from architecture. In the Sixties and after, sculpture extended itself so it explored almost the same space as the architect's. Not quite the same space, because sculptors' space always, it seems, demanded an invisible wall between spectator and work.

23. Frank Gehry, acceptance speech for the Pritzker Architecture Prize, at http://www.pritzkerprize.com/gehry.htm as of January 11, 2005.

In those days sculptors were absorbed with making a new vocabulary for sculpture and that meant getting right away from old-fashioned modes and methods. Styling solves nothing. Nevertheless, to have realised the closeness of abstract sculpture to architecture would at that time have horrified us. All the same we were using rods that felt like handrails even if they were not for grasping, making intervals like doorways even though one could not go through them, enclosing space in works that felt like rooms though one could explore them with the eyes only.[24]

Caro confronts us here with an anxious proximity between sculpture and architecture that announces the retrospective "horror" of their closeness and concludes with a series of suggestive itemizations of their allusive dysfunction. The sculptural "rods," "intervals," or enclosed "space" of which he spoke offer intimations of their more concrete architectural correlates—handrails, doors, rooms—yet do not precipitate the specific action or experience associated with them—grasping or holding, entering and exploring (with the body). This hedged proposition speaks quite powerfully to the type of abstraction for which Caro reached, one that dwells in formal implication, invoking—but always deferring—the specificity of situations that are lifelike, embodied or programmed by function. At the same time, it suggests the measure of his separation from the generation that succeeded him—and from the rise of architectural practices inhabiting a similar revision, for almost everything that Caro counts out here, but particularly, of course, the relegation of somatic perception, became crucial elements of the Minimalist platform.

Caro appears to have responded later in his career to this shift—by virtue, in good part at least, of a direct encounter with Gehry in the late 1980s. Early on, however, Caro, along with Morris Louis, Kenneth Noland, and Stella, became one of a handful of American and British artists (and the privileged sculptor) who received special sanction from the kingpins (and queenpins) of formalist criticism, Clement Greenberg, Michael Fried, and, slightly later, Rosalind Krauss. Around 1966 or 1967, at the height of Caro's new celebrity, the debate around his work taken up by Fried and Krauss specifically focuses on the question of its "compositionality." The initial and most extended article in this loose critical sequence was Fried's "Notes on Not Composing," written for the *Lugano Review* in 1965. Here he argues as follows: "My basic contention is this: that there is an important sense in which it may be said that both Caro's sculpture and Noland's paintings are not composed—that the decisions that go into their making are not compositional decisions."[25] In relation to Noland, Fried is able to substitute another modality of production for the compositional. This he terms "deductive."[26] Defining "traditional composition" as

24. Anthony Caro, "Through the Window" (March 1991). Edited version of speech delivered at the Tate Gallery, March 1991, revised June 2001, at http://www.anthonycaro.org/ysp1-thru-the-window.htm as of January 11, 2005.

25. Michael Fried, "Anthony Caro and Kenneth Noland: Some Notes on Not Composing," *Lugano Review* 1, nos. 3–4 (Summer 1965): 198.

26. Fried develops a theory of deductive structure for Noland in his essay for the exhibition Three American Painters at the Fogg Art Museum in Cambridge in 1965 and in the Noland retrospective at the Jewish Museum in New York in 1965.

the engendering of "balance" between differential elements whose relative "pulling-powers" are resolved into "equilibrium," Fried determines that Noland's work—with its "perfect lateral-symmetry"—would look "trivial, even vacuous" when measured by these parameters.[27]

Caro, Fried claims, shares Noland's resolute retreat from the precepts of composition, but has failed to formulate a "positive alternative" that would answer to Noland's pictorial "deductions." As evidence of Caro's noncompositionality, Fried quotes from an article published in the *Washington Post* (February 21, 1965), in which the sculptor bluntly states, "I don't compose," and from an early interview with Lawrence Alloway during which he notes that his "decisions" are "not compositions."[28] With reference to the viewer, Fried makes a brief attempt to follow through the consequences of this double retreat from composition. The new methods of Caro necessitate a kind of deferment of vision and a new predication of "close-up-ness" for which a "point of no view" is substituted for the traditional "point of view."[28] The inevitability of compositional intuition is a consequence of "stepping back" to take in the wholeness of the sculpture. Caro himself censures the gestalt unities involved in "stepping back," and his refusal of outdoor locations interfered with by landscape or any other aspect of the public domain involves a similar retreat. Such literal and interpretational interiority gives rise to a social abstraction formed in a metaphorical gestalt that itself resembles the gesture of "stepping back." The resolute antisociality, internality, even myopia encoded in the "point of no view" returns an abstract viewing environment that appears to be the internalist inverse of what Krauss would later describe as the effects of the "expanded field."[30]

Writing two years later, Krauss argued against the noncompositionality proposed by Fried, again using the modeled similarity read from an American painter back onto the works of Caro. The newer works of Stella are held to mark "a withdrawal from the kind of structure which obviated the need for compositional decision within the interior of his painting, to one that now calls for relationships between parts of the paintings' fields." With reference to Caro's *Carriage* (1966), Krauss argues that "[i]t seems, at least to me, that the far-flung disparateness, the quality of being uncomposed, the sense in which the parts of the sculptures did not relate compositionally to one another, has been withdrawn or at least modified." Color, for example, has been prepared for "by a kind of composing that he now allows himself, and it is that kind of composition that I wish to discuss." Krauss traces the origin of this mode back to the historical avant-garde, claiming that the effects of *Carriage* resemble some of the pictorial revolutions of the Cubist movement around 1910 to 1912: "This was not an abstraction of objects, but the abstraction of

27. Fried, "Anthony Caro and Kenneth Noland," p. 203.

28. Interview with Lawrence Alloway in the first edition of the one-page *Gazette*, ed. Lawrence Alloway, Lawrence, Gordon House, and William Turnbull (London?: n.p., 1961).

29. Fried, "Anthony Caro and Kenneth Noland," p. 205.

30. See Rosalind Krauss, "Sculpture in the Expanded Field," in *The Originality of the Avant-Garde and Other Modernist Myths* (Cambridge, MA: MIT Press, 1985).

what lay behind the presentations of objects in painting: the abstraction of illusionism itself." In this sense, somewhat unusually, Caro's work is described as "the first really Cubist sculpture," a sculpture that "is almost totally diagrammatic."[31]

The diagram stands here as an image of the "metacompositional," implicitly replacing the Dada diagramming of Francis Picabia, which is its formal adversary and parodic inverse. For Caro, such new compositionality releases what are almost pure emotional effects, the new "effulgence" and "dimensionality" of color, with its hints of the beginning of a new retinal solecism—a new abstract "impressionism" (or better, a new interiority of vision).

Two decades elapsed between the highly nuanced formation by Caro and his critics of one of the most intense renegotiations of compositional abstraction and the summer of 1987, when Caro and Gehry came together at the Triangle Workshop at Pine Plains, New York, to collaborate on an architectural/sculptural "village." A recent account of this meeting notes that:

> There have long been elements of buildings in his [Caro's] work but it was after a summer workshop in America in 1987 with architect Frank Gehry that the idea of exploring the relationship between architecture and sculpture took off. Freed from the constraints of functionalism bar [sic] the need to make their structures stand up, Caro and Gehry knocked up over a period of two days a sprawling, quirky and extraordinary hybrid construction in wood that combined ramps, steps, towers and other architectural elements, all used creatively and intuitively as sculptural elements.[32]

The effect on Caro and his work is obvious: The extended practicum with Gehry engendered the possibility that a direct relationship between sculpture and architecture, once termed horrific, could not just be redeemed into some kind of new permissibility, but might actually take over as the driving force of his later career: "[T]he most ambitious area of his output is only just coming to fruition, an area he calls 'sculpitecture.'"[33] It is tempting to suggest that for Gehry, always less direct and usually more cautious about the attribution of specific determinants for his work, the effect was somewhat equal and opposite. In other words, the experience of modeling, experimenting, and playing with one of the magi of high-modernist three-dimensional form allowed him to redigest aspects of the imaginative free play of shapes and volumes that in the same year he would begin to lay down as one of the foundations of the Guggenheim Bilbao.

Such a conclusion is surely too conjectural—and too pat. But while the momentum behind the pen that worked up Gehry's famous napkin sketches—those almost mythological blueprints consecrated to the foundation of the Bilbao museum—cannot by any means be attributed to Caro, the meeting between them and Caro's emblematization of

31. Rosalind E. Krauss, "On Anthony Caro's Latest Work," *Art International* 11, no. 1 (January 20 1967): 26–27.
32. Tim Marlow, "Man of Steel," *Cambridge Alumni Magazine* (Lent Term 1997), at http://www.anthonycaro.org/Interview-MoS.htm as of January 11, 2005.
33. Ibid.

advanced sculptural abstraction constitute one strand of the formative interplay between sculptural and architectural discourse that I am attempting to trace here.

Another arises from a second set of interrelationships, both personal and professional, this time with Serra. Caro's "horror"—whether feigned or projected—notwithstanding, Serra's views on architecture were altogether tougher. During a series of interviews in the 1980s, most notably with Peter Eisenman in 1983, Serra established several of the grounds for his dispute with architecture. These include the propensity of both modernist sculpture (he mentions the "portability" of Alexander Calder and Isamu Noguchi and the "site-adjusted folly" of Henry Moore) and midcentury architecture to be bound by their points of origination in the studio—with the result that both practices default on their relationships with scale and context. "Architects," he notes, "suffer from the same studio syndrome. They work out of their offices, terrace the landscape, and place their buildings into the carved site. As a result the studio-designed then site-adjusted buildings look like blown-up cardboard models." There are designated "exceptions," of course, and—significantly for the present context—Serra's list reads as follows: "Le Corbusier, Wright, Kahn, Gehry."[34]

Second, Caro's rather coy "horror" is converted by Serra into a more menacing scene of "annoyance" engendered "when sculpture enters the realm of the non-institution, when it leaves the gallery or museum to occupy the same space and place as architecture." This move, and its concomitant redefinition of "space and place" in terms of what Serra calls "sculptural necessities" precipitate, then, one of the antagonisms on which his practice thrives … and about which "architects become annoyed." In the end, annoyance (on the part of architecture), though never quite counted out, was quickly converted into the communal currency of New York postmodernism in the 1980s, as Serra made it over in his very next sentence as critique (from the point of view of sculpture): "Not only is [architecture's] concept of space being changed, but for the most part it is being criticized." In this process, the self-referentiality so coveted by the modernist paradigm is formatted as an aggressive reterritorialization: "The criticism can come into effect only when architectural scale, methods, materials, and procedures are being used."[35]

Third, Serra is also critical of attempts by postmodern "contextualists" such as Robert Venturi (with whom he once had an extended argument) who seek to transpose the site-specific into an extension of the "indigenous cultural situation," outflanking it, as it were, with an overdose of vernacular trappings—and in the process dooming the result to nostalgia and mere contextual affirmation. Fourth, in a position drawn out by Eisenman, Serra speaks once more to the idea of "noncompositionality," here derived form the absence of a "hierarchy of parts" he perceives in the paintings of Jackson Pollock and set against the European pictorial tradition discussed above—Matisse, the Cubists, Mondri-

34. Richard Serra, interview by Peter Eisenman, first published in *Skyline* (April 1983), pp. 14–17, in Richard Serra, *Writings and Interviews* (Chicago: University of Chicago Press, 1994), pp. 145–46.

35. Ibid., p. 146.

an. Reacting to Serra's anticompositional activation of voids and spaces, Eisenman suggests that "it is not the elements of composition in architecture—the bay, the column, the window—that are interesting, but what is between them."[36]

And finally, Serra returns to another issue also raised by Caro: the question of the "inhabitability" of his work, particularly the urban sculptures such as *Rotary Arc* and *Tilted Arc* in New York and *Clara-Clara* in Paris, which, as Alfred Pacquement put it, may "discover their identity through the people who pass them by."[37] Serra offers two responses. One recaps the stringent separation he always maintained between sculpture and architecture by underlining that the critique his sculpture brokers exposes the "deficiency" of architecture precisely because its scale and situation are produced on comparable terms. The other appears to concur with Caro's view, and even specifies virtually the same details: "[my sculptures] have passageways, but no doors, no windows, no roofs." While Caro understands the similarity in difference between sculpture and edifice as an abstract allusion, Serra insists on pressing home what he considers the most consequential implication of the modernist separation of sculpture from the pedestal—that, from this moment on, it always has the potential "to become a structure that you can enter into."[38]

These are some of the contexts, then, for the installation in 1999 of Serra's massive hot-rolled Cor-Ten steel sculptures, the *Torqued Ellipses*, in the Fish Gallery on the ground floor of the Guggenheim Bilbao. This gargantuan space, reached directly from the soaring central atrium, is a little longer than a football field and about half as wide, comprises nearly thirty-five-thousand square feet, and is topped by a dramatically various ceiling that ranges from around thirty-five to seventy-five feet high. In their discussion of this work, "Sculpture in the Space of Architecture," Aruna D'Souza and Tom McDonough, rehearse Serra's "notoriously complex relation to architecture" as he "is seduced by its ability to definitively shape our experience of the world, and yet harshly critical of the continuous compromises—of program, budget and pragmatic vision—to which it is subject."

Their suggestion, however, that the *Torqued Ellipses* function as "meta-architecture, that is, as a discourse about architecture and its possibilities," seems somewhat misplaced. It overlooks the striking *accommodation* of Serra's massive, but transient curves within Gehry's structural undulations—a situation that is founded almost on rhyme or mimicry—and, on the other hand, whatever is residual in that resistant critical capacity of his sculptures to challenge the architectural, even on its own terms. From within the inner sanctum of a space that may have responded to their gravitational pull, Serra's sculptures concur with the double agenda of autonomy and contextualism that he has always maintained as the goal of a "symbolic," "poetic," and finally "useless" art. Sculpture can subsist

36. Ibid., pp. 148–49.
37. Alfred Pacquement, "Interview by Alfred Pacquement," in Serra, *Writings and Interviews*, p. 162.
38. Ibid.

on the threshold between autonomy and site, but architecture, with its necessary dependence on program and function, client and commission, simply cannot.[39]

Dan Graham, the third artist I will discuss, has opened up the space between art and architecture in probably the most materially diverse and conceptually complex series of interventions of any artist working in the postwar period. But because he—like Robert Smithson or Gordon Matta-Clark—has had little or no direct contact with Gehry, I will limit myself here to a brief sketch of his concerns. In a formative essay, "Homes for America" (published in 1966), Graham addressed the critical typology and socially segmented permutation of tract homes. The construction of these units, he argued, "subverts" both architecture and craftsmanship in the name of a "rootless" "predetermined, synthetic order" governed by the most economically permissible modular standardization.[40] In the decade or so between the mid-1960s and late 1970s, when he commenced his signature pavilion sculptures, Graham produced an extraordinary sequence of reflections on architecture's relations to performance and bodily space; video and temporality; urbanism and suburbanism; design and the history of gardens; as well as essays on building types and genres, including the atrium, the pergola, and the conservatory; and reflections on artists (such as Gordon Matta-Clark) and on topics characterized by titles that range from "The City as Museum" to "Corporate Arcadias."

The pavilion sculptures, begun in the late 1970s and discussed in the fourteen short reflections collected in the anthology *Two-Way Mirror Power* (1999)[41] represent Graham's most developed interrogation of the intersection between sculpture and architecture. This body of work convenes many of Graham's interests—in transparency, social formations of leisure, "minimalist" design, and experiential occupancy—moving them from concerns with the public interaction of multiple selves (in "Public Space/Two Audiences," 1976) and interference in suburban space (in "Alteration of a Suburban House," 1978), addressed in the first two texts, toward the site-specific, freestanding, frame and glass/mirror structures the artist offers as commentary on the pavilion tradition. The ensuing pavilions are multifunctional objects, signifying as sculptural-type art objects, architectural "modifications," reflective arenas (in which bodies and environments are literally reflected, while the space itself promotes reflection), and allusive, participatory spaces.

Thus, Graham describes perhaps the best known of these pieces, his *Two-Way Mirror Cylinder inside Cube and Video Salon*, made in 1989 for the roof at the Dia Center for

39. See the profile of Richard Serra by Calvin Tomkins, "Man of Steel," *New Yorker* (August 5, 2002), pp. 52–63. According to Serra, "[I said that] art is purposely useless, that its significations are symbolic, internal, poetic—a host of other things—whereas architects have to answer to the program, the client, and everything that goes along with the utility function of the building. Now we have architects running around saying. 'I'm an artist,' and I just don't buy it . . . there are some comparable overlaps in the language between sculpture and architecture, between painting and architecture. There are overlaps between all kinds of human activities. But there are also differences that have gone on for centuries. Architects are higher in the pecking order than sculptors, we all know that, but they can't have it both ways" (p.54).

40. Dan Graham, "Homes for America" in *Rock my Religion: Writing and Art Projects 1965–1990*, ed. Brian Wallis (Cambridge, MA: MIT Press, 1993), pp. 14–23.

41. Dan Graham, *Two-Way Mirror Power: Selected Writings by Dan Graham on His Art*, ed. Alexander Alberro, intro. Jeff Wall (Cambridge, MA: MIT Press, 1999).

the Arts in New York, as "an open-air, rooftop performance space, observatory/camera obscura/optical device/video and coffee bar/lounge, with other multi-use possibilities."[42] Connected typologically with pantheons, follies, mausoleums, Zen gardens, gazebos, and grottos, occupationally with the art audience, children, and skateboarders, functionally with bridges and viewing rooms, and iconographically with labyrinths, hearts, the Star of David, and the yin/yang symbol, Graham's pavilions are finally machines, as he puts it, that "call attention to the look of the spectator, who becomes the subject of the work,"[43] precipitation chambers for the layering of social interactions.

Conclusion

While I have tried here to work up some frames for a matrix within which discussion of architecture's relations to sculpture might be situated and Gehry's special contribution somehow located, I am left feeling that I have only scratched the surface. So many important contributions have been omitted—many of which modify or occasionally refute what I have filtered through the discourse of composition and the almost allegorical arbitrations of Caro, Serra, and Graham. I have said nothing about architects who have opposed transitive relations between the two domains—such as Rafael Viñoly, who recently contended that sculptors and architects work through very different "chain[s] of thought" and expressed a concomitant antagonism toward interdisciplinary collaboration.[44] And I have not commented on what appears as virtually the opposite situation, in which one of the high priests of architectural modernism, Philip Johnson, mused near the end of his brief address at the age of ninety-four dedicating the Turning Point Garden (featuring his own sculptures), that "architecture is sculpture, depending how you use it. And we're using it just fine, thank you."[45] Nor have I attended to any of the numerous institutional and exhibitional manifestations of the new relations now in train between architecture and sculpture—which include the Chinati Foundation's Art and Architecture symposium, held in

42. Ibid., p. 165.

43. Ibid., p. 166.

44. See *Art and Architecture News* at http://www.artandarchitecture.co.uk/LecturesRafael.htm as of January 11, 2005: Rafael Viñoly "prefaced his stimulating lecture to a packed Art and Architecture audience in October 2003 by stating categorically that Architecture is not Art. What architects did was a profession, a trade, part of a collaborative process, he explained, where freedom to innovate and experiment was hard won. Both architects and artists might appreciate light, pattern and texture, the material they use is the same, but the difference between 'big sculpture and architecture is the waterproofing'. A simplistic reading, he acknowledged, but nevertheless one which indicates a different 'chain of thought' between the two. It was interesting to establish a relationship with artists but in his experience, one needed to have patience. 'Don't collaborate, let them do they own thing—there is no need for collaboration'. Referring to Richard Serra with whom he has worked, Viñoly said, 'I don't pay for anything, Richard does', suggesting that whoever pays the bills, calls the shots."

45. The project is described on a university Web site as follows: "These lighthearted new additions to the CWRU public art realm, which blur any distinction between pure sculpture and utilitarian amenity, were designed by the architect Philip Johnson to complement his esteemed work Turning Point, a group of five sculptures located twenty yards to the northwest. Situated around a raised earthen crescent and terraced amphitheater are a rippling curtain-like enclosure with built-in benches and walls of chain-link fencing (all painted sky blue); a cartoonishly distorted green pillar; a short, yellow curving wall that doubles as a settee; and a conical burgundy spiral enclosing a tiny amphitheater." http://www.cwru.edu/pubs/cwru-mag/summer2001/features/sculpture/article.shtml as of January 11, 2005.

Marfa, Texas in April 1998 (with artists Roni Horn, Robert Irwin, Coosje van Bruggen, and Oldenburg, architects Frank Gehry and Jacques Herzog, and several critics and scholars). Or, in a different vein, exhibitions such as Transposed: Analogs of Built Space, at The Sculpture Center, New York (March 30–May 6, 2000),[46] Intricacy, curated by Greg Lynn at the ICA, Philadelphia, March–April, 2003 (described as "a dialogue between painting, sculpture and architecture"),[47] and many others.

More, too, should be said about the negotiation with architecture taken on by Oldenburg or by Smithson, whose slide lecture on the Hotel Palenque to architecture students at University of Utah (the text of which was reprinted in *Parkett*) offered up so provocatively the term "dearchitecturalization." Or about Vito Acconci, who in the early 1980s began designing architectural structures, like "Instant House," a phone-booth-sized cabinet with collapsible walls emblazoned with American and Soviet flags, which he generally presented in museums and galleries, but who ten years ago officially stopped making art and established the Acconci Studio, near the Manhattan Bridge in Brooklyn, where he works with half a dozen young architects on projects that range from an elementary school courtyard to a floating island in the middle of the Mur River in Austria. "Do I think I'm an architect?" he was asked in a recent newspaper interview, responding, "I think we do architecture."[48]

Let me close by shuttling to the end of the long tradition of countercompositional discourse and invoking a scene of compositional diminishment that seems quite alien even to the theatrical futurism of the Guggenheim Bilbao. This move surely signals some of the limit terms of the revitalized compositionality defended by Gehry. Paul Virilio claims that it is in cinema that we can locate an ultimate composite sign technology that announces the final decomposition of the discrete, rule-bound, and now historical arts of painting, sculpture, and even architecture.

Cinema is the end in which the dominant philosophies and arts have come to confuse and lose themselves, a sort of primordial mixing of the human soul and the languages of the motor soul. The chronology of the arts in history already demonstrates this decomposition.[49] Virilio takes these questions further in *Lost Dimension*, where he writes that what "we are living is a system of technological temporality, in which duration and material support have been supplanted as criteria by individual auditory and retinal instants." He continues:

46. See Betti-Sue Hertz, "Convergences of Architecture and Sculpture: The Consequences of Borrowing" in *Transposed: Analogs of Built Space*, exhibition catalogue, The Sculpture Center, New York, March 30–May 6, 2000.

47. See www.icaphila.org (last accessed January 11, 2005) and the review by Mark Rappolt at http://www.contemporary-magazine.com/arcitech49.htm as of January 22, 2005.

48. See Mia Fineman, "A Gallery Hater and His New Gallery: A Foe of Galleries Takes One on Using 15 Tons of Steel" *New York Times*, March 2, 2003 (on Kenny Schachter's six-month-old gallery in Greenwich Village, NY, designed by Vito Acconci).

49. Paul Virilio, *The Aesthetics of Disappearance*, trans. Philip Beitchman (New York: Semiotext(e), 1991), p. 105.

The perspectival effects of classical ornaments and the cinematic characteristics of certain styles, such as baroque, liberty or neo-liberty, is replaced by an integral cinematism, an absolute transitivity, involving the complete and thorough decomposition of realty and property. This decomposition is urban, architectural, and territorial. It is based on the deterioration of the ancient primacy of the physical separation and spatial limitation of human activities. And this very deterioration occurs so as to facilitate the interruption and commutation of time—or better, the absence of time—in instantaneous intercommunication.[50]

Thinking well beyond the parameters of the art world, the "decomposition" envisaged by Virilio is urban, social, and political. Decomposition has become a name for the commutative, even the disappearing, action of time.

50. Paul Virilio, *The Lost Dimension* (New York: Semiotext(e), 1991), pp. 84–85.

Media Architect

BEATRIZ COLOMINA

That the Bilbao Guggenheim is media architecture is by now a commonplace, attributed in great part to Thomas Krens. Krens is understood as a designer, the architect of the "Bilbao Effect." Frank Gehry is just the architect of the building. But to understand the Bilbao Effect that Krens so cleverly engineered, one has to understand that Gehry himself was already a special effect, a media effect.

Gehry is not just a celebrated architect, but also the architect of the critical reception of his work. It is by carefully controlling the reaction to his work that Gehry designs himself in architecture. In that sense, he is a media artist whose designs are embedded within a media campaign he carefully orchestrates. Gehry arrived in Bilbao as an expert in the construction of his own aura. Krens took this capacity, this magic effect, to the next level and in so doing, Gehry was able to reinvent himself.

In fact, both Gehry and Krens reinvented themselves. Gehry's aura fed the Guggenheim aura, which fed back into Gehry again. Guggenheim Bilbao was Krens and Gehry feeding each other, both getting bigger and bigger.

To understand this phenomenon, we have to understand what Gehry brought to the equation. Although the Guggenheim Bilbao is the project with which Gehry made his name in the global market as a superstar architect, the project with which he first made his name in architecture's star system was his own house in Santa Monica.

The House that Built Gehry

What can one say about Gehry's house that has not been said already? What is there to add to the discussion of the most discussed house of the postwar period? What is left to say, after so many articles, in so many venues, from newspapers and popular magazines to architectural tabloids, airline magazines, art journals, professional reviews, museum catalogues, real-estate sections, publications, and monographs? The question seems to have puzzled Gehry himself as early as 1986, when on the occasion of the Walker Art Center retrospective he said: "My house. I'm afraid so much has been said about it that

it is very difficult for me to add anything except that living there is very comfortable. It does leak a little and we are working on fixing that."[1] The architect of a notorious object can only point to its basic ability to provide shelter. All the talk comes down to a leak or two. Yet for all of Gehry's reluctance to engage in any intellectual discussion of his work, practically everything that has been written about his house—and I suspect about Bilbao, too—can be traced back to apparently casual, off-the-cuff statements repeated by him over the course of the years. The suspicion with which critics, reasonably enough, usually regard the statements of the most theoretically minded architects is suspended—as if Gehry could only be telling us the truth, or there was no reason to suspect his statements, no need to question the casual posture, despite the obvious clichés, the systematic repetitions, and the calculating intelligence of it all. The critics see only what Gehry wants them to see.

From museum catalogues to *People* magazine, Gehry is presented as "childlike," "ingenious," "nonverbal," "intuitive," "visceral," "naïve," "lighthearted," "uninitiated," "unrefined," "prelogical," and "primitive." The viewer is dumbed down, too, encouraged to become a child when facing the work: "It is important to see all of Gehry's work from a perspective of blissful ignorance, to observe his structures from the childlike viewpoint of one who has no preconceptions about what architecture must be," says the *Los Angeles Times.*[2] The work, it seems, falls outside traditional modes of judgment. Critical viewing and discourse are abandoned. "It's so far out of normal expectations that it defies traditional criticism," says Philip Johnson.[3] Terence Riley, curator of design at New York's Museum of Modern Art (a position deemed responsible for determining the legitimacy of styles), declares it "outside the 'style wars' of the last thirty years."[4] Charles Jencks, the reigning master of categorization in architecture, claims that it fits every label and is therefore "unclassifiable."[5]

The difficulty in pinning Gehry down is often traced back to his refreshing lack of theorization: "He wrote no papers and advanced no theories. The only consistent direction in his work was an increasingly sculptural approach to architecture."[6] But is sculpture outside theory? Can one still pretend that objects simply stand in front of us, exuding certain qualities independently of the way they are framed by countless discourses, including those of the artists? Can one really ignore the way Gehry frames his own work?

1. "Commentaries by Frank Gehry," in *The Architecture of Frank Gehry*, exhibition catalogue (Minneapolis: Walker Art Center; New York: Rizzoli, 1986), p. 34.

2. John Dreyfuss, "Gehry: The Architect as Artist," *Los Angeles Times*, November 7, 1979, part 4, p. 8.

3. Philip Johnson, interview by Stanley Tigerman in "Building of the Quarter: The Gehry House, Per Voco," *Archetype* 2 (Spring 1979): 23.

4. Terence Riley, quoted in Calvin Tomkins, "The Maverick," *The New Yorker*, July 7, 1997, p. 43.

5. "Just call me Daniel Boone, Frank Gehry said to me after I had called him that and everything else I thought appropriate: the Industrial Adhocist, the father of the Botched Joint, the son of Bruce Goff, the Noble Savage of Santa Monica, the Leonardo of Galvanised Sheet-Metal, the Malevich of Lighting and Rodchenko of the Non-Sequitur . . . the Charlie Chaplin of Chain Link, the Over-Psychoanalysed Jewish Master Builder, the Zen Priest of the Unfinished Finish, the Martin Escher of Reverse Perspective and Impossible Space, the first Deconstructionist Architect, and so on. . . . The problem with Frank . . . is that many labels work. He is almost unclassifiable." Charles Jencks, "Frank Gehry—The Deconstructionist," *Art and Design* 4, no. 4 (May 1985): 14.

6. Tomkins, "The Maverick," p. 43.

Gehry himself feeds the view that architecture can be practiced outside theory: "I think that it's nice to be able to master verbal gymnastics and exercise your head too, and it may not have anything to do with the work of art. The expert, the majordomo of that game is Peter Eisenman. His talk has nothing to do with his work. It does and it doesn't; I think the good stuff that he does is intuitive."[7] But if Eisenman hides his intuition behind theory, could it be that Gehry, who insistently presents himself as an intuitive architect, is in fact hiding his intellect behind folksy stories? He is, of course, not as innocent as he pretends to be. We see only what he wants us to see.

So what does Gehry want us to see? Many things. Gehry has not just one theory regarding his house, but many well-thought-out, persuasive, provocative, captivating, irresistible theories. This collage of theories is like the collaged structure of the house itself, in which fragments fly off in independent directions.

He literally designs the response to his house by presenting an attractive range of precooked readings that target every possible respondent, providing many enticing narratives, one appropriate for every occasion. Critics can't stop themselves from repeating them. Part of what makes Gehry's narratives so appealing is that they are not presented as theories. They slip under the radar and into the head of the critic. The architect weaves a whole series of intersecting narratives that form a fabric, an open structure, through which the house is seen and not seen at the same time. The architecture of his theory has all the complications and seductive force of his house.

Let's follow ten stories, ten threads of Gehry's web.

Outrageous House

Even before the house was built, it was controversial. Newspapers and magazines anticipated the event describing Gehry as an instigator of conflict: "Radical stuff: a house deliberately left unfinished, with posts and beams standing naked to the world … a porch enclosure made of chain-link fencing," the *Los Angeles Times* said.

The first critics of the house were the neighbors—the house was still under construction—and Gehry's first account of the house came in response to their complaints. The neighbors became the vehicle for his first spin. Symptomatically, it was again the *Los Angeles Times*, rather than an architectural magazine, that provided the coverage. "Gehry's Artful House Offends, Baffles, Angers His Neighbors," blared the headline. The author describes the building as "shocking," "like no house ever seen before," and quotes the neighbors' account of it as "offensive," "anti-social," a "monstrosity," a "prison," while at the same time declaring it a "strange, exciting, thought provoking building of highly sophisticated beauty" that would be "sure to attract national attention."[8] Little did he know. This pattern is repeated in article after article. Descriptions of apparently shocking violations

7. Frank O. Gehry, interview by William Ted Georgis, in "Interview: Frank Gehry," *Archetype* 2 (Spring 1979): 10.

8. John Dreyfuss, "Gehry's Artful House Offends, Baffles, Angers His Neighbors," *Los Angeles Times*, July 23, 1978, part 8, pp. 1, 24–25.

of traditional norms give way to praise and celebration. What is celebrated in the end is the shock.

Most of this shock seems to stem from the unconventional use of materials: the corrugated steel, the plywood, and particularly the chain-link fencing. But what really offends is not simply the use of these unconventional materials, but the ongoing presence of the original house, trapped as if it was inside a foreign body. Far from being removed or simply assaulted, the house is being tortured in public. That it remained on display is what aroused the anger of those who lived in similar houses. They felt themselves under attack. Their reaction was intense. There were protests and hecklers from the neighborhood, phone calls and letters to the mayor and to the newspapers. A lawyer down the street tried to sue Gehry; an architect tried to get the building department to put him in jail; Paul Lubowicki, a recent graduate working with Gehry on the project, says the neighbors used to shout at him;[9] an architecture critic would walk his dog on the lawn; and on two occasions, someone fired a bullet through a window.[10] Neighborhood war.

Gehry is no stranger to violence. Or at least he wants us to believe that he is tough, reminding us that he used to be a truck driver, worked out through middle age as a boxer, and even earned a belt in full-contact karate.[11] More recently, he took up ice hockey, "rough ice-hockey, on a team he organized himself, with his two sons and some ex-college hot shots thirty or forty years younger than he is."[12] Then there are the stories of his friendship with some Mafia guys and the prank he once played with them on Peter Eisenman.[13] And when told that a Basque sculptor, Jorge Oteiza, was so upset about the Guggenheim Museum Bilbao that "he threatened physical violence against the architect," Gehry responded, "I could relate to that. I feel sort of the same way when I. M. Pei builds something in Los Angeles."[14]

The architect as street fighter. Gehry had role models. Le Corbusier made the boxer the paradigmatic inhabitant of his interiors (modern man as sportsman and fighter), and he appeared in an early photograph boxing with his partner and cousin Pierre Jeanneret on the beach. The boxer exemplifies the image of the avant-garde artist as a provocateur, brutally reconfiguring everyday life.

Gehry's house is intended as an aggression. As he used to say, "it's tough." Its architecture is calculated to produce the desire for a counterattack. The neighbors' shock and

9. Frank O. Gehry, quoted in Sarah Booth Conroy, "The Remodeled American Dream, East and West," *Washington Post*, May 25, 1980, p. D2.

10. Frank O. Gehry, interview by Barbaralee Diamonstein, "Frank O. Gehry," in *American Architecture Now*, ed. Barbaralee Diamonstein (New York: Rizzoli, 1980), p. 44, and Tomkins, "The Maverick," p. 42.

11. Thomas S. Hines, "Heavy Metal: The Education of F.O.G," in *The Architecture of Frank Gehry*, p. 13.

12. Tomkins, "The Maverick," p. 40.

13. Gehry told Charles Jencks: "So when Peter came to LA for a visit I took him to an Italian restaurant where I know real mafioso—who owe me some favours. After dinner I arrange for Clarkie to sit down next to Peter and put in the knife: 'I hear you been messing around wit my friend Frangough. The boys don't like suckers who fink on their buddies, understand? I'm afraid you gotta lose more than one finger Mr. Egg-head.'" Charles Jencks, "Frank Gehry—The Deconstructionist," pp. 15–16.

14. Gehry, quoted in Tomkins, "The Maverick," p. 39.

anger, designed and taken advantage of by Gehry the fighter, are institutionalized by the critics and transplanted into architectural discourse. The house is presented by even some of the most knowledgeable historians as subversive and anti-architecture, as if these critics of modern architecture were suburban neighbors astounded by the renovation of a modest house on a corner in Santa Monica. Gehry celebrates: "I wish we had sold popcorn," he says of the continuous stream of visitors.[15]

Striptease House

More than anything else, Gehry wants us to see his house as a sex act, a striptease. His most insistent descriptions of what he was trying to do with this house involve voyeurism. He even declares, "I am a voyeur. I like to see what other people do."[16] When asked, "Is anything falling apart?" Gehry answers: "Oh you think I do falling aparts. It is an act. Do you know where I learned that? You know those vaudeville acts where the guy pulls the string and his clothes all fall off? I used to go to a lot of dirty vaudeville shows when I was a kid in Canada."[17]

Others soon start seeing it this way. Stanley Tigerman speaks of the house as "undressing, as seeing through a building." Barbara Goldstein speaks of the "half-built" house as if it is a half-dressed woman with whom Gehry is in love.[18] And Sharon Lee Ryder (in an article aptly titled "Brutally Frank") says, "It is the quintessential house in drag, appearing to be what it is not, while at the same time being all the things it pretends not to be: a conventional house dressed up in the clothing of another genre."[19] Even the neighbors, its first audience, see the house as an offensive act: "It is a dirty thing to do in somebody else's front yard."[20]

Reviews are dominated by the sexualized metaphor of stripping, littered with phrases such as "undressing," "naked," "exposure," "peeking," "hard shell–soft core," "SM house," "view of raw building," "perversity," "disturbing kind of satisfaction," and so on. But the sexual act they describe is carefully choreographed. It is precise and controlled. The original structure is "tenderly undressed," in Gehry's own words. One critic expresses amazement that Gehry's wife "willingly" allowed the old house to be "stripped then swathed in tin clothes."[21] Exposed, then partially, more seductively, concealed. Simultaneously revealing and concealing, the architectural act is at once more attractive and more provocative. No wonder it aroused so much.

15. Gehry, in Michael Webb, "A Man Who Made Architecture an Art of the Unexpected," *Smithsonian* 8, no. 4 (April 1987): 54.

16. Gehry, interview by Georgis, "Interview: Frank Gehry," p. 11.

17. Ibid., p. 10.

18. Barbara Goldstein, "In California un oggetto architettonico," *Domus*, no. 599 (October 1979), p. 9.

19. Sharon Lee Ryder, "Brutally Frank," *Residential Interiors* (November–December 1979), p. 58.

20. Dreyfuss, "Gehry's Artful House Offends," p. 1.

21. Suzanne Stephens, "Out of the Rage for Order: Frank Gehry's House," *Progressive Architecture* 61, no. 3 (March 1980): 83.

Cozy House

Do we really need to know, as every critic is fond of repeating, that Gehry has married twice, that he has two daughters from the first marriage, two sons from the second, that he loves his beautiful Panamanian-born wife, Berta Isabel Aguilera? When asked about his house, Gehry always responds with folksy domestic stories, starting with the discovery by his wife of a little old house:

> *Diamonstein*: Can you tell us what your intentions were there?
>
> *Gehry*: It had to do with my wife. She found this nice house—and I love my wife—this cute little house with antiques in it. Very sweet little things.[22]

Everything continues this way, from the "dumb little house" to "my little addition," which is also described in a folksy way, as in a fairy tale or a folk song:

> My wife, Berta, found this beautiful … anonymous little house, and I decided to remodel it, and … since it was my own building … explore ideas I'd had about the materials I used here: corrugated metal and plywood, chain link… And, I was interested in making the old house appear intact inside the new house, so that from the outside, you would be aware always that the old house was still there.[23]

While generations of historians have dug into Le Corbusier's archives to find the smallest clues about his enigmatic relationship with his wife, Yvonne Gallis, Gehry leaves it all hanging out. We can even make out what he eats. In photographs, the glass doors of his kitchen cabinets, which are an extension of an old bay window, prominently display ordinary packaged food, as if to insist on the ordinariness of the house's inhabitants: Lipton Cup-o'-Soup, Morton Salt, Ronzoni Spaghetti, Glad, Ala Mashed Potatoes, Kikkoman Soy Sauce, Manischevitz Matzo Crackers, Crisco Shortening, Folgers Instant Coffee, Taster's Choice Decaffeinated Coffee, Bertoli Olive Oil, Marukan Cup-o'-Noodles, and so on.

A photograph of Le Corbusier's Villa Garches shows an open-mouthed fish, an electric fan, a pottery jug, and a metal oil jar arranged on the kitchen counter as in an avant-garde still life. The Eameses's house is filled with what they called "functioning decoration"—kachina dolls, shells, baskets, blankets, buttons, pebbles, driftwood, Japanese wooden combs, English pillboxes, Mexican masks, Chinese kites, Indian fabrics, and so on. And Gehry displays through the glass doors of his kitchen cabinets the everyday products of American food culture. Unlike Le Corbusier and the Eameses, he has the objects arranged with no regard to classical artistic compositional guidelines. It may have some relation to Pop—Gehry has expressed his admiration for Andy Warhol's *Campbell's Soup Cans* series—but it is not high art, and it is not beautiful. It is a declaration of ordinari-

22. Gehry, interview by Diamonstein, "Frank O. Gehry," p. 43.
23. Gehry, quoted in Bletter, "Frank Gehry's Spatial Reconstructions," in *The Architecture of Frank Gehry*, p. 32.

ness, as if to say: "I am the all-American middle-class boy with the all-American split family and we eat all-American food." Other photographs of the house demonstrate a similarly self-conscious casualness. It is easy to imagine people living there, even though they do not appear in the photographs. No avant-garde lifestyle here. The breakfast table is set as though awaiting the family, each plate a different color. The backyard, with its toy dump trucks, looks as though it was recently abandoned after an active play session. The vegetables on the counter look as if they have just been pulled out of the refrigerator. Two half-empty glasses of water sit there, as if the children have just run out. The mobile storage units are left ajar. A lived-in house with a little messiness.

There is a systematic effort to present an image of normal domestic life within an abnormal house. The strident polemical exterior gives way to an easygoing interior. Gehry insists that the house is very "comfortable." In the house of a famous furniture designer, there is no designer furniture in sight. Everything, aside from an isolated cardboard chair that may have just been put there for the photograph, is distinctly ordinary: flower-patterned couches, decorated bedspreads, ornamental houseplants. Familiar comforts. The coziness serves to make the radical qualities of the house even more dramatic.

The generation of historians brought up on TV, with its endless display of the private realm in public, digs into the archives to find traces of the personal, carefully hidden by the architect and previous generations of critics. The TV generation of architects provides their own script. But isn't this another form of hiding?

Construction-Site House

Time and again, Gehry insists that he likes the look of unfinished buildings, that they are "more poetic" and "fresh."[24] And critics have echoed this theory, describing his house as a "well-stocked lumberyard viewed from a telescope"[25] or a "perpetual construction site"[26] and the architect as a "one-man demolition crew."[27]

Buildings under construction have fascinated many architects. Le Corbusier's first manifesto of modern architecture was the naked structure of the Domino system. Mies van der Rohe photographed himself in front of the frame of his Farnsworth House while it was under construction. And the Eameses hopped on top of the frame of their Case Study House as soon as it was up: the structure as photo opportunity—as in those photographs of the Empire State Building showing workers hanging dangerously from the unfinished structure. But there are no photographs of the Gehry house under construction. For Gehry, this is not simply a stage of the project: The finished building is a construction site.

24. "Most frame buildings look great under construction, but when they are covered they look like hell." Gehry commentay in *The Architecture of Frank Gehry*, p. 56.

25. Wolf von Eckardt, "The Good, the Bad and the Tricky," *Los Angeles Times,* July, 18 1980, part 5, p. 17.

26. Ross Miller, "The Master of Mud Pies" (conversation with Frank Gehry), *Interview* 20, no. 1 (January 1990): 46.

27. Jane Holtz Kay, "Deconstructivist Architecture," *The Nation*, October 17, 1988, p. 360.

Gehry the fighter is also a defensive Gehry. As long as the building is not finished, he is not accountable. The project can't be criticized. The exposed inner structure is his armor.

Casual House

The perpetually unfinished condition of the house resonates with the unfinished condition of its materials. The chain-link fencing, the plywood, the corrugated steel, the asphalt—all are simply appropriated as found; none is finished. He presents himself as a *cheapscape* architect, offering various rationalizations for his use of cheap materials.

But this cheap and casual look are carefully controlled: "My buildings look as if they are just thrown together. We work very hard to achieve this."[28] And it extends beyond the house to Gehry's own look. He wears chinos and open-collar shirts, the studied cheapscape look. But this look also protects him from attack. What is modest, casual, informal, temporary, childlike, and poor is hard to criticize. Informality is both weapon and defense.

Art House

From the beginning, the house has been presented as an artwork, a painting or a sculpture—as when Gehry complains that living in his house is "like living in your own painting,"[29] or when he says casually, "I had a funny notion that you could make architecture that you would bump into before you would realize it was architecture,"[30] a reference, in fact, to Bryce Marden's comment that sculpture is what you bump into when you back up to look at painting.

Repeatedly, Gehry drops the names of his artist friends, colleagues, collaborators, role models, and clients. The list has become enormous. Critics have added other names, so that now the whole history of avant-garde art—from Europe in the early twentieth century to Southern California at the end of the century—has become involved.

He traces specific qualities of his house to the influence of specific artists or movements: "If you look at the corner window you'll notice that one of the glass surfaces protrudes, unframed, beyond the corner. What I was trying to do there was to create a movement, almost like a Duchamp 'Nude Descending the Staircase.'"[31] "The wireglass in the skylights, which was not required by the building code, was intentionally used to portray a layer of lines that would relate to the diagonals of the chain-link so that it's almost like a Bryce Maroin layered drawing where a similar kind of depth is created with line work."[32] "I guess I was interested in the unfinished—or the quality that you find in paintings by Jackson Pollock, for instance, or de Kooning, or Cézanne, that look like the paint

28. Gehry, quoted in Thomas Hine, "A Careless Design—Carefully Done," *Philadelphia Inquirer*, January 13, 1980, p. 1K.
29. Gehry, quoted in Jayne Merkel, "It's Just a Colonial Turned Outside-In," *Cincinnati Inquirer*, August 3, 1980, p. E8.
30. Gehry, interview by Diamonstein, "Frank O. Gehry," p. 46.
31. Frank Gehry, "Suburban Changes: Architect's House Santa Monica 1978," *International Architect* 1, no. 2 (1979): 45.
32. Ibid., p. 42.

was just applied."[33] With yet another list of artists, he points to their influence on the house without specifying exactly what influenced what.[34] But it is not just that artists affected the details of the house. The very idea that a utilitarian object could be transformed into an artwork was itself an idea that came from a particular set of artists: "I wanted to prove you could make an artwork out of anything. This is being done, of course, in sculpture, and I find myself influenced by artists such as Rauschenberg, Serra, Carl Andre, Donald Judd, Heizer."[35]

Critics of the house also have their lists of relevant artists and movements. The role call includes Carl Andre, Chuck Arnoldi, Larry Bell, Billy Al Bengston, John Cage, Christo, Ron Davis, Louis Dazinger, Giorgio De Chirico, Michael Heizer, Robert Irwin, Jasper Johns, Donald Judd, Ellsworth Kelly, René Magritte, Kazimir Malevich, Ed Moses, Bruce Naumann, Claes Oldenburg, Eric Orr, Kenneth Price, Robert Rauschenberg, Simon Rodia, Ed Ruscha, Kurt Schwitters, Richard Serra, David Smith, Frank Stella, Jacob van Ruisdael, Edouard Vuillard, Andy Warhol, Cubism, Dada, Constructivism, Expressionism, Futurism, Neoplasticism, action painting, Abstract Expressionism, Minimalism, Conceptual Art, Process Art, California environmental art, Pop, and so on.

Faced with such a pantheon of artists, one is left wondering, where is Gordon Matta-Clark, whose stripping, cutting, and exposure of the timber frame of an old house is perhaps the most obvious reference point in Gehry's house?[36] And before that, where does Michael Graves's 1969 Benacerref House—a radically modern addition to a traditional house in a traditional neighborhood in Princeton, where the new elements slide out of the old—fit in to all of this?[37]

Very rarely do Gehry or his critics refer to the influence of other architects. Indeed, artists seem to release him from the influence of architects. Once again, the house is relieved of the usual scrutiny by architectural critics. It's off the hook.

Museum House

Many of the houses that Gehry has built have been for his artist friends, the domestic house becoming an art gallery and a reflection of the artist's philosophy. In this, Gehry's

33. Gehry, interview by Diamonstein, "Frank O. Gehry," p. 36.

34. For example, see Gehry quoted in Kay Mills, "Prefab Aesthetics: Making Beauty Out of Junk Is Frank Gehry's Mission," *Los Angeles* Times, January 18, 1981, part 5, p. 2: "I think the real turning point in my work, my thoughts, is my interest in Southern California artists"; and Gehry commentary in *Gehry Talks: Architecture and Process*, ed. Mildred Friedman, with an essay by Michael Sorkin and commentaries by Frank O. Gehry (New York: Universe Publishing, St. Martin's Press, 2002), p. 57: "The influences were from Joseph Cornell to Ed Moses to Bob Rauschenberg."

35. Gehry, "Suburban Changes," p. 34.

36. Only once, much later (in 1986), did Gehry mention Matta-Clark—not in relation to his house, but in relation to the unrealized renovation, the Carriage House (1978), for the Christophe de Menil House in New York. See Gehry's commentary: "Since I worked on it, the building has been changed by Doug Wheeler and other artists; it was an interesting continuum. It fits my idea, which was to have the late Gordon Matta-Clark do the demolition and then work against it. I would have loved that." "Commentaries by Frank Gehry," in *The Architecture of Frank Gehry*, p. 57.

37. Graves's project had an enormous impact on artists during the 1970s. Dan Graham, for example, says: "It influenced all of us. It influenced Matta-Clark and it influenced me and it may have influenced Frank Gehry." Dan Graham, interview by author, February 2000.

houses follow the tradition of Le Corbusier's domestic designs of the 1920s, where the house was often also a studio and a gallery. Likewise, Gehry's own house is treated as an art gallery. Like Le Corbusier, Gehry describes it in terms of a promenade, a succession of events:

> From the entrance gate onwards, entry is intended as a procession. As you walk up the stairs and enter the door you turn towards the cedar trees and in the evening the sun backlights them—a powerful image... Once through the entrance door you are confronted by the entrance door of the old house—so that you really know that you are going in... Throughout the house we left portions of cornices, moldings and frames: old windows became paintings on the wall in an exposed frame wall—all sculptural ideas for leaving parts of the old house as references.[38]

The house is turned into a sequence of images, a trajectory encompassing diverse paintings that might have been made by different artists. Gehry suggests that this became his way of thinking about architecture in general: "After I did my house I tried to see every event in a piece of architecture as a painting: the corner window, the front window, the kitchen window."[39]

The theme had already been studied by Le Corbusier. In the little house for his mother on the shores of Lake Leman, a "window" cut into a garden wall frames a view of the lake. The outside, the garden surrounded by a wall, is treated as an inside, and the landscape beyond becomes a painting on the wall, as though in a living room. For Le Corbusier, "the outside is always an inside."[40] For Gehry, on the other hand, the inside is always an outside. In his house, a twisted version of Le Corbusier's window is cut into the corrugated-metal fence, framing, from the street, a view of a huge cactus in the backyard. The window frames the cactus for the passer-by, not the inhabitant. From the inside of Gehry's peek-a-boo house, multiple cuts frame fragments of the old house, foliage, the sky, the moon—but not the surrounding neighborhood. Inside, it is not possible to see the streets from the above-eye-level windows.

If Le Corbusier's idea of the house as a space for a promenade was the idea of the house as a stage set for an imaginary film, Gehry's house is a stage set for an ongoing soap opera: the neighbors' soap opera, the family soap opera, the architectural-world soap opera. As if to reinforce that sense, from the back of the house you see the theatrical props: the fencing wall held by diagonal bracing, the cactus propped up. From the street, these tricks are not visible. The cuts provide glimpses not only of the cactus and of architectural fragments, but of what is going on inside, the domestic life of the house's inhabitants, the ongoing soap opera.

The house as a sequential display of different artworks becomes a gallery of Gehry and his life: Gehry's house ends up being a museum of Gehry himself.

38. Gehry, "Suburban Changes," pp. 34, 40.
39. Gehry, quoted in Miller, "The Master of Mud Pies," p. 48.
40. Le Corbusier, *Precisions* (Cambridge, MA: MIT Press, 1991), p. 64.

Drama House

Philip Johnson said of Gehry's house that he liked the "sense of confusion in the dining room. I asked myself when I was there: 'Am I in the dining room or in the driveway?'"[41] Johnson was, in fact, replaying what Frank Lloyd Wright reportedly asked him on his visit to Johnson's Glass House in New Canaan, Connecticut, when, according to Johnson, he "strode in and said, 'Philip, should I take off my hat or leave it on? Am I indoors or am I out?'"[42] It was a big compliment, then. It had the effect of positioning Gehry's house in a grand lineage of masters stretching back through Mies to Wright. In fact, Johnson even said on another occasion, "It is my house thirty years later."[43]

This lineage of architects struggling with the relationship between inside and outside goes back to Adolf Loos's experiments—carried out in the early decades of the twentieth century in Vienna—with the idea of the house as a theater of domestic life. Loos was reacting to the emergent metropolis; Gehry was responding to the uniquely deterritorialized condition of Los Angeles.

Loos's houses turn their backs to the street to protect their intimacy and Mies's glass houses exhibit themselves to the public. Gehry's house simultaneously defends itself against the neighborhood and puts its intimacy on display. As Gehry notes, it is easier to look inside his house from the street than into any of the neighbors' houses. But at the same time, he blocks the view of the neighborhood from the inside of the house. From the windows of Gehry's double house, one can see fragments of the sky, or of trees, or of the interior of the other house (the interior of the interior). The house closes itself up to the street by doubling itself through a series of angled skins—or are they jabs?—and this opens up a distance, a protective gap, as if the house is defending itself from an attack while at the same time opening itself up to public view.

Gehry talks about how, when becoming "acquainted" with his future neighborhood, he became aware of the "body language of the neighbors' houses":

> Window blinds are always closed to the street and for the most part, these pseudo-cute little structures which suggest humanity say "stay out; leave me alone." … I wanted to expose the beautiful specimen cactus in my garden to the public view. I wanted to present it like a public sculpture. I wanted to deal with the shut-out attitude of my neighbors, to demonstrate to them that one could have windows that offer views into the private realm of the house without compromising the privacy of the house.[44]

And yet, in photographs, the windows in the front of Gehry's house always have their shades closed. Like his neighbors, Gehry is closed off. People can't look in. The dynamic confusion of inside and outside only really happens inside. Outside, even if peo-

41. Philip Johnson, interview by Tigerman in "Building of the Quarter," p. 23.
42. Philip Johnson, *Writings* (New York: Oxford University Press, 1979), p. 193.
43. Johnson, interview by Tigerman in "Building of the Quarter," p. 24.
44. Gehry commentary in *Gehry Talks*, pp. 38–39.

ple can't look in, they are portrayed as looking in—because Gehry talks that way. We don't even notice that the blinds are drawn.

Play House

Gehry's best friend when he was growing up, he says, was his maternal grandmother, who used to get down on the floor with him to build houses and cities out of wood scraps from his grandfather's hardware store: "That's what I remember, years later, when I was struggling to find out what I wanted to do in life. It made me think about architecture. It also gave the idea that an adult could play."

Not surprisingly, critics have also written about Gehry's house in terms related to play and children. The house is described either as an ideal place for children, "a timeless incarnation of all the houses that children have imagined in their dreaming and playing in attics," or as a place that appears as if it had been done by children: "It looks from the outside as though some energetic children had built it out of demolition-yard leftovers."

The house seems to suggest a child's perspective. Within, a lot of the views involve looking up. The addition makes parts of the old house seem to float higher. The main view from the kitchen is up at an angle. The bed is very low. The exposed structure of the ceiling becomes a major event, pulling the eyes toward it. The windows are above eye level, which leads to another question: Are the occupants of the house, the visitors, and even the viewers of it in publications, like the critic and the architect, turned into permanent children?

And what kind of childhood would this be? In another continually repeated story, Gehry talks again about his adventures with his grandmother: "Every Thursday, we'd go to the Jewish market, we'd buy a live carp, we'd take it home … we'd put it in the bathtub and I would play with this … fish for a day … until she killed it and made gefilte fish."[45] The point is not, as Gehry suggests, that he ended up with a lifelong obsession with fish, an obsession that he would work into most of his projects. The point is that play and trauma are inseparable. The dismembering of the fish is inseparable from the intense pleasure of its shiny skin and endless movements. In the end, Gehry eats his playmate.

Couch House

Most architects conceal their private life; Gehry flaunts it. The house is presented as his autobiography. From the very early coverage of the house, psychoanalysis enters the scene. Gehry repeatedly speaks about his personal problems, his separation from his first wife, Anita Snyder, his marriage to Berta, his two sons, his psychoanalyst, Milton Wexler, "a well-known shrink to the stars," whom he started seeing in the mid-1960s at the time of his separation from Anita. He even tells us what the psychoanalyst advised him in

45. Gehry, quoted in Hines, "Heavy Metal," p. 13.

terms of his architecture: "Wexler hammered at me to be one thing or the other… He'd say, 'Look, you're an artist. Just do jobs you can do. Don't try to be Skidmore, Owings and Merrill.'" The shrink even makes comments to the press about Gehry (isn't this stuff supposed to be confidential?). He says, "he has all the traits that a child has—loneliness, impulsiveness, playfulness, fighting the world"—feeding one of the most insistent interpretations of Gehry.

The fact that Wexler is Jungian activates some of the critics, as when a skeptical journalist describes the house a "manifestation of non-linear logic, visual symbolism and the Jungian collective unconscious… They did this sort of thing some 65 years ago in Zurich and called it Dada."[46] A more sympathetic critic writes: "Through his preoccupation with the insides of a house, Gehry has discovered something about the inner mind, and in stripping away old shingles and plaster he also laid bare part of his soul, and part of ours as well."[47] Even Gehry's sister, Doreen Nelson, joins in, interpreting the house in terms of family history:

> Here's this flat sheet of metal outside and Frank saying: "I've parted it for you so you can come in." And what's inside is our grandparents' house in Toronto on Beverly Street, with the dark stairway leading up to the bedrooms. When Frank bought that pink house, he did a transformation not only on the house but on himself. He put all this stuff around it to present himself as a new person, but an old new person who's still connected to where he came from and who he was.[48]

The house is a form of therapy for Gehry, who treats himself as the patient. He presents himself as simultaneously soft and tough: "In my life, I was always the quiet, nice guy, the pussycat, the 'Aw, shucks,' guy. The reality is I'm an angry s.o.b., pushy, ambitious like everyone else."[49] The house puts the anger on the outside and the pussycat inside.

Only much later, in 1997, did Gehry start thinking of himself as the shrink and the client as the patient. As he told Kurt Forster, "I am a good shrink. I listen."[50] In the same year, his design process was described in *The New Yorker* as "an intense sort of listening that involves paying attention not only to specific requests but to body language, facial expressions, unfinished thoughts, and other indicators. Having thus uncovered needs and desires that the client might not even been aware of, Gehry starts making drawings."[51]

But what would it be to turn psychoanalysis toward the house itself? What would one make, for example, of the doubling of inside/outside? To look out through the windows of the old house only to see another inside is to delay the encounter with the out-

46. Von Eckardt, "The Good, the Bad and the Tricky," p. 17.
47. John Pastier, "Of Art, Self-Revelation and Iconoclasm," *AIA Journal* (May 1980): 172.
48. Doreen Nelson, quoted in Joseph Morgenstern, "The Gehry Style," *New York Times Magazine*, May 16, 1982, p. 60.
49. Gehry, quoted in Cathleen McGuigan, "A Maverick Master," *Newsweek*, June 17, 1991, p. 56.
50. Gehry, quoted in *Frank O. Gehry/Kurt W. Forster*, ed. Cristina Bechtler (Ostfildern-Ruit Germany: Cantz, 1999), p. 83.
51. Tomkins, "The Maverick," p. 41.

side. Perhaps the house is primarily a form of resistance. The house permanently under construction is another form of delay, the delay of a final critical response (another form of encounter with the outside). Gehry is not finished and therefore can't be criticized. He is protecting himself. The insistence that his architecture is developed without a critical apparatus can also be seen as an effort to keep critics at bay. Gehry offers us his biography instead of theory. But he is speaking for his building when he speaks for himself. The house built him. The house is him.

In Conclusion

These are ten of Gehry's lines, but there are numerous others. So many lures for the critics. And this is the mystery.

Why does he spend so much time spinning these theories? Why is he so much the architect of critical reaction to the house? Why has his private space been made into the object of thirty years of public, even global speculation? In controlling the reaction to his house, he is designing himself in architecture.

Before the house, Gehry was, as he is fond of saying, "in the service business,"[52] designing shopping malls for developers and other nondescript buildings for institutional clients, "straight stuff," as it has been called[53] to differentiate it from his more experimental designs for private clients. And then there was the house, the project that he built for himself and that in turn "built" him.

What the house really is, then, is the launching pad of a career. Like many of his contemporaries, and almost all of the twentieth century's most prominent architects, Gehry made it with a house. It is the house that builds the architect, not the other way around. It constructs the figure. Gehry is cannily aware of this: "The little jewel—a one-family house—can be a powerful instrument for ideas, and [to] get attention."[54]

52. Gehry, interview by Georgis, "Interview: Frank Gehry," p. 10.
53. Stephens, "Out of the Rage for Order," p. 80.
54. Gehry, quoted by Webb, "A Man Who Made Architecture an Art of the Unexpected," p. 51.

Index

Kneese de Mello, Eduardo Augusto, 134

Koolhaas, Rem, 16, 89, 118, 145, 192n

Koons, Jeff, 65, 90, 117, 159, 160, 171, 189, 222–23, 231, 233–35

Kopper, Hilmar, 117

Krauss, Rosalind E., 12, 248, 249–50

Krens, Thomas: auction houses and Wall Street, 151, 162–68; and Basque artists, 158–60; and Basque politics, 160–62; and Basque taxpayers' money, 151, 159, 163, 165, 202; and blockbuster exhibitions, 156–58, 206, 208n, 223–24; criticism of, before Bilbao Guggenheim, 23; education, 55–56, 112–13; financial crisis, 2002, 120–21, 167–68; and financial crisis of Guggenheim, New York, 113–15, 163; and franchise fee, from Basques, 23, 116, 148, 215; and Gehry, 152–54, 162, 222, 223, 257; global intentions of, 7–8, 16, 17, 56, 65, 112, 115–17, 119–20, 132, 147–50, 157, 186–88; and Guggenheim, New York, initial appointment, 16, 112, 113; and Guggenheim Bilbao, as seduction process, 64, 150–52; and Guggenheim Bilbao, beginnings, 115–17, 147–48; and Guggenheim Bilbao, control of, 8, 149, 151, 159, 163, 165, 202; and Guggenheim Bilbao, influence on building of, 220, 222, 224; Guggenheim manifesto, 190–91; "Krensification" process, 147–68; and Las Vegas, 113, 119, 157; lifestyle, 113, 164–65; management style, 55–56, 57n, 113–15, 162–68; and media hype for Guggenheims, 7, 82, 154–56, 257; and Messer, Thomas, 111–12

"Krensification," 8; auction houses and Wall Street, 162–68; and blockbuster exhibitions, 156–58, 223–24; defined, 147; and great local artists, 158–60;

and local politics, 160–62; media hype, as condition for, 154–56; ruination of place, as prerequisite for, 152–54; as seduction process, 150–52; and sexed-up buildings, 155–56

Kunsthistoriches Museum, Vienna, 88, 89, 119, 187

Kuntshalle, Bilbao. *See* Rekalde Exhibition Hall, Bilbao

Kursaal, San Sebastián, 199–200

Kwon, Miwon, 193

Laboratorio de tizas sculpture (Oteiza), 199

Lacy, Julie A., 23

Lamm, Robert C., 73, 79, 82

Lampugnani, Vittorio Magnano, 15

Lanfant, Marie-Francois, 62

Las Vegas Guggenheim, 8, 57, 113, 118, 120, 145, 157, 167–68. *See also* Guggenheim-Hermitage Museum, Venetian Resort-Hotel-Casino, Las Vegas

Law of Museums, administered by Basque Autonomous Government, 104, 109

Lawson-Johnston, Peter O., 113, 115

"Learning from the Guggenheim" symposium, Nevada Museum of Art, Reno (2004), 17–18

LeFrak, Samuel J., 115

Legge, Elizabeth, 144

"Le problème des musées" (Valéry), 10

Levine, Sherri, 218

Lewinsky, Monica, 115

Lewis, Peter B., 55, 115, 120, 164, 168

Lion Gate, Mycenae, 235

Lippard, Lucy, 18, 59–69, 187

Loos, Adolf, 267

Losada, Manuel, 99

Los Angeles County Museum of Art, 239

Lost Dimension, The (Virilio), 255–56

Lottery of the Sea, The (film work), 211

Louis, Morris, 248

List of Contributors

Jon Azua Mendia is chairman of Enovatinglab, a Bilbao think-tank organization focused on strategy, competitiveness, and regional development. He has served the Basque government as deputy prime minister (1991–95), minister of industry and energy (1991–95), minister secretary of the presidency (1987–89), and minister of health and labor (1985–87). He is a former member of the Basque Parliament and former CEO of the Bilbao Stock Exchange. He was a recipient of the Eisenhower Fellowship in 1998. He is on the board of directors of various companies and is senior advisor to Bearingpoint, as well as various cities, governments, and corporations. Azua is the author of numerous scholarly publications. He has been a visiting professor for strategy, business, and government and industrial policy at several universities, including Monterrey Technical Institute, Deusto University, and Harvard. He also has been a member of the board of trustees of the Solomon R. Guggenheim Foundation since 1997. His last two published books are *Alianzas competitivas para la nueva economia: Empresas-gobiernos-regiones innovadoras* (2001) and *Netting Competitive Strategies* (2002).

Ery Camara is one of the main specialists in museology in Mexico. He has been vice-director of the National Museum of Anthropology, the Museum of Popular Culture, and the Virreinato National Museum and member of the National Institute of Anthropology and History of the National Council for Culture and the Arts. He has organized many exhibits, both artistic and ethnographic: El xoloiztcuintle en la historia de México, Xichitécatl, museo de sitio, Tepito, mito mágico albur del tiempo, Danzas y espejos del arco iris, Arte contemporáneo senegalés, and Ecos de reflejos. His publications include "The Language that We Share," "Mirando al Xoloitzuintle," *Africa hoy, arte animista*, and *Senegal, nuestro país, tradiciones culturales de las etnias*.

Beatriz Colomina teaches in the School of Architecture at Princeton University. She is the author of *Privacy and Publicity: Modern Architecture as Mass Media* (1994) and the editor of *Sexuality and Space* (1992), both of which won the International Book Award given by the American Institute of Architects. She is co-editor of *Dan Graham* (2001) and *Frank O. Gerhy: The Art of Architecture* (2003). Colomina is Samuel H. Kress Senior Fellow at CASVA—the Center for Advanced Studies in the Visual Arts—at the National Gallery of Art, Washington, D.C., where she is working on a book about the relationships between war and modern architecture.

Andrea Fraser's work has been identified as "institutional critique." Since the mid-1980s, she has produced site-specific performances, videos, installations, and publications for museums, foundations, and temporary exhibitions in the United States, Europe, and Latin America. She has taught at the Tyler School of Art, Cooper Union, UCLA, the Staedelschule, and at the Bard College Center for Curatorial Studies. Her performance scripts and essays have appeared in *Afterimage, Art in America, October, Texte zur Kunst,* and *Social Text.* A survey of her work to date appeared at the Kunstverein in Hamburg in the fall of 2003, and her collected writings will be published by MIT Press in 2005.

Jeremy Gilbert-Rolfe teaches at the Art Center College of Design in Pasadena, California. He has been awarded the National Endowment for the Arts Fellowships in painting and criticism, as well as a Guggenheim Fellowship in painting. Among his books: *Immanence and Contradiction: Recent Essays on the Artistic Device* (1986), *Beyond Piety: Critical Essays on the Visual Arts 1986–1993* (1995), *Art As a Philosophical Context* (1996), *Beauty and the Contemporary Sublime* (1999), and *Frank Gehry* (2002). He participated in *Sticky Sublime* (2001). Reputed critic, painter, and writer, Gilbert-Rolfe provides a critical reconsideration of the classical philosophical distinctions between beauty and the sublime.

Anna Maria Guasch is Professor of Art History and Art Criticism at the University of Barcelona (Spain). She is the editor of a series on contemporary art in Akal/Arte Contemporáneo (Madrid). Her recent publications include: *El arte del siglo XX en sus exposiciones: 1945-1995* (1997), *El arte último del siglo XX: Del postminimalismo a lo multicultural, 1968-1995* (2000). She is also the editor of *Los manifiestos del arte posmoderno: Textos de exposiciones, 1980–1995* (2000) and co-author of *Crítica de arte: Historia, teoría y praxis* (2003). She has been awarded the Espais Prize for Art Criticism (1998) and ACCA Prize for Art Criticism (2001). She has been a Visiting Fellow at Princeton, Yale, and Columbia Universities and a Visiting Scholar at the Getty Research Institute, Los Angeles.

Serge Guilbaut is Professor of Visual Arts at the University of British Columbia (Vancouver). His main field of interest is postwar American and French history, including the history of postwar Franco-American relations in relation to art. His publications include *How New York Stole the Idea of Modern Art* (1983), published also in French, Spanish, Polish, and German; *Sobre la desaparición de ciertas obras de arte* (1995). He is co-editor of *Modernism and Modernity* (1983), *Reconstructing Modernism: Art in New York, Paris, and Montreal, 1945–64* (1990), and *Théodore Géricault. The Alien Body: Tradition in Chaos* (1997).

Hans Haacke moved to the United States in 1961. He taught at Cooper Union from 1967 to 2002. His works have been included in Documenta and the Biennials of Venice, São Paulo, Sydney, Tokyo, and Johannesburg and the Whitney Biennial, New York. A renowned conceptual artist, he conceives his work as a critique of the politics of art and the ideologies of culture. One of his most well-known works, *Shapolsky et al. Manhattan Real Estate Holdings, A Real-Time Social System as of May 1, 1971,* exposed the malpractice of

Harry Shapolsky's real-estate business and caused Haacke's April 1971 exhibition at the Guggenheim to be cancelled. Among his latest exhibitions are *The Last Picture Show: Artists Using Photography, (1960–1982)*, *Berlin-Moskau-Berlin 1950–2000*, *A Simple Plan*, *Dreams and Conflicts: The Dictatorship of the Viewer*, and *Antagonismos*.

Lucy Lippard is an art critic, theorist, and political activist (she prefers "cultural critic"). She is the author of eighteen books on subjects ranging from Pop Art to Native American art. Her theorizing reaches into all realms of art. Her texts offer new ways to understand the social and political impulses that create art, which art, in turn, creates. As one of the earliest contemporary feminists, she brought the aesthetic, economic, material, and practical concerns of women artists into the art-historical dialogue. Her most recent book, *On the Beaten Track: Tourism, Art, and Place* (1999), unpacks the cultural voyeurism implicit in the act of "going sightseeing."

Dean MacCannell received a Ph.D. in development sociology from Cornell University. He is currently a faculty member of the Department of Environmental Design and Landscape Architecture at the University of California, Davis. His book *The Tourist: A New Theory of the Leisure Class* (1976) is the canonical work in the interdisciplinary field of tourism studies and has been translated into several languages. Among his other notable publications are *The Time of the Sign: A Semiotic Interpretation of Modern Culture* (1982, co-authored with Juliet Flower MacCannell) and *Empty Meeting Grounds* (1992), a selection of his essays on tourism and community development. He is presently writing a book called *Landscaping the Unconscious*.

Keith Moxey is the Ann Whitney Olin Professor of Art History at Barnard College and Columbia University in New York City. He is the author of books on the historiography and philosophy of art history, as well as on sixteenth-century painting and prints in Northern Europe. His publications include *The Practice of Persuasion: Politics and Paradox in Art History* (2001), *The Practice of Theory: Poststructuralism, Cultural Politics and Art History* (1994), and *Peasants, Warriors, and Wives: Popular Imagery in the Reformation* (1989). He is also co-editor of several anthologies: *Art History, Aesthetics, Visual Culture* (2002), *The Subjects of Art History: Historical Objects in Contemporary Perspective* (1998), *Visual Culture: Images and Interpretations* (1994), and *Visual Theory: Painting and Interpretation* (1991).

Antoni Muntadas is a visiting professor of art at the Massachusetts Institute of Technology. He has taught and directed seminars at the University of California, San Diego, the Ecole des Beaux Arts in Bordeaux and Grenoble, the San Francisco Art Institute, the Ecole National de Beaux Arts de Paris, the Cooper Union in New York, and many other institutions. He has received several prizes and grants, including those of the Guggenheim Foundation, the National Endowment for the Arts, and the New York State Council on the Arts. His works haven't been exhibited throughout the world: the Venice Biennale, Documenta VI and X in Kassel, the Biennale de Lyon, the Museum of Modern Art in New

York, the Berkeley Art Museum in California, the Museo Nacional Centro de Arte Reina Sofia in Madrid, and the MACBA in Barcelona.

Allan Sekula is a photographer, writer, and critic. His published books are *Photography Against the Grain, Fish Story, Geography Lesson: Canadian Notes,* and *Dismal Science,* with *The Traffic in Photographs* forthcoming from MIT Press. Sekula has been described as a pioneer in what is usually called "social realism." His photographs most often focus on people engaged in political or economic struggles or on iconic structures as part of his exploration of global economic systems. As a theorist, Sekula had pleaded in the late 1970s for a reinvention of documentary techniques. His work has been shown in solo exhibitions at the Folkwang Museum in Essen, the Vancouver Art Gallery, the University Art Museum at Berkeley, the Witte de With in Rotterdam, the Moderna Museet in Stockholm, the Tramway in Glasgow, Le Channel and the Musée des Beaux Arts in Calais, Camerawork in London, the Munich Kunstverein in Munich, the Palais des Beaux Arts in Brussels, P.S. 1 in New York, and the Henry Art Gallery in Seattle.

Javier Viar Olloqui is the director of Bilbao's Fine Arts Museum. He was one of the members of the committee of experts that served as consultants to determine the artistic policies of the Bilbao Guggenheim. Besides his long involvement as a board member for Bilbao's museum and as a councilor for the Basque government, Viar is known for his literary and essayistic publications (ten books), as well as his extensive work as an art critic in the main Spanish newspapers and art journals (over a hundred articles). He has curated several art exhibits, is a frequent lecturer, and is a regular participant in conferences and debates on art.

John Welchman is Professor of Art History and Theory at the University of California, San Diego. He works at the intersection of the history, theory, and practice of visual arts. He is the author of *Modernism Relocated: Towards a Cultural Studies of Visual Modernity* (1995); *Invisible Colours: A Visual History of Titles* (1997), and *Art after Appropriation: Essays on Art in the 1990s* (2001). He is co-author of *The Dada and Surrealist Word Image* (1987) and of *Mike Kelley* in the Phaidon Contemporary Artists series (1999), as well as editor of *Rethinking Borders* (1996). He has published in *Artforum, Screen, Art + Text, Third Text,* the *New York Times,* the *International Herald Tribune,* and other journals and art catalogues. With Mike Kelley, he has co-authored *Foul Perfection: Essays and Criticism* (2002) and *Minor Histories: Statements, Conversations, Proposals* (2004).

Joseba Zulaika received a Ph.D. in cultural anthropology from Princeton University. He is currently the director of the Center for Basque Studies at the University of Nevada, Reno. He is the author of a dozen ethnographic books on Basque culture, art, and politics. On Bilbao's Guggenheim, he has published several articles, as well as *Crónica de una seducción* (1997) and *Guggenheim Bilbao Museoa: Museums, Architecture, and City Renewal* (2003).